Masters of Caricature

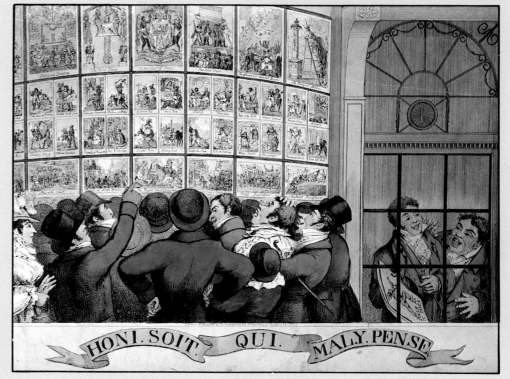

ABOVE *George Humphrey's print shop in St James's Street,*
12 August 1821, by Theodore Lane.
ENDPAPERS *Detail from an etching by William Hogarth (1697–1764).*
FRONTISPIECE *'Three of Society's intelligentsia' by Sem (Georges*
Goursat, 1863–1934): (left to right) caricaturist Leonetto Cappiello,
writer and traveller Francis de Croisset and playwright Paul Hervieu.

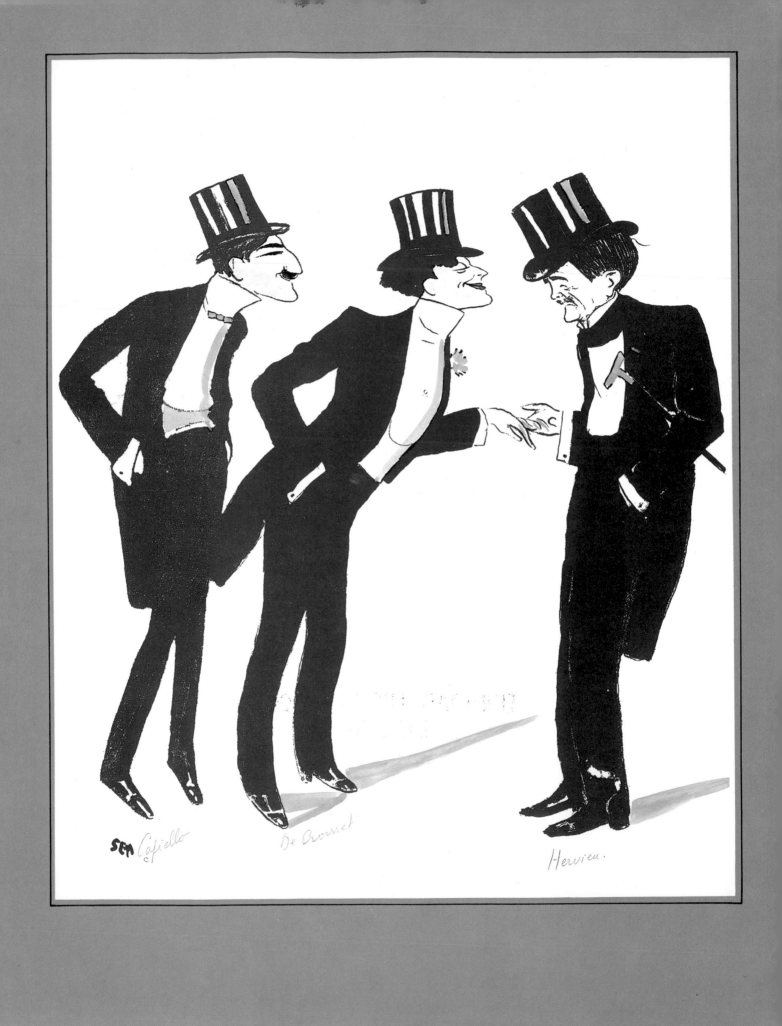

Masters of Caricature

from Hogarth and Gillray to Scarfe and Levine

Introduction and commentary by
William Feaver

Edited by
Ann Gould

Alfred A. Knopf
New York 1981

Library of Congress Cataloging in Publication Data
Feaver, William
Masters of caricature
Includes Index.
1. Caricatures and cartoons. 2. Wit and humor,
Pictorial. 1. Title.
NC1340.F4 1981 741.5′9 81–47020
ISBN 0–394–50904–B AACR2
Manufactured in Hong Kong
First American Edition

Publishers' Note

The word 'caricature' derives from the Italian *caricare*, meaning 'to load' or 'to surcharge'. By 1755 the word was included in Dr Johnson's first dictionary: 'Caricature: *v.* to hold to ridicule. . . . A drawing . . . intended as humour, satire and comment'. For the purposes of this book we have taken caricature to mean the art of the distorted representation of particular people rather than of general types. Problems of definition and classification arise partly because many caricaturists are also cartoonists, and also because most humorous drawings contain an element of caricature. Broadly, those selected for this book are practitioners of the art of portrait caricature or *portrait-charge*.

The caricaturists, with their known dates, appear in approximate chronological order, depending on the period during which they produced their most significant work; as many of them worked for several decades, however, the order cannot be absolute. The length of each artist's entry should not necessarily be seen as a judgment of their relative importance; usually it merely indicates how much is known about them.

The sequence of entries is occasionally interrupted by a commentary written by William Feaver on the important movements in the development and history of caricature. The entries themselves have been compiled by a group of international authorities, listed below. In addition, the publishers and editor would like to thank Keith Mackenzie for his initial work on the conception of the book and for his advice on contributors and the compilation of the list of artists to be included, as well as for his great help in the collection of illustrations; and Germano Facetti, Draper Hill and the Paul Mellon Centre for Studies in British Art for their general help and guidance.

Contributors

The biographical entries in this book have been written by a number of contributors, without whose specialist knowledge it would have been impossible to achieve such a wide coverage of the subject. The publishers are particularly indebted to the editor, Ann Gould, who has written the majority of the entries on British caricaturists; and would like to express their gratitude to the following people who have contributed entries, for their research and invaluable advice: Gunnlaugur S.E. Briem (Royal College of Art, London), David Cuppleditch, Professor Rosette Glaser (University of Mulhouse), John Jensen, Susan Lambert (Assistant Keeper of Department of Prints and Drawings, Victoria & Albert Museum, London), Vane Lindesay, Keith Mackenzie, Professor Roy Matthews (University of Michigan), Terry Mosher, Doreen O'Neill, Professor Charles Press (University of Michigan), Bernard Reilly (Curator of Prints and Photographs Division, Library of Congress, Washington DC), John Wardroper and Frank Whitford (Homerton College, Cambridge).

Contents

7

Introduction

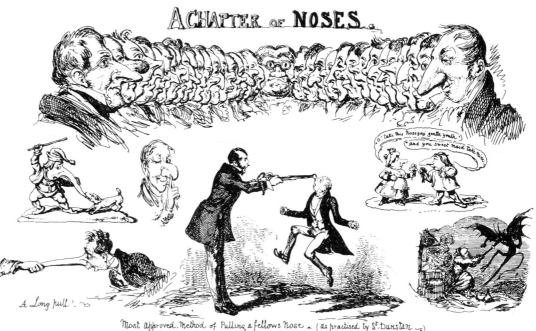

George Cruikshank's variations in My Sketch Book (1833–36) play on a rich caricature theme, the nose. He has included a portrait of the Duke of Wellington (thirteenth from left in top row) and three self-portraits (far left in top row, tipping a wink, and standing, centre).

THE CARICATURIST is getting his own back. Feet together, legs braced, he leans forward slightly and, using tongs as tweezers, grips the offender by the nose and lifts him clean off the ground. This is George Cruikshank's way of making it absolutely clear that, no matter what he says, the snivelling pipsqueak William Kidd is not, in fact, his publisher.

'Most Approved Method of Pulling a fellows Nose' is the centrepiece of a page headed 'A Chapter of Noses' in *My Sketch Book*, published by the artist himself and issued in nine parts between 1833 and 1836. Cruikshank was then in mid-career. Having spent nearly thirty years at the beck and call of publishers and printsellers ('I had to work for others instead of them for me, and my motto was "At It Again"'), his patience had worn thin. So he gave Kidd the sort of treatment he and his father Isaac before him, and James Gillray, had so often dished out to Napoleon Bonaparte. 'That's the Way to Do It!', as Punch repeatedly squawks when laying into the Wife, the Law, the Preacher and the Hangman. The Publisher can only clench his little fists, gasp and tread air, as he dangles at the mercy of the unyielding Caricaturist.

By 1834, when Cruikshank staged this particular comeuppance, there was no longer much of a market for scurrilities such as he had supplied on demand during the Regency era. A great transition was taking place in terms of style and publication, a shift from broadsheet to periodical, from etching to lithography and wood engraving. Cruikshank himself veered from pictorial satire to comic illustration and burlesque.

My Sketch Book was a display of virtuoso etching, a compendium of puns, asides and observations, served up as family entertainment. Each plate represented Cruikshank's off-the-cuff thinking on a topic. Thus 'A Chapter of Noses' proves to be something

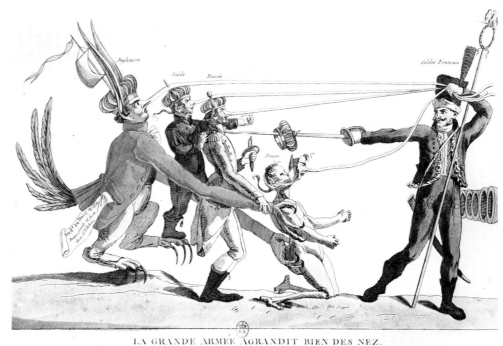

LA GRANDE ARMÉE AGRANDIT BIEN DES NEZ.

An anonymous French propaganda print ridiculing George III who, it implies, is forcing a coalition of European powers into conflict with France. The ass's ears, turkey's tail and prescription from Dr Willis recall his recurrent madness.

between a revue and an iconography of The Nose in Caricature; an elaborate skit, a treatise in miniature.

The baiting of Mr Kidd demonstrates the crude pillory approach. Cruikshank was so pleased with this method of caricature retaliation he used it again, many years later, on another publisher, 'Brooks alias Read', who committed a similar offence. Even in 1834 the idea was far from original. As he indicated in one of the vignettes that surround the nose-pulling operation, it derived from a legend he himself had already illustrated ten years before in *Hone's Every-Day Book*:

> *St Dunstan, as the story goes,*
> *Once pull'd the devil by the nose*
> *With red-hot tongs, which made him roar,*
> *That he was heard three miles or more.*

Most themes in caricature can be traced back into archetype and folklore. For example, the dwarf at bay on the left-hand side of 'A Chapter of Noses', stuck with a nose so long that he cannot fend off the dog worrying the end of it, comes direct from one of Cruikshank's illustrations to Grimms' Fairy Tales, published as *German Popular Stories* in 1826. Old jokes never fail. Traditional personifications (wily fox, lustful goat) hold good. Devils, ogres, fools and twerps are unchanging.

Caricaturists harp on recognized routines, partly because this encourages the onlookers: the set-up is no sooner seen than understood. And with understanding comes connivance. Caricature is always Us against Them. The joke is shared; so is the hate. Watch out for *double entendres*: in 'A Chapter of Noses' a tap on the nostril from

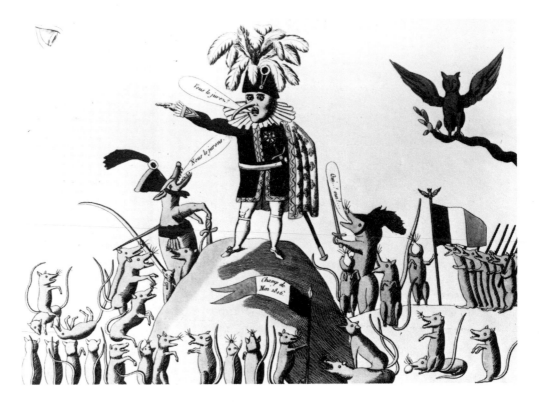

Napoleon, exiled to St Helena, is reduced to lording it over its only inhabitants – the rats. Anonymous French print, 1815.

The headpiece for Figaro in London, *a paper which attacked both the Whig government and the Tory opposition.*

a grotesque, Punch-like Cruikshank, a smirk and a leery wink, are enough to remind one that for 'nose' read 'penis' throughout. Caricature is riddled with sign language. Pinocchio's nose grows with every lie he tells. Cuckolds sprout horns, dupes are led by the nose. Fools stick their noses in the air and fail to notice the open manhole.

Across the top of Cruikshank's engraving runs a frieze: the 'Chapter of Noses' proper. The artist himself is first in line, ready for inspection. His features are rather more swollen and distorted than when dealing with the wretched Kidd, but less so than when tipping us the wink. He remains the straight man, the escort, the epitome of no-nonsense, the standard by whom all the rest are measured. They are a bizarre lot, a complete range of nasal types, reading from left to right: bottle nose, prig nose, barrister beak and so on round to the thirty-third and last, an amazing port-and-snuff specimen, a nose of noses, sticking out like an inflamed sugarloaf.

'A Chapter of Noses' is not only a show of versatility – everything from doodle to set piece – but also a play on 'correct' taste (as specified by drawing masters in copybooks) and a skit on the physiognomic analyses then fashionable. A system of classification is implied; noses, Cruikshank suggests, betoken personalities, just as the bumps on a man's head, interpreted by a phrenologist, spell out his true character.

At its most direct, caricature is the art of pulling faces, pummelling and tweaking them into shape. Public figures are set up, dressed up, then teased and assaulted. Robert Seymour, who provided most of the first caricatures for *Figaro in London* in 1831, probably devised the paper's emblematic headpiece, a representation of the satirist/caricaturist at work. Figaro, the valet turned barber, strops his razor. At his feet runs the maxim:

> *Satire should, like a polish'd razor keen,*
> *Wound with a touch that's scarcely felt or seen.*

Figaro lathers his subjects; takes them by the nose to hold the face still and draws the blade lightly down the cheeks. He dresses wigs, attends to his 'blockheads' – Wellington, Brougham, Grey and the rest – entertains them with small-talk, then

laughs in their faces. In 1832 both Philipon, the founder of *La Caricature* (a model for *Figaro in London*) and his most promising young caricaturist, Honoré Daumier, were imprisoned for Going Too Far. No harm in a bit of fun, the authorities have always tended to argue in these cases; but overstep the mark and caricature becomes subversion. Figaro the Barber of Seville turns into Sweeney Todd the legendary Demon Barber, cheerfully slitting each customer's throat and then tipping the bodies through a trapdoor into the meat pie factory below.

Philipon disposed of King Louis-Philippe by transforming him into a pear. Daumier drew him as Gargantua on a commode and got five months for it. Caricature, it can be argued, is only truly successful when it stings enough to bring about a rash of graffiti copies (as did 'La Poire'), charges of 'bad taste', a *cause célèbre*, and at least a token term of imprisonment.

In England, theoretically, there was licence to berate Government and Opposition alike. The *Figaro*'s editor, Gilbert à Beckett, instructed his caricaturists Seymour and Heath ('Paul Pry') to represent politicians as pantomime, farmyard and Punch & Judy characters. 'Wellington may be considered the stock Punch of the country, both on account of his bullying, blustering and butchering propensities' You could tell he was Punch by his hump-back and counterbalancing nose. And that he was Wellington, no less, because of his hawkish profile, as seen thirteenth from the left in Cruikshank's 'Chapter of Noses'. Wellington was second only to Napoleon as leading player in early nineteenth-century caricature. His authoritarian nose featured in John Doyle's vapid 'Political Sketches'. It jutted odiously in radical penny woodcuts, such as those by C. J. Grant in *The Political Drama*. A nose with which to smite the downtrodden, a nose garlanded with the wild words of Wellington's toast to his cronies: 'Here's Rory Tory Boys, Brigands, Bishops, Butcheries, Brutalities, Barbarities, Bastiles, Bludgeonmen, Bullets, Bayonets, Bloody bones, and Bombshells'.

These are the easy targets: skittle-alley blockheads ripe for splattering with invective. The right of Grant and others to insult at will was essential to the rude

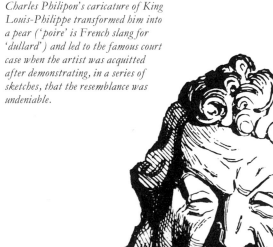

Charles Philipon's caricature of King Louis-Philippe transformed him into a pear ('poire' is French slang for 'dullard') and led to the famous court case when the artist was acquitted after demonstrating, in a series of sketches, that the resemblance was undeniable.

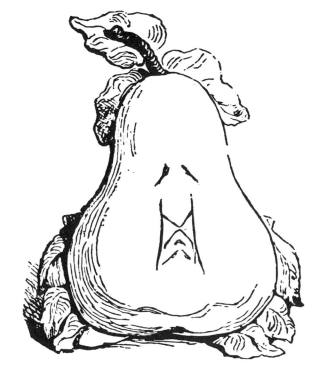

health of caricature. The artist's immunity was that of the Fool or Court Jester. In graphic images, in mime and quip as it were, he could be more adroit than any writer. Outspokenness landed the likes of Cobbett and Hunt in jail and led to Cruikshank's pamphleteer publisher William Hone being charged with blasphemy. Caricaturists, like blackmailers, were harder to nobble.

Some of them could, of course, be bribed. 'I'll buy 'em *All* up, D— me!', as Cruikshank had the Prince Regent cry in one of his more flagrant *double entendre* designs in his 1819 series, *Royal Hobby's*. Sure enough, a year later the Royal Household approached Cruikshank with just such a deal. But he no sooner came to an arrangement (£100 'in consideration of a pledge not to caricature His Majesty in any immoral situation') than he dodged it. He decided to show the former Regent not actually sinning but making amends, standing on a stool in church to do penance for his innumerable adulteries.

The Free born Englishman, whom Cruikshank had depicted the previous year in chains, weeping, hands tied behind his back, mouth padlocked, thereupon shrugged off his bonds and sniggered. John Bull, Houdini-like, was himself again. In those Gag Act years, when Hone and Cruikshank likened Wellington to a scorpion, poised to sting any who dared question the edicts of Rory Tory rulers, caricature spelt defiance.

The Free born Englishman, together with animal companions such as the British Bull-dog and his even more conceptual associates Justice, Death and Peace, were

One of the Penny Political Prints, crude and vigorous wood-cuts by Charles Jameson Grant (w.1831–46), leading propagandist of the Radical Press. In this attack on the Establishment, William IV sits between Whig and Tory ministers, each of whom toasts his own interests – all of which had been served, Grant suggests, by the recently passed Reform Bill, falling far short of Radical demands. (Left to right) Lord Chancellor Brougham, Whig leader and Prime Minister Earl Grey, the King, ex-Tory Prime Minister Wellington and a stereotype bishop.

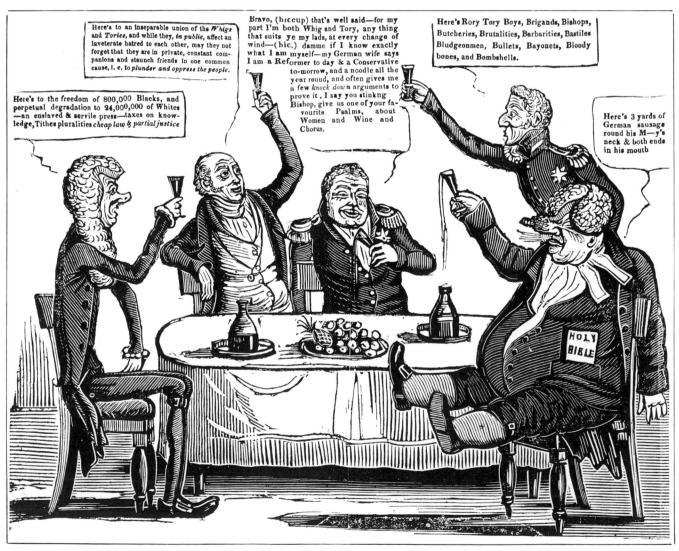

useful types for the political caricaturist. But true caricature is not the formulation of such symbolic, synthetic beings; it is concerned with the comic or monstrous potential of real people. Take Gillray's 'Wierd Sisters; Ministers of Darkness; Minions of the Moon', published in 1791 (see page 55). The subject is ostensibly political, the cover story Shakespearian, the manner mock-Baroque, a variation on that starkest form of chiaroscuro, the 'Keepsake' silhouette. In this Coven of Noses, three Tory ministers – Dundas, Pitt (third from the left, you may have noticed, in the Cruikshank 'Chapter of Noses') and Thurlow – anxiously observe the emergence of Queen Charlotte as the power behind the throne while George III drifts into lunacy; they are dreading what will befall them if the Prince of Wales takes over as Regent. The silhouette had been popularized by Johann Kaspar Lavater in his *Physiognomische Fragmente* of 1775, in which he had expounded a system of using it to read character; his methodology had become something of a parlour game. To caricaturists, needless to say, it was nothing new. They had always based insinuations on length of nose, curl of lips, forehead gradient, excess chin or chinlessness. As far as they were concerned, chaste profiles, whether silhouette, cameo or on medallions or coins of the realm, were sitting ducks just waiting to be picked off and violated.

The permissible extent of the violation had already been carefully considered in 1743 by William Hogarth, who went to great lengths to distinguish between Characters and *Caricaturas*, or the likeness and the skit. In a print designed as a subscription ticket for

One of George Cruikshank's series on the peccadilloes of the Royal Family shows the Prince Regent tiring of his mistress, Lady Hertford, who sits astride him on the newly invented velocipede, nicknamed the Hobby. The figure in the background, his brother, the Duke of York, was also a subject of scandal.

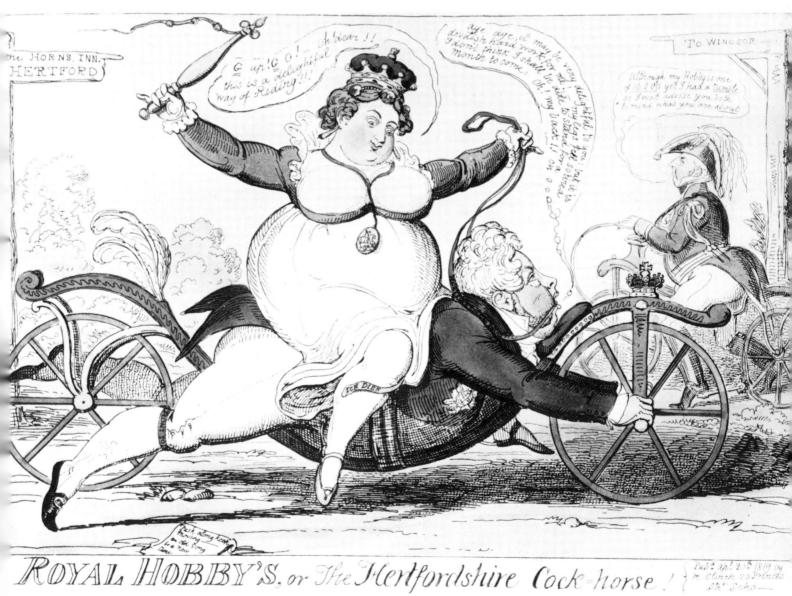

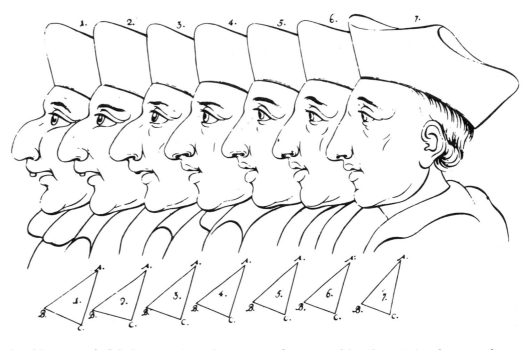

An illustration from Johann Kaspar Lavater's Physiognomische Fragmente *(1775), a treatise linking facial types with character traits.*

his *Marriage à la Mode* engravings, he presented an assembly of men's heads, everyday varieties above, specimens from Raphael below, together with grotesques drawn by Leonardo, Annibale Carracci and Pier Leone Ghezzi. 'For a farther Explanation of the Difference Betwixt Character & Caricatura', Hogarth referred readers to the preface of *Joseph Andrews* (a novel by Henry Fielding which was itself calculatedly Hogarthian in style), in which the author discusses the respective strengths of portrait painting, pen portraits, the comic sketch and the caricature: 'Now what *Caricatura* is in Painting, Burlesque is in Writing; and in the same manner the Comic Writer and Painter correlate to each other. ... He who should call the Ingenious *Hogarth* a Burlesque Painter, would, in my Opinion, do him very little Honour; for sure it is much easier, much less the Subject of Admiration, to paint a Man with a Nose, or any other Feature of preposterous Size, or to expose him in some absurd or monstrous Attitude, than to express the Affections of Men on Canvas.'

The wigged heads herded together in Hogarth's engraving amount to a Chapter of Characters. These are the tradesmen, lawyers, parsons, clerks and schoolmasters who endure such vicissitudes in Fielding's writings and Hogarth's own narrative works. Far from being shadow puppets, they are the leading figures in his home-grown style of History Painting (also his audience: every one of them is a potential subscriber). Hogarth scorned *Caricatura* as frivolous. It struck him as being an essentially foreign art, inimical to his determinedly unpretentious, defiantly British attitudinizing: '*Caricatura* is, or ought to be, totally divested of every stroke that hath a tendency to good Drawing. ... Let it be observed, the more remote in their Nature the greater is the Excellence of these Pieces; as a proof of this, I remember a famous *Caricatura* of a certain Italian Singer, that Struck at first sight, which consisted only of a Straight perpendicular Stroke with a Dot over it'

Caricatura, then, was for the virtuosi, the hoodwinkers, those whose weapon was the pen:'Je n'ai point de sceptre mais j'ai une plume,' as Voltaire boasted.

Hogarth drew John Wilkes in that sort of role, holding court. Wilkes had been arrested for implicitly insulting George III in print; his acquittal was a popular triumph, much to the annoyance of Hogarth, whose treatise *Analysis of Beauty* (1753) and conduct (as no longer an exponent of 'manly satire') had been witheringly criticized by Wilkes in his periodical, *North Briton* no. 17. 'Drawn from Life', Hogarth emphasized, to show that his view of the man, sly and blatantly opportunist, was not

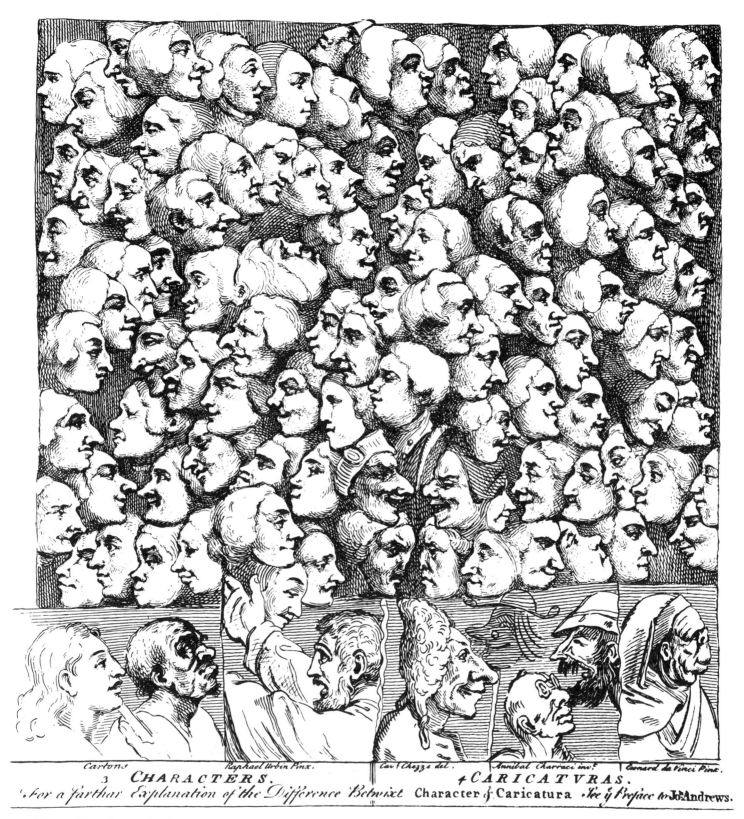

Cartons | Raphael Urbin Pinx. | Cav.^r Chezzi del. | Annibal Charraci inv.^t | Leonard da Vinci Pinx.

3 CHARACTERS. 4 CARICATVRAS.

For a farthar Explanation of the Difference Betwixt Character & Caricatura See y.^e Preface to Jo.^h Andrews.

William Hogarth's engraving of 1743 illustrates the distinction between 'characters' and 'caricaturas'. In this print, designed as a subscription ticket to his Marriage à la Mode *series, he drew on Italian models to advance his argument.*

ABOVE *John Wilkes, whom Hogarth had sketched in court in 1763 when Wilkes was on trial for insulting the King.*

RIGHT *Pier Leone Ghezzi's portrait of a leading Italian merchant, c.1740s.*

caricatura but reportage. Sir Joshua Reynolds, the politest painter of the age (no mean caricaturist himself), was equally caustic about Wilkes: 'His forehead low and short, his nose shorter and broader, his upper lip long and projecting, his eyes sunken and horribly squinting' To him, Wilkes was the opposite of the flushed military commanders, the peers of the realm and literati who attended his studio for portrait sittings. He was an ungainly brute, a libertine, a scribbler. A prime example of the *Monstrous*.

Hogarth's preliminary sketch of Wilkes and his published etching, in which the emblems (a Liberty cap and copies of his offensive publications, *North Briton* nos. 17 and 45) are fully elaborated, bring together two traditions of caricature. His portrait can be said to be 'divested of every stroke that hath a tendency to good Drawing'. There is no elegance or stylishness about the way Wilkes slumps in his chair, no hint of that serpentine 'Line of Beauty' Hogarth had identified in his *Analysis* as the moving force that animates all good composition. Deliberately lumpen, Hogarth's image of his enemy is as much a broadsheet riposte as a sneering artistic *divertimento*. One of the rogue's squint eyes is trained on the pulpit, as it were, the other on the artist's easel.

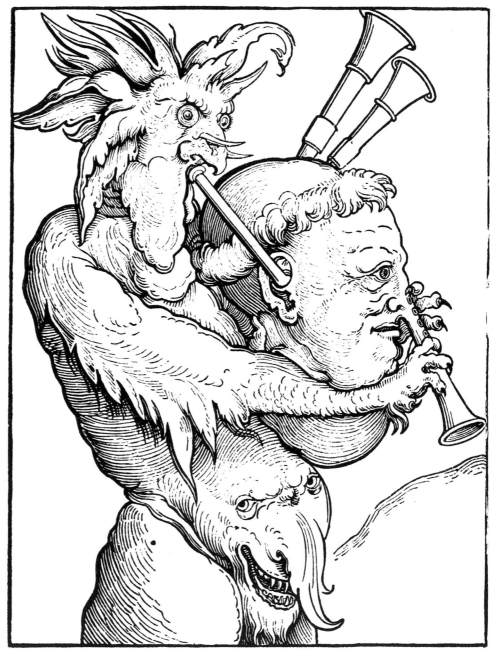

From the pulpit come ritual denunciations, the very stuff of polemical caricature, thundering down the centuries. Instead of elaborate figures of speech – 'The whore of Babylon' and suchlike – spelt out in sermons, in printed caricature from the sixteenth century onwards there is violent graphic abuse: the pulling of Roman noses, the bundling of Pope and Cardinals in full regalia, idols, encyclicals, mistresses and all into Hell's mouth. Or, from the Counter-Reformation propaganda press, visions of the many-headed monster of heresy being broken on wheels, licked by flames, put to the sword and consigned to everlasting torment. Here kings are paraded as martyrs (the sainted Charles I) or grossly humiliated (Charles II has his nose put to the grindstone by the Calvinist Scots). The body politic is represented as a whale, disgorging putrescent Jonahs. Kingdoms become middens whereon fox bishops preach to geese. The pamphleteer–caricaturist enters a conspiracy with his reader; both know what is signified by each emblem and gesture. Everything conforms to code. As Gulliver discovered in the Kingdom of Tribnia – evidently a land of caricature – the artists there would 'decipher a Close-stool to signify a Privy Council; a Flock of Geese a Senate; a

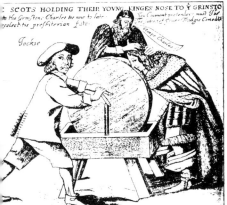

lame Dog, an invader; the Plague a Standing Army; a Buzzard a Minister; the Gout a High Priest; a Gibbet a Secretary of State; a Chamber Pot a Committee of Grandees; a Sieve a Court Lady; a Broom a Revolution'

The broadsheet and frontispiece caricatures based on such analogies assumed a common knowledge not so much of the real appearance of those represented as of the symbolic positions they occupied. Luther, for example, was the monk in the pulpit, decked out as either a fount of wisdom or a raving anti-Christ. Characters were concocted from allegory, nicknames, Old Testament similes and sheer prejudice. In the perpetual struggles everybody conformed to type: haloes for some, or laurels; for the rest, squints, hunchbacks, obesity, gout – outward manifestations of their moral deformities. Hogarth's reprisal on Wilkes is a combination of stock abuse and personal attack. The distinction between 'character' and 'caricature' is bridged, as observation fuelled by grudge is worked up into diatribe.

Raphael (and Hogarth) on one side; Ghezzi, Carracci and Leonardo (as caricaturist) on the other. What Hogarth is demonstrating in his assembly of heads is the lack of probity in the grotesque: 'The more remote in their Nature the greater is the excellence of these Pieces.' Yet here, in the *caricatura*, the caricature as character-study, as shorthand reaction, was invented. 'A Straight perpendicular Stroke with a Dot over it' stood for a singer. Elongated noses, blubbery lips, scrag necks, wrinkles and carbuncles distinguished the creations of the studios of late seventeenth-century Bologna and Rome. The practice spread. Indeed, the urge to guy those the portrait painter normally had to observe and paint in all seriousness was irresistible. Ghezzi, Bernini, Ricci and others made fools of their sitters. Their private amusement caught on: burlesque became all the rage. Milords with cuckold horns, ladies with absurd adornments, swollen bellies, bloated faces, spindle shanks and ponderous backsides paraded through the *caricatura* albums. Here, as in Restoration comedy, as in *opera buffa*, characters took on the dimensions of fops and boobies. The thin were made skeletal, the fat were impossibly distended. The courtiers fawned, the scolds raged, the villains strutted. These were people such as Lemuel Gulliver who, to a Lilliputian friend, appeared 'a very Shocking Sight. He said he could discover great Holes in my Skin; that the Stumps of my Beard were ten Times stronger than the Bristles of a Boar; and my Complexion made up of several Colours altogether disagreeable'. The

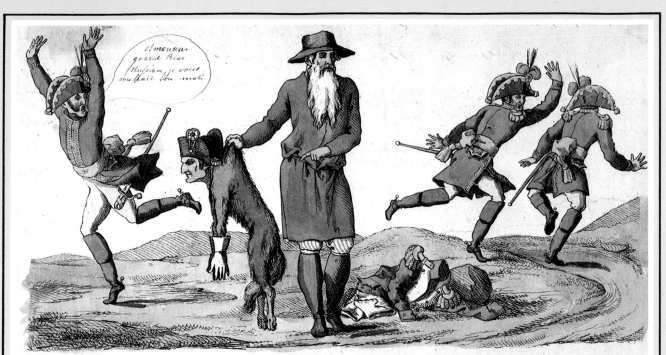

ПАСТУХЪ И ВОЛКЪ.

Радуйтесь пастухи добрые! уже бы больше не потерпите недочету въ вашихъ овечькахъ; зверь обнаруженъ. Онъ былъ страшенъ только тѣмъ, которые не умѣли за него взяться. А я попросту, какъ въ старину бывало: принаровилъ, схватилъ, и какъ хочу, такъ теперь его и поворочу.

Иванъ Теребенѣвъ.

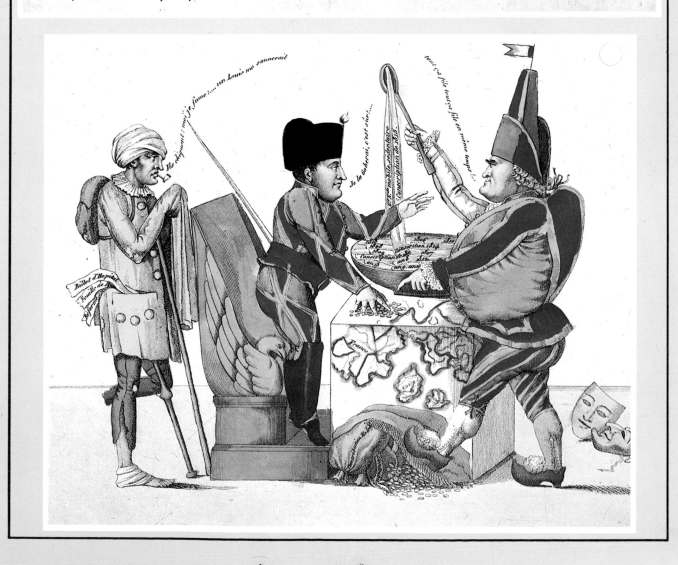

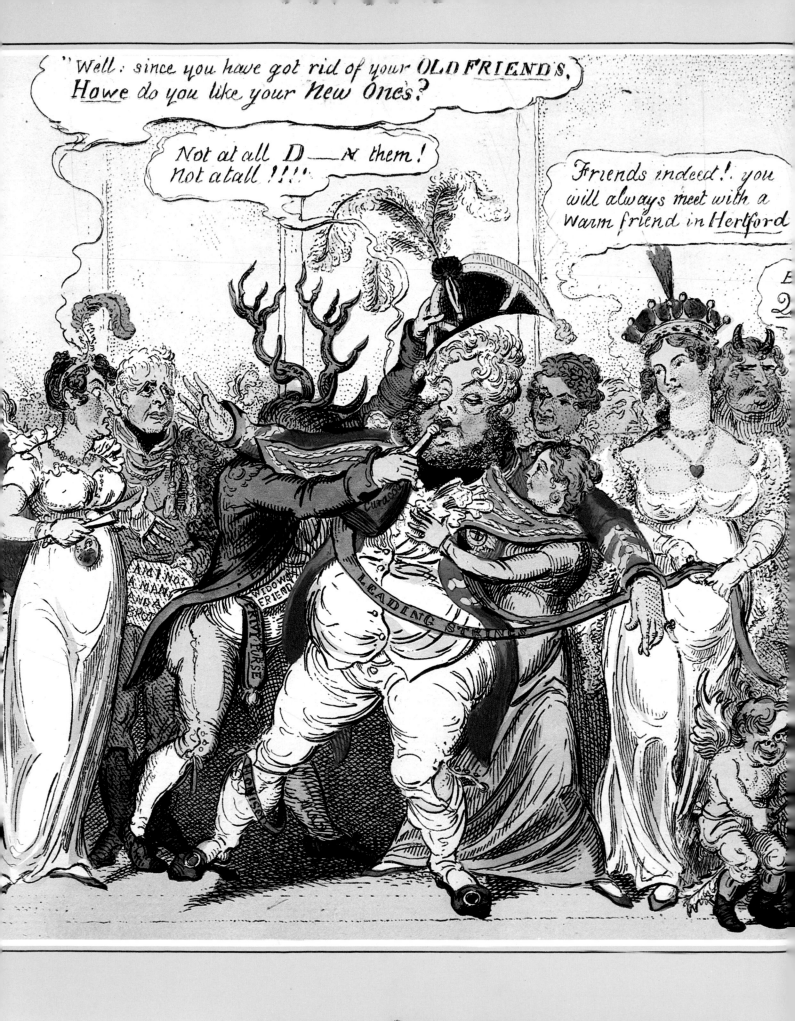

exaggerations of scale and temperament meant that anyone singled out for the treatment was bound to be made a freak.

This in itself is a form of flattery. No one is ordinary: drones are transformed into adventurers, tongues are loosened, self-satisfaction takes over. Furthermore, the tendency in comic personality drawings is always to bring out the characteristics of a man in such a way that he becomes more recognizably a coterie notable. The ability to take a joke against oneself has always been said to be the test of a good club member. To be caricatured, not for publication but for private circulation, could thus be taken as a mark of esteem.

Whereas in broadsheet caricature the personages were characterized by uniforms, badges, tools of trade or staffs of office together with famous distinguishing features – Pitt's gimlet nose, Napoleon's pigmy stature – in *caricatura* there were likely to be signs of direct observation. The tilt of the head, the fatuity of the grin, the limpness of wrist and style of wig now become all-important. Besides, if the artist was normally employed in the portrait business, delegating much of the work to assistants, the impromptu sketch, the doodle showing what he really felt about the client, was likely to be not just more direct but more perceptive. These shadow figures of lords and singers, pimps and retainers flit past the heirloom portrait, the discreet conversation piece, the usual representations of polite society, at home or abroad. Familiar in literature and gossip-mongering, they are startling in the field of fine art, almost unthinkable in works from the studios of the leading practitioners.

Sir Thomas Lawrence, for instance, who took infinite pains to achieve the sheen of satins, the requisite glint of the eye and fold of the neckerchief, was even more reliable than Sir Joshua Reynolds as a stately-portrait businessman. He invested the Prince Regent with the good looks of Adonis, the fearsome majesty of Mars. But turn to James Boswell, Dr Johnson's confidant, as seen by Lawrence in *caricatura* style (see page 52), and the virtuosity changes. The sideline caricature – the artistic diversion – advances in status. Here at least Hogarth's suspicion of all ventures into '*outré*' character-sketching proves unfounded. The jabbing finger, the ridiculous stub nose, the flounces and jowls and bags under the eyes, the clubman's wheezy bearing, add up to the best portrait that exists of the master-biographer.

In a closed society caricature such as this amounts to idle entertainment or backbiting. The qualities are very much to do with baring and tickling. Fashions are shown to be absurd, what with towering head-dresses and ill-conceived *décolletages*. The beau-monde is held up as a nest of fools and scolds. Antonio Zanetti's Venetian society, Bunbury's Londoners and Parisians, Kay's Edinburgh worthies, Goya's Spanish court, Lord Townshend's fellow-nobles are all members of an order of dupes and butts. Sometimes the amusement gives way to outrage. Politics come to the fore, scandal flares up. But the emphasis remains amateur. These are caricatures done for the initiated; indeed it can almost be assumed that the subject himself was likely to be the first to see how he had been treated.

But the differences between Goya, say, and Townshend, Kay and Zanetti were such that their work has practically nothing in common beyond acerbity. Some were light-hearted satirists; others gouged and scoured. And behind the work of many, from Rowlandson to the Carracci brothers, lay ambitions that classification as 'comic artists' could only frustrate.

Annibale Carracci, later cited by Hogarth as one of the *caricatura* men, protested against the quick dismissal of his skills:

Is not the caricaturist's task exactly the same as that of the classical artist? Both see the lasting truth beneath the surface of mere outward appearance. Both try to help nature accomplish its plan. The one may strive to visualize the perfect form and to realize it in his work, the other to

OPPOSITE *A detail from George Cruikshank's 'Princely Predilections, or Ancient Music and Modern Discord', 1 April 1812. The caricature followed the Regent's assertion, justifying his change of support from the Whigs – his 'old friends' – to the Tories, that he had 'no predilections to indulge' in political matters. The cuckold on his right and the woman on his immediate left are Col. John McMahon, his private secretary, and Mrs McMahon. His present mistress, Lady Hertford, holds his leading strings; behind her are Mrs Fitzherbert, his former mistress, and Lord Hertford.*

Three examples of the burlesque form of portrait caricature that Hogarth disdained: (right) Bernini's delightful portrait of the captain of the Papal Guard of Pope Urban VIII; (far right) Marco Ricci's portrait of a Venetian notable; (below) his uncle Sebastiano Ricci's portrait of Ranuccio il Farnese, Duke of Parma, all three done c.1680.

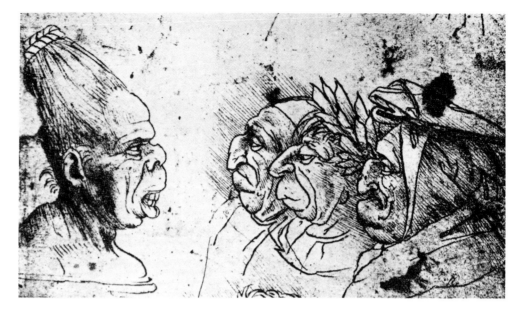

These heads by Leonardo da Vinci show how closely Renaissance artists based their drawings of grotesques on observations of disease and deformity.

grasp the perfect deformity, and thus reveal the very essence of a personality. A good caricature, like every work of art, is more true to life than reality itself.

To see in a glance, to penetrate the cover, to perceive by intuition, these are the qualities Carracci regarded as essential to the sprightly side of his art. His frescoes made his prestige reputation, the Farnese Gallery being one of the greatest decorative schemes of the High Renaissance; but his caricature drawings speak more clearly to us. They are 'true' because they are not studied, reworked, subjected to the processes of redefinition and refinement, from sketch to palace wall. Equally, the caricature is the means whereby standards of beauty, theories of proportion, are assessed.

The grotesques that leer from Leonardo's notebooks are mutations of the classical ideal. Starting with the correct human proportions, carefully ascertained ('From the chin to the nostrils is a third part of the face; and the same from the nose to the eyebrows'), he proceeded to manipulate. To express anger, for example, he advised: 'Let him have his hair dishevelled, his eyebrows knit together, his teeth clenched, the two corners of his mouth arched.' This is as much emblematic as symptomatic anger. But, moving beyond dumb show, Leonardo set himself the task of analysing facial expression in precise detail: 'When the lateral muscles pull, so shortening themselves, then they pull behind them the lips of the mouth and so the mouth is extended. . . .'

The toothless ancients gape. Not for them the *gravitas* of Roman funerary busts: they purse lips or cackle. 'Mona Lisa' smiles faintly. A scenario for caricature is established: observation – remark – reaction – laughter.

Leonardo, though, was not consciously contriving a species or sub-category of art called '*caricatura*'. Comic art, like wood-cut polemic, was none of his concern. His studies of grotesque humans were akin to zoological drawings; from physiognomy, exhaustively classified, sprang the conventions of caricature as a comedy of manners. Yet it is also a language of line. Hogarth recognized the comic similarities between children's drawings and the rapid strokes of a spontaneous *caricatura*. It was important not to labour the joke, not to polish it up or rely too heavily on ornamental accessories. The approach had to be predatory: each notion stalked, seized and set down in a twinkling. The alternative, the elaboration of conceits, as in Archimbaldo's visages composed of mixed vegetables, often resulted in witless intricacy.

Cruikshank's 'Chapter of Noses' can be regarded as a synopsis of both the *caricatura* tradition, from Leonardo's grotesques onwards, and the scolding, feuding conventions that stretch back through Hogarth engravings and Protestant wood-cuts

('Maddened the Pope with these pictures of mine, have I!', Cranach crowed) and droll misericord carvings to the primeval origins of farce. Such themes as the nose-pull, the leg-pull, the poke of the pitchfork and the Janus-headed double-take have remained in constant use, particularly in comic strips and cartoon films.

The *portrait-charge* or loaded likeness, on the other hand, developed in two ways. Firstly, it came to dominate the peepshow scenes – encounters between emblematic figures and politicians (e.g. Napoleon III as Harlequin propositions an outraged Britannia) – that became the most renowned feature of *Punch*. Secondly, it flourished in the personality-cult publications of the mid-nineteenth century onwards, *Vanity Fair* for a start, then picture-papers, gossip columns and, latterly, fan magazines.

Portraits-charges have always required a special tone, intimate but not necessarily friendly, informal but not casual, a bedside, levee, manner. The venomous aplomb of a James Gillray was unsuitable. Besides, his labour-intensive copper engravings, slow to make, slow to print, quickly worn out, were unusable in publications like Philipon's *La Caricature* and *Le Charivari*. These contained wood engravings – which could be incorporated with the letterpress – and, of far greater importance, lithographs. The latter technique enabled the artist to think in terms of the *portrait-charge*, working rapidly, drawing directly on the lithographic stone, thus getting his images reproduced without limitation or undue intervention. Grandville, Gavarni and, above all, Daumier so exploited the medium they made it the basis of a whole vignette genre of caricature.

Daumier's lithographic style was careful to begin with. The protagonists would be isolated on the page, tightly organized and detailed; but his confidence grew, his handling loosened up. The crayon lines ripened, became faster, more animated. He had continual demands to meet, output to sustain. Between 1832 and 1872 the cartoons poured forth: overweening justices, domestic tyrants, con men, drudges, Louis-Philippe the Citizen King, Louis-Napoleon with his false airs, and his ardent, rabid, ludicrous supporter, the archetypal tearaway Bonapartist 'Ratapoil'.

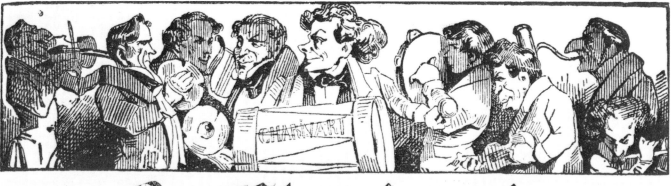

Le Charivari,

JOURNAL PUBLIANT CHAQUE JOUR UN NOUVEAU DESSIN.

ABOVE *Daumier's headpiece for Philipon's journal,* Le Charivari, *launched in 1830, includes portraits of Philipon (centre), Daumier (fourth from right), Traviès (second from right) and Grandville (far right).*

OPPOSITE *Napoleon III's remark to Britannia refers to France's invasion of Italy in 1859 to help the Italians under the Piedmontese premier, Cavour, regain northern Italy from the Austrians, in return for Nice and Savoy.*

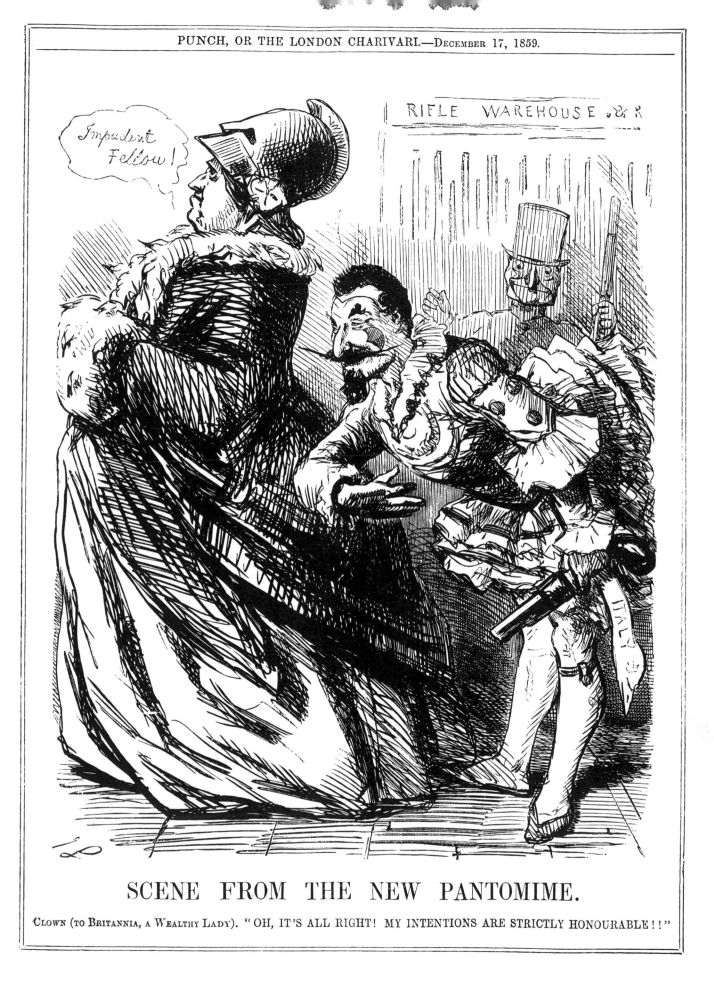

SCENE FROM THE NEW PANTOMIME.

Clown (to Britannia, a Wealthy Lady). "OH, IT'S ALL RIGHT! MY INTENTIONS ARE STRICTLY HONOURABLE!!"

Ratapoil was one of the characters Daumier modelled in clay, the better to visualize him before adding him to the list of *Charivari* celebrities. He also made a bust of the Comte d'Argout, Louis-Philippe's Minister of Arts and Public Works and, in his view, the most absurd politician of the age. The shaping of his 'M. D'Argo' was not unlike the sorcerer's practice of making statuettes of selected victims and sticking pins into them. Daumier hollowed the cheeks, hunched the back, ran his fingers along the nose, squeezing gently to lengthen it to an ultra-Wellington, almost Cyrano de Bergerac, beak, then added a matching chin, a vapid smirk and a pair of ears like footprints trampled into the oafish skull.

When the clay Minister emerged for the first time as a lithograph in *La Caricature*, his smirk altered to a condescending leer, Philipon created an accompanying heraldic device: censor's scissors rampant behind a severed nostril. Daumier then spent five months in prison. Following his release in 1833 he did a full-length d'Argout, laying further emphasis on the nose and drawing attention, for the first time, to the flat feet and sagging girth. Then, in 'Le Ventre Législatif', a special large print designed to help pay fines and legal costs, he showed the Minister seated in the Assembly, third from the right in the front row, surrounded by other cheats and boobies. A government ruled, he suggested, by its bellies.

When censorship was re-imposed under Napoleon III, Daumier was obliged to concentrate once again on picaresque and purely social subject-matter. The overweening individuals were supplanted for a time by *rentiers* and the *petit-bourgeois*, people romanticizing in dreary *quartiers*, enduring discomfort in third-class railway carriages, disputing the grocer's bill. Here the *portrait-charge* and the comedy of manners are brought together, not in the vitriolic, cock-a-snook Gillray style, but in more subtle, humane ways. Daumier's Paris is also Balzac's and Zola's. There is much chiaroscuro. The chalk lines flicker and trail away into the dark. Footlights glare upwards, suffusing chins, pinpointing noses. The symbolic light of Truth, Freedom, The Press (and especially *La Caricature*) blanches all it falls on. A blank, neutral light silhouettes the raddled yet heroic figures who play out the disasters of the Franco-Prussian War, fervent to begin with, shrouded at the end. Ratapoil bites the dust.

The previous year, in January 1869, Benjamin Disraeli appeared as the first eminent personality to be caricatured in *Vanity Fair*. The artist was Carlo Pellegrini, the medium was chromolithography, and the success of this first of over two thousand weekly caricatures established the name of the magazine as virtually a synonym for a new breed of *portrait-charge*. Suddenly *Punch*, *The Tomahawk* and foreign equivalents such as *L'Éclipse*, not to mention *Le Charivari*, looked faded. But then *Punch* had never been chic, whereas *Vanity Fair*, serviced anonymously by some of the smartest wits in Society, exuded an exclusive air. It was like a club, membership 6d weekly. The caricatures were ideal for framing.

Soon smoking rooms and lawyers' offices throughout the British Empire were lined with Pellegrinis (signed 'Singe' or 'Ape'), Tissots ('Coïdé') and Leslie 'Spy' Wards. From Disraeli and Gladstone onwards, through to the First World War, the parade continued, a host of characters, some exotic, some notorious (Oscar Wilde, hand on hip), mostly, regrettably, merely worthy. They were all posed like platform speakers, addressing their public. Occasionally backgrounds were added: jockeys had patches of turf; foreign potentates were afforded appropriate props – harem dolls for Abdul Aziz, Sultan of Turkey, crushed peasants for the Tsar; *La France* in Marie Antoinette milkmaid costume as escort for an ailing Napoleon III, pictured in September 1869, immediately before his downfall.

Unlike Daumier's lithographs, these were not executed by the artist himself but worked up by chromolithographic craftsmen from the original watercolour drawings. The transformation from sketch to polished clarity was remarkable. It gave each

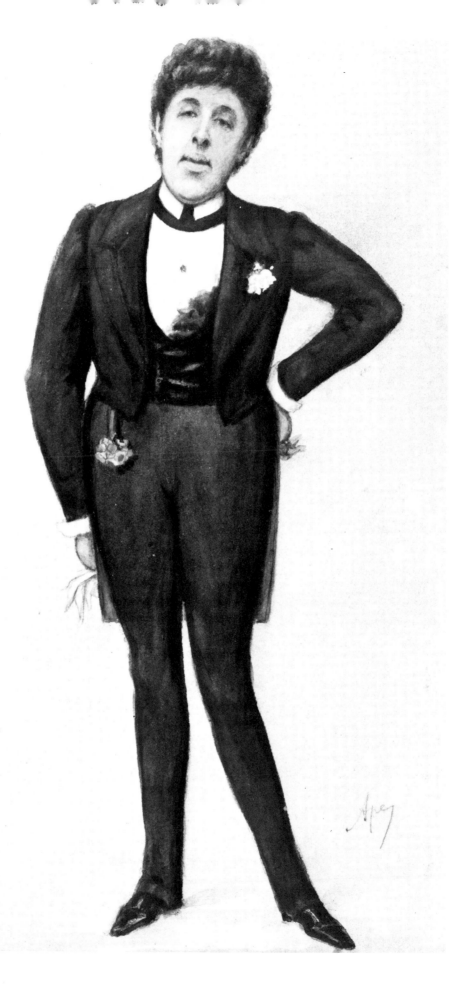

The playwright Oscar Wilde,
caricatured by Ape (Carlo
Pellegrini) for Vanity Fair *in 1884.*

Vanity Fair alumnus a whiff of house style: General Kitchener with his immaculately groomed hair; Keir Hardie, rumpled but clubbable; Tolstoy looking every inch a gentleman peasant; Beerbohm drawn by Sickert in the standardized fashion, uncannily dapper; Ruskin, his nose a–quiver as though about to sniff out the Snark.

The rise of *Vanity Fair* in the 1870s coincided with the development of process engraving. This made line reproduction a comparatively simple matter; sketchiness inconceivable in terms of commercial wood engraving now became a matter of course. Indeed, caricature styles from then on were increasingly insistent, what with wild, swirling penwork, unprecedented heights of exaggeration and copyright graphic idiosyncrasies. Anything to prove the caricaturist's unique eye and free hand.

Although photo-process was an undoubted boon, photography itself had been regarded as something of a threat or illicit aid to caricature. Photographic cartes-de-visite of celebrities standing poker-stiff between urn and salon backdrop could hardly be regarded as competition. Yet even these small images had insidious effects. They weakened the caricaturist's faith in his powers of observation. They provided a useful source of reference. Now people could get to know what their leaders really looked like, not dolled up for the portrait painter or dramatized in caricature.

The elderly Cruikshank found himself among the 'Modern Celebrities' on a page of heads pasted together, like Hogarth's 'Characters', in an album of *Photographic Groups of Eminent Personages*. He shared a page with seventy-eight others, including the Queen, Napoleon III (this was in 1869), Gladstone, Pope Pius IX, 'the late' Abraham Lincoln and 'the late' David Livingstone. Photography meant a reshuffling of the pack. Anybody could now be immortalized. Likenesses could be passed from hand to hand, sent through the post, propagated as never before.

In 1852 the caricaturist Nadar had planned a similar massed portrait, a 'Pantheon' comprising four enormous lithographs crammed with the heads of the most admired artists and artistes of the day drawn from his repertoire. He worked on it for two years and during this time took up photography, initially as an *aide-mémoire*. He photographed Daumier, who in turn drew Nadar photographing Paris from a balloon. There is also a photograph of him in this pioneer role, becalmed in his dangling basket in front of studio clouds. From certain angles (a fat man like Nadar shot from below, for example) a photograph could be said to have caricature qualities.

Nadar, Doré, Gill and, it may be assumed, practically all their colleagues found their outlook as makers of *portraits-charges* modified as a consequence of the coming of the camera. Those, like Gill, who specialized in bold, phantasmagoric close-ups of head and shoulders stuck on dwindling bodies became very much beholden to lens vision: anamorphic noses, swollen brows and nostrils, protruberant eyes, flyaway hair. They seized on photographic data, added their characteristic dash and thereby anticipated the art of candid camera; that is to say, clever shots of celebrities caught off-guard or in mid-laugh.

News photography and newspaper cartoons became viable more or less simultaneously, as the growth of a mass market for newspapers that resulted from the provision of universal elementary education in Britain, Germany, France and elsewhere in the 1870s brought with it a demand for pictures. The *Daily Mail* was launched in 1896, the *Daily Mirror* in 1904. Comic papers, such as *Tit-Bits* and *Ally Sloper's Half Holiday*, were already providing laughs for a public that fell outside the gentry readership of *Punch. Kladderadatsch, Le Journal Amusant, Le Rire,* and, from 1896, *Simplicissimus*, met rather more sophisticated readership requirements: politics spiced with innuendo and laced with sauciness. The business of daily papers, on the other hand, was to provide spontaneous coverage and quick reactions to occurrences. New formulae were needed for this.

The plate camera on its tripod had an appreciable effect on the staging of

In the Petit Journal pour Rire, *the cartoonist Marcelin pokes fun at the highly contrived settings of the portrait photographers' studios, as the craze for cartes-de-visite sweeps Europe in the 1860s.*

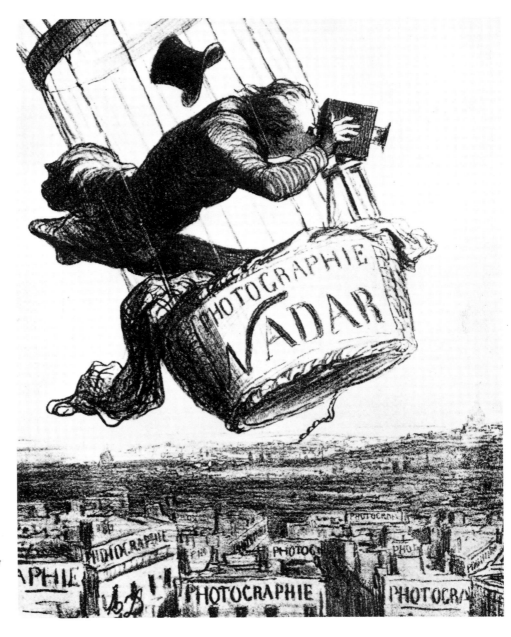

Daumier's lithograph of Nadar (Gaspard Félix Tournachon), who was best known for his influence on the development of photography but also became France's leading caricaturist, working for Philipon on Le Charivari *from 1847 to 1862.*

ceremonies, official arrivals and departures, débuts and cortèges. The photo-call became a recognized event. News photography shaped its own genres: the 'Historic Encounter', the 'Trail of Devastation', the 'Wedding of the Year' and the *deus ex machina,* or triumphant aviator alighting from his plane. Picture libraries were built up, files stocked with 'human interest' and 'leading figures': Members of Parliament, Chiefs of Staff, Society, City and Turf. Once again caricaturists faced challenge from the photograph. This time the threat was greater. The camera could now catch a man in any mood, and the image could be reproduced a million times in a matter of hours.

The newspaper caricaturists, however, had certain advantages. They could use their imagination. They were not tied to events. They had freedom to contrive incidents, both to flatter and to castigate. F.C.Gould, the first regular staff cartoonist on a paper (he was appointed to the *Pall Mall Gazette* in 1888), watched parliamentary business from the Press Gallery and drew his 'Picture Politics' according to his own notions, turning debates into battles or scenes from nursery literature . The caricaturist who operated as a day-to-day commentator had to rely on running gags, routine hyperbole: expressions of flabbergasted wrath, unrelieved cheerfulness. But Gould in the *Pall*

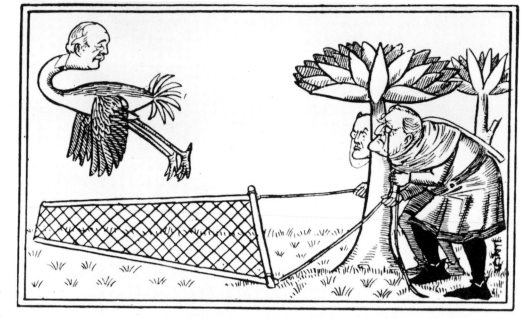

BIRD-SNARING IN HAMPSHIRE.

FCG (Sir Francis Carruthers Gould), who established the political cartoon in Britain's daily Press, shows Conservative Prime Minister Arthur Balfour in 1903 avoiding the issue of tariff reform that was to lead to his resignation two years later. The two politicians attempting to ensnare him are Austen Chamberlain and Sir William Harcourt.

Mall Gazette, and later in the *Westminster Gazette*, shared with his select – predominantly Liberal – readers certain assumptions. His leading characters were well known. He therefore had only to dress them up and present the issues in appropriate guises. He served as a promoter of political interests and, in a sense, as a maker of reputations. Caricature could be a help to the ambitious backbencher, a means of emerging from the crowd. So much so that Gould's colleague Harry Furniss made the not entirely jocular suggestion that it paid to cultivate a caricaturable appearance: 'My advice to young politicians is – be "eccentric" in dress, if not in address.' Successful men, he argued, had to be distinctive:

Prince Bismarck was, to the German caricaturist, what Mr Gladstone was to his English *confrère* with the exception that, whilst we in England always treat our politicians with a kindly satire, Germans are no exception to the other Continental caricaturists in being gross and malicious. Mr Gladstone's collar was merely a creation, dealing with an eccentricity of dress – it became a trademark; but the three hairs – the trademark of the Bismarck portrait in caricature –

'Getting Gladstone's collar up', by Harry Furniss. The winged collar was seized on by Furniss as a point of departure for many flights of fancy in his Gladstone caricatures.

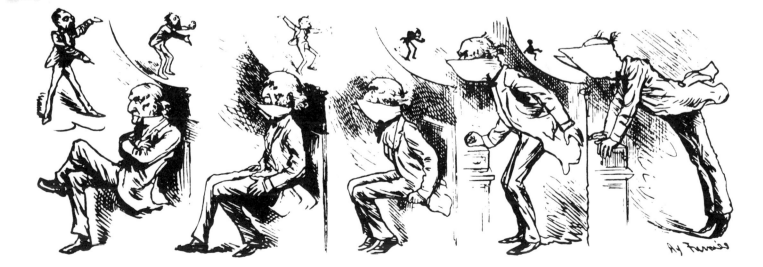

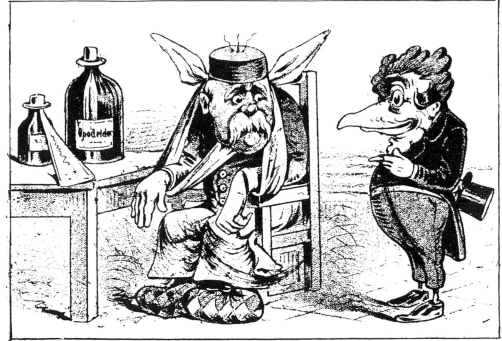

'Prince Bismarck's rheumatism', an anonymous Austrian caricature from Kikeriki, 1882, which plays on a pun in the German on arms and armaments, features the three hairs that so offended Harry Furniss.

were a libel on the great Chancellor's hirsute adornment, and drew attention to a failing of nature – very different from a mere eccentricity of the shirt-maker.

True, in an England where Queen Victoria was taken to be Britannia incarnate and where Edward VII was customarily depicted as a benign influence, stately in his bearing, 'kindly satire' was the rule. In the land of Wilhelm Busch, where devious schoolboys played tricks on animals and jokes tended to involve deep humiliation, *Simplicissimus* almost invariably showed Britannia as an imperious old frump and the King and Emperor as an obese lecher. Hostilities grew. In caricature diplomacy was soon exhausted. As the storm clouds gathered, John Bull rolled up his sleeves, the Kaiser stood firm. Here nationalist style was indistinguishable from country to country: Tenniel may have developed it in the first place, Nast, Scholz, Partridge and others furthered the show-down idiom. The Great War was waged in caricature with a notable unanimity of style: heavily crayonned threats, reproaches and calls to arms taking place on rocky isles, Patriotism, Valour, Victory and (to a lesser extent) Peace being invoked on all sides, under darkened skies.

In reaction against all that this type of war-effort cartoon stood for, Dada took hold in Zurich and Berlin, anti-Patriot, anti-official, anti-affirmative, anti-Fatherland. Post-war Dada represented a detestation of rhetorical draughtsmanship, of slick, portentous lithography, classical drapes and heroic stances. It also involved a ransacking and remixing of the arts. Cabaret, puppetry, soap-box oratory, typography, recitation, etching, photography, broadsheets, advertising matter, poetics, comic strips were entangled. George Grosz's barbed, cut-throat manner did away with polite fictions and the cultivation of technical qualities: 'For me art is not a matter of aesthetics,' he maintained. 'Drawing is not an end in itself without a meaning – no musical scribbling to be responded to or fathomed only by the sensitive educated few . . . against the brutality of the Middle Ages and the stupidity of people, drawing can be an effective weapon.'

Dada portraiture was all caricature: Raoul Hausmann's 'The Art Critic', for example, a figure composed of a photograph overlaid with rubber stampmarks, cut-out eyes and mouth and with a portion of a fifty-mark note stuck to his back, representing either a dagger or fairy wings. Grosz and Heartfield left no room for

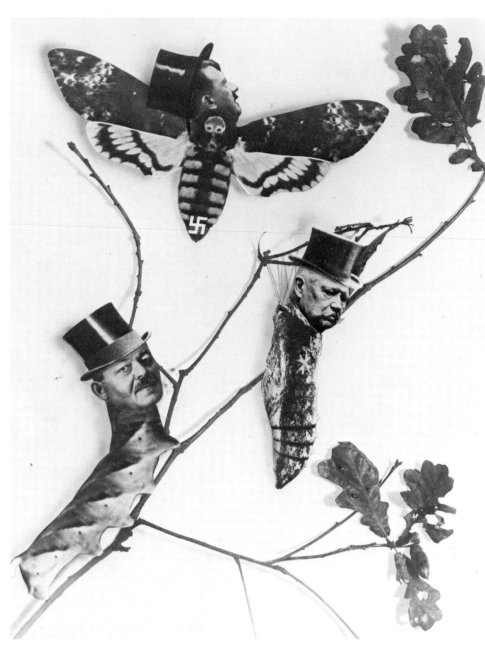

A photomontage by John Heartfield in 1934 of the metamorphosis of a death's-head moth, incorporating the heads of Germany's successive leaders, Ebert, Hindenburg and Hitler.

ambiguity. To them the Enemy was the Military, with duelling scars and vainglorious moustaches, the Industrialist, whoring all day while his workers slaved to make his profits, and the Bourgeois, whose only interests, it appeared, were petty bullying and compulsive greed. Grosz and Heartfield made puppets of those they detested. Heartfield went to elaborate lengths to concoct photomontages in which the villains of Weimar and the Third Reich were planted at the scene of the crime, armed with butcher's cleavers, drenched in blood as they slaked their foul appetites.

Art may not have been 'a matter of aesthetics' to the caricaturists and polemicists of Dada and the *Neue Sachlichkeit*. But, inevitably, the means proved to be as influential – in caricature circles and among artists and graphic designers in general – as the diatribal messages. In fact, once Grosz left Germany and settled in the United States his style, or rather his fine virulence, died away. 'There is very little scope in the noble art for mockery and taunts and a satirist's insinuations,' he wrote.

By snipping photographs to pieces and reassembling them in destructive manner, by plastering faces with slogans, by defacing masks and assaulting by means of graffiti,

Max Beerbohm's portrait of Major Esterhazy, the French army officer who forged the evidence that convicted Alfred Dreyfus in 1894.

33

Grosz and his colleagues restored to caricature the power to shock. They re-animated the language of scorn, put caricature back where it belonged: one foot on the sidewalk ready to trip the victim, the other in the gutter. Hitler, Heartfield showed, was a ranter sustained by a spinal column of deutschmarks. Grosz, Dix, Hoch and Hausmann all insisted that the loathsome deserve special treatment, that imagery is not enough. Caricature – even if it is labelled 'New Realism' – has to break all the rules of fair conduct. It must be merciless.

How different from the languid, dilettante impression a casual inspection of Max Beerbohm's drawings tends to create. But here too, the style is paramount. Each subject, whether celebrity, idol or literary lion, is reduced to a spectre. The treatment is alternative *Vanity Fair*. The amateur album is invoked. Personalities such as the Prince of Wales (failing to establish mutually agreeable lines in conversation with his mother, the Widow of Windsor, Queen Victoria), Kipling, Oscar Wilde and George Moore slither out of Pellegrini focus and into the dimmed, stunned world of Beerbohm. There is a complete change of emphasis, from public stage to private box.

It is assumed by Beerbohm that whoever looks through his pencillings will know all about Wilson Steer, Lord Alfred Douglas and the difference between Hardy-esque depressive rural realism, say, and Masefield melancholic rural realism. The clues are faint, the allusions discreet, not to say nebulous. But the Beerbohm drawing-room manner, with its carefully sustained effortless ease, its attenuations and gingerly watercolour washes, is a brilliant exercise of *caricatura* privileges. He who understands can consider himself something of an insider, a member of a charmed circle. The style is a guise. It shrinks the subjects, reduces them all to Beerbohm ciphers, to be fed with lines and put in situations where their vanities and weaknesses can be best exposed.

'Nothing,' Osbert Lancaster has written, 'not even women's hair-styles nor the music of the late Ivor Novello, dates so quickly as the apt comment.' In the age of

Beerbohm's self-portrait on a thank-you note to a friend, 1923.

'Mickey-Mouse', Karl Arnold's comment in 1931 on the changing nature of fame.

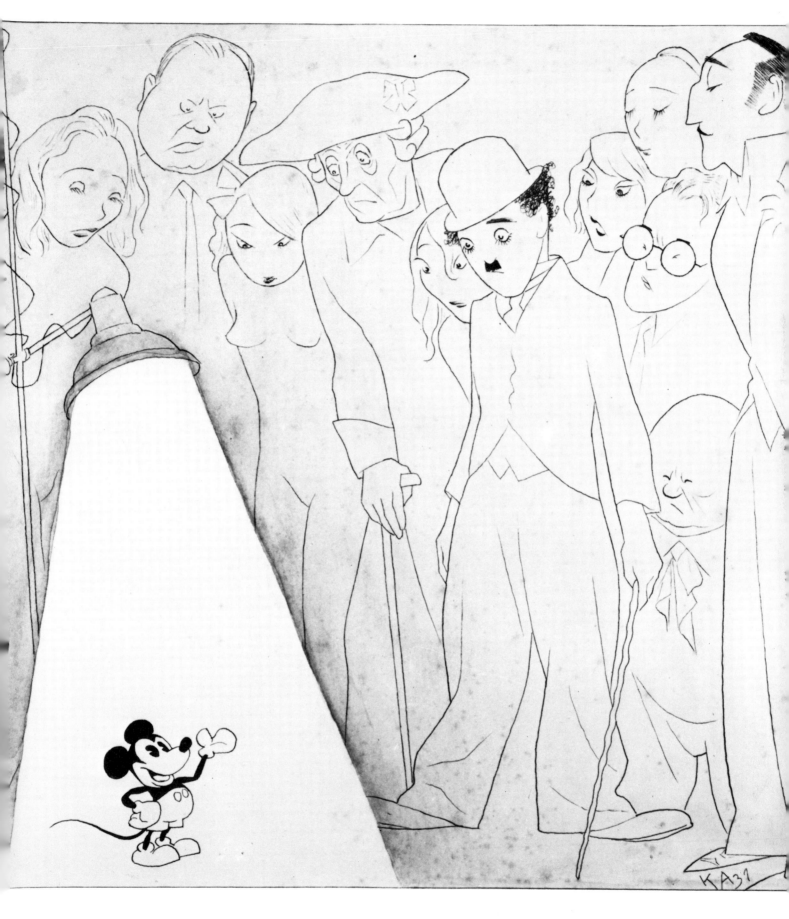

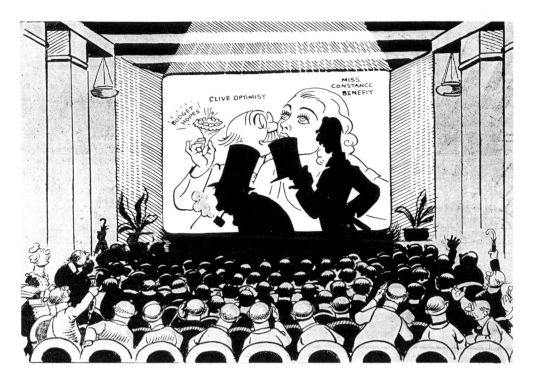

'Sit Down!', Sidney Strube's Daily Express *cartoon of Prime Minister Stanley Baldwin and Neville Chamberlain, 6 March 1933.*

psychoanalysis and the Social Sciences, caricature has been threatened both by accelerating topicality and unprecedented levels of self-consciousness. Heroes have changed. They come and go more rapidly than ever. Beliefs are more susceptible to challenge; images are more blatantly contrived.

The two mainstreams of caricature – the vicious attack (Cruikshank assaults the publishers; Grosz takes on the Weimar racketeers) and the cunning likeness (Beerbohm, like Ghezzi before him, dealing out glancing blows) – have both broadened and diversified. The art has been extended through the mass media, the catchphrase radio sketch, the impersonation. Television puppets vie with human 'Talking Heads'. Politicians are schooled by their media experts to project themselves as caricatures – that is, to be Statesmanlike, after the pattern of Nast's Abe Lincoln, or a Man of Destiny, like Churchill photographed by Karsh of Ottowa. Alongside them, Mickey Mouse gains credibility.

But these same figures get burnt, in effigy, outside looted embassies. They are vilified on wallposters. Redundant politicians are consigned to the waxworks melting pot. Aspirants have to be identifiable in caricature shorthand. The failures are the faceless ones, without even a pipe or a bag of peanuts for identification.

The Strube cartoon in the *Daily Express* of 6 March 1933 was primarily concerned with Budget hopes. But it happens to be an excellent illustration of the conflict of caricature species. The scene is a cinema. A romantic drama starring Constance Bennett ('Miss Constance Benefit') is unfolding. An audience entirely composed of reduplicated Strube 'Little Men' is restive. 'Sit Down!' they shout as the unmistakable silhouettes of Stanley Baldwin and Neville Chamberlain pass across the screen. Once again, 'Character and *Caricatura*' are at odds. A Little Man ('Clive Optimist') leans forward to kiss Miss Bennett, the Screen Goddess. The Idyll, however, is interrupted by the shadows of the Ridiculous, with their emblems (Baldwin's pipe, Chamberlain's umbrella) and their attributes (top hat: sign of the toff politician). Real shadow or romantic projection? In caricature both are essential, parody as well as archetype, mimicry and exaggeration.

'Strube is a gentle genius,' Stanley Baldwin remarked. 'Low is a genius but he is evil and malicious.' That is as it should be. The victim should not think too well of his

OPPOSITE *'Le régime parlementaire', a portrait of Napoleon III by Coïdé (James Tissot), the first in his series of* Sovereigns *for* Vanity Fair, *4 September 1869.*

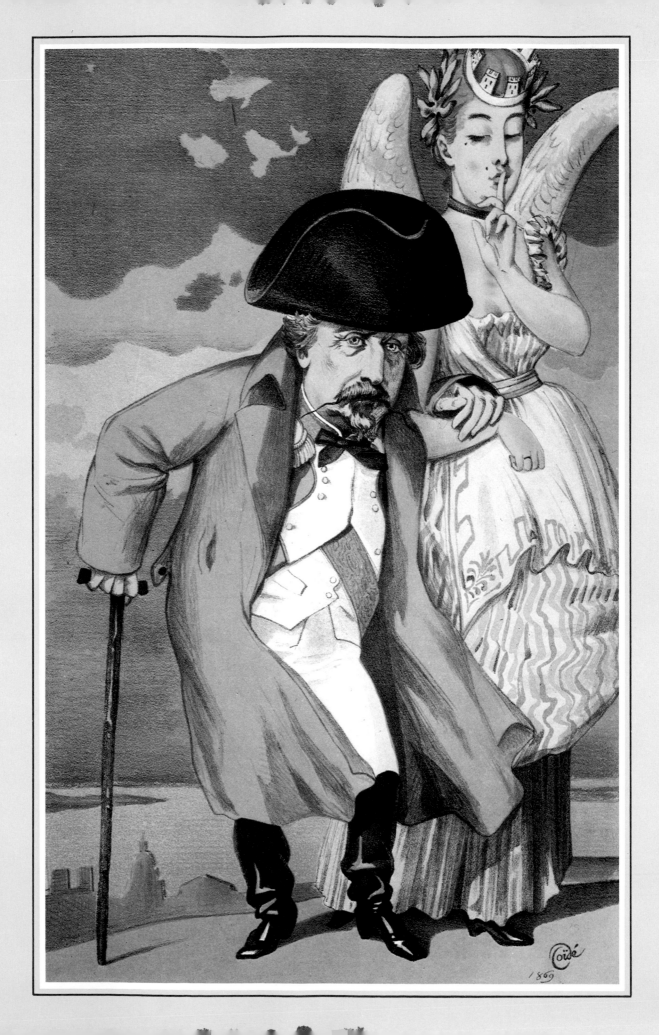

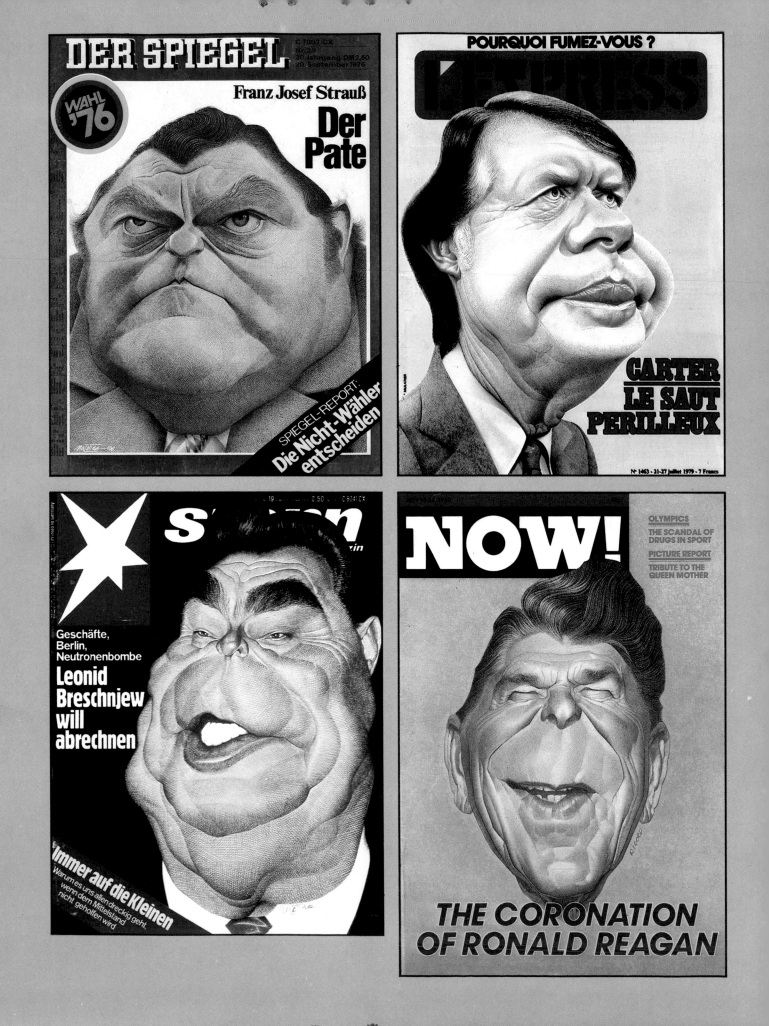

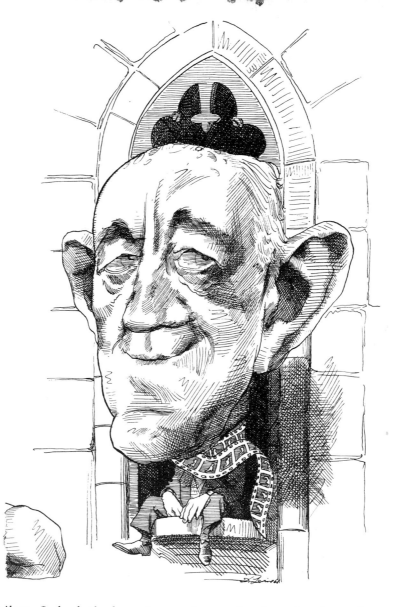

The actor Alec Guinness, caricatured by David Levine in the Daily Telegraph Magazine, *23 February 1968.*

assailant. Indeed, the besetting weakness of caricaturists down the generations has been their inability to renew their wrath and scorn. This is the reason why the difference between the situation-caricature and the *portrait-charge* remains so significant. An artist can do both – in fact he who cannot invent as well as portray is only half a caricaturist. But the essential skill is the power to grab someone by the nose and hold him there, wriggling on paper.

Photographs have their uses. Tradition supplies tested stances. (Where would David Levine be without photo-archives and his great exemplar, André Gill?) But the caricature instinct comes first. The types pass in lightning review, the prim, the pompous, the hamfisted, the sly, the self-satisfied. The caricaturist stores impressions, chapter after chapter of noses, mouths, complete expressions. The line skitters from forehead to chin and back again, jabbing as it goes, striking at the vain, tormenting the smug. Caricature is the quickest of arts and the most disconcerting.

Pier Leone Ghezzi
1674–1755

Ghezzi worked as an assistant in his father's studio in Rome before turning to illustration and portrait caricature in the Carracci tradition, a choice possibly made on the advice of Bernini. His own caricatures are noted for their vivacity and sketchy exuberance, rather than for profound draughtsmanship, but they gained wide circulation and great popularity in Rome, particularly among the English colony. The set of twenty-five caricatures after Ghezzi etched by Arthur Pond and published in England in 1744 were of major importance in setting the fashion for *caricaturas* among the nobility in England.

'A Travelling Govenour': a caricature of Dr Hay, 1737. The tutors who conducted young English noblemen on the Grand Tour were popularly known as bear leaders.

Dorothy Boyle, *née* Savile
1699–1768

Lady Dorothy Boyle, the heiress daughter of the Marquis of Halifax, was married to Richard, 3rd Earl of Burlington and 4th Earl of Cork. He was noted for his interest in architecture and design, and they had a wide circle of friends in the world of literature and the arts. After his appointment to the Privy Council, her own reputation as a patroness of music and an artist 'with a genius for caricature' may have led to her collaboration with the royal family's drawing master, Joseph Goupy, who helped her to etch the drawing below.

The lanky, arrogant Senesino and the dumpy songstress Cuzzoni sing a duet. Slumped in the chair is the Swiss impressario, Heidegger, who introduced Italian opera to London and was later appointed Master of the King's Revels.

Thou tunefull Scarecrow, & thou warbling Bird,
No shelter for your Notes these Lands afford
This Town protects no more the Sing Song Strain
Whilst Balls & Masquerades Triumphant Reign.
Sooner than midnight revels ere shoud fail
And ore Ridottos Harmony prevail.
That Cap (a refuge once) my Head shall Grace
And Save from ruin this Harmonious face

Joseph Goupy
d. 1763

A native of Nevers, France, while still a youth Goupy moved to London, where his two uncles were artists. He enrolled at Sir Godfrey Kneller's Painting Academy in Great Queen Street in 1711. An accomplished miniature painter, he worked in pastel and etched. In 1720 he was engaged to paint scenery for the Italian Opera at the Haymarket Theatre. Appointed Cabinet Painter to Frederick, Prince of Wales in 1736, he also advised the amateur artists at court. At the time of his death, 'at an advanced age', he was in receipt of a pension from George III.

'The Charming Brute', 1754 (detail). After a dinner given by Handel, who had apologized for the frugality of the meal, Goupy had observed his host in another room, seated at a table set with delicacies. He drew this as a result.

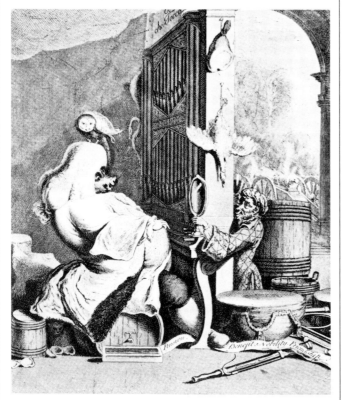

Thomas Patch
1725–82

Born in Devonshire, Patch spent most of his life in Italy. From 1747 onwards he studied in Rome under Vernet and achieved some success as a purveyor of genre scenes to Englishmen making the Grand Tour. He may also have met Ghezzi, whose influence is apparent in his caricatures. Expelled from Papal territories in 1755, possibly as a result of religious bellicosity, Patch worked thereafter in Florence, where his engravings of Florentine fresco cycles and good-humoured portraits and group-caricatures found great favour with the English collectors; Sir Joshua Reynolds and Horace Walpole were among his admirers.

 Patch's patron, Sir Horace Mann, described him as 'really a genius. . . . I took very much to him, and though he does not live in my house, he is never out of it a whole day. He has an excellent turn for caricature, in which the young English often employ him to make conversation-pieces of any member, for which they draw lots; but Patch is so prudent as never to caricature anybody without his consent, and a full liberty to exercise his talents.'

A notorious quack oculist, known as the Chevalier or Cavaliere Taylor, 1770.

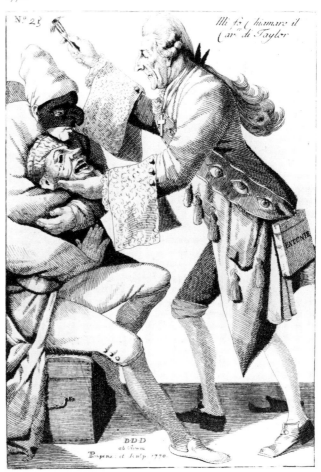

William Hogarth
1697–1764

Considered to be the father of English caricature, Hogarth was a 'history and portrait painter', independent of patrons, who sought to elevate humour to the rank of fine art. His career spanned the rise of the political satire, from the emblematic prints of the Dutch engravers at the time of the South Sea Bubble to the vogue for amateur and cheap coloured prints in the mid-eighteenth century.

Hogarth's early life was marred by hardship; his family lived in the Fleet Prison for four years with his father, a bankrupt teacher from the north of England. At seventeen, Hogarth became apprenticed to a silver engraver, copying 'monsters of Heraldry', after which he set up as an engraver of trade cards. His early satires dealt with the follies of investors and the 'taste of the town', deploring the influx of foreign actors and artists. He satirized the heroic subject, the classical props of the painters, the smoked canvas and pretensions of official portraiture. In 1866, Richard and Samuel Redgrave wrote of him in their *A Century of British Painters*: 'Began to think for himself! Here is the true master key . . . began to look at the world around him instead of at dark canvases, begrimed, botched, tinkered with . . . began to think that gods and goddesses had had their day, and . . . enough of saints and martyrs at second-hand . . . even Beer Street and Gin Lane might be made to teach better morality and fresher art. He grew so profane as to admire Nature beyond the finest productions of Art.'

Hogarth attended Vanderbank's Academy and Thornhill's Free Art School in Covent Garden, and eloped with Jane, daughter of Sir James Thornhill. His family groups and portraits have a broad freedom of brushwork and a directness which were rare at the time, and they failed to make his livelihood. He established himself by an enterprise

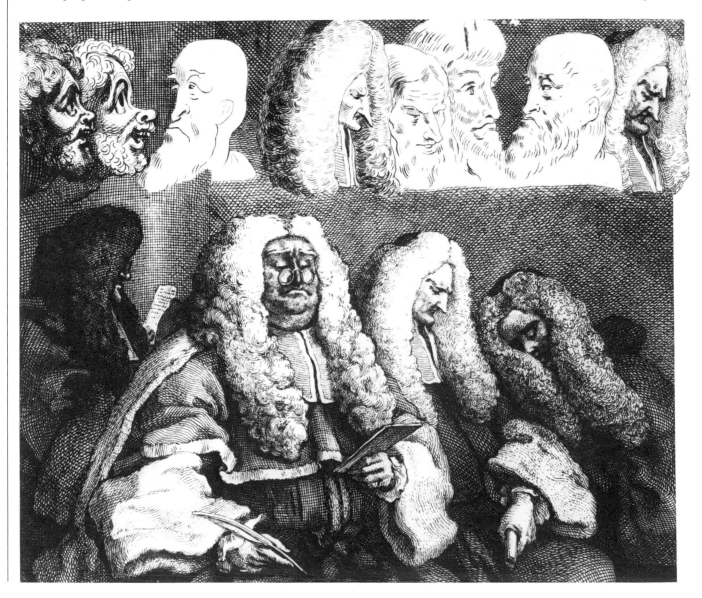

in publishing by subscription, which reached a wider public. In the narrative series of *Marriage à la Mode*, *The Rake's Progress*, *Industry and Idleness* and later themes engraved from his own paintings, he exposed social hypocrisy in contemporary settings of interiors and street scenes. A protagonist of social reform, he conceived his subjects with a moral purpose, as suitable and moderately-priced art for the new middle classes. His comedy was based on observations of character, and the satires were elaborate and complex allegorics. He despised the Italian *caricaturas* as trivia detracting from the ideals of art. His only party political prints, *The Times* (1762), stirred up such hostility from John Wilkes and his followers that Hogarth was harassed and persecuted for the remainder of his life. His friend Garrick intervened with Churchill, scurrilous writer of *North Briton* fame: 'I must intreat you by the Regard you profess to me, that you don't tilt at my friend Hogarth. ... You cannot sure be angry at his print? There is surely very harmless tho very entertaining stuff in it. He is a great and original Genius, I love him as a Man and reverence him as an Artist.'

His proposals for the copyright laws were eventually accepted by Parliament, protecting artists and writers from the piracy he had suffered. His work established the tradition of caricature in England.

George Townshend
Fourth Viscount, First Marquis
1724–1807

Unlike most noblemen setting out on the Grand Tour, Townshend did so in 1749 after several years of active public life, fighting at Culloden, and serving under Wolfe in Canada and as aide-de-camp to his guardian, the Duke of Cumberland, in Flanders. He had sketched when on army service and must have seen the *caricaturas* of Ghezzi, which were so much in vogue among the English circles in Italy. His first political caricatures, published by Darly in 1756, were comic figures of prospective ministers appearing in the print, 'The Recruiting Sergeant'. Walpole wrote to a friend: 'I laughed till I cried. ... This print has so diverted the Town that today a Pamphlet against George Townshend was produced called "The Art of Political Lying". His genius for likeness is astonishing.' He was described as 'Mercurial-humorous and witty, with a violent temper, disposed to ridicule, hasty judgements ... destitute of tact and decorum', and the ribald humour of his naïve drawings carried the comic edge of opinion and prejudice, in welcome contrast to the allegories of the artist-engravers. Sheer enjoyment won the public over to the erratic lines of the amateurs, a style which was to shape future caricature from Gillray to Vicky.

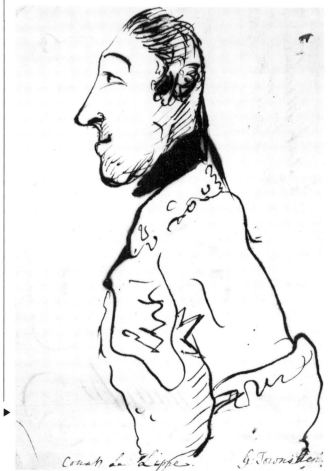

OPPOSITE '*The Bench*', *1758. The central figure is the Lord Chief Justice, Sir John Willes. Notoriously immoral, he had figured in Hogarth's early seduction scenes, 'Before and After', of 1730. Lord Bathurst and another judge are dozing beside him. Hogarth was working on additions to this plate the day before he died.*

RIGHT '*Count de Lippe*', one of many hundred such caricatures Townshend made in his sketchbooks while on military service in Canada and Flanders.*

Matthew Darly
w. 1750–81

Publisher, engraver and drawing master, Darly, together with his wife, Mary, was at the heart of the vogue for amateur prints. English public taste had tired of academic allegories, preferring the humour of the light line. At their shop opposite the Acorn pub by Hungerford Bridge, on the Thames, the Darlys advertised: 'Sketches or Hints sent post paid will have due Honour shown them.' They gave lessons, and engraved and improved on clients' ideas and sketches. The Marquis of Townshend was their most notable customer, working on Darly's innovation of small prints mounted on paste-card, to enable them to be sent by post. The size of the plate and the limited skills of the pupils demanded a simplified scale and these mini-satires were a great success – the naïve and comic figures were recognizable, effective and entertaining.

Though Darly had been active in political prints until 1766, after that date he turned to the beau-monde, publishing 'A series of Drol Prints, consisting of Heads, Figures and Satires upon the Follies of the Age'. His prints of 'Macaronis' ridiculed the foppery of the dilettantes returned from the Grand Tour. Until the fad became outmoded in 1776 (when Fanny Burney pronounced them 'no longer Bon Ton'), the Macaroni series proved as distinctive and popular as *Vanity Fair* portraits a century later.

Darly's first exhibition of caricatures in 1773 listed '73 Ladies, 106 Gentlemen and 54 Artists'–all anonymous. Keen though the amateurs were, few came near the zeal and talents of the professionals.

Mrs Darly recognized the therapeutic value of the pastime: in her *Book of Hints* she recommends it as 'a diverting species of designing that will certainly keep those that practise it out of the hipps or vapours'. The Darlys' enterprise did much to promote the light comedy of caricature.

The Darlys' shop in the Strand, with the series of Macaroni portraits on display in the windows, probably engraved by Darly from Edward Topham's design. Topham was caricatured by Rowlandson and can be seen in the 'Vauxhall Gardens' detail on page 49.

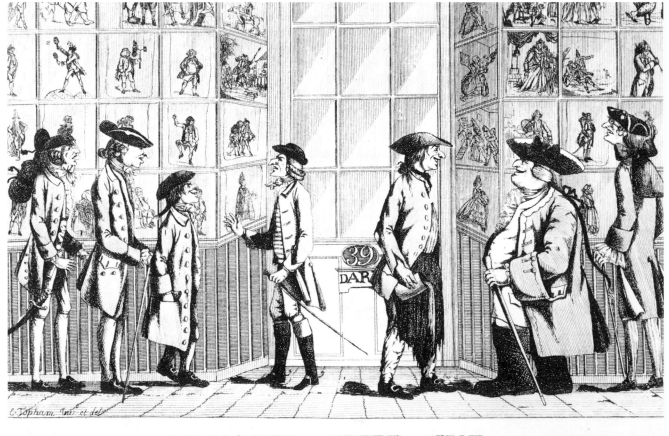

THE MACARONI PRINT SHOP.

The Amateurs

IN THE MID-EIGHTEENTH CENTURY the ability to draw an outrageous likeness became a distinct social accomplishment. Not an essential skill, of course, like horsemanship and cardplay; more a waspish sideline, much the same as a talent for mimicry or satiric couplets. Amateur status was all-important. It meant that the caricaturist was voluntarily engaged in irritating and entertaining his peers, striking out among his equals, not soliciting their patronage or sniping at them from below. He was not a subversive.

The whole business of etching the designs, printing them and – increasingly, as time went on – distributing them at large was left to reliable engravers like Matthew Darly. But the relationship between an eminent amateur like George Townshend and a professional like Darly went much further than that between an equivalent writer and his printer-publisher. Indeed, it amounted to a collaboration. As the credits on such caricatures put it, the amateur 'Invt', the professional 'Fecit'. The amateur's inside knowledge was combined with the print-maker's know-how.

The original drawing would be essentially an idea, a topic, a pose. This initial treatment would be tidied up, modified where necessary, and made fit to be turned into a printed image. This was the process Rowlandson later referred to as 'taking in other men's washing'. Inevitably the professionals took over from the amateurs. Rowlandson moved from semi-professional to all-purpose comic illustrator; Gillray triumphed; Isaac Cruikshank established caricature as a family business, carried on by his sons Robert and George. The print-sellers commissioned subjects and their shop windows became popular spectacles. The exclusive gossip and scandal of high society was transformed into colourful pantomime that every man in the street could comprehend.

Caricatura was, as Hogarth repeatedly pointed out, a foreign, essentially Italian art, an art of light-fingered whim and skit. It was the inspiration of the amateurs. The style of Ghezzi and others, encountered in the course of Grand Tours, was developed back in England into graphic tittle-tattle. Whereas the Italians had gone in for *caricaturas* as a form of diversion, a relaxation from High Art, the amateur Milords and gentlemen drew to make mischief, to create a stir.

The importance of the amateurs in the history of caricature rests not so much on their skills as on their privilege. They knew their victims. They shared many of their assumptions, they moved in the same circles. But the art of Townshend, Bunbury and the others was severely limited in ambition and manner. It was, after all, escapade squibbery, designed for drawing rooms and officers' quarters. Such drolleries went out of fashion. Or rather, the caricature industry grew up. Prints became available for hire; they were collected in portfolios, passed around after dinner. Single-figure caricature was no longer enough: scenes were needed, fully elaborated, complicated enough to sustain discussion, dramatic enough to stick in the memory. Here Gillray was unrivalled.

François Joseph Foulquier
1744–89

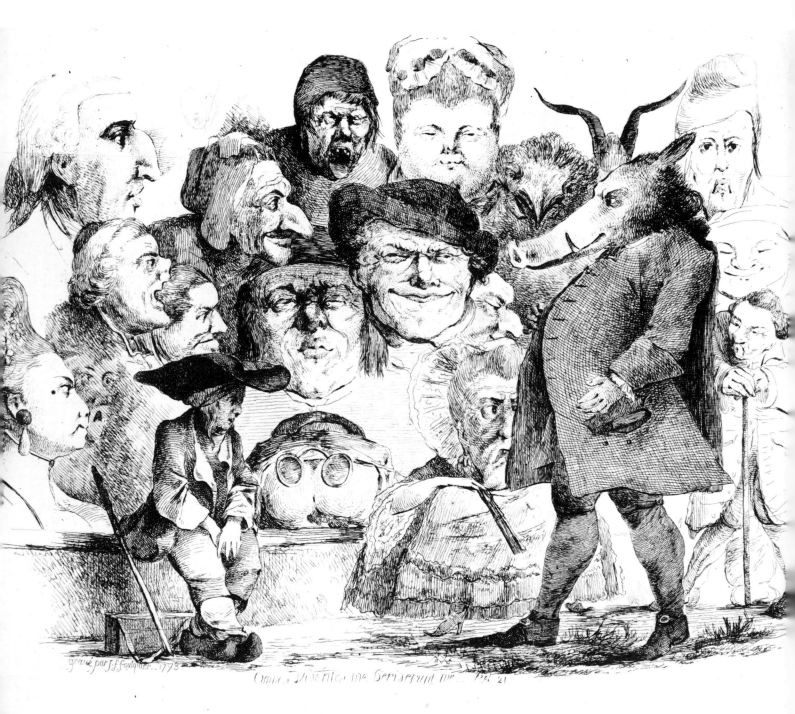

From a wealthy Toulouse family, Foulquier was sent to Paris while still a boy to study under de Loutherbourg and the miniaturist, Hall. Though he later held political posts in the regional administration, as Conseiller au Parlement de Toulouse, he continued to etch as an amateur, making satirical prints of grotesque and surreal imagery.

'Omnes Videntes me Deriserunt me'
(*All who saw me derided me*), *1773.*

46

Carington Bowles of St Paul's Churchyard, later Bowles and Carver

This long-established print-shop and map warehouse in St Paul's Churchyard, London, was the centre of the popular print trade. Bowles published the work of many artists in mezzotint, supplying prints of notable military and naval officers, politicians and comic conversation pieces for the flourishing export trade. Among those frequently providing the pictures were:

John Collet, working in the 1770s, an accomplished painter of genre scenes, described as a gentleman of private income and member of the Beefsteak Club, and believed to have been a pupil of Hogarth. His satires on fashions and social life give 'upstairs, downstairs' glimpses of eighteenth-century town life.

Henry Wigstead, London magistrate, exhibiting regularly at the Royal Academy, 1784–88, and a friend of Rowlandson, who engraved many of his drawings of humorous domestic scenes of fireside groups and snoozing clergymen.

John Nixon, working in the 1790s, an official of the Bank of England and a city merchant, who lived above the counting house in Basinghall Street. Bon viveur and secretary of the Beefsteak Club, he had his watercolours exhibited at the Royal Academy, 1784–1815; his occasional caricatures had striking political effect.

ABELARD AND ELOISA.

'Abelard and Eloisa', 1788, a mezzotint published by Carington Bowles. In the manner of Collet and several other artists published by Bowles, and subsequently reprinted without attribution, this portrays Mrs Montagu (1720–1800) and her admirer, the Rev. William Mason, Walpole's literary correspondent.

Nathaniel Hurd

1730–77

A detail of the engraving which illustrated the broadsheet 'Hudson's Speech from the Pillory', printed by Hurd in Boston, 1762.

Like the majority of the engravers of political satire in the American colonies, Hurd was an ordinary artisan gold- and metalsmith, whose main graphic output consisted of bookplates and frontispiece portraits. His 'True Profile of the Notorious Doctor Seth Hudson' is a somewhat vilifying portrayal of a convicted forger of the day.

Samuel Hieronymus Grimm
1734–94

Grimm was a watercolourist from Burgdorf, Switzerland, who settled in London and exhibited his paintings at the Royal Academy. He occasionally produced caricatures, lively satires on the foibles and fashions of the day: 'The French Lady in London' ridiculed the extreme coiffures and head-dresses of 1771 and the comic effects they might cause.

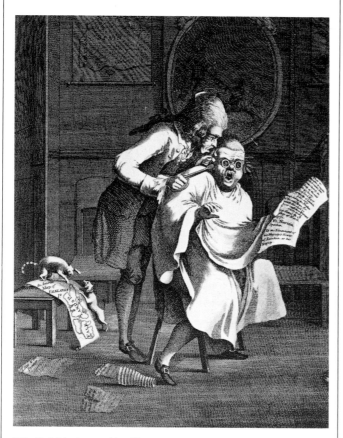

'The Politician', 1771 (detail).
Prime Minister Lord North, in a
state of alarm over continual attacks
on his ministry, is further dismayed
by the whisperings of his French
hairdresser and reminders of the loss
of the Falkland Islands to Spain.

Thomas Rowlandson
1757–1827

Rowlandson was born in Old Jewry in the city of London. His father was a Spitalfields silk merchant who went bankrupt in 1759. After this Thomas was brought up by his uncle James, a prosperous silk-weaver, and his French wife. After schooling in Soho Square, he entered the Royal Academy Schools in 1772, and at sixteen was sent to Paris for two years' study. Early surviving drawings show the influence of Ghezzi and John Hamilton Mortimer, a brilliant draughtsman with a taste for the macabre. Rowlandson returned to the Royal Academy, exhibiting in 1775, and gained the silver medal in 1777. In 1784, his 'Vauxhall Gardens' was exhibited; it was considered one of the most accomplished and elaborate of his watercolours. His mastery of the topographical genre of line and delicate wash gave him a facility for swift sketches, and led to his reputation for being 'talented but idle'. Despite a legacy from his aunt, his convivial life and passion for gambling kept him always short of funds, and he frequently executed drawings in payment of debts.

Throughout the 1780s Rowlandson was engaged in political caricature, and his distinctive vibrant line was also evident in his engravings of other people's drawings for print-sellers. 'Rolly' made frequent tours round the countryside, journeying in company with the actor John Bannister, fellow-caricaturist Wigstead and his friend and patron, Matthew Mitchell. The thousands of drawings he did of English towns and contemporary life, and of the Continent, were scarcely appreciated during his lifetime. But the rococo vitality of his comic draughtsmanship and the delicacy of his use of colour are now recognized as those of a major artist.

'Vauxhall Gardens', 1785 (detail).
Rowlandson's elaborate composition
of the famous pleasure gardens is
packed with the celebrities of London
society, including Captain Edward
Topham, shown eyeing the ladies
through his monocle. An adjutant in
the Life Guards, Topham was also a
playwright, amateur caricaturist and
founder-editor of a notorious, scandal-
mongering daily paper, The World,
in which capacity he must have found
Vauxhall a fine source for comment.

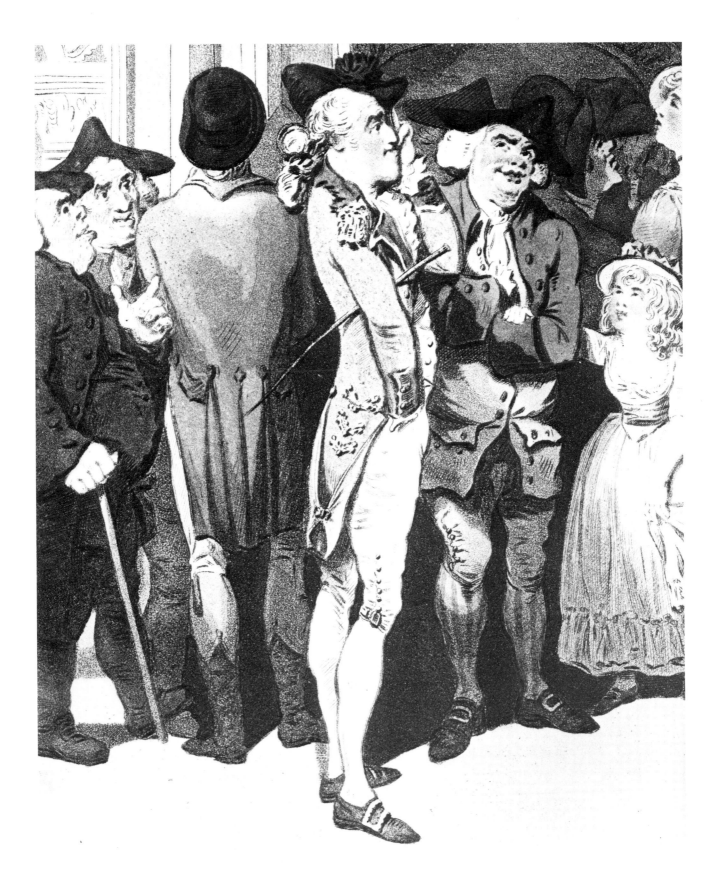

Daniel Chodowiecki
1726–1806

The only eighteenth-century German caricaturist comparable to the English masters, Chodowiecki owed much to them, especially to Hogarth, who inspired him to produce his own series of *Rake's Progress* engravings in 1773. Unlike Hogarth, however, Chodowiecki was not interested in low-life scenes and restricted his satire to the aristocracy, the military and the church, which he treated with considerably less bite than his English colleagues. Chodowiecki was also an illustrator (*Don Quixote*, Sterne's *Sentimental Journey*), and he produced no fewer than two thousand caricatures between 1780 and 1802, some of them physiognomical types commissioned by Lavater for his comparative studies and classification of human expression and behaviour.

'Taste', from the series of prints,
Natural and Affected Behaviour,
1780.

Henry Bunbury
1750–1811

The son of a baronet clergyman of Mildenhall, Suffolk, Bunbury went on the Grand Tour after studying at Cambridge, where he had started etching. His first caricatures were printed in 1771, and he engraved his early designs himself. His work was full of character and genre groups; one of the most descriptive and original was his view of the Englishman abroad, showing one of the hundreds of young English noblemen *en route* for the indispensable dose of culture. Though he worked as an amateur, his designs were keenly admired among his circle and he had a great reputation for wit and observation. His later prints were engraved, from his drawings, by his friend Rowlandson and others. He became equerry to the Duke of York; when Fanny Burney met him at Windsor, in 1787, she thought him a 'rather dangerous man to be brought to court'. She was clearly disappointed and disapproving of their conversation, and reported him 'superficial and haughty ... Mr Bunbury did not win my good will. Plays and players seem his darling theme, he can rave about them from morning till night'.

From a page of sketches.

Francis Grose
1731–91

In his youth, Grose was Adjutant and Paymaster in the Surrey Militia. However, unable to keep accounts, he had to foot the losses, and turned to drawing. He had embarked on a survey of 'Antiquities of England and Wales' when his father, the jeweller of George II's crown, died and left him an independent income. Though he settled in Canterbury with his family, his peregrinations of the British Isles continued over twenty years, during which time he produced volumes of 'Views and Prospects'. His *Rules for Drawing Caricatures, with an Essay on Comic Painting* were published in 1788 and 1791, with seventeen plates etched by Grose. Then, a colleague relates, 'he turned his eyes to Ireland, who seemed to invite him to her hospitable shore, to save from impending oblivion her mouldering monuments. . . .' But this ardent conservationist and Fellow of the Royal Society of Antiquaries failed to realize this fair prospect: he died of apoplexy soon after his arrival in Dublin. Among the many friends he made on his travels was Robert Burns, who celebrated him in verse.

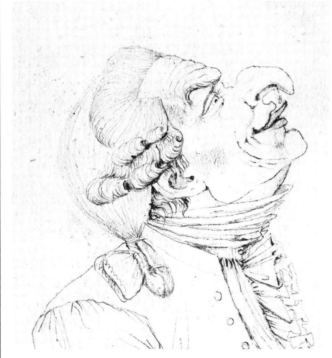

Drawing in pencil and wash, one of a set of four grotesque heads.

'MUSTARD GEORGE'
George Murgatroyd Woodward
c. 1760–1809

An amateur watercolourist and occasional caricaturist, Woodward seems always to have had his work engraved by professional artist-engravers, particularly his drinking companion, Rowlandson. In great demand by print-sellers, his comic figure of the 'British Sailor Ashore' became a popular theme. In common with the work of many amateurs, re-issued prints often omitted his name as original artist. He is best known for his comic Lilliputian figures, particularly the droll military character, General Discontent, and for the collections of coloured prints published at the beginning of the nineteenth century by Tegg of Cheapside under the title *The Hudibrastic Mirror*.

A portrait of James Gillray by Woodward and Rowlandson which appeared in A Lecture on Heads *(1808), a book by George Alexander Stevens, under the title 'An Old Bachelor'.*

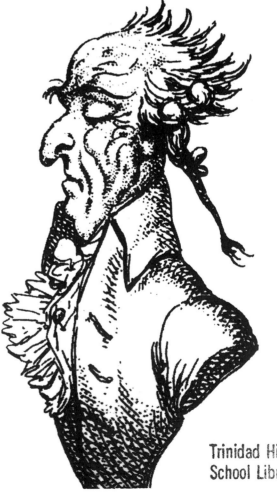

Samuel Collings
w. 1780–91

Although Collings, who occasionally signed his work 'Annibale Scratch', is considered among the minor English caricaturists, his drawings for *The Picturesque Beauties of Boswell*, a parody of Boswell's and Dr Johnson's Hebridean tour, were highly popular. The set of twenty plates were engraved by Rowlandson, and provide an example of how the spirited line of his etching could transform the drawings of others. Collings exhibited at the Royal Academy from 1784 to 1788, and died in Soho in 1793.

Detail of the drawing of Dr Johnson and James Boswell in Edinburgh, later engraved by Rowlandson.

Thomas Lawrence
1769–1830

The masterly English portrait painter of the Regency period had first shown his extraordinary talent as a young boy. His father showed him off to guests at their inn; when wealthy visitors stayed on their way to Bath, the beautiful child was presented to draw their portraits. He was taken on a tour of the West Country, displayed in Oxford and Weymouth, and when the family moved to Bath he began to paint and meet connoisseurs and collectors who recognized his ability. He became the breadwinner of the family and, after exhibiting at the Royal Academy in 1787 and meeting Sir Joshua Reynolds, he settled in London. On Reynolds' death in 1792, he succeeded him as Painter-in-Ordinary to the King, and two years later was elected Academician. Some of the informal sketches and caricatures of his friends in these years have survived, and show the force of his drawing, which he held to be the essential basis of his painting.

He was knighted in 1815, and the patronage of the Prince Regent led to his mission to Austria and Rome in 1819 to paint Archduke Charles in Vienna and Pope Pius VI. In 1820, when George IV succeeded to the throne, Lawrence was elected President of the Royal Academy.

The first comprehensive exhibition of his work was held at the National Portrait Gallery in London, 1979–80.

Pen and ink caricature c. 1790 *of an ageing Boswell.*

James Gillray
1757–1815

Surely the greatest of all English caricaturists, Gillray spent his childhood in the morbid constraints of the Moravian religious sect: his father, a pensioned-out Scots soldier, was sexton at their Chelsea Chapel. In his teens, he became an apprentice to a city engraver, but found the task of drawing maps and bank notes like that of 'a spider, busied in the spinning of lines', and ran off to join some travelling players.

In 1778 he entered the Royal Academy Schools as a student of the leading engraver of the day, Bartolozzi. Early commissions included illustrations for Fielding's *Tom Jones*, Goldsmith's *The Deserted Village* and political prints for William Humphrey. Most probably he expected to make his livelihood from fine-art engraving; the market for reproductions of history paintings made master-engravers among the most highly-paid of artists. He had accompanied the King's favourite painter, Philip James de Loutherbourg, on a battlefield tour of Flanders, sketching the figures for 'The Siege of Valenciennes'. But despite his undoubted virtuosity and robust line, he failed to attract any major commissions.

In fact, his already distinctive manner may have made artists wary of trusting him with the transposition of their paintings to stipple-engravings, which demanded the accuracy of the copyist rather than any individual traits of the artist.

Meantime, the political satires he produced for various London print-sellers gained notice. The expressive distortion and harrowing likenesses kindled political wit and faction, yet, despite the degree of ridicule and venomous attack, victims of his parliamentary parodies considered it a mark of acclaim to be featured in the caricatures. Many even sought to be included, as the print-shop window display was equivalent to the newspaper headline and television news flash of today. In 1798 the whole of London was said

George III and Queen Charlotte support the embargo on sugar not as a protest against slavery, Gillray suggests, but as a pretext for yet another household economy.

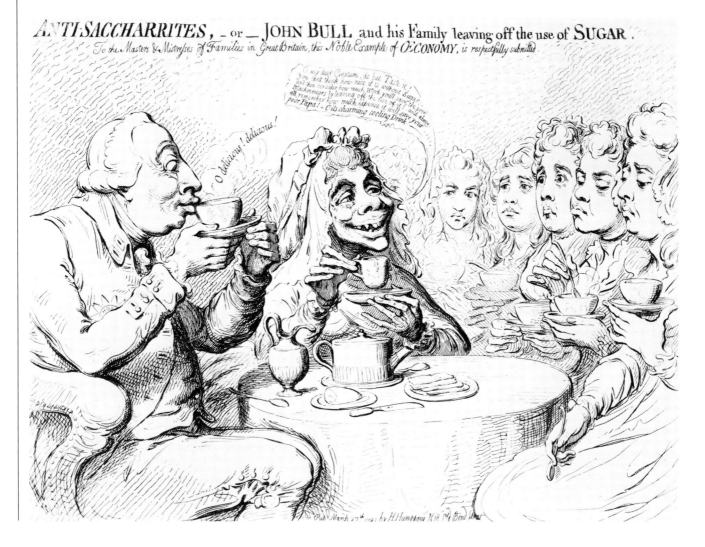

53

to view Gillray with a mixture of approval and fear.

Having worked for William Holland, Humphrey, the Darlys and Fores, leading London print-sellers throughout the 1780s, he then came to work exclusively for Mrs Hannah Humphrey, living and working in the shop in St James's Street for the rest of his life. He was the first truly professional caricaturist, devoting his considerable talents entirely to this end. His style evolved as a diffusion of the traditional allegories and graphic polemics of the artist-engravers, and the irreverent humour and naïve line of the amateurs and 'phiz-mongers'. Graphic metaphor and verbal quips interwove, in an age rich in the literary satire of Sterne, Swift and Fielding. His personification of Little Boney, in the anti-French prints issued from 1798 on, proved powerful propaganda, and became the international image of Napoleon, imitated across Europe. Champfleury wrote in retrospect, 'Bonaparte had for adversary the pitiless Gillray, veritable incarnation of John Bull, who roused the fibres of patriotism.'

His latter years were racked with bouts of ill health, and his obsessive anxiety about failing eyesight was reflected in prints and drawings; 'Pity the Sorrows of a Poor Blind Man' is believed to be a self-portrait. His friend Henry Angelo described him as 'always Hypped', and he was certainly known as a heavy drinker all his life. From 1811 he was subject to fits of madness, and spent his last two years confined to the attic above the print-shop.

Gillray was without doubt the major formative influence on the art of caricature. In the words of David Low, from 'the infantile, incoherent and fitful state of caricature after Hogarth, Gillray fashioned for himself a medium that ... caused England to become known as the House of Caricature'.

OPPOSITE, TOP *Tory ministers Dundas, Pitt and Thurlow watch apprehensively as Queen Charlotte emerges into a position of influence.*

OPPOSITE, BOTTOM *Gillray's print refers to suggestions that Prime Minister Pitt was raiding national reserves to finance war against France. A week previously, Sheridan had referred to the Bank of England in a House of Commons speech as 'that old lady'; his phrase was also a dig at Pitt's engagement to a lady in her thirties, Miss Eden, which was said to have been broken off because neither partner had a private income.*

TOP *1803 print of the Marquis of Blandford, George Spencer, later 5th Earl of Marlborough, who was Whig MP for Oxfordshire before turning Tory. He wears a modish tail-coat and Hessian boots.*

RIGHT *The long liaison of the Prince of Wales and Mrs Fitzherbert met with the constant hostility of the King, who was trying to negotiate a royal marriage for his son, and of society. In this print, loaded with Welsh allusions – the leek in the hat, the mountain goat – Gillray shows the Prince on a visit to the newly married Duchess of York, who refused to receive her 'sister-in-law'.*

The Visit to Piccadilly; – or – A Prussian Reception.
Representing Shon ap Morgan, Shentleman, of Wales, introducing his Old Nanny-Goat into high Company.

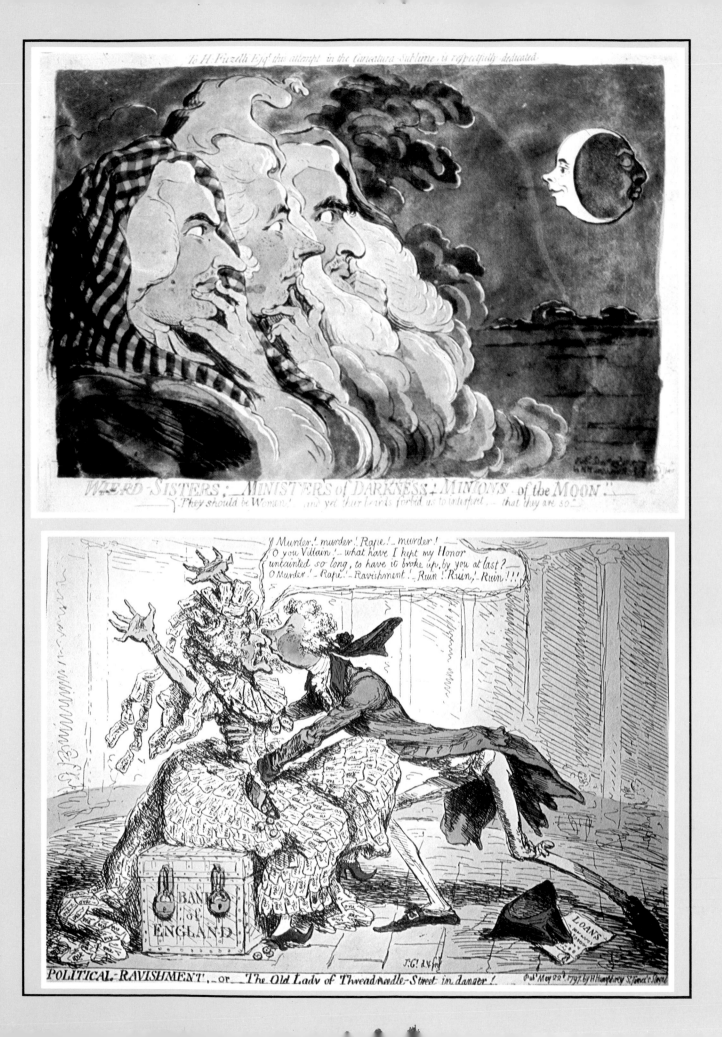

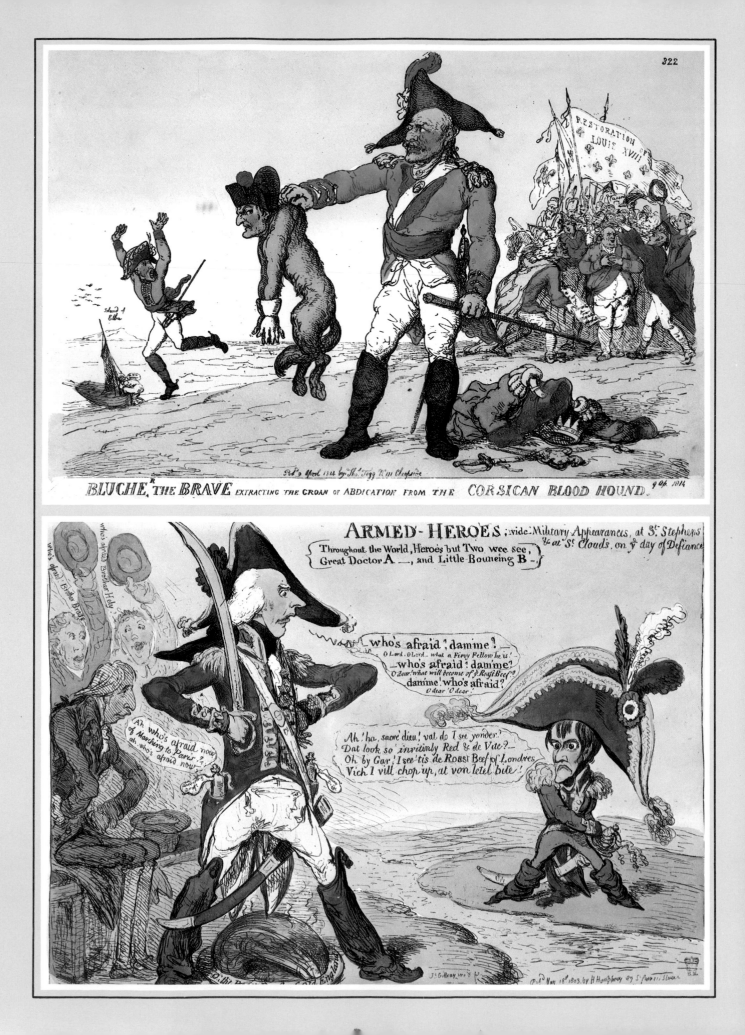

BLUCHER THE BRAVE EXTRACTING THE GROAN OF ABDICATION FROM THE CORSICAN BLOOD HOUND.

Boney-Bonaparte

NAPOLEON BONAPARTE was a caricaturists' delight, a continual inspiration for over twenty years, but it took quite a while for his image to be established. Isaac Cruikshank, probably the first British caricaturist to pay attention to him, represented him in 1797 as a typical snarling Sans Culotte with his name written on his liberty cap. But then, thanks largely to Gillray, who drew on French representations of him as a dashing young officer, he rapidly emerged, kicking and fretting, an evil starveling, a vehement dwarf in military attire, posing as a colossus.

The more he threatened British and Russian interests, in particular, the greater the graphic indignities to which he was subjected. He was grilled and pitchforked, booted around, farted on, frozen, eaten alive by lions, bears, ogres and Cossacks. He shrank in size, from dwarf to imp, until he was almost snuffed out by his enormous plumed hat. Because his name was so easily and conveniently shortened to 'Boney', it followed that he had to look that way. Besides, being French and power-hungry, it figured that he was the sort of emaciated character Hogarth had conceived all Frenchmen to be. This led to difficulties late in the Napoleonic Wars when engravings based on official portraits of the Emperor showed him to be a more stocky and sallow-looking man than had previously been assumed. Modifications were made, particularly in profile portraits made up, in the Archimbaldo manner, from the corpses of his victims, ingeniously fitted together. Cruikshank, for one, remained faithful to the image of Napoleon as he had always pictured him: forever ranting, whether buried in snow during the retreat from Moscow or standing astride his island of exile, the Colossus of St Helena, hurling imprecations at the sun.

Napoleon was the first universal figure in caricature. His image was relayed from country to country, across the battle lines. For propaganda reasons the ban on topical and personal caricatures in Russia was lifted between 1812 and 1814. Terebenev drew on European examples as well as Russian folklore sources. Cruikshank produced English versions of several of these caricatures. The image of Napoleon as upstart, as stunted dandy, as vermin, remained more or less constant. The *idea* of Napoleon, or rather a set of ideas fed on rumour, prejudice and French portraits that were in effect icons, dictated the appearance of the tiny Corsican, part genie, part Rumpelstiltskin. It was only later, when the Napoleonic Wars receded into the history books, that the standard caricature of the brooding Emperor was developed: wide hat, heavy coat, one arm behind his back, the other tucked into his waistcoat. This, rather than Gillray's manic midget, is the Bonaparte most easily recognized by posterity.

OPPOSITE, TOP *In a print published in 1814 by Tegg of Cheapside, Rowlandson shows Prussian Field Marshal Prince von Blücher holding Napoleon by the scruff of the neck, a pose borrowed from Terebenev's engraving (see page 19) in which the Tsar receives the credit for Boney's downfall.*

OPPOSITE, BOTTOM *Dated 18 May 1803, the day that Britain renewed war with France, Gillray's print shows an outwardly defiant but terrified Henry Addington, then Prime Minister, backed up by two cheering relatives and an anxious Baron Hawkesbury.*

James Sayers
w. 1781–90s

The son of a merchant captain of Great Yarmouth, Sayers qualified for a legal career and served as an attorney before turning to caricature. As he gained favour with William Pitt, the Prime Minister, his prints featured Opposition members Charles James Fox and Lord North. Though his draughtsmanship was shaky, his likenesses were strong and distinctive and his ideas had keen political insight. His portrait caricatures of 1782 onwards were evidently a close source of reference for Gillray, and were imitated by many others. Sayers' image of Fox with a sinister swarthy face was, like that of Richard Nixon and his five-o'clock shadow, a character assassination that dogged the victim throughout his career. Sayers was rewarded by Pitt with a courtesy post, as Marshal of the Court of the Exchequer. From 1790 onwards he worked intermittently, tending to deal with social subjects and political satire in songs and verse.

'Carlo Khan's Triumphal Entry into Leadenhall Street', 1783 (detail).
Fox, astride an elephant with the face of Lord North, is led into the City by Edmund Burke.

William Dent
w. 1782–93

Little is recorded of Dent's life, apart from his prints. He is known to have been working in London from the early 1780s, publishing many of his own engravings which, despite the amateur quality of his drawing, evidently gained wide popularity; these were sold through a number of the leading print-sellers. The subjects included attacks on Charles James Fox and various protests about the burden of taxation.

A sinister, swarthy Fox is cast as a conspirator with the French revolutionaries.

John Kay
1742–1826

The son of a mason, Kay was apprenticed to a barber in Edinburgh and started up his own business in 1771, making portrait sketches in his spare time. Despite the naïvety of the drawings, they were strikingly good likenesses which gained him a reputation and pleased his subjects. One of them, Mr Nisbet of Dirleton, 'treated him as friend and equal', and left him an annuity of £20 per annum when he died in 1784. With this, Kay gave up his barber-shop and spent the rest of his life etching. Among the 900 portrait plates that exist, most are figures of the notable Scots of his time and members of Edinburgh University, portrayed with directness and humour. This original, self-taught artist provided a rare archive of documentary portraits of his contemporaries. A number of these are now in the collection of the National Portrait Gallery of Scotland, in Edinburgh.

Isaac Cruikshank
1762–1811

The son of a customs officer at Leith, Isaac Cruikshank was active in London by 1784, as is shown by his earliest surviving caricatures. Like James Gillray, he had higher ambitions – he exhibited genre paintings three times at the Royal Academy between 1789 and 1792 – but it is for caricature that he is remembered. In that golden period of the art he ranks after only Gillray and Thomas Rowlandson in both political and comic subjects. In politics he is notable for the apparent indifference or cynicism with which he lashes all sides – Fox and Pitt, Jacobins and courtiers, Napoleon and George III. His sons George and Robert learned to draw and etch under his tutelage and became leading caricaturists of the next generation.

'The British Antiquarian', Captain Francis Grose, during his visit to Edinburgh in 1789. Robert Burns described him as

'A fine fat fodgel wight,
Of stature short, but genius bright.'

The profiles of Prime Minister Pitt and George III, 1794, in a print reflecting misgivings on the state of the nation.

Robert Dighton
c. 1752–1814

Dighton gained early recognition for his watercolours and exhibited at the Royal Academy from 1769. At the outset of his career, this industrious artist advertised for custom: 'Correct elegant likenesses in miniature for half a guinea.' He undertook to attend at any distance within ten miles of his Charing Cross studio. *Postures*, a series of mildly satirical social portraits, was published in mezzotint by Carington

Bowles, the print-seller of St Paul's Churchyard, between 1774 and 1794. After this Dighton turned to full-length profiles, which seem to anticipate the caricatures of *Vanity Fair*. His distinctive linear style, with slight accentuations of feature, was accompanied by a trace of humour in the captions: an admiral was entitled 'A First Rate Man of War'; a bishop, 'A Pillar of the Church'. The faint satire proved a most popular and fashionable trend.

For many years a familiar figure in the Print Room of the British Museum, Dighton was discovered to have removed a number of original prints and replaced them with copies. Though all the originals were discovered hoarded in his rooms, this incident left him somewhat discredited in art circles.

Pub.ᵈ Jan.ʸ, 10ᵗʰ, 1810, by Dighton 6. Charᵍ Crofs

A VIEW from TRINITY COLLEGE, CAMBRIDGE.

William Lort Mansel (1753–1820), Master of Trinity College and later Bishop of Bristol, who was noted for his wit and mimicry.

Johann Gottfried Schadow
1764–1850

Director of the Academy of Fine Arts in Berlin from 1815, Schadow was one of Germany's leading neo-classical sculptors, best known for the Quadriga on Berlin's Brandenburg Gate. He occasionally produced caricatures and his drawings of Napoleon and his generals are rightly regarded as some of the best examples of the genre to have been made in Germany in the early nineteenth century. His linear parodies of the English caricaturists are a sophisticated blend of Townshend and Gillray figures.

James Akin
c. 1773–1846

After a childhood in the port of Charleston, South Carolina, Akin emigrated northward, while a teenager, to Philadelphia. Here he spent the greater part of his life, working at various times as miniature painter, apothecary and proprietor of an eating house and hotel. Akin claimed that he had had formal artistic training 'from the most celebrated and esteemed masters in Europe', but this is doubtful. Nonetheless, on the strength of his powers of humorous characterization, a fair degree of draughtsmanship and a large measure of social concern, he did succeed in producing a vivid record of Republican and Jacksonian times.

As a caricaturist, Akin owes much to the works of Rowlandson and Cruikshank. His prints exposed the folly in presidential politics and genteel society, and the foibles of lower-class life. Never the detached cynic, Akin was often motivated by sincere humanitarian concerns.

'Seize Berlin !' 1813 (detail).
Schadow signed this Napoleonic print
'Gilrai'.

Richard Folwell, printer-editor of the
Philadelphia paper, The Spirit of
the Age. *He was a dwarf, and on one*
occasion some practical jokers made a
pig run between the little man's legs
and carry him along the street, as if he
were riding it.

Charles Williams
w. 1797–1830

Williams worked in London as engraver, illustrator and chief caricaturist for Fores of Piccadilly, one of the leading print-shops and publishers. One of his tasks for Fores was to copy Gillray's plates, and his own drawing showed the influence of Gillray. Much of his work was published anonymously. His early pseudonyms included 'Ansell' and 'Argus'.

'Spectres visiting John Bull', 1808 (detail). In travesty of Fuseli's painting, 'The Three Witches', Fox, Pitt and Burke return to denounce the bombardment of Copenhagen.

George Cruikshank
1792–1878

George Cruikshank was taught to draw and etch as a child by his father, Isaac Cruikshank, and was scarcely in his teens when he began earning money with simple work for publishers of chapbooks and other ephemera. When his father died in 1811, George, not yet eighteen, became a full-time caricaturist, working for more than a dozen London print-shops. He quickly achieved a mature style and revelled in depicting the misfortunes of Napoleon and the misdemeanours of the Prince Regent and his circle of relations, cronies and ministers. Another frequent target in that period of rapid change was the folly of fashion and social pretension.

When the conflict between the government and radicals became intense in 1819–21, most of his political caricatures were anti-government, but he also depicted the radicals as fearsome villains; and during the 1820s he became increasingly conservative. He had begun as an heir of James Gillray, and was the last great master of the etched caricature print; but after the 1820s he devoted himself almost entirely to comic work suitable for all the family, book illustration, and, from 1847, the Temperance campaign.

OPPOSITE, TOP *Napoleon's Grand Army in Defeat, drawn in a style very close to that of Gillray, parodies the propaganda of the bulletin, introduced by Bonaparte as the first news reports from the front line.*

'The Dandy of Sixty', a portrait of the Prince Regent, one of Cruikshank's illustrations to William Hone's verses in The Political House that Jack Built *(1819).*

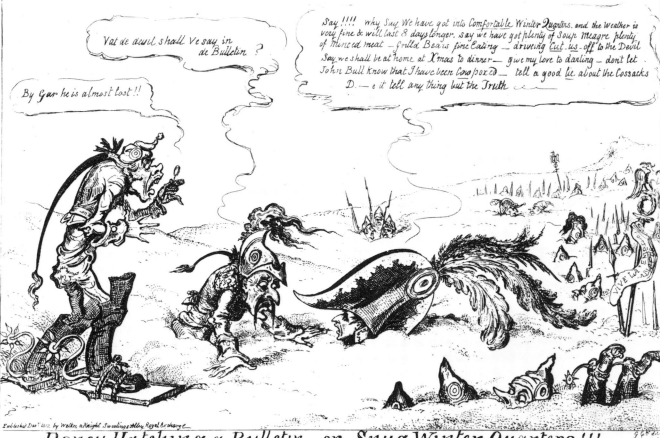

Boney Hatching a Bulletin or Snug Winter Quarters!!!

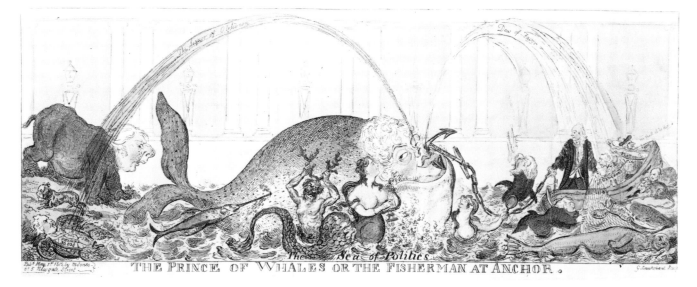

THE PRINCE OF WHALES OR THE FISHERMAN AT ANCHOR.

The Regent bestows political and financial favours on the Tories (in the boat on the right) and amorous ones on Lady Hertford (centre, between her cuckolded husband and the rejected Mrs Fitzherbert), unaware of the behaviour of his Privy Purse, Col. McMahon (the swordfish bleeding him of his money). The rejected Whigs (left) include Sheridan, by then an alcoholic, as a hippopotamus.

William Elmes

w. 1811–20

Elmes' lively and crudely drawn prints are characterized by an impetuous broken line in the manner of Rowlandson. His characters have grotesque shapes and expressions, and his focus on foreign affairs, such as a series on a raw British colonial's arrival in the West Indies, and caricatures of Jack Tar and the Yankee Torpedo (following the New York blockade), have led to the supposition that he was a sailor.

Johann Michael Voltz

1784–1858

A humorous genre painter and masterly draughtsman, Voltz, who lived and worked in Munich, was a prolific illustrator of a wide range of work, from the popular illustrated broadsheets known as *Bilderbucher* to fine publications of the classics. He also produced narrative, costume and descriptive drawings and etchings, of which over four thousand have been preserved. His line-and-wash scenes of village schools and contemporary life in Germany reveal the eye for detail and humorous observation of Hogarth and Rowlandson. He was held in great esteem by his contemporaries.

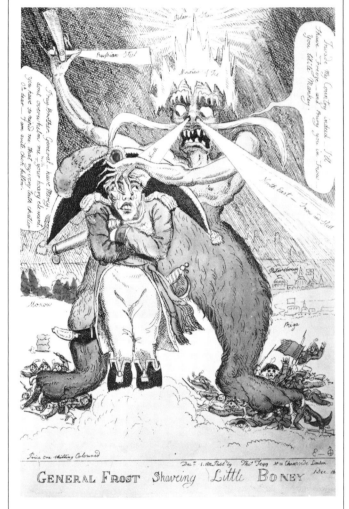

In December 1812, news of the retreat from Moscow was caricature's dominant theme. Elmes was the first to use shaving as a symbol of defeat.

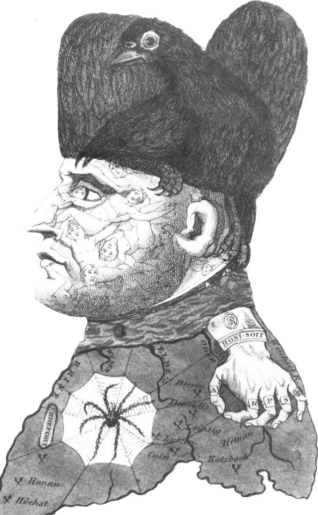

'True portrait of the Conqueror', 1804. A much-adapted idea, the coat in this original version is made up of a map of the battles of the Leipzig campaign, and the epaulette of a grasping hand ringed with the initials of the Allies.

Louis Léopold Boilly
1761–1845

Boilly was first taught by his father, a wood-engraver and sculptor, who hoped he would become an architect; his first large-scale work was produced when he was only eleven. He gained the patronage of a nobleman, which enabled him to study engraving and painting. By 1784 he had completed some 300 portraits in Paris, besides the many popular engravings of *Scènes Galantes* and the extremes of fashion of *Les Incroyables*. His studies of facial expression, doubtless inspired by Le Brun's *Méthode pour apprendre à dessiner les passions* and the classifications of Lavater, which had such a marked influence on the French artists, culminated in a famous series of lithographs, *Les Grimaces*, published in 1823. He received low prices for his work during his lifetime, accepting a few francs for the prints; but his fellow artists respected him highly. He was awarded the Légion d'Honneur by Louis-Philippe in 1833 and continued to paint vigorously into his eighties.

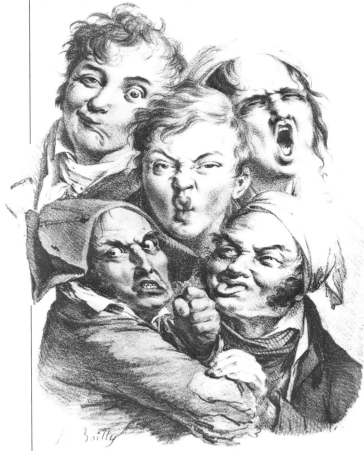

From Les Grimaces. *In the 1820s, face-pulling competitions were a popular Parisian entertainment.*

J. Lewis Marks
w. 1814–30s

Marks was thought one of the most shameless exploiters of the print trade, publishing his prints from a number of different addresses, seizing on the most offensive themes of royal scandal. He also printed Toy Theatre prints and pamphlets. After some years of inactivity, he reappeared, as public agitation rose over the Reform Bills of 1831–2, with a series called *The Chronologist*, selling at a penny plain, twopence coloured, the last of the coloured print trade. The public had believed William IV, the popular 'Sailor Bill', to be in favour of Reform; disillusioned when he appointed Wellington to form a new ministry, they blamed the influence of the Queen, and referred to her as 'German Bitch', 'King's Evil', 'German Governess' and 'Frow'. The constant appearance of brooms as a symbol of Germany in Marks' prints is an allusion to the German pedlars who sold household wares from door to door.

Queen Adelaide, complete with German accent, broom, and a bowl of Sauerkraut, in the second print of the series about the Reform Bills, The Chronologist.

'PAUL PRY' William Heath
c. 1795–1840

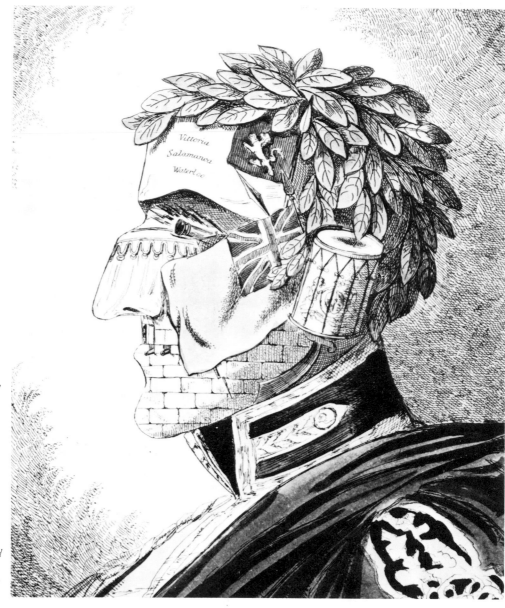

Caricatures of Wellington.

RIGHT *'Portrait of a Noble Duke'*, *1829.*

OPPOSITE, TOP *'Lot 1', a coloured print, 1829, by Henry Heath, possibly related to William Heath. He worked* c.*1824–42 in a very similar manner, sharing the 'Paul Pry' monogram.*

OPPOSITE, BOTTOM LEFT *'A Wellington Boot, or the Head of the Army', 1827: the spur carries the initials of the Duke's orders.*

OPPOSITE, BOTTOM RIGHT *'Good Humour', 1829: the Duke views the prints of himself in McLean's print-shop window.*

Little is known about Heath's early life. It is believed that his childhood was spent in Spain, on the evidence of his 1820 print on the Spanish revolution, with colloquial text. Though he described himself as an ex-captain of Dragoons and military painter, his name has not been found on any army lists. His series of prints, *Military Progress*, followed the downfall of an army officer from the purchase of his commission to debtor's prison. His work shows the influence of Gillray, and typical themes included an attack on the archbishops as mendicants, in 'Coming out of Church' (1828), and a savage portrayal of the bookmaker Crockford, whose famous 'gaming hell' opened in St James's Street in the same year. Many of his prints were signed with the tiny figure of Paul Pry, a popular stage

character of the day, but as this was constantly plagiarized he reverted to his own name, and from that time onwards was published solely by his agent, McLeans of the Haymarket.

He devised a variety of prints on Wellington but, as John Doyle's lithographed caricatures gained favour, Heath was replaced as the major contributor to the monthly political sheet *The Looking Glass* by Robert Seymour. In 1831 he turned to illustration and topographical prints, achieving some financial success with the new vogue for coaching prints. His coloured etchings were original, finely-drawn characterizations, showing keen political insight, and appeared during the final phase of the issue of single-sheet engravings by print-shops.

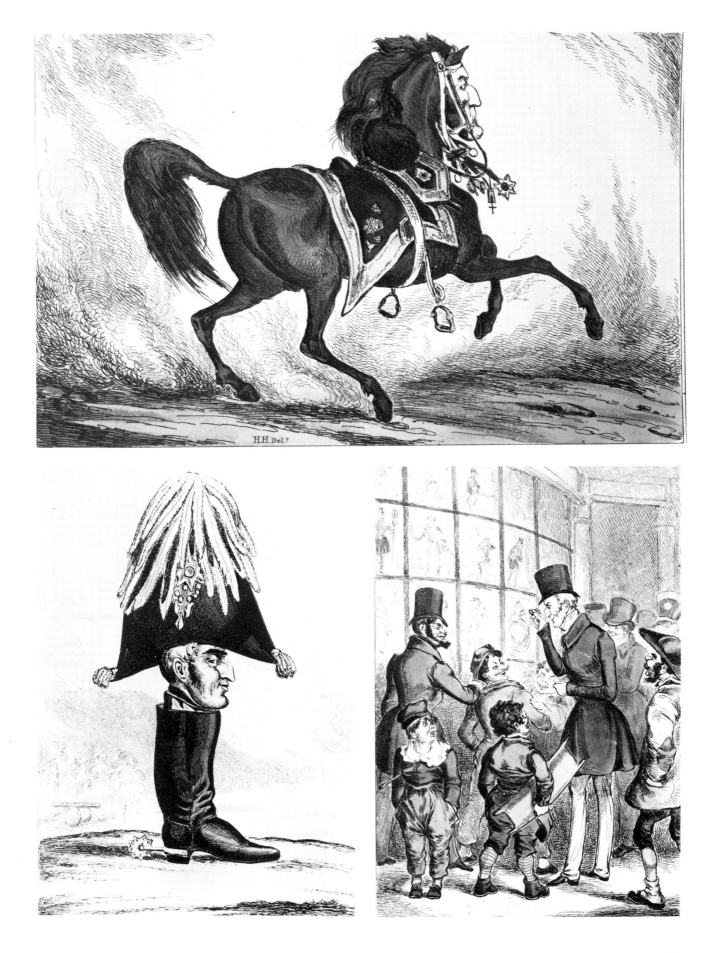

Edwin Henry Landseer
1802–73

Such was the popularity of Landseer's paintings of animals – works such as 'Monarch of the Glen' and studies of dogs with titles like 'Dignity and Impudence' became best-sellers as engravings – that the vivacity and humour of his drawings is seldom mentioned. Encouraged and taught from an early age by his father, a well-known engraver and art critic, Landseer was only thirteen when he first exhibited at the Royal Academy. He was a superb draughtsman, and many of his portrait sketches show a keen edge of satire. He was knighted in 1850.

Richard Dighton
1795–1880

Richard Dighton continued the series of portrait etchings started by his father Robert, from 1815 to 1828. George IV purchased some of them and approved of the anti-Radical sympathies of the political prints. The delicacy of his line illustration was evident in a series on the innovations of the day, such as the advent of gas light and consequent mishaps.

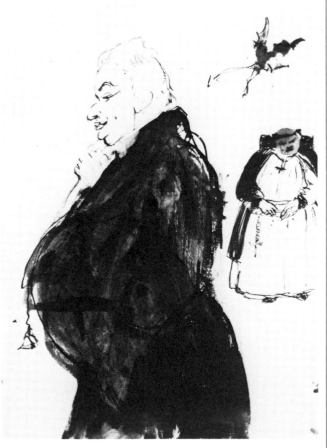

The Reverend Sydney Smith (1771–1845), Canon of St Paul's, famous wit and essayist of forthright opinions.

Charles Wheatfield Squires, an eccentric who rode to town on a velocipede to deliver his protests, drawn by Dighton under the pseudonym Simon Pure, a character from a play. Squires is shown in the garb of a Puritan.

'HB' John Doyle
1797–1868

Born in Dublin, Doyle studied landscape and miniature painting at the Royal Dublin Society. When he settled in London in his early twenties, he was encouraged by McLean, publisher of caricature sheets, to draw portrait satires. He came to the political scene at a moment when, for the first time in a century of caricature, there was no reigning artist: Cruikshank, who had succeeded Gillray, had turned from radical protest to illustration. Doyle's first prints appeared anonymously in 1827–8. From 1829 the monogram 'HB' concealed his identity, which remained a secret for years. His lithographed *Political Sketches* were finely drawn likenesses, with none of the distortion or vulgarity of the prints of the previous decades. The mild humour of his satires met with approval, as public taste veered to restraint and decorum. The series ran for twenty years, numbered to the final 917th print, and issued with keys to identify the subjects. Thackeray wrote in 1840: 'You never hear any laughing at HB; his pictures are a deal too genteel for that – polite points of wit, which strike one as exceedingly clever and pretty, and cause one to smile in a quiet gentlemanlike kind of way.'

His son, Dicky Doyle, was a most versatile illustrator, and designed the *Punch* cover of Mr Punch and his dog.

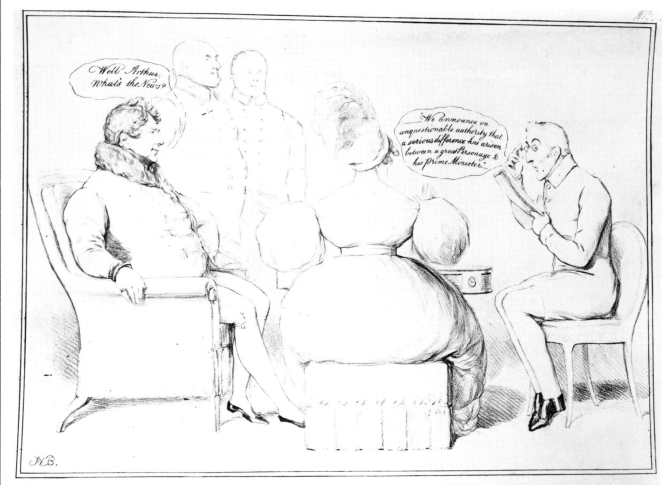

READING THE TIMES.

'Reading the Times', 1829. Seated between George IV and Wellington is Lady Conyngham, generally suspected of being the power behind the throne; her husband stands next to the King. The print – which, according to a contemporary, particularly amused the Duke – alludes to the friction between the King and his ministers.

Henry R. Robinson
w. 1830s–50s

One of the most prolific and influential of American publishers of political cartoons, Henry R. Robinson is known today only as the sum total of his works. Frederic Hudson, in his *History of Journalism in America* (New York, 1873), recalls that Robinson 'lined the curbstones and covered the fences of New York with his peculiarly characteristic caricatures during Jackson's and Van Buren's administrations, which frequently produced a broad grin on the face of the metropolis in those days'. Beyond this we know only that early in his career Robinson was in business as a carver and gilder. From the mid-1830s to the early 1850s, however, he was the bane of political administrations, corrupt New York city politicians and American public figures in general. Although many theatrical, sporting and sentimental subjects did appear under Robinson's imprint, the chief staple of his operation was satire. A demonstration of the duplicity of the commercial publisher lies in Robinson's marketing of both scurrilous attacks and dignified portraits of Jackson and Van Buren.

Cartoons printed and issued by Robinson were turned out by a stable of satiric artists including Henry Dacre, Edward Clay and Napoleon Sarony (later to achieve renown as a theatrical portrait photographer). Although their works ranged from strict caricature to burlesque, there is a general consistency of style and approach maintained by the proprietor in all of the productions of his shop. Robinson, as an entrepreneur and, perhaps, as an artist himself, was a prime force in American caricature during the two decades preceding the Civil War.

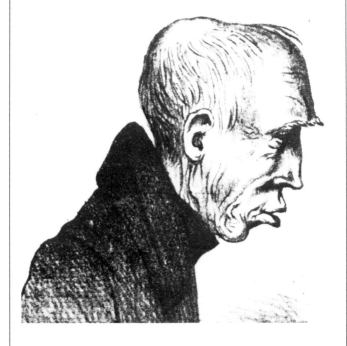

A print dated 1838, entitled 'The Globe-Man. After hearing of the Vote on the Sub-Treasury Bill.'

Charles Philipon
1806–62

It was Philipon who prophesied: 'Caricature will henceforward be Truth.' He started drawing caricatures for a living in 1823, settled in Paris and learned the lithographic process, marrying into the Aubert family of leading Paris printers and publishers. In 1830, three months after Louis-Philippe, 'King of the French People', had replaced Charles X, the last 'King of France', Philipon, who had taken an active part in the revolution, started the weekly *La Caricature*. It was hoped that Press censorship would be relaxed, but *La Caricature* soon fell foul of the law and within months prosecutions followed. In 1832, Philipon launched *Le Charivari* to diversify production. After *La Caricature* was banned in 1834, his caricatures became less personal and political, and he fostered such gifted artists as Daumier, Gavarni, Traviès, Grandville and Monnier, and the sixteen-year-old Doré. In 1838 he launched a new paper, *La Caricature Provisoire*, which met with immediate success: the 'Provisoire' was soon dropped. Yet another publication, *Le Journal pour Rire* of 1849 (later *Le Journal Amusant*), took the form of newspaper sheets filled with woodcuts by Nadar and a new generation of artists including the young André Gill.

Philipon's enterprise had a tremendous impact on the development of lithography, and on the use of the *portrait-charge* as an effective weapon. In his own capacity as a caricaturist, Philipon's best known work was the sensational representation of Louis-Philippe as a pear. Philipon was acquitted of the charge of defamation after sketching the transformations from head to pear and asking the jury, 'Is it my fault if His Majesty looks like a pear?'.

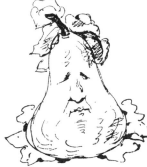

The sketches Philipon made in court in 1831 to convince the jury that the King resembled a pear.

The Rise of the French

WHEN LOUIS-PHILIPPE came to power in France following the July Revolution of 1830, he proclaimed freedom of the Press. Independent caricature was thereby sanctioned. Charles Philipon promptly founded his satirical weekly *La Caricature* and almost immediately overstepped the mark; that is, he failed to exercise editorial discretion. Instead of treating King and Government with undying gratitude or even mild jocularity, he started to undermine Authority.

The notion of representing the King as a pear, his jowls and side-whiskers coalescing into the ripeness that precedes rottenness and downfall, was Philipon's. The image – part pun ('poire' can mean numskull), part sleight of hand – was both a brilliant demonstration of *caricatura* drollery and a deadpan enquiry as to the precise whereabouts of the dividing line between licensed jest and *lèse-majesté*. Philipon published the metamorphosis in full, as a phase by phase sequence, in his daily paper *Le Charivari*. At each stage a caption insisted on the inevitability of it all. The resemblance was perfect. Variations on the theme – Louis-Philippe as Buddha, as a gigantic obstruction, as a sheer lump – proliferated. For once, a caricature had not only brought a nick-name into being, it had – not altogether justly – epitomized all that there was to be resented about a style of government. In September 1835, after an assassination attempt on the King, censorship was re-imposed. As it happened, *La Caricature* had ceased publication, for financial reasons, a week or so before.

Once again caricature had to be generalized, directed not against individuals in power but against traditional targets: the Law, the *rentier* class and the bourgeoisie as a species. In 1848 freedom of the Press was re-established, with the arrival of Louis-Napoleon, but once he became emperor the usual restrictions were applied. In retrospect the years 1830–35 came to be seen as the heyday of French political caricature.

Certainly it was the period of French ascendency in the art. Philipon and his colleagues were imitated and emulated in other countries, Britain in particular. Weekly comic–caustic magazines sprang up and died away. They were illustrated as a rule with wood engravings: lithographs did not catch on in Britain except in album and broadsheet formats. What they all lacked, however, was the combined spiritedness and sophistication of the French papers. *Punch*, started in 1841, did survive, and for a few years to begin with it had radical pretensions; but it continued and prospered largely because it refrained from raising the hackles of its readers. The full-page 'cartoons' by John Leech and subsequently John Tenniel depicted political occurrences in terms of amateur theatricals, usually with the leaders of the day clad in fancy dress and engaged in allusive dialogues. Within five years of being founded, *Punch* was staid, and by 1850 it had become institutionalized.

Meanwhile, despite restraints, Philipon, Gavarni, Monnier and Daumier flourished. Prevented from alluding too closely to matters of government and the characters of those in office, they victimized whole layers and sectors of Parisian society. Daumier's contribution to caricature was akin to Cruikshank's and not altogether different from Hogarth's. He delighted in complacent greengrocers, mewling plaintiffs, dyspeptic judges. He preferred foibles to vices, petty weaknesses to major crimes. His subjects reveal themselves to be deluded fools, vain windbags, sad drudges. His Macaire, his Prudhomme, have lordly airs but, close to, the assurance proves to be all smirks and eyebrow-raising.

In this *comédie-humaine* caricature, these thousands of lithographs produced to meet almost daily deadlines, year after year, the sly, the greedy, the ponderous and the meek rub shoulders. Attention is drawn to the characteristic rather than the exceptional. The lithographic crayon brings out the greyness of the streets, the echoing gloom of the courts. It also plays gently over aging flesh, over bloodshot eyes and mouths opened in alarm and protest. Daumier's Parisians are all manifestly real characters. By contrast, Louis-Philippe the pear-king was just a figure-head, an emblematic freak.

Jean-Pierre Edouard Dantan
1800–69

Dantan came from a Normandy family of craftsmen carvers and gilders. Apprenticed to his father at the age of thirteen to carve rifle butts, he then worked as a sculptor on public buildings, and entered the École des Beaux-Arts in 1823. When his small caricature statuettes were exhibited in Susse Frères in the Passage des Panoramas, a fashionable shopping arcade off Boulevard Montmartre, they attracted public attention and were widely copied on walking sticks, umbrella-knobs, fans, masks and all kinds of gimmicks. The *portraits-charges*, only nine inches high, of celebrated singers, writers and musicians pleased most of the subjects, including Strauss, Liszt, Paganini, Balzac, Dumas and many actors of the Comédie Française. During one of his visits to London he tricked his way into the chorus at Covent Garden; dancing across the stage in masked disguise, he observed the King's party. The statues he later produced of them were disapproved of and seized. Over the next twenty years he sculpted 700 portraits, designed stage sets and costumes and wrote and produced two pierrot-pantomimes.

Dantan's caricature heads, together with those of Daumier, had a great influence on caricature in the early 1830s. His subjects, drawn from the art world rather than the political scene, won the approval of the establishment, and he was made Chevalier de la Légion d'Honneur.

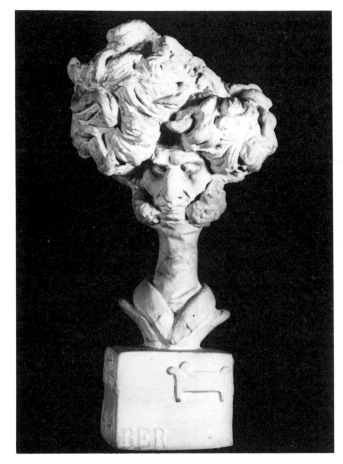

The statuette of Berlioz, only nine inches high and sold originally for five francs.

'TRAVIÈS'
Charles-Joseph Traviès des Villers
1804–59

After studying painting at the École des Beaux-Arts in Paris, Traviès found that his talents lay in draughtsmanship and lithography. He invented Mayeux, a comic dwarf who epitomized man's vanities and prejudices and gave Victor Hugo the idea for Quasimodo. Traviès drew for *La Silhouette*, and was one of the first regular caricaturists on *Le Charivari*. When his series of Mayeux prints came to an end, he began a humorous yet compassionate documentary of Paris street life. But the public preferred the comedy of Mayeux and, like so many of the characters he depicted, Traviès died alone and poor in a Paris hospital.

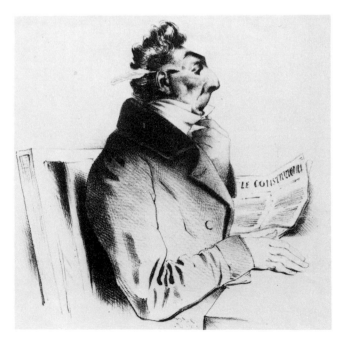

'Portraits-Charges, No. 1. Mr Stéphanus', a ministerial portrait in Le Charivari, *1832.*

David Claypool Johnston
1798–1865

Born in Philadelphia, Johnston was named after the
publisher who employed his book-keeper father. Although
he wished to study painting, his parents' humble means
made them urge him to take up the more practical trade of
engraving. After his apprenticeship he set out on his own in
1819 as a print-maker, to make a livelihood by caricaturing
local dandies and military men, but this soon brought
threats of libel suits. In his spare time Johnston, a strikingly
handsome man, took to the stage; but his efforts here also
met with limited success.

 Boston provided a more congenial home for the artist.
Although his acting career there lasted only a single season,
Johnston reigned as Boston's major comic artist for over
three decades. From the beginning his caricatures and comic
illustrations followed British models like Gillray and
George Cruikshank. His *Scraps*, a series of satirical etchings
published at irregular intervals between 1828 and 1849,
were inspired by Cruikshank's *Scraps and Sketches*. They
lampooned various aspects of American culture with a
spirited humour that pervades most of Johnston's works.
His *Trollopania*, a series of prints parodying passages from
Frances Trollope's infamous critique of American domestic
manners, was, understandably, warmly received.

*'Richard III', 1828, a bust of
presidential candidate Andrew
Jackson made up of symbols of his
Civil War experiences. Below it is a
quote from Shakespeare, 'Methought
the souls of all that I had murder'd
came to my tent'.*

'BENJAMIN' Benjamin Roubaud
1811–47

After studying under the leading genre painter, von
Hersent, Benjamin specialized in portrait caricature. He
worked with Lorenz on the *Panthéon Charivarique*, 100
lithographed portraits of men of the day which first appeared
in Philipon's *Le Charivari*, and were published as an album
in 1840; they included his self-portrait.

 His achievement in caricature is acknowledged by the
inclusion of his name among those of the great men of
France inscribed in the Panthéon in Paris.

Philipon, from the Panthéon
Charivarique, *1838.*

73

Honoré Daumier
1808–79

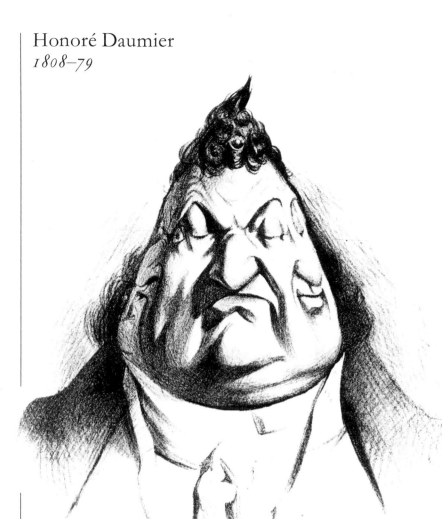

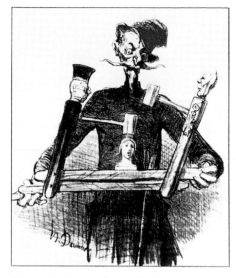

Daumier's character Ratapoil, the secret agent, with the beard and moustaches of Napoleon III, controls justice and authority in their repression of the common man.

F.D.

'Past, Present and Future', a variation of Louis-Philippe as a pear from Le Charivari, 1834.

Daumier's fame as a caricaturist eclipsed his reputation as a painter during his lifetime. His use of low-key colours and the vigour of his broad brush strokes were in advance of contemporary taste, and his overall achievement has been recognized only in retrospect.

The son of a Marseilles glazier, Daumier had an impoverished childhood. At the age of thirteen he started work in a bailiff's office in Paris, which left him with a loathing for legal bureaucracy. He then worked for a bookseller and, encouraged by the artist Albert-Auguste Lenoir, drew and learned lithography. His prints appeared in *La Silhouette* and he was among the artists drawing for *La Caricature* in 1830. His notorious cartoon of Louis-Philippe as Gargantua outraged the authorities: he was arrested and sent to prison. Soon afterwards, he made a number of small caricature busts in clay of the leading ministers, observing them from the Press Gallery in the Chambre des Députés. These not only served as studies for his own drawings, but were used as references by the various artists drawing for Philipon's journals. Henry James later wrote that Daumier was 'the political pencil of *Le Charivari* . . . the pencil of

truth, portraying public life, the sovereign ministers, the course of justice, . . . the glories and scandals of the moment'

With the arrival of total censorship on political subjects, Daumier turned to social satire. The character of Robert Macaire, a scoundrel in a current melodrama acted by Frederic Lemaître, became the archetypal swindler and double dealer as characterized in his prints. His depiction of episodes in the lives of city dwellers, his narrative humour and his scathing attacks on social injustice produced truthful and artistic works close to Hogarth's ideal.

Daumier was a great draughtsman and a master of lithography. Sometimes working under the pseudonym 'Rogelyn', he is recorded as having produced over 4,000 lithographs and wood engravings, 1,000 drawings and 300 paintings. For three years he attempted to live by painting alone, but he returned to *Le Charivari* in 1863.

His last series, *Actualités de 1866–72*, was made in the shadow of approaching blindness. His final years, during which he was unable to work, were eased by the kindness of fellow-painter and friend, Corot.

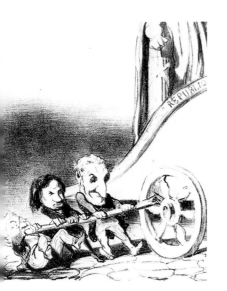

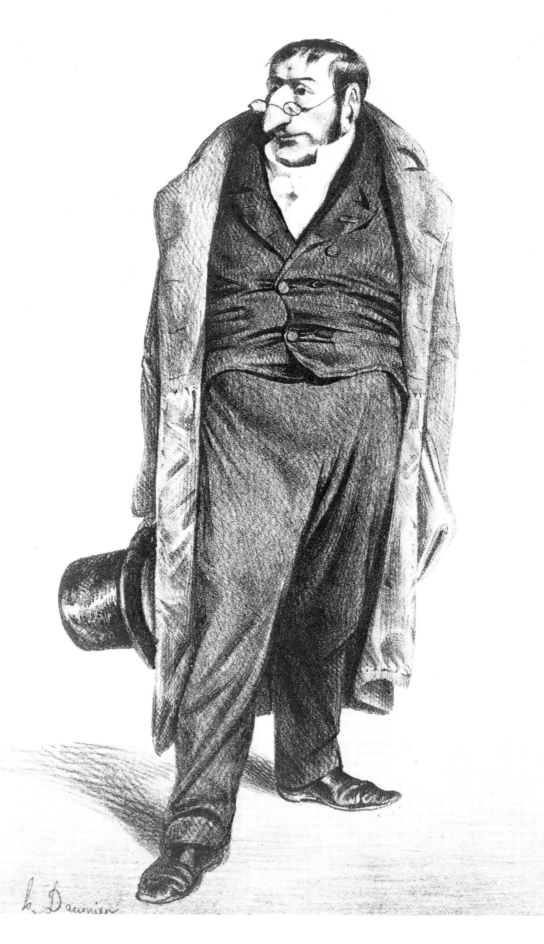

ABOVE *A detail from a print in which Thiers (left) and two other government ministers vainly attempt to halt the progress of the French Republic towards universal suffrage.*

RIGHT *'Mr d' Argo . . .', from* La Caricature, *1833. To avoid risk of prosecution, the full name of Comte d' Argout was not printed.*

Jacques Lefebvre, one of the small clay busts of government ministers modelled by Daumier in 1832. Those that survived were cast in bronze a century later.

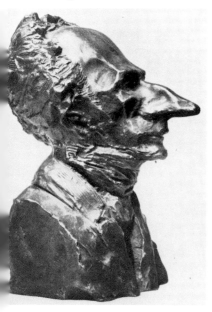

Etienne Carjat
1828–1906

Carjat's reputation has been overshadowed by that of Nadar: they were both photographers as well as caricaturists and thus had very much the same kind of career. The younger Carjat, who started as a technical draughtsman, no doubt emulated Nadar; his caricatures in pen and ink or pen, ink and paint reveal a similar technique and, like Nadar, he often simultaneously caricatured and photographed his sitters, using one means of representation to improve on the other. But whereas Nadar drew portraits of literary men, Carjat specialized in caricatures of actors (a selection of which appeared in *Le Théâtre à la Ville*), politicians and all the fashionable people who went to take the waters at Baden-Baden, where he settled for several seasons.

Carjat had several strings to his bow, and his published work includes a few slim volumes of poetry.

Honoré de Balzac (1799–1850), whose great novels chronicled the lives of the French bourgeoisie, from Diogène, *1856.*

Er. CARJAT. G. PERRICHON.

John Leech
1817–64

Leech was educated at Charterhouse School, where
Thackeray was a fellow-pupil, and studied medicine before
turning to art: he continued to use a leech-bottle as an
alternative signature. His first lithographs, published when
he was eighteen, were of street scenes and political carica-
tures. In 1840 his collaboration on several books with a
student friend, Percival Leigh, showed his talent as an
illustrator, and he also drew for *Bentley's Miscellany*, the
illustrated periodical which had first published Dickens in
serial form.

 He joined *Punch* in 1841, shortly after it was founded.
After a public display of cartoons for the frescoes at the new
Houses of Parliament, Leech produced a drawing for *Punch*
showing a poverty-stricken group in front of some of the
pictures. It was entitled 'Cartoon no. 1 – Substance and
Shadow' and the caption read, 'The poor asked for bread,
and the philanthropy of the State accords – an exhibition'.
Thus 'cartoon' became the term for topical caricature and
soon after, the large 'cut' (woodcut) of the week became
known as the cartoon. Leech's editorial cartoons helped to
establish the format of *Punch*; during twenty-three years, he
contributed 700 cartoons and over 3,000 illustrations.
Thackeray wrote: 'There is no blinking the fact that in Mr
Punch's Cabinet John Leech is the right-hand man.'

*An engraving signed 'Paul
Prendergast'.*

William Makepeace Thackeray
1811–63

Although he is best known as a novelist and critic,
Thackeray's early ambition was to illustrate. When his
father, an official of the East India Company, died in 1815,
'Billy-boy' was sent from Calcutta to England, to Miss
Pinkerton's School in Chiswick. At the age of eleven, he
went to Charterhouse School, and later went up to Trinity
College, Cambridge. After a tour of Germany, as his legacy
dwindled, he decided to take up law and entered the Middle
Temple, but this was short-lived and he moved to Paris
where he studied art while working as a correspondent for a
London paper. After the publication of *The Paris Sketch
Book* in 1840 he collaborated with John Leech on an *Irish
Sketch Book*. He felt deeply disappointed that Dickens
rejected him as illustrator for *The Pickwick Papers*. His
comical drawings and stories appeared in *Punch* through the
1840s; early pseudonyms were 'Yellow Plush' and 'Michael
Angels Titmarsh'. The successful publication of his novel
Vanity Fair led him to resign from *Punch* to further his
career as a writer, illustrating many of his own books: *Flore
et Zephyr* (1836), *The Book of Snobs* (1846), *Vanity Fair* (1847),
The Rose and the Ring (1854) and *The Virginians* (1858–9).

Self-portrait, 1855.

Jean-Ignace-Isidore Gérard Grandville
1803–47

Grandville satirised the bourgeoisie in several series of small lithographs, notably *Les Métamorphoses d'un Jour*, 1829, in which he first parodied people as animals, a powerful and often used device. He contributed to *La Caricature* and *Le Charivari* from 1830 to 1835, then turned increasingly to book illustration. Works include *Scènes de la vie publique et privée des animaux*, *Un Autre Monde* and *Les Fleurs Animées*.

Voltaire and Frederick the Great weigh themselves as Galileo and Newton play with a celestial sphere.

Caspar Braun
1807–77

A pupil of Peter Cornelius, in 1844 Braun founded the Munich satirical paper *Fliegende Blätter* and a publishing firm with Friedrich Schneider. His woodcuts dealt with topical issues, depicting types rather than individuals. His comic characters and clear line may have influenced Wilhelm Busch, who worked on *Fliegende Blätter* from 1859 to 1871.

Braun's crisp delineation of personalities influenced the artists who worked for him on Fliegende Blätter.

'NADAR' Gaspard Félix Tournachon
1820–1910

Although his reputation stands mainly as a master photographer of the new art's formative years, Nadar, son of a bankrupted publisher from Lyons, added caricature to his list of pursuits – medical student, clerk, tobacconist, coalmerchant, journalist, and eccentric-of-all-trades – when his work appeared in *Le Charivari* in 1847. In spite of taking off on a wild scheme to liberate Poland with a band of Parisian socialists, and his dangerous hobby of ballooning, by 1851 Nadar had become France's leading caricaturist, under the guidance of Philipon. He executed as many as 100 commissions a month, with ten or more draughtsmen completing 'the master's' hurried sketches. In 1854 he produced 'Le Panthéon Nadar', a single-sheet lithograph of 250 literary figures of the day, compiled from the studio accumulation of portraits. With the profits from the triumphant sell-out, he established a luxuriously equipped photographic studio. After the death of Philipon, he ceased caricature altogether, though his work continued to appear in publications up until 1870.

Charles Philipon, with quill and crayon-holder denoting his dual role of journalist and caricaturist.

Frank Henry Temple Bellew
1828–88

As colourful a personality as any cartoonist of his age, Bellew came to the profession an accomplished dilettante. Born in India, the son of an Irish captain in the British army, he was educated in France and established as an architect in London by 1852. He wrote and illustrated a travel account of the Scottish countryside which, published as *A Cockney in the Highlands*, was a considerable success. His literary graces brought him into contact with the Rossettis, Thomas Carlyle, Wilkie Collins and others. Bellew was described as a dapper, polished figure, the personification of Thackeray's Colonel Newcome as drawn by Doyle.

Ambition propelled Bellew to the United States in 1853, where he made his name as an illustrator for *Harper's Weekly*, *Yankee Notions* and several children's books, but his second career failed to earn him economic security or contentment, and financial and marital troubles plagued his later years.

'A "Rail" Old Western Gentleman': Abraham Lincoln, 1860.

Claude Monet
1840–1926

When Monet was about five, financial hardship forced his family to leave their grocer's shop in Rue Lafitte, Paris, for Le Havre. As a schoolboy he had had a great flair for caricatures, which were sold at a local stationer's shop; in Le Havre he met the former shopkeeper, Eugène Boudin, who encouraged him to paint 'en plein air'. Monet recounts that, on their painting expeditions, his eyes were opened: 'My destiny as a painter was revealed to me.'

The later life of this great painter is well known: military service in Algeria, the decades of constant hardship and discouragement, friendships with fellow-artists Courbet, Pissarro, Sisley, Renoir and Cézanne, and the founding of the Société des Artistes-Peintres in 1874, deprecatingly dubbed 'Impressionists' by critics and public.

Jules François Félix Champfleury, historian and art critic, author of Histoire de la caricature antique et moderne, *1865.*

Adalbert John Volck
1828–1912

During the American Civil War, the South had a single eloquent spokesman in the art of visual satire. Volck had emigrated to the United States from Germany, along with thousands of other dissenting idealists of the abortive 1848 revolution. When Maryland joined the Union camp at the outset of the Civil War, Volck, by then a dentist of considerable distinction in Baltimore, turned smuggler, spy and caricaturist. In a number of masterfully-drawn satirical etchings, published under the pseudonym V. Blada (a reversal of letters in his true name), he expressed the indignation and bitterness of the Confederacy against the Northern oppressor.

His style is reminiscent of certain German illustrators of the mid-nineteenth century, particularly Moritz Retsch. His remarkable ability to bring out the diabolical in his subjects makes his caricatures particularly effective. Volck's isolation as an 'amateur' or independent artist was probably largely responsible for his avoidance of the contemporary formulae in caricature adopted by many of the commercial cartoonists. Sadly, this same isolation doubtless contributed to the absence of imitators in American satire.

Abraham Lincoln and General Benjamin Butler as Don Quixote and Sancho Panza, an illustration to a verse satire on the much-hated General's career published in 1863.

Wilhelm Scholz
1824–93

Although he had ambitions to practise Fine Art, after the death of his father Scholz was forced to look for work in newspapers and magazines. He began work for the Berlin humorous journal *Kladderadatsch* in 1848 with its second issue and remained with it as a major contributor for almost forty years. For most of that time he was the paper's only illustrator and cartoonist, a fact which helped to give *Kladderadatsch* its remarkably unified appearance. Extraordinarily productive, Scholz also worked for many other humorous magazines in Berlin, among them the *Krakehler* and the *Grossmaul*.

Scholz's caricatures, in many respects like those of Tenniel, are never cruel and often laudatory; the texts, always written by others, supplied the sharp edge of comment. His portrayals of Bismarck and Louis Napoleon are particularly strong.

'Our Pride', from Kladderadatsch, *1884. In answer to the artist's rhetorical question, 'Where do we stand in the world today?', Bismarck displays a tail showing the extent of the German empire.*

Wilhelm Busch
1832–1908

'The first modern of the art', Busch is best known today (at least in Germany) for his cautionary children's tale *Max und Moritz*, for which he also provided the amusing and often frightening illustrations. But he deserves to be more widely celebrated for his breathtakingly innovative caricatures (like those of Napoleon and Frederick the Great), in which apparently free doodles are turned into expressive and immediately recognizable faces. These are entirely modern in their economy and directness; so, too, are the short-hand graphic conventions Busch invented to convey the impression of movement and even of states of mind.

Busch trained first as a painter but in 1859 began to make drawings for Caspar Braun on the Munich weekly *Fliegende Blätter*, at that time the leading humorous illustrated journal in Germany. Later he also worked for another Munich paper, the *Münchener Bilderbogen*. In the pages of these magazines and in a series of popular books he developed the picture-story, the forerunner of the modern comic strip. Indeed, *Max und Moritz* itself was later used as the basis of the highly successful American comic strip, *The Katzenjammer Kids*.

TOP *Busch's classic how-to-do-it sketch of Frederick the Great.* ABOVE *Onkle Fritz, from* Max und Moritz. *Busch's economical line has influenced many comic artists of this century, in particular Trier and Hoffnung.*

John Tenniel
1820–1914

Son of a dance master and Maitre d'Armes of Huguenot descent, Tenniel grew up in Kensington, London. Though he received little formal art training, he joined the Clipstone Street Art Society with the ambition of becoming a historical portrait painter. His fresco of St Cecilia was among those chosen for the new Houses of Parliament in 1845. But when a fencing accident blinded him in one eye, he was obliged to abandon painting and turned to black-and-white illustration. His *Aesop's Fables* of 1848 were noticed by Mark Lemon, the editor of *Punch*; when Dicky Doyle left (in

protest over *Punch*'s anti-Catholic views), Tenniel was taken on to draw decorative initial letters, and before long he was drawing the political 'cuts' of the week. His heroic and patriotic cartoons of the 1850s featured the British Lion and Britannia. On the death of Leech in 1864, Tenniel succeeded him as first artist, drawing the cartoon of the week until his retirement in 1901.

The epic quality of his weekly leader became the hallmark of the *Punch* cartoon, a tradition followed by Raven-Hill, Partridge and Illingworth. Though the sensitivity of his

RIGHT *'The Eagle in Love', 1853. This strange caricature of Napoleon III, after the announcement of his engagement to Mlle de Montijo who became the Empress Eugénie, gives a foretaste of the fantasy of Tenniel's* Alice *illustrations.*

OPPOSITE, LEFT *The lead* Punch *cartoon of 14 March 1868 shows Disraeli, the Prime Minister and leader of the Conservatives, closely watched by the great Liberal leader, Gladstone.*

'PILOTELL' Georges Labadie
1844–1918

pencil drawings was lost in the process of wood-engraving, the strength of his line and shading gained an emphasis and style that was much admired and imitated. His *Punch* cartoon of the Kaiser and Bismarck, 'Dropping the Pilot', is one of the classic references of caricature. Tenniel's characters assumed the postures of the great men, and his works had the austere humour of state charades. The element of risk in commenting on foreign affairs, with the time-lag in communications, was evident in 1885 at the fall of Khartoum. Never doubting that General Gordon would be relieved, Tenniel drew his celebratory 'cut', entitled 'Saved'. It was only the following week that the bowed figure of a weeping Britannia appeared over the caption 'Too Late'.

Tenniel's cartoon style, characterized by the solemn, academic grand manner, suited the Victorian mood, and the continuity of his graphic comment provides a summary of political highlights over his forty-seven years with *Punch*. His real masterpieces, however, were the illustrations he produced in 1865 for Lewis Carroll's *Alice's Adventures in Wonderland*, and, seven years later, *Through the Looking-Glass*. He was knighted in 1894.

Pilotell began to make his name as a caricaturist in France at the end of the Second Empire, when laws relaxing the rigid censorship of the Press were introduced. Politically a deeply committed radical, he kept up his attack under the Government of National Defence, producing a series of loose sheets entitled *Croquis Révolutionnaires*, and set up the short-lived newspaper *La Caricature Politique* in February 1871. Under the Commune he worked at the Préfecture of the Police and was also Director of Fine Arts. With the return of order, he sought refuge in London, where he exhibited etchings at the Royal Academy in 1875.

Pilotell was drawn into the field of caricature as an outlet for his political beliefs. His works depend for their effect on the exaggeration of the facial features of well-known figures combined with biting captions which emphasize the weaknesses of those caricatured.

General Louis-Jules Trochu, Governor of Paris from August 1870 to January 1871 during the German invasion of France, depicted as a pious, ineffectual lawyer in contrast to Léon Gambetta, enthusiastic leader of the Army of the Loire.

RIVAL STARS.

MR. BENDIZZY (HAMLET). "'*To be, or not to be, that is the question:*'—Ahem!" .
MR. GLADSTONE (out of an engagement). [Aside.] "'*Leading business,*' forsooth! His line is '*General Utility!*' Is the Manager mad? But no matter-rr—a time WILL come——"

Chez Deforest & Courtier Libraires Éditeurs, Rue St Marie Petit Champs 64 Imp TALLIS, M^{on} S^t Honoré 19
UN PETIT AVOCAT ET UN GRAND GÉNÉRAL.

'CHAM' Amédée de Noé
1818–79

When he was only six, Cham was already drawing the faces of his parents' friends. He joined the *Charivari* team of artists in 1843, and stayed with the newspaper until his death. His father approved his choice of pseudonym: it ensured that the family name was not publicized, yet contained a key to his origins – Cham (Shem) was, after all, the son of Noé (Noah). He was a most prolific and popular draughtsman, producing as many as thirty caricatures in a week, often using the zestful line of Gavarni and Daumier. As a member of the aristocracy, he was one of the few caricaturists to side with the Versaillais party in 1871, and he was bitterly critical of the 'follies of the Commune'.

Cham did not confine himself to caricature: he was the author of several plays and collaborated with Henri Rochefort, writer and polemicist. He was a frequent visitor to England, where his sister was married to Russell Henry Manners, later Admiral of the Fleet, and many of his drawings were published in English magazines.

Bismarck, in Le Charivari, *July 1870, encounters unexpected resistance in his attempt to devour the French as he has the Austrians (symbolized by the wine-glass bearing the name of the battle that finally crushed them).*

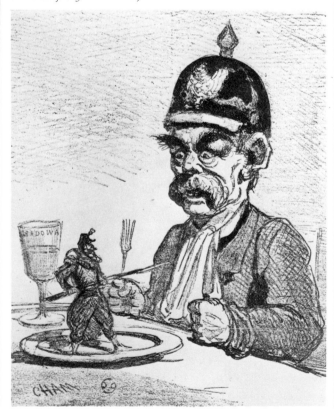

'FAUSTIN' Faustin Betbeder
1847–after 1910

Faustin was born at Soissons in France. A student at the École des Beaux-Arts in Paris when the Franco-Prussian War was declared, he quickly became one of the most successful caricaturists attacking the Imperial Government; one of his caricatures of Napoleon III was said to have made him a small fortune. His work shows him to have had no more sympathy for the Government of National Defence, during whose rule he brought out a scathing series entitled *Les Hommes du Jour* and contributed to another on *Nos Grrrands Généraux*, than he had for the Commune's brand of chaos. Though not particularly original, his caricatures convey the climate of feeling in Paris during this period.

Once peace was restored he moved to London, where he married and set up a print business. He contributed to the *London Figaro* and designed theatrical costumes for the Alhambra, the Lyceum and the Comic Opera. He also had some success as an oil painter, painting among other subjects the Coronation of George V, and executed some attractive pastels.

'Les Masques' links France's enemy, Bismarck (top left) with (clockwise from centre) Napoleon III; Émile Ollivier, a left-wing convert to the Imperial party; the Empress Eugénie; the Prince Imperial; and Prince Napoleon, the Emperor's nephew.

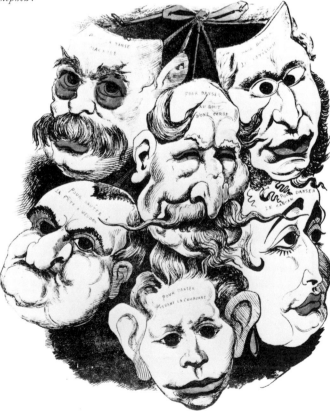

The Portrait-Charge

THE CROWDS DISPERSE. In the hands of Nadar, Doré, Cham and Gill, leading personalities come to the fore. Their heads are swollen; their self-assurance is startling.

But then to be singled out by André Gill, ushered under the spotlight and given the full-page treatment in *La Lune* (or, after its suppression in January 1868, *L'Éclipse*) was a singular honour. Those chosen included painters and writers, even caricaturists. The aim was to amuse rather than puncture and deflate. For the *portrait-charge* was a focusing of attention, a means of peering at a man, scrutinizing him with a fortune-teller's deliberation, noting every crease and wrinkle.

The caricaturist could go further than the photographer. Not only could he provide a meticulous account of the subject's appearance (photographs came in useful as reminders), but he could also accentuate the significant characteristics. The moustache: whether curled or waxed; the eyes: whether rabidly protuberant or sunk in their sockets, indicating either shrewdness or deep, congenital cunning. In the *portrait-charge* the contours of nose and brow loom as though under a magnifying glass; the nostrils dilate; shadows multiply under the chin. The personality is moulded into definitive shape. The notables line up like exhibits in a toby-jug waxworks.

In a sense the *portrait-charge* is the ripest form of caricature. It brings out the force of personality rather than the whole man. The Carracci brothers drew such beings: homunculi, grinning sadly, knowing they were prized for their freakish qualities alone. The outsize head, set low on the shoulders above a tapering, almost irrelevant body and legs, is the thinking-man's caricature. But it also represents the 'Cat may look at the King' point of view. As every animal instinctively knows, the face is what has to be watched intently during an encounter; the eyes especially, because they react to every thought and so betray the next move.

Crowned heads, heads of state, 'talking heads', deskbound heads, 'great minds', bosses, commanders, grown-ups, are depicted in the *portrait-charge* more or less as we envisage them in the mind's eye. People of no account are faceless or pinheaded. Those to be reckoned with are distorted accordingly: salient features foremost, the rest minimized. This is also, of course, how we see ourselves, close-to in the bathroom mirror. It is how we regard ourselves from within, looking out, sensing ourselves as somehow immeasurably big-headed, our brainpans bulging and overflowing with desires, sensations and wild impulses.

John Tenniel was chosen by Lewis Carroll to illustrate *Alice in Wonderland* and *Through the Looking Glass* in the 1860s because he was so adept at merging the fantastic and the prosaic. The Ugly Duchess is descended from Renaissance prototype; the Walrus and the Carpenter are not unlike Disraeli and Gladstone; the court of the Queen of Hearts is a meeting-place for emblematic playing-card figures and obstreperous, egomaniac *portrait-charge* characters. Alice, caught up in this overwrought throng, is torn between sympathy for their plights and impatience with their perpetual mystification.

In real life, Napoleon III's Second Empire, which had grown ever more vainglorious and alarmist, came to an end with the Franco-Prussian War of 1870. Daumier saw only a land planted with bayonets, a wilderness patrolled by death, a desolation of corpses. Gill and the others – in particular Alfred Le Petit – apportioned blame, loading the bloated head of the Emperor with signs of dishonour. Heads rolled.

Gustave Doré
1832–83

The son of a civil servant, Doré showed an early talent for music and drawing, had a great admiration for Grandville, and learned lithography while still a schoolboy in Bourg. In 1847, accompanying his parents on a visit to Paris, he passed the print-shop, La Maison Aubert. Struck by Philipon's display of caricatures there and searching for any opportunity to stay in the capital, he quickly drew some, and called at the shop. Philipon was so impressed that he persuaded the parents to let the boy stay on and work for him. While still a pupil at the Lycée, his weekly front-page cartoons for *Le Journal pour Rire* paid his way. On the sudden death of his father in 1849, he became the main support of the family: his mother came to Paris, where they stayed for the rest of his life. He worked for *Le Journal* until 1854, when he published 'La Sainte Russie', provoked by the Crimean War. His major work of book illustration began with wood-engravings drawn directly on to blocks for Rabelais' *Contes Drolatiques*. At twenty-two he was famous.

Doré visited England each year, where his painting was highly regarded; a Bond Street gallery had a permanent exhibition of his work. His views of London in the 1870s, the East End, the Docks, Penny Theatres and the slums are dramatized documentaries; one, called 'Over London by Rail', revealed the no-man's-land of Victorian poverty. The enormous output of wood-engravings was made while he led a fashionable social life in London.

After the Franco-Prussian War he turned to sculpture, with a monument to his friend Alexandre Dumas. His own funeral at Père Lachaise cemetery in Paris was given the full military honours accorded to an officer of the Légion d'Honneur.

A Député at the Versailles Parliament, 1871, sketched by Doré when he and his mother had fled the Paris Commune.

A. A. Gaillard
w. 1840–85

Gaillard was a lithographic draughtsman who worked mainly in Lyons. He appears to have visited Paris when short of commissions. The subject matter of his work was varied, ranging from illustrations of a history of Lyons (1847) and views of his home town to political caricatures. The latter gained in force considerably when censorship of the Press was relaxed at the end of the Second Empire, making their appeal through the bluntness of their images.

This Gaillard may be the same person as Arthur Gaillard who was born at Chaumont, studied with Gérôme and Becker, and exhibited paintings at the Paris Salon from 1878 to 1882.

Lyon, J.B. Gadola, Édit. Cours de Brosses, 2

GAILLARD

UN COCHON ENGRAISSÉ PENDANT 20 ANS POUR LE ROI DE PRUSSE

Napoleon III as 'a pig fattened up for twenty years for the King of Prussia'.

Alfred Le Petit
1841–1909

Le Petit, who sometimes used the pseudonyms 'Zut', 'Caporal' and 'Alfred Le Grand', came from a family of clock-makers and was brought up by Jesuits. He studied in Rouen and then went to Paris. In 1870 he set up *La Charge*, in which he published vicious caricatures against the Empire, causing the paper to be suspended. At the same time he produced a series of caricatures, signed 'Zut', in which he implied improper relationships between the Empress Eugénie and members of the government. In 1870–71 he published two series of caricatures, *Fleurs, fruits et légumes du jours* and *Hommes de la Commune*, showing little sympathy for the Government of National Defence and the Commune respectively. Once order was restored he contributed to various publications, including *Le Charivari*, *Le Journal Amusant*, *La Fronde* and *Sans-Culotte*. In 1877 he set up *Le Pétard* and from 1879 to 1885 he stepped up his anti-clerical attack. In 1888 he again took over control of *La Charge*. Many of his caricatures show a lively use of line and a clever play between words and images, while others resort less successfully to the use of the grotesque.

From 1873, when he produced his first oil, Le Petit longed to devote his energies to painting. According to his son, he used to complain: 'I am condemned to the torture of producing caricatures forever.'

LE PIF IMPÉRIAL, PAR ALFRED LE PETIT

SUPPLÉMENT DE *LA CHARGE* No 6.

T'a encore l' temps d' faire ton nez, mon bonhomme, si tu crois r'venir à Paris, tu peux t' fouiller.

The Republic cocks a snook at Napoleon III.

Alfred Bryan
1852–99

Bryan was among the first artists to work for the Dalziels after they acquired *Judy*, initially founded in an attempt to rival the success of *Punch*. He illustrated the theatre page as well as the political highlights of the week. His caricatures were noted for their degree of likeness. He became the mainstay of *Moonshine*, founded in 1879, drawing the double-page cartoon, a feature called 'Days with Celebrities', and many of the illustrations. At the same time he continued to draw for *Judy*, the *Illustrated Sporting and Dramatic News*, *Ally Sloper* and other papers. One of his pupils was J. A. Shepherd, whose animal caricatures, *Zigzags at the Zoo*, won great popularity in *Punch* from 1894 on. Bryan's early death was a great loss to the many black-and-white journals and their readers.

Félix Elie Régamey
1844–1907

A painter of portraits, historical subjects and genre scenes as well as an etcher and draughtsman, Régamey studied with his father, the painter Louis-Pierre Guillaume Régamey, and with the painter Horace Lecoq de Boisbaudran. He taught at the École des Arts Décoratifs and at the École d'Architecture.

He first made his name as a caricaturist contributing to *Le Journal Amusant*, *La Vie Parisienne*, *Le Monde Illustré* and *L'Illustration*. In 1870 he founded the short-lived *Salut Public* and in 1871 contributed to *La République à Outrance*. His caricatures tend to elucidate major issues rather than to ridicule individuals, and depend for their visual impact on the use of light and dark masses as much as on the linear exaggeration of the characteristics of the people portrayed.

In 1873 he visited England and the USA, and toured Japan with Emile Guimet, whose *Les Promenades des Japonaises* he illustrated. He became an inspector of drawing in the schools of Paris in 1881. He died at Juan les Pins.

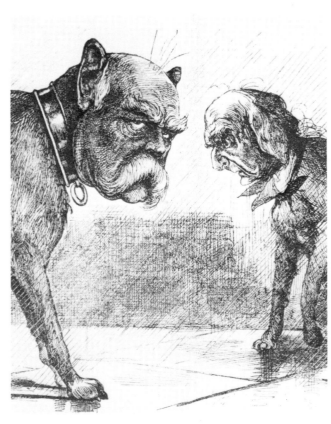

'Cast out', from Moonshine, *1890.*
Both leaders had been ousted,
Bismarck by the Kaiser and
Gladstone by the British electorate.

'The solemn entry of the Emperor of
Germany into Paris', a prediction of
capitulation in La République à
Outrance, *18 February 1871.*

Alphonse Jacques Levy
1843–1918

Levy, who used the pseudonyms 'Saïd' and 'Coco', was a painter of genre scenes, draughtsman and print-maker as well as a caricaturist, and is particularly known for his portrayals of Jewish life. He was a student of the painter Gérôme and first showed at the Paris Salon in 1874. He obtained the distinction of a special mention at the Exposition Universelle in 1900 and became an Associate member of the Salon de la Nationale des Beaux-Arts from 1901.

His caricatures show him to have been a patriotic, left-wing member of the bourgeoisie. They tend to depict major political figures in simple poses that epitomize his attitude to them.

Emile Evrard
w. 1871

The Paris Commune of 18 March–28 May 1871, a short-lived uprising against the Government of National Defence which had been set up after the collapse of Napoleon III's Second Empire, provoked a burst of propaganda publications which gave caricaturists their first opportunity since 1830 to express themselves in print. Evrard was one of many artists who contributed caricatures, but about whom nothing else is known.

'Quelle Tuile !', an ironic expression of shock implying that Government ministers Favre (left) and Thiers secretly welcomed the Commune's rebellion on 18 March 1871.

Léon Gambetta, backed by sympathizers in Bordeaux in favour of continuing the fight against the Germans, glares at the listless Jules Favre as Paris capitulates.

'ANDRÉ GILL'
Louis-Alexandre Gosset de Guines
1840–85

Though Gill died fairly young, having stopped work in about 1880, he is forever remembered as the supreme exponent of the *portrait-charge*, the genre introduced by Philipon's artists in *Le Charivari* during the 1830s. When still in his teens he was befriended by Nadar, who was struck by his talent, and Gill was the last of the young artists to be launched by Philipon. He started on *Le Journal Amusant*, under the pseudonym which he chose in homage to Gillray, and made his name with the series of portraits for *La Lune* entitled *The Man of the Day*. Many people became household names through his portraits, and his image of Thiers became the prototype followed by other caricaturists. He himself drew over 500 images of Thiers, though he boasted that he never actually met the man.

His caricatures were strong likenesses, subtle portraits in depth, yet also amusing and devoid of malice. People wanted to be caricatured by him: to appear on the pages of *La Lune* was a mark of distinction. The Emperor Napoleon III, however, was less amused to find himself caricatured in the character of Rocambole, ruffian-hero of a popular novel of the time. *La Lune* was banned in consequence in January 1868, only to resurface a few weeks later under the new title of *L'Éclipse*, with Gill again the chief caricaturist. The Government became obsessed with Gill's caricatures, even censoring his drawing of a cantaloupe melon for fear the captionless picture had some ironic significance. Gill maintained there was no ambiguity.

Though Gill did participate in the Commune, drawing for Jules Valles' socialist newspaper *La Rue*, he was not a committed radical. He drew a melancholy 'Burial of Caricature' in 1873 when stringent censorship crushed the freedom of the Press, but continued to work for various publications. Like Gillray, the man he so wished to emulate, Gill died a prey to fitful madness.

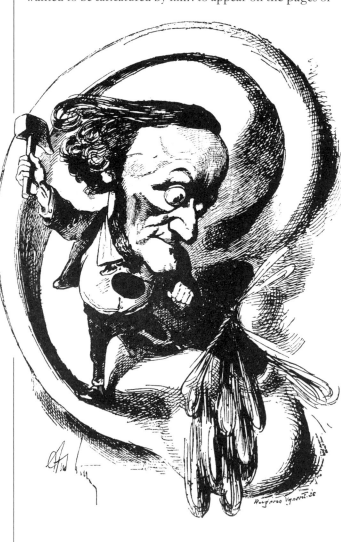

Richard Wagner, the composer.

LES DEUX COMPÈRES, par GILL.

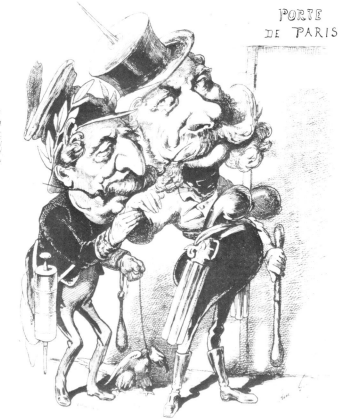

Published as a supplement to the newspaper L'Éclipse, *this hand-coloured engraving shows Napoleon III and the German Emperor William I in the roles of melodrama's villainous accomplices, Bertrand and Robert Macaire, popularized by Daumier.*

RÉDACTEUR EN CHEF
F. POLO
—o—
ABONNEMENTS
PARIS
52 numéros............ 6 fr.
26 numéros............ 3 —
—
Les abonnements partent du
1er de chaque mois
—o—
BUREAUX
16, rue du Croissant, 16

DIRECTEUR
F. POLO
—o—
ABONNEMENTS
DÉPARTEMENTS
52 numéros............ 6 fr.
26 numéros............ 3 —
—o—
ANNONCES
Fermage exclusif de la publicité
ADOLPHE EWIG
16, rue Taitbout, 16

CANAILLE & Cⁱᵉ, par GILL

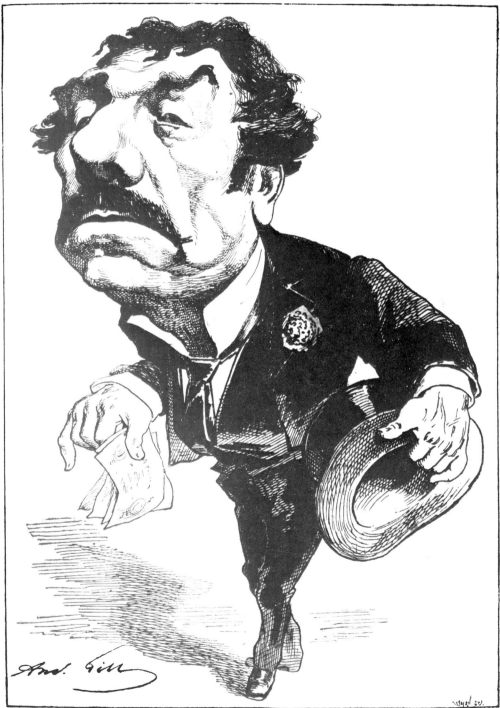

Paulin Ménier.

RIGHT *Actors such as Ménier,
shown in his role as Martel in*
Canaille et Cie., *used to mimic the
appearance and gestures of public
figures – in this case those of the Duc
de Nemours.*

'MOLOCH' Alphonse Hector Colomb
1849–1909

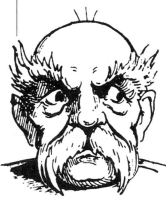

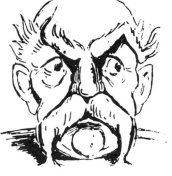

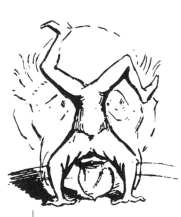

'All there is in the face of M. de Bismarck.'

'Bismarck prepares to write his memoirs.'

Moloch's career as a caricaturist started during the Franco-Prussian War, when he took the side of the Commune against Thiers and the Parliament of Versailles. His first drawings were bitter indictments of the legal government and impressions of life in Paris under siege. He took up *portrait-charge* in the manner of Gill, publishing in the political journals *L'Éclipse* and *Le Grelot* between 1870 and 1885, satirizing both General Boulanger and the Jesuits during the 1880s. He participated in the Dreyfus affair on the side of Dreyfus, drawing for *Le Sifflet*, with Ibels and Hermann Paul.

The passionate political commitment which had prompted his fearsome choice of pseudonym seems to have abated in later years. After 1885 he contributed to *La Caricature*, *La Silhouette*, *Le Chat Noir* and the *Almanach Vermot*, a light-hearted publication of jokes and puns. From 1901 to 1904 he worked for Pellerin, the publishers of the popular coloured prints, *Les Images d'Épinal*, contributing caricatures to a series called *Images Supérieures*. Elected Officier d'Académie in 1902, in 1906 he was appointed Officier de l'Instruction Publique, on the recommendation of President Magnaud.

Thomas Nast
1840–1902

Exalted as the 'father of American political cartooning', Thomas Nast was more than merely a hired pen, unlike many cartoonists of his day. He was a public figure whose stature and influence were, for a time, equal to those of any contemporary politician or journalist. While less gifted artists were content simply to reflect and express public sentiment, Nast was an estimable force in the formation of American political opinion for three decades. His ability to perceive and portray issues and forces in simplified terms, as elements in the struggle between good and evil, was his chief gift as a satirist. Nast created and employed the definitive symbols of political forces in the forms of the Tammany tiger and the elephant and donkey of the Republican and Democratic parties respectively. During the course of his career he brought down the mighty New York graft empire of William Marcy Tweed and earned commendations from several American presidents and the status of something of an institution in American political caricature.

Nast was once described by Art Young as 'a dapper, olive-skinned Bavarian, with owl-like features and a smile that lifted his white teeth and flaring moustache to first place'. He was born in the town of Landau-in-der-Pfalz, the son of a liberal-thinking trombone player. The family's emigration to the United States in 1846 was probably brought about by the elder Nast's politics.

Coming of age in New York, Nast elected, against his parents' wishes, to study for a career in art. His attendance at the National Academy of Design and training in the studio of historical painter Theodor Kaufman were brief. In a rather spunky effort to convince his parents of the economic viability of his choice, the young artist called on Frank Leslie, the publisher of New York's largest illustrated newspaper, and gained entrance to the world of sensational pictorial journalism. During the Civil War, Nast was in the field as a correspondent artist for the *New York Illustrated News* and, later, *Harper's Weekly*. As chief artist of the latter, he eventually became one of the magazine's principle features.

In his caricatures Nast's debts to certain artists are clearly discernible. Dramatic effects from the repertoire of Gustave Doré (whom Nast idolized), the handling of linear technique and comic expression and proportions of the Englishman John Tenniel, and the expressive force of the French caricaturists of the Franco-Prussian War and the Commune are all present in his drawings. Nast's own peculiar virtues, though, are responsible for the exalted place he occupies in American caricature. The artistic vitality of this relatively untrained draughtsman and his unswerving commitment to political reform have provided a model which has inspired ensuing generations of American political artists.

Senator Leopold Morse, c. 1896:
'*An aerogonous, cryptogamous plant....*'

Henry Cabot Lodge (1850–1924),
US *Republican senator.*

The Newspaper Cartoon

THE SPREAD OF compulsory elementary education in Europe and the United States from the 1870s onwards, coupled with universal (albeit adult males only) suffrage, created an enormous newspaper readership–cum–electorate. Cartoons were the most vivid and popular means of putting political issues across. Leading articles could urge and fulminate, but only the caricaturist could exaggerate regardless, insinuate without fear, sneer and tease at will, praise without qualms and dish out otherwise unthinkable retribution.

Thomas Nast started out as a pictorial journalist, reporting on the Civil War and its aftermath in increasingly allegorical and *tableau vivant* terms. By 1870 he had become a full-blown caricaturist, working mainly for *Harper's Weekly*. His style was not distinguished, being a conglomeration of Tenniel, Doré and German broadsheet mannerisms, such as those of the *Münchener Bilderbogen*. But his work had the virtue of being more awkward, more primitive and hence, perhaps, more sincere in tone than anything produced in the sophisticated capitals of Europe. So when Nast took to exposing big city corruption, most notably the Tammany Hall Ring run by 'Boss' William Marcy Tweed, his honest-to-goodness awful-warnings rang true. It was graphic Abe Lincolnism.

Nast invented the 'Tammany Tiger' prowling the streets of New York, and the Republican elephant. But in caricature his supreme achievement was the portrayal of Boss Tweed, a bald-pated oaf, patently stupid with his rheumy eyes and flabby nose, like a power-mad ant-eater. Nast poked away at his prey throughout the election season of 1871. Bribes were offered to his superiors at *Harper's Weekly*. Circulation tripled. As a result of Nast's perceptible influence on the voters, Tammany Hall changed leaders and underwent a semblance of reform. Eventually the Boss was sentenced to twelve years in prison. He said, 'I don't care a straw for your newspaper articles, my constituents don't know how to read, but they can't help seeing them damned pictures.'

Significantly, Nast was at his best when engravers translated his drawings on to the block, augmenting his rather wooden, evenly cross-hatched technique. In the 1880s, mechanical process engraving made it possible for his work to be reproduced with greater fidelity. By this time his ideas were giving out; his line faltered. Finding ideas soon became a nightmare for all professional newspaper cartoonists as, with the development of process engraving, it became possible – indeed mandatory – to illustrate popular daily papers. The caricaturist was thus under pressure to produce running commentary. On the *Pall Mall Gazette* F. C. Gould illustrated and dramatized parliamentary proceedings. His audience was small and relatively well-informed; even so he had to spell out his ideas, labelling personalities and underlining points with great deliberation, for a number of years.

Newspaper caricature became rapidly more sophisticated as illustration increased. Once photographs had become reproducible, the need for drawings to record events virtually ceased. The caricaturist was left facing the challenge of the photographer. He had the advantage of being able to make up incidents, to draw his characters as and when he chose; but then, working to daily deadlines, there was no time for hesitation or second thoughts. A situation arose; a treatment suggested itself. All that then mattered was the nifty resolution, the bundling of personalities, predicament, joke and moral into a single drawing ready to meet the deadline.

John Wilson Bengough
1851–1923

Bengough is considered the first important cartoonist that Canada produced. His working career paralleled that of its first Prime Minister, Sir John A. Macdonald, and his caricatures on the subject of Macdonald and his political activities provide an excellent documentary of that turbulent period. What Bengough lacked in technical ability he made up for with clout. He was a great admirer of his brilliant American contemporary, Thomas Nast, and indeed many ideas that Bengough applied to Canadian politics in his drawings were taken directly from those of Nast.

Bengough started as a reporter. In 1872 he established a weekly humour publication in Toronto called *Grip*, named after the raven in Charles Dickens' *Barnaby Rudge*. *Grip* rode to success on the back of Sir John Macdonald and the Canadian Pacific Railway scandal of 1873. A life-long liberal, Bengough drew a weekly cartoon in addition to editing and writing articles for *Grip* for the next twenty years. In 1892 he left the magazine, which was to fold shortly after. He then worked at different times for the *Montreal Star*, *The Globe*, the *Canadian Courier*, *Moon* and other Canadian publications.

Bengough was a gifted speaker and travelled throughout Canada giving a series of illustrated lectures which came to be known as 'Chalk Talks'. He also published poetry.

'So Very Much Alike', from Grip, *shows 'A friendly game of Euchre at Hughenden, between the two great statesmen of modern times' (Disraeli and Sir John Macdonald):*
Sir John (loq.) – 'I wonder where all the bowers are?'
Earl Dizzy – 'Don't know, I'm sure.
I have only three in my boot.'
Sir John – 'And I have just one up my sleeve!'

Joseph Keppler
1838–94

Although less celebrated than Thomas Nast, Joseph Keppler had an equal hand in shaping the character of late nineteenth-century American caricature. Born in Vienna, he studied there for a time at the Akademie der Bildenden Künste. Even before leaving Austria he had begun drawing satirical cartoons which were published in the Viennese magazine *Kikeriki*. At thirty years of age he emigrated to the United States and settled in St Louis, home of a large German-speaking population. After a brief spell as an actor, he founded *Die Vehme*, a humorous magazine for the immigrant residents of St Louis which failed after only a year.

In 1872, Keppler moved to New York to join the staff of *Leslie's Illustrated Newspaper* at the invitation of Frank Leslie who evidently hoped that Keppler would prove a competitor as a cartoonist to *Harper's Weekly*'s Nast. Whether for the sake of ambition or editorial freedom, Keppler soon left and, in collaboration with Adolph Schwartzmann, a printer, founded *Puck*, which quickly established itself as the leading popular humour magazine in the United States, offering a number of colour caricatures and cartoons in each issue.

Keppler was at first editor and principal artist of the magazine and, predictably, it was his own style that became associated with the journal and carried the publication for many years. This style marked a clear departure from that of Nast, which had dominated caricature during this period. Keppler introduced more amply developed compositions and livelier and more penetrating characterizations. Humour was an essential ingredient in his works. In addition his cartoons display an agility of drawing and a familiarity with the French satirical artists of the Commune period and the German illustrations of *Fliegende Blätter*.

Eventually Keppler attracted a number of talented comic artists and illustrators like F. B. Opper, Arthur B. Frost, and Bernhard Gillam. At his death his role at *Puck* was assumed by his son, Joseph Keppler Jr. By this time Keppler had generated a style and approach to caricature that was to dominate *Puck*, its competitors and American pictorial humour for years to come.

OPPOSITE *'The Raven', 1890. Keppler caricatured Benjamin Harrison,* US *President from 1889 to 1893 and grandson of President William Henry Harrison, in a series of cartoons in which he was gradually engulfed by his 'Grandpa's Hat'. The raven watching from the bust of the elder, more illustrious Harrison, is James Blaine, then Secretary of State, who opposed Harrison's protective tariff policies.*

Livingstone Hopkins
1846–1927

Hopkins' caricatures of his fellow-artists first appeared in the New York weekly journal *Wild Oats*, where his fine line showed great comic style. Like many contemporary up-and-coming young artists, he drew for the *Daily Graphic*, New York's first illustrated newspaper. In 1882 he went to Australia to work on the *Sydney Bulletin*, and established his reputation as the leading cartoonist on the paper, becoming one of the richest and most successful of all cartoonists; he was rumoured to have become a millionaire. He remained with the *Bulletin* and made his home in Australia for the rest of his life.

Caricaturist Frank Bellew, included in a series of wood-engravings, Fun Makers of New York, *in* Wild Oats, *1874. His portfolio sports the triangle with which he signed his work.*

James Albert Wales
1852–86

The first major native-born cartoonist on the lively caricature scene that developed in America from the 1870s on, Wales first drew for *Wild Oats*, the New York weekly illustrated journal 'of Fun, Satire, Burlesque, Hits at Persons and Events of the Day'. He also produced masterly coloured cartoons with strong caricature portraits for *Puck*, the magazine founded and published by the Viennese cartoonist Keppler, who had introduced the colour lithograph into American magazines. After a quarrel, Wales left in 1881 to found his own journal, *The Judge*, drawing the striking cover cartoons, which maintained political impartiality. Despite the lively art-work and comment, the magazine suffered constant financial problems and he was obliged to sell out in 1885. The new proprietor turned it into a pro-Republican paper, and enticed Gillam away from *Puck* to draw for him. Keppler and Wales were reconciled, and he returned to *Puck* until his early death the following year.

The cover of The Judge's *first issue, showing Senators Kelly and Conkling, signalled its political impartiality.*

98

Frederick Waddy
w. 1870s

Apart from a single entry as an exhibitor at the Royal Academy in 1878, details of Waddy's life are unrecorded. He engraved ornamental initial letters for various journals, and a number of his caricatures were reproduced as wood-engravings in periodicals including the *Illustrated London News*, signed with his decorative monogram. His subjects were notable men of the day, particularly writers; the large portrait head and dwarf body of stock caricature were enlivened by imaginative details – Mark Twain astride a leaping frog, Anthony Trollope with puppet characters, Wilkie Collins confronted with the Woman in White.

Adriano Cecioni
1838–86

A sculptor and painter, Cecioni was the leader and principal theorist of the anti-academic 'Macchiaioli' group of artists, contemporaries of the early French Impressionists, whose activities centred on Florence. Following critical acclaim in the Paris Salon of 1870, Cecioni went to London, where he contributed twenty-six caricatures – among them ones of Wilkie Collins, John Ruskin and Charles Kingsley – to *Vanity Fair* in 1872. He worked also in the less usual field of comic sculpture, exhibiting works in this genre at Turin and Rome in 1880. His *Collected Essays* were published in Florence in 1905. Originals of his caricatures are in the collections of the Uffizi, Florence, and the National Portrait Gallery, London.

Wilkie Collins, the American-born author of The Woman in White, *3 February 1872.*

Henry Stanley, the journalist who tracked down David Livingstone.

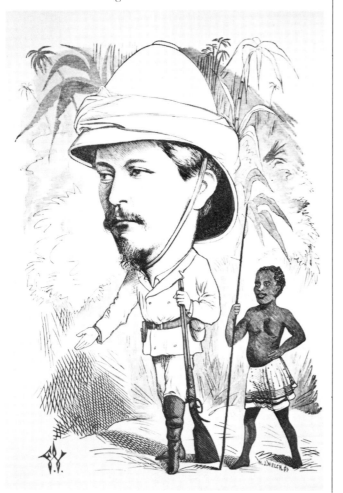

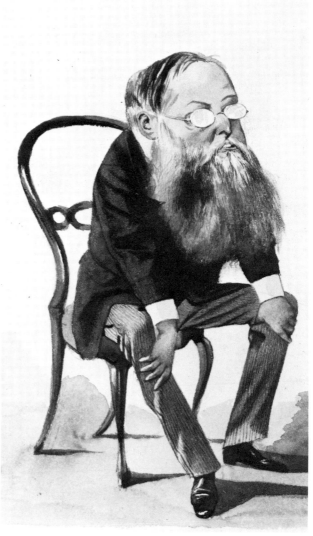

99

'COÏDÉ' James Joseph Jacques Tissot
1836–1902

Tissot is now remembered mainly as a society painter of fashionable scenes of meticulous detail. His reputation was well established by exhibitions at the Paris Salon and the Royal Academy before he fled to London after the Paris Commune. Brought up in Nantes, of a pious Catholic family, he had studied at the École des Beaux-Arts in Paris, where Ingres was among his teachers and Whistler a fellow-student.

A close friend of Bowles, the editor and proprietor of *Vanity Fair*, Tissot collaborated with him on *The Defence of Paris*, published in 1871, while Bowles was correspondent there for the *Morning Post* and Tissot was in the sharp-shooters. He had contributed to *Vanity Fair* in 1869 with *Sovereigns*, a brightly-coloured series on the crowned heads of Europe, and altogether made some fifty portraits from 1869 to 1877, in a style often closer to realism than caricature, drawn directly on to the litho stone. Settling in London, he had an entrée into society and the art world. But he abandoned it all in 1882, after rumours of a tragic end to a romantic liaison, and from 1885 he devoted himself to religious subjects, journeying to the Holy Land for his illustrations for *The Life of Our Saviour Jesus Christ*.

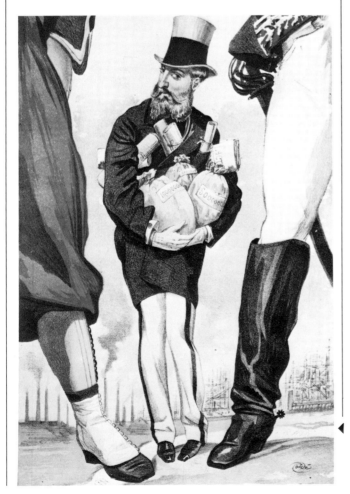

'APE' Carlo Pellegrini
1838–89

From a noble Capuan family (his mother was of Medici descent), Pellegrini grew up in fashionable Neapolitan society, where his early caricatures, in the manner of Melchiorre Delfico, won him acclaim among his friends. As a youth, he joined Garibaldi and fought with his volunteer army. He came to London in 1865 and was engaged by Bowles to work for *Vanity Fair*. His caricature of Disraeli was the first of the lithographs to appear in that magazine. The instant sell-out of all editions established the colour portraits as an essential feature from then on. The pseudonym 'Singe' which he used on the first two plates (of Disraeli and Gladstone) changed to its English equivalent, 'Ape', thereafter.

A protégé of the Prince of Wales, and connected with the Marlborough House set, he had a ready entrée into London Society and a wide circle of friends – and subjects. Max Beerbohm called him 'the only true caricaturist in England', though he considered that Ape had eventually succumbed to the English atmosphere, 'becoming mild and gentlemanly'. Nevertheless it was his manner that determined the 'house style' of *Vanity Fair*. His association with the journal continued throughout his life. When offered a subject he did not relish, he would say: 'I don't like 'im. Send Ward – he can run after 'im better.' (Leslie Ward, 'Spy', was then the junior artist.)

Ever in financial straits, Pellegrini called at the office fortnightly to collect his £20, yet seldom arrived home, a mere 200 yards away, with enough to pay his landlady. A most popular and generous figure in bohemian London, he was dubbed by his friends 'one of Nature's saints'. Frank Harris described him as 'a grotesque caricature of humanity, hardly more than 5′ 2″ in height, squat and stout, with a face like a mask of Socrates and always curiously ill-dressed, yet always and everywhere a gentleman – and to those who knew him, a great deal more'.

Though he often drew from memory, he liked a friend to accompany him when drawing from a sitter, to make conversation. A collection of work dating from his friendship with the Prince of Wales (later Edward VII) is preserved in the Royal Library at Windsor. During one of the rifts with Bowles, while Coïdé was in favour, he undertook to portray all 400 members of the Marlborough Club – but only twenty were completed in 1873, when he returned to *Vanity Fair*. His admiration for Whistler, one of his close friends, instilled in him great ambitions for more serious painting. When he was plagued by illness in his later years, his friends rallied to provide him with funds. His last sketch was of Thomas Edison, inventor of the phonograph.

'Sovereigns, no. 3 Un roi constitutionnel', from Vanity Fair, *9 October 1869. Leopold II, King of the Belgians, is threatened on both sides by France and Prussia.*

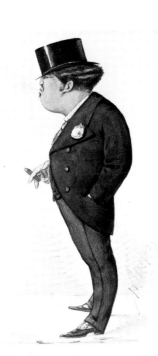

The evolution of the caricature of the Duke of Hamilton, Lord Lieutenant of Lanarkshire: ABOVE *the completed drawing in line and wash, from which the chromolithograph was prepared for publication in* Vanity Fair: RIGHT *the preparatory sketch.*

Harry Furniss
1854–1925

The son of a Yorkshire engineer working in Ireland, Furniss first showed his flair for caricature while a pupil at the Wesleyan School in Dublin. At seventeen he was a contributor to *Zozimus*, the Irish *Punch*. He became special artist on the *Illustrated Sporting and Dramatic News* in London, and at twenty-six joined the staff of *Punch*, depicting *The Humours of Parliament* over the next fourteen years. A superbly fluent and inventive draughtsman, he focused on personal quirks, having little interest in politics; Mr Gladstone's winged collar was the target for some masterly flights of fancy. Furniss was one of the few artists to draw directly on to the boxwood block, and the engravings displayed the spontaneity of his line. A prolific illustrator, he contributed 2,600 drawings to *Punch*. For seven years he collaborated with Lewis Carroll on *Sylvie and Bruno*.

Furniss's advertisement for Pear's Soap, showing a tramp writing the testimonial, 'Two years ago I used your Soap, since when I have used no other', was a landmark in advertising history. On retirement from *Punch*, Furniss launched the weekly *Lika Joko*, and continued to write as copiously as he drew. His egocentric accounts of his life and those of his contemporaries transmit his *joie de vivre* and irrepressible sense of fun.

A typically spontaneous and lively caricature of Judge Edward Parry, one of Furniss's fellow-members of the Garrick Club.

Sir Arthur Wing Pinero,
playwright.

'PAL' Jean de Paleologu
w. late 1880s

Of Rumanian extraction, Pal was among a number of occasional artists to appear in *Vanity Fair* after the death of Ape in January 1889, and Bowles' sale of *Vanity Fair* in March 1889 to Arthur Evans. Spy was the chief artist and the use of more English cartoonists was marked, though Lib (Liberio Prosperi, Italian protégé of the Duke of Hamilton working 1886–94, and later) specialized in sporting characters.

William Ewart Gladstone, leader of
the Liberal Party, Prime Minister
four times between 1868 and 1894.

Spy (Sir Leslie Ward) at work, a
watercolour for the Vanity Fair *plate*
of 23 November 1889.

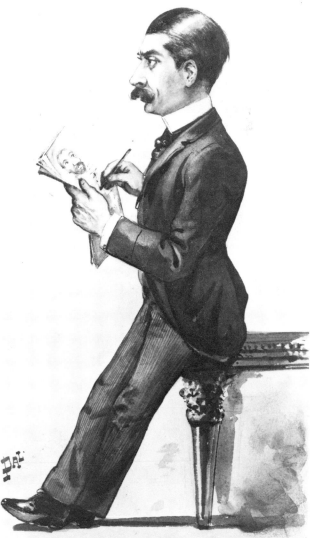

Vanity Fair

THE CARICATURES that account for the success of *Vanity Fair* between 1869 and 1913 were considerably less ebullient than those in *La Lune* and *L'Éclipse* over the preceding period. Instead of pout and thrust, there was dapperness and benevolence. True, there were occasional lapses into raw politics. Napoleon III, for instance, was shown being escorted past the scene of imminent disasters, yellow in the face and doubled over with gout and guilt. But the chromolithography meant that lines were softish and the entire image was suffused with placidity.

Those who were singled out for inclusion in the *Vanity Fair* portrait gallery were invariably Men of Distinction, Men of Letters, Men of the Moment or plain Men's Men: stalwarts of club, mess and Inn of Court. Foreigners were admitted; but naturally the magazine concentrated on the land of its subscribers, on the lean-jawed, gangling, tweedy Englishmen who subsequently served as models for the idiot Imperialist Britishers in *Kladderadatsch*, *Le Rire* and *Simplicissimus*.

Vanity Fair assumed pre-knowledge among its readers. The weekly caricature confirmed a man's standing, emphasized his already well-known personality. There was no need for introductions to be made. Those who were not altogether *persona grata* were notorious: Oscar Wilde, Algernon Swinburne, Abdul Aziz, the Sultan of Turkey, and Keir Hardie, the Socialist. Even an outsider could quickly grasp the main points of the portrait; the response aimed for was a chuckle of recognition.

Carlo Pellegrini ('Ape') established the *Vanity Fair* style; Leslie Ward ('Spy') came to be its chief exponent. The average caricature represented a barrister in profile against an eau-de-nil background. Everything about him would be mildly exaggerated, his height, his stance (nonchalant in the extreme, yet eager), his ruddy good looks. But in a good week there might be a contribution from Tissot, the Italian artist Cecioni or, best of all, Beerbohm.

Vanity Fair caricatures were so worked over by intermediary craftsmen, transferring the original drawing to the multiple lithographic stones, that it was hardly surprising that most of the vitality was smoothed away. Beerbohm's caricatures were best reproduced by photo-process, for he reversed the *Vanity Fair* order. He made fun of the gloss and the elasticated faces of the magazine's habitués. His drawings reflected the style dimly, delicately. He strove for the least emphasis, the minimum of fuss and polish, and restored some of the eighteenth-century amateur virtues to the highly professional caricature field of the 1890s. Most important, he insisted in every wheeling line he drew that the prime quality of caricature is not cut and thrust but precise, remorseless needling.

OPPOSITE '*English Cricket*', a portrait by Ape (Carlo Pellegrini) of Alfred Lyttleton (1857–1913) from Vanity Fair, 20 September 1884. Lyttleton was wicket-keeper for England against Australia that year. He was also a first-class tennis, racquets and football player.

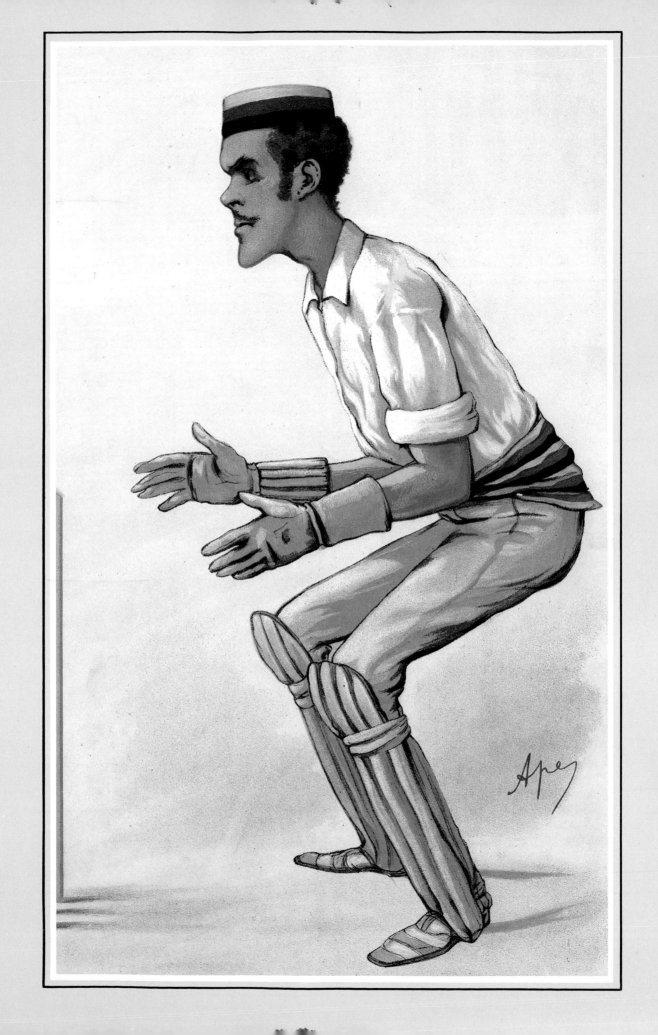

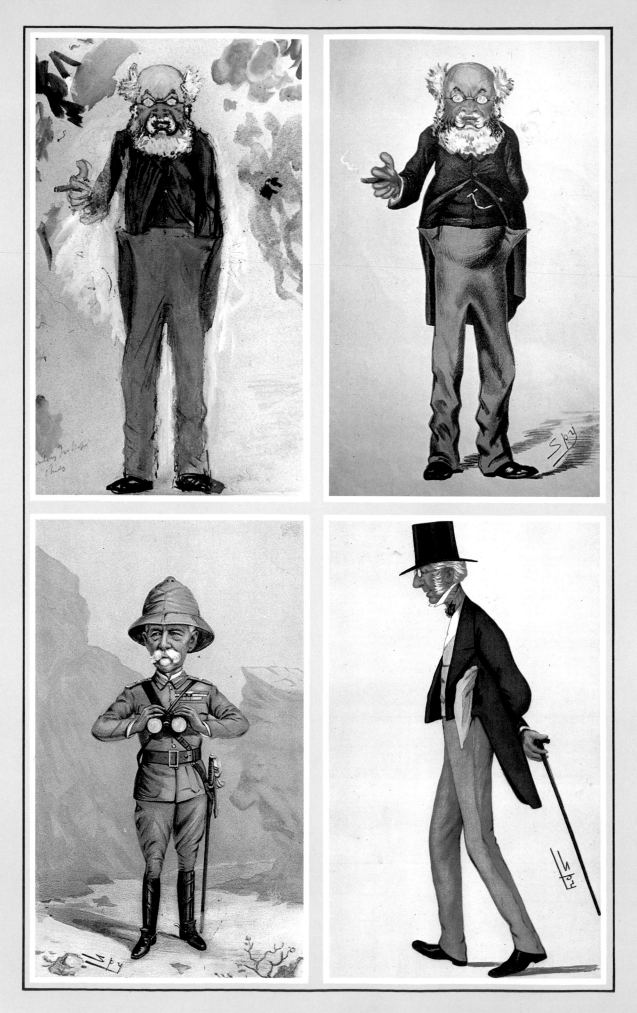

'SPY' Leslie Ward
1851–1922

The son of two famous artists, E. M. Ward and Mrs Henrietta Ward, Leslie was reared surrounded by painters, writers and eminent Victorians. He attended Salt Hill and Eton, where he caricatured his masters and classmates. His father, desirous of an architectural career for his son, placed him in the studio of Sidney Smirke and, later, Sir Edward Barry. Leslie's dislike for architecture led to a family crisis that was resolved when W. P. Frith took him in as an apprentice. Soon Ward was exhibiting at the Royal Academy and painting commissioned portraits.

In 1873, at the age of twenty-two, Ward, upon the suggestion of Sir John Millais, sent some of his caricatures to Bowles at *Vanity Fair*. Bowles recognized Ward's talent and hired him to replace Ape who had recently left the magazine after one of their frequent disputes. Taking the nom de crayon 'Spy', Ward contributed over 1,000 of the 2,387 caricatures in *Vanity Fair* for forty years. Such prodigious efforts resulted in the *Vanity Fair* caricatures being identified as 'Spy prints', regardless of who was the artist.

During his years at *Vanity Fair*, Ward sketched some clever caricatures in the Italian classical style perfected by Pellegrini. Among them were those of Dr Richard Owen, John Stuart Mill (both unsigned) and Anthony Trollope (signed). Judges, barristers, clergymen and dons, whom he stalked for hours in their locales and then drew from memory, were his favourite targets and best caricatures. His most popular was 'Bobs', Lord Roberts, whom he sketched during the Boer War. Ward was too deferential to women and to royalty; consequently these caricatures were often bland if not flattering. Perhaps because of his close identity with the English establishment or his own personal values, he was not as penetrating as Ape. However, he recognized that a genuine caricaturist needed to combine a 'profound sense of character' with humour in order to rise above the mere obvious idiosyncrasy and to 'translate into terms of comedy a psychological knowledge unsuspected by those who uncritically perceive and delight in the finished caricature'. In recognition of his contributions Ward was knighted in 1918, four years before his death.

Fellow-members of the Garrick Club, George Grossmith, the actor-playwright and co-author of Diary of a Nobody, *and barrister Corney Grain, who wrote musical sketches.*

OPPOSITE *Four portraits by Spy (Sir Leslie Ward) for* Vanity Fair:

TOP *The novelist Anthony Trollope as he appeared in the* Men of the Day *series on 5 April 1873, and in Spy's original watercolour sketch. Trollope was displeased with the portrait.*

BOTTOM LEFT *Frederick, Lord Roberts, commander-in-chief of*

British forces in the Boer War, 1899–1900. The rock profile is that of Paul Kruger, the Boer leader.

BOTTOM, RIGHT *'Colonial', a portrait of Charles Cox, Chief Clerk and Chancellor at the Colonial Office, 2 July 1881.*

Edward Linley Sambourne
1845–1910

'Now that Sir John Tenniel has laid down his pencil, there is no English artist who surpasses Mr Edward Linley Sambourne as a master of the cartoonist's art,' wrote Hammerton on Sambourne's succession to Tenniel as leading cartoonist on *Punch*.

The son of a prosperous City merchant, educated at the City of London School and Chester College, Sambourne was apprenticed at sixteen to a marine engineer at Greenwich. He was introduced to Mark Lemon, editor of *Punch*, who judged him to be 'a young draughtsman with a great future', and his first drawings were accepted in 1867; within four years he was elected to the editorial board. The emphatic line and surreal comedy of his early *Punch* cartoons were in dramatic contrast to the more academic touch of Tenniel's editorial 'cuts'. Throughout the 1870s he followed topical features in *Punch's Essence of Parliament* and *Mr Punch's Portraits*. His book illustrations revealed a line of great sensitivity: the drawings for Hans Andersen's stories and Charles Kingsley's *The Water Babies* were described as 'brimming with humour and pathos'.

He was knighted in 1908; his name is recalled in the title of his great-great-grandson, the Viscount Linley.

PUNCH'S ESSENCE OF PARLIAMENT.

'*Punch's Essence of Parliament*', *19 August 1876, a rare piece of fantasy, shows Disraeli as a flying fish and Lord Hartington, leader of the Liberals, as a mollusc.*

INEM coronat opus" is the Parliamentary setting of the old Classic saw.
" Work crowns the Session's end—Talk its beginning."

So now the House sits even on Saturdays, and Government claims every day and all day long—even to Wednesdays. And this while the Dog-Star rages at red heat!

Saturday, August 5—RICHARD was himself again, on Third Reading of the Education Bill—which he denounced " as the worst measure, the most unjust, and most tyrannical in spirit, since BOLINGBROKE'S Schism Bill—in the reign of QUEEN ANNE."

Big words, and bold words, Brother RICHARD. Even those who have opposed the PELL element of the Bill most strongly admit that,

Bernhard Gillam
1859–96

Born in England, Gillam moved to the United States at the age of nine. His education was fitful. He left school in Brooklyn, studied law, and eventually turned to sketching, designing and portrait painting. As his bent for comic characterization manifested itself, Gillam drew for *Harper's Weekly*, *Puck* and *The Judge*. The artist became part owner of the last-named and served as director-in-chief until his death from typhoid in 1896. In portraying Presidential candidate James Blaine as a tattooed man during the election campaign of 1884, Gillam seized upon an image which gained him instant and widespread public recognition as a satirist. His attack on Blaine is credited as a significant factor in Grover Cleveland's defeat of Blaine in that bitterly contested election.

The general profile of the artist which comes down to us is of an intellectually well-bred, conscientious figure, fearless in his convictions and eloquent in their expression.

'Ben and Bizzy', from The Judge, *suggests that politician-soldier General Benjamin Butler should be sent by President Harrison on the US mission to Samoa to stand up to the bullying tactics of Bismarck.*

William Giles Baxter
1856–88

Beginning as an architect's apprentice, Baxter first published lithographs of *Sketches of Buxton* when he was twenty-one. In Manchester, he founded a satirical weekly, *Momus*, which featured his notable life-size heads of Dickens' characters. He designed Christmas cards in London until his meeting with Charles H. Ross, journalist and newspaper proprietor, who had devised the character of Ally Sloper, grotesque comic boozer and key figure of the first cheap comic, *Ally Sloper's Half Holiday*. Published with the Dalziels in 1884, and enthusiastically hailed by William Morris, it was, at a halfpenny weekly, the poor man's *Punch*. Baxter took it over, re-drawing Ross's idea, and adding detail and definition. The front page always featured Ally and friends on some outing – at the seaside, boating on the Thames. Whatever the situation, it carried some topical issue such as pollution, new-fangled fashions or current events of the week, high-lighted by the outrageously cheeky fellow, and often including caricatures of the personalities involved.

'The Claimant', August 1884. Ally Sloper (right) proposes that Arthur Orton (left), who had failed to establish his identity as Roger Tichborne and so claim the Tichborne inheritance, be released from prison.

Arthur George Racey
w. 1898–1918

Son of an Edinburgh doctor, Racey was educated at the High School in Richmond, Quebec. He showed an early talent for caricature, and first contributed to *Grip*. He had a long association with *Life* and *Punch*, and worked on the *Montreal Witness* for nine years before joining the *Daily Star*. He was the author of *The Englishman in Canada* and many other works.

Sir Wilfrid Laurier, from The Globe, *1896, Prime Minister of Canada after two decades in opposition.*

'FCG' Francis Carruthers Gould
1844–1925

FCG recommended Izaac Walton's advice to the angler as the cartoonist's approach to his victim: 'Put your worm on the hook as if you loved him.' The first staff caricaturist on a daily paper in Britain, he presented the personalities and current issues of Parliament from the Liberal viewpoint in parodies of popular tales which were notable for their humour and lack of personal malice.

The sketches he drew as a schoolboy in Barnstaple brought protests from local dignitaries. He then moved to the London Stock Exchange, which proved a lively field for his caricatures. He turned professional in 1888, when he was invited by Stead, editor of the *Pall Mall Gazette*, to join the paper. When the staff moved *en bloc* in 1894 to form the new Liberal evening paper, the *Westminster Gazette*, FCG's *Picture Politics* became a vital feature, maintaining a great popular following across Britain over the following twenty years, and establishing the role of the newspaper cartoon in the daily Press. Never academic, he had a great flair for likeness and ingenious transformations. He wrote and illustrated numerous satires and children's books, as well as the *Political Powder and Shot* issues. He collaborated on the *Political Struelpeters* and with Saki on *The Westminster Alice*. Lord Rosebery called him 'one of the most remarkable assets of the Liberal Party'. He was knighted in 1906.

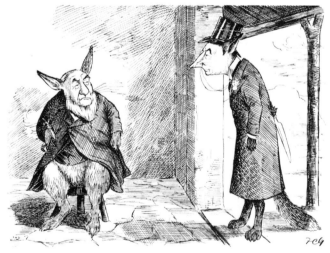

'The Point', from the Westminster Gazette, *14 July 1899. Joseph Chamberlain, Britain's Secretary of State for the Colonies, as Brer Fox, asks Boer leader Kruger, as Brer Rabbit, how he would like to be cooked:*
'Brer Rabbit up en say he don' wanter be cooked t'all.
Brer Fox he grit his toof. "Youer gittin' 'way from de point, Brer Rabbit," sez Brer Fox, sezee.'

'ZIM' Eugene Zimmerman
1862–1933

Zimmerman was working as a sign painter when Keppler discovered him and launched him as one of his protégé artists in *Puck*. When Bernhard Gillam moved to work on *The Judge*, Zimmerman went too. He was closely associated with Grant Hamilton, who succeeded Gillam on his death in 1896. Zim's later caricatures, fluent, linear drawings, were well-drawn, witty and sophisticated portraits. From the 1890s he was one of the band of humorists and political caricaturists whose drawings entertained America in the daily Press.

THE TWO HENRYS.

'The Two Henrys'. Henry Irving, veteran of many lucrative theatre tours in the States, shakes the hand of Henry Ward Beecher, about to set off on a lecture tour of Britain which promises to be a great financial success, and says: 'Well, Henry, I raked the Boodle in America, but you take the cash in England. That makes honours even.'

Henri Julien
1852–1908

Henri Julien, born in Quebec City, became interested in caricature through the woodcuts of Jean-Baptiste Côté in *La Scie*. Julien was to become the most accomplished draughtsman and the best-known Canadian cartoonist of his time. He began as a printer's apprentice in Montreal and became an expert engraver. In 1874 the *Canadian Illustrated News* sent him on a sketching tour of western Canada, where he produced numerous drawings of Indian life on the plains. He also worked frequently for *L'Opinion Publique*, and over the next ten years contributed to numerous publications including *Le Farceur, Le Grelot, The Jester, Le Canard* and *Grip* in Canada, plus *Harper's* and *Le Monde Illustré* abroad, becoming the first Canadian to establish any kind of international reputation. He was also the first to work as a full-time cartoonist for a Canadian newspaper, the *Montreal Star*, which hired him in 1888. His most famous caricatures were a series of drawings of Laurier and members of his cabinet, sketched from the Press Gallery in Parliament in Ottawa, portrayed as Negro minstrels. These were eventually published in a popular booklet entitled *The By-Town Coons*. Julien is also remembered for his portraits, paintings and drawings interpreting historical Quebec life and politics.

Sir Wilfrid Laurier, one of a series of caricatures of government ministers as Negro minstrels.

George Benjamin Luks
1867–1933

With a firm belief in himself as one of the 'only two great artists in the world' (Frans Hals was the second), the American caricaturist George Luks pursued his artistic career with a singular sense of purpose. Encouraged from childhood by his physician father, who was also a draughtsman, and his painter mother, Luks studied painting in all the established European centres of art training: Düsseldorf, Munich, Berlin, Paris and London. He worked as a staff artist for the *Philadelphia Press* and studied painting at night with Robert Henri. In 1895 and 1896 he was a correspondent for the *Philadelphia Inquirer* in Cuba, whence he sent home imaginary reports and drawings of incidents in the anti-Spanish rebellion. On moving to New York in 1896 he drew cartoons for the *New York World*.

His caricatures, which appeared in *The Verdict*, a rather short-lived political journal, were in the style current in comic weeklies like *Puck* and *The Judge*, but were decidedly bolder and looser in execution. His true ambitions lying in the finer arts, Luks abandoned caricature soon after 1900, when his paintings began to sell. By 1905 he was spending most of his time painting street urchins, wrestlers and scenes from New York's East Side. Luks also acquired a reputation (largely self-fabricated) as a boisterous, hard-drinking ex-pugilist.

'CARAN D'ACHE' Emmanuel Poiré
1858–1909

Though born and educated in Russia, Poiré always considered himself French as he was the grandson of a Napoleonic officer. As a nom de plume he adopted the Russian name for lead pencil – appropriately, as his style was supremely linear.

At the age of twenty, after completing his schooling at the Moscow Gymnasium, he was sent for by his father in Paris. He joined the French army with the ambition of becoming a military painter, but it was through his humorous narrative caricatures that his talents were recognized. His strong anti-British feeling was reflected in many cartoons, until his encounter with an Englishman – no less a person than Edward VII – changed his views (how they came to meet is unknown). In February 1898, he joined with Jean-Louis Forain to set up *Psst . . . !*, a weekly magazine mainly concerned with presenting anti-Dreyfusard opinion, which ceased publication in autumn 1899. During his highly successful career, he also contributed frequently to *Le Figaro Illustré*, *La Caricature* and *Le Chat Noir*.

H. M. Bateman expressed his admiration in no uncertain terms: 'Caran d'Ache was the greatest master of the art of telling a story in pictures, without words. . . . He combined the perfection of the droll story with superb draughtsmanship, and an astounding observation and knowledge of humanity. For me he defies criticism – I simply admire.'

OPPOSITE *'The Verdict', March 1899. Marcus A. Hanna: 'That man Clay was an ass. It's better to be President than to be right!' Hanna, a wealthy businessman, had raised over three million dollars to fund Republican candidate William McKinley's presidential campaign in 1896.*

'The last skittle' : a French army officer eggs on the Baron de Rothschild, 'Just one more, dear Baron, and the game's ours.' Zola was one of several notable people whose campaigning led eventually to Dreyfus's release.

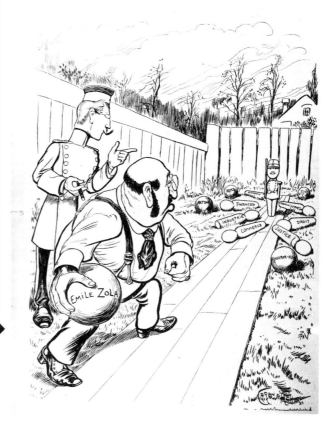

Aubrey Vincent Beardsley
1872–98

Beardsley's unique linear style and mannered designs blended an exotic severity with fin-de-siècle decadence. He was the dominant influence in Britain and the USA on the graphic art style of the 1890s and later.

His flair for the arts was already evident when he was a schoolboy at Brighton Grammar School. On leaving school, Beardsley went to London, working in an insurance company until 1891, when the Pre-Raphaelite painter Burne-Jones encouraged him to take up art professionally. After attending classes at the Westminster School of Art, he obtained his first commission from the publishers, J. M. Dent, to illustrate a new edition of Mallory's *Le Morte d'Arthur*. The first edition of *The Studio* featured an article on his work by Joseph Pennell, and in 1894 his most important early work, the illustrations for Oscar Wilde's *Salomé*, appeared, a stylish blend of erotica and elements of caricature.

After Wilde's arrest, Beardsley was forced out of his position as art editor of *The Yellow Book* and he joined *The Savoy*, working with Arthur Symons. In 1896, after he had completed the illustrations for *The Rape of the Lock* and *Lysistrata*, his health finally broke down from advancing tuberculosis. His last major works were his remarkable drawings for *Mademoiselle de Maupin*, and the illustrations for *Volpone*. He died at Menton, at the age of twenty-five.

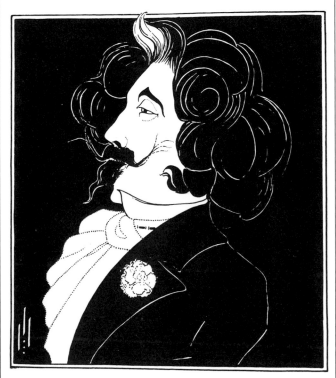

James McNeill Whistler, the American painter.

Francis Gilbert Attwood
1856–1900

Born in Jamaica Plain, Massachusetts, Attwood entered Harvard in the class of 1878, but left three years later without graduating. He was one of the four founders of the *Harvard Lampoon* and 'artist' for the Hasty Pudding Club. After Harvard he attended Boston Art Museum's School and did general illustration chores until the founding of *Life* in 1883. At about the same time his work appeared in *Cosmopolitan*.

For every issue of *Life*, beginning in January 1887, he featured a page of satiric comment on the month's events using a number of miniature tableaux. In these pages he caricatured all the leading politicians of Europe and the Americas, with especially sharp comment on Europe's kings and queens. Like many of *Life*'s satirists and writers, Attwood was a political independent with broad humanitarian sympathies. His drawings, with their fine lines and filigree detail, are similar to those of *Punch* artist Dicky Doyle.

General Benjamin Butler, from Life, *June 1884.*

Henri de Toulouse-Lautrec
1864–1901

Of all the French painters, Toulouse-Lautrec is one of the most widely popular. His life and work have become part of the legend of bohemian life in *fin de siècle* Paris.

His aristocratic origins, his childhood in the family château at Albi, the hereditary factors and accidents which stunted his growth and his early vocation for drawing are already well known. From 1886, he drew for the *Courrier Français* and other Paris newspapers. He made his life in Montmartre among fellow-artists who acclaimed his talent in adapting Impressionist techniques in his tremendous output of paintings, drawings and prints. Though many painters make occasional caricatures, in a moment of amusement, the element of caricature was fundamental to Lautrec's sketches. He captured the essence of the dramatic and the grotesque in the gestures and characters of street life, in the bars, music halls and brothels. Yet his drawings are more than caricature – Jane Avril, May Belfort, Yvette Guilbert, La Goulue, Aristide Bruant and the Negro dancer Chocolat are brought to life in them. His evocation of the atmosphere of Montmartre cabarets, behind-the-scene glimpses of artists and audience, have a sense of actuality rather than the barb of satire.

His lithographs and posters had a dynamic effect: with their large areas of colour and emphatic line, they were a major influence on the growing field of commercial art. His illustrations, book-covers and lithographs were published by Vollard and others. Towards the end of his tragic life, cut short by illness and alcohol, his exhibition at the Goupil Gallery in London was cold-shouldered by critics and public; it gave perhaps too vivid a view of Paris for the Victorians to appreciate. Only one picture was sold – to the Prince of Wales.

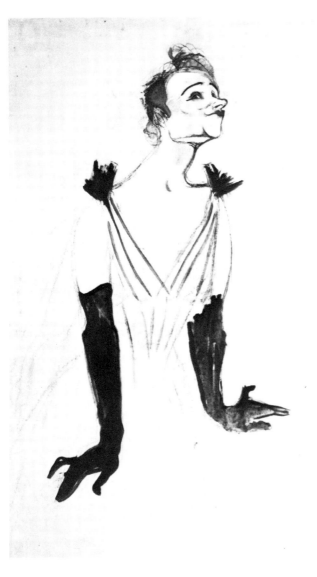

LEFT *Yvette Guilbert, the chanteuse and music-hall star, whom Toulouse-Lautrec immortalized in his 1894 posters.*

Jane Avril, dancer at the Moulin Rouge in Montmartre, 1892.

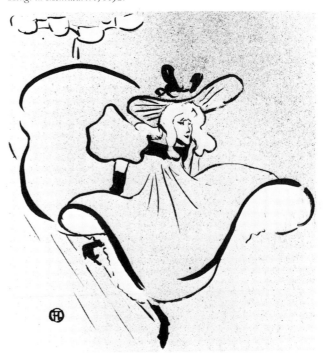

Walter Richard Sickert
1860–1942

Born in Munich, the son of a painter, Sickert combined his inherent talent for art with his mother's great love for the theatre, but gave up acting to enter the Slade School of Art, London, in 1881. He was first and foremost a painter, but his versatility and range of work encompassed caricature. He drew for *Vanity Fair* in the 1890s and later in 1911 for the *New Age*. His portraits of Beardsley, Israel Zangwill and George Moore verge on caricature, as do some of the etched portrait sketches of Roger Fry. His main inspiration stemmed from the music halls and working-class domestic interiors; his low-key use of colour became a feature of the painters who followed him, known as the Camden Town school. Sickert was elected to the Royal Academy as Associate in 1924, and as Academician in 1934, but resigned the following year.

Max Beerbohm, from Vanity Fair*, 1897.*

James Abbott McNeill Whistler
1834–1903

Himself the subject of caricature by many of his contemporaries, including Ape, Beardsley and Beerbohm, the American-born painter and etcher Whistler was a leading bohemian figure of the aesthetic movement in England. Many of his sketches of his friends have a strong element of caricature. After studying in Paris, he settled in London in 1859. An advocate of 'art for art's sake', he invited hostility through his mercurial temperament and innovations of style and theory. His delicate colour harmonies and atmospheric impressions, signed with his butterfly emblem, inspired by the decorative simplicity of Japanese prints, aroused violent reactions from critics and public. In his book *The Gentle Art of Making Enemies*, Whistler described the libel case against John Ruskin, a *cause célèbre* of the art world. His *Nocturne* paintings of the Thames had provoked Ruskin to write: 'I never expected to hear a coxcomb ask 200 guineas for flinging a pot of paint in the public's face.' When cross-examined at the trial about the price of two days' work, Whistler answered that this was not the charge for two days, but for the knowledge of a lifetime.

Oscar Wilde.

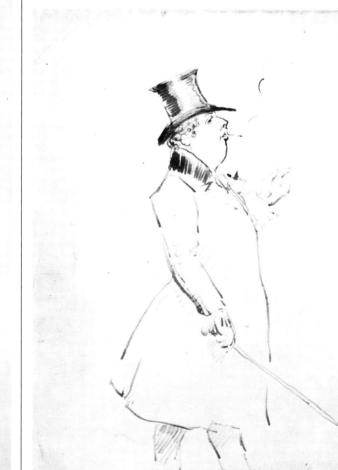

Philip William May
1864–1903

During his early struggle to survive as an artist, Phil May worked as a scene painter at the Leeds Grand Theatre. His early caricatures bear the influence of Sambourne and Caran d'Ache. He related: 'I never had a drawing lesson in my life, but I can't remember a time when I didn't draw. . . . When I was sixteen I made up my mind to come to London. . . . I had no friends and no introductions But in six months, I worked for *Society*, the *Penny Illustrated*, *St Stephen's Review* and the *Pictorial World*.'

In 1891, the publication of *The Parson and the Painter*, May's series from *The Graphic*, made his name overnight. His swift penline, evolved from his experience of newspaper cartoons, was reproduced perfectly by the new photogravure process. His scenes of Cockney types with brief captions of comic repartee won instant popularity.

May was a flamboyant and genial figure, generous to friends and spongers alike. Despite his early death from cirrhosis of the liver, he left thousands of drawings and several publications.

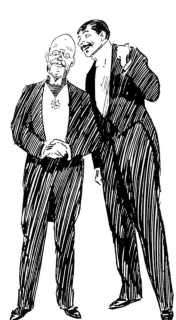

'Deuced Funny!' 1895: Melton Prior, journalist and war-time reporter, and the Punch *artist A. C. Corbould.*

Gustav Lærum
1870–1938

One of Norway's leading artists, Lærum was a painter, sculptor and draughtsman. A number of his monuments and portrait busts are on display in Oslo and other towns, and a sculpture of Hellig Olav may be seen at Norway House, London. The series of caricatures of Ibsen shown here were made when he observed the old man on his ritual daily walk to the café, and were seen in London in the National Theatre exhibition on Ibsen in 1978.

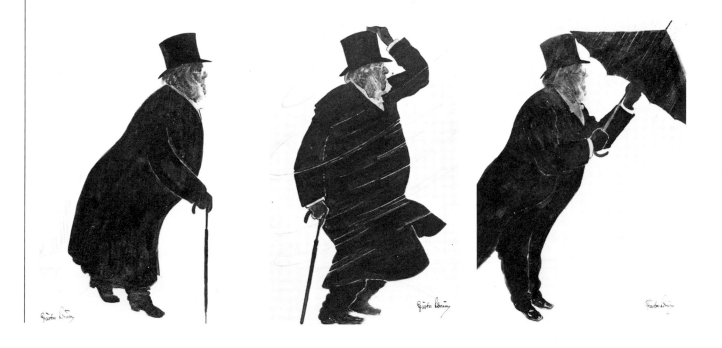

William Nicholson
1872–1949

Nicholson's family moved to London from Newark-on-Trent when his father was elected a Member of Parliament. Weekly art lessons and sketching holidays paved the way to art school. At sixteen he left school to study with Herkomer, and while a student met Mabel and James Pryde. At the age of twenty-one, he secretly married Mabel and with his brother-in-law set up a poster studio as the 'Beggarstaff Brothers'. Their starkly simple designs of bold colour contrasts, stencilled lettering and outline revolutionized advertising art in England, though their venture was a financial failure. He worked for the publisher Heinemann for four years, having been recommended by Whistler. This period established his reputation as the leading wood-engraver, and led to publication of the *Almanac of Sports*, *Alphabet* and *London Types* from 1898. His *Twelve Portraits* for *The New Review* sprang from his Jubilee portrait of Queen Victoria (*below*); later subjects included Whistler and the Kaiser.

Nicholson became a portrait and landscape painter of great sensitivity and was knighted in 1936. His striking use of woodcuts for portraiture has frequently been regarded as caricature and, though there was little evidence of satiric intent, they were a marked influence on caricature style in England and Germany.

Charles Léandre
1862–1930

Léandre was the outstanding exponent of the *portrait-charge* in the 1890s, portraying his subjects with such artistry and verve that he stands as true successor to Daumier and Gill. The force of his drawings lies not only in their use of satire and allegory, but in the masterly degree of likeness. Since his childhood in Champsecret, Orne, he had sketched those around him. At sixteen he entered the Montmartre studio of a leading historical painter and later studied at the École des Beaux-Arts. As a young man, he frequently accompanied his uncle, a Député in Parlement, to receptions and meetings, where he observed notable figures of the day. His caricatures of local types and depictions of the humorous incidents of village life appeared in *Le Rire*, in a series called *Ma Normandie*, and won enormous national popularity. His cartoons and illustrations appeared in all the leading journals – *Le Chat Noir*, *Quat'z Arts*, *Le Grand Guignol*, *La Vie en Rose* and *L'Assiette au Beurre*.

Many of Léandre's portraits were of celebrated musicians and actors of the Comédie Française; others revealed his strong concern with current issues, as shown in the grim humour of his attack on the anti-Semite, Drumont. His savage portrayals of Queen Victoria carried the full force of French feeling against the British over the Boer War, and provoked diplomatic protests. Léandre was a supremely skilful sculptor and draughtsman; his caricatures have a power and quality that set him apart from most of his contemporaries.

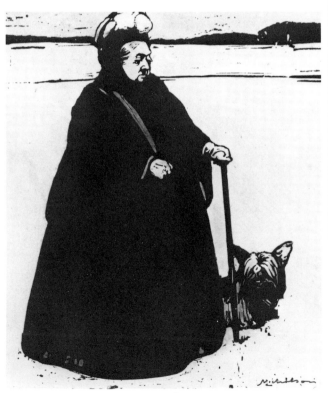

H.M.The Queen.

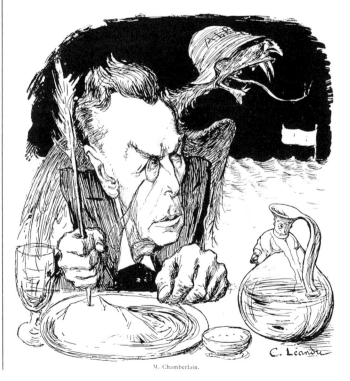

M. Chamberlain.

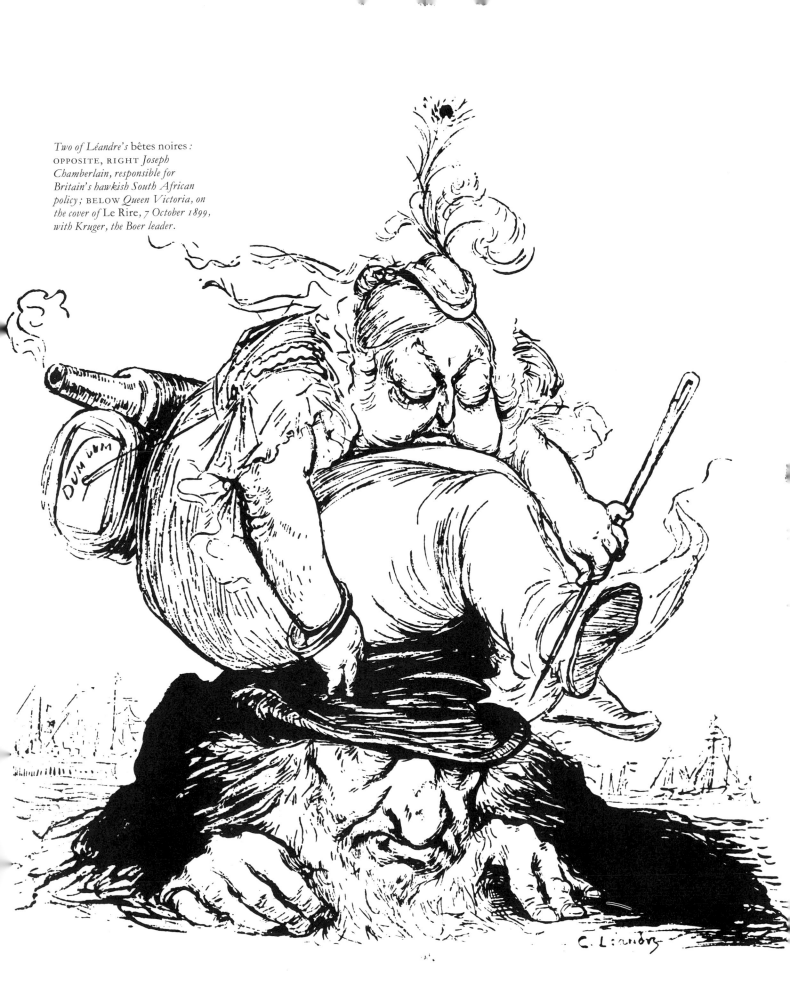

Two of Léandre's bètes noires : OPPOSITE, RIGHT *Joseph Chamberlain, responsible for Britain's hawkish South African policy;* BELOW *Queen Victoria, on the cover of* Le Rire, *7 October 1899, with Kruger, the Boer leader.*

Homer Calvin Davenport
1867–1912

Known as 'a simple, rough-hewn fellow, good company and a splendid story-teller', Homer Davenport became the highest-paid American political cartoonist of his time. It was William Randolph Hearst who brought Davenport east from San Francisco in 1895 to draw for his *New York Evening Journal*. Hearst publicized his protégé as the successor to Thomas Nast, whose fortunes were then on the wane following his departure from *Harper's Weekly*. Although Davenport was hardly a substitute for Nast, whose style he adopted fairly literally, he inherited the latter's position as a force in the shaping of public opinion. In his attacks on monopoly, child labour and political corruption, Davenport's remarkably inventive mind conjured up a number of forceful political symbols. His gargantuan 'trusts' and his caricature of the corpulent scoundrel 'Dollar Mark' Hanna aroused a proper measure of public antipathy toward the unbridled capitalism which they epitomized. Government officials of New York answered Davenport's caricatures with an attempt to pass an anti-cartoon law in the state legislature.

In 1897 Thomas Platt (right) attempted to introduce an anti-cartoon bill into the New York legislature. Davenport's response in the Journal *evoked memories of Tweed, in a pastiche of the Nast image.*

"They Never Liked Cartoons."

Frederick Burr Opper
1857–1937

After his initiation to newspaper work at the age of fourteen, Frederick Opper, the son of an Austrian immigrant to the American midwest, embarked on a fifty-eight-year career as a cartoonist. His activity spans two major ages of American political caricature, those of the comic weekly and the daily newspaper cartoon.

Opper spent eighteen years on the staff of *Puck*. In 1899 he was swept along with the tide of comic illustrators drawn from the weekly journals to the daily newspapers, and went to work for William Randolph Hearst's *New York Evening Journal*. Here his comic strips *Happy Hooligan*, *Willy and his Poppa* and *Her Name Was Maude* appeared. His political satires show the influence of Thomas Nast, an early colleague and competitor whose anti-Catholic bias Opper caricatured, as he did his associates on the staff of *Puck*. 'John Public', the proverbial embodiment of the American common man whose name has become a part of America's household vocabulary, was one of Opper's inventions. After a number of years on the staff of the *New York American*, Opper retired in 1932 due to failing eyesight.

Nast's images of Tweed and corrupt government were to dog politicians for years after. Here Richard Croker, as Hamlet, is under suspicion, in 'The Latest Version', from Puck, *1894.*

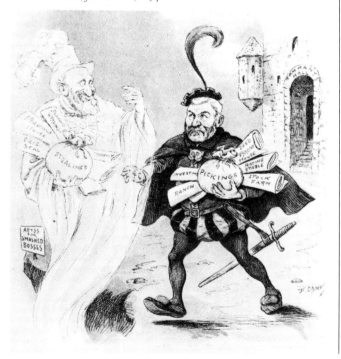

Jean Veber
1864–1928

Born in Paris, Veber intended to be a painter and trained with Maillot and Cabanel. He became a satirist by chance when his brother Pierre, a journalist on *Gil Blas*, asked him to draw caricatures and satire for the paper. Needing to make a living, Jean Veber took the job and his drawings soon became popular. His poetic style, allied to a keen sense of humour, produced original drawings which were soon in demand on magazines other than *Gil Blas*. In 1897, his composition 'Butchery', showing Bismarck as a butcher of people, provoked an official outcry while ensuring his popularity among the public. Soon he was asked to work for *Le Rire*, in which he caricatured fashionable people and socialites. He became a regular contributor to *L'Assiette au Beurre*, which published his most famous caricature, 'L'Impudique Albion', featuring the face of King Edward VII imprinted on the posterior of a leering Britannia.

Jean Veber stopped drawing caricatures around 1912, devoting the rest of his life to his first artistic pursuits, painting and lithography.

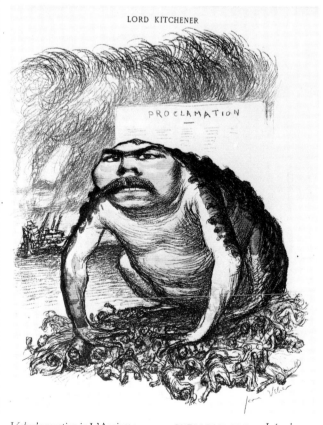

Veber's reaction in L'Assiette au Beurre, *28 September 1908, to Kitchener's report that peace had been achieved in the Transvaal without bloodshed.*

OVERLEAF, LEFT *'Shameless Albion', 28 September 1901.*

OVERLEAF, RIGHT *Léandre suggests that Wilhelm II, who in 1896 had congratulated Kruger on a British defeat, has turned pro-British but is passing off his treachery as grand-filial affection for Queen Victoria.*

L'Impudique Albion

N° 265. 6° année. 2 Décembre 1899.

15 centimes.

Le Rire

JOURNAL HUMORISTIQUE PARAISSANT LE SAMEDI

Un an : Paris, 8 fr.
Départements 9 fr. Etranger, 11 fr.
Six mois : France, 5 fr. Etranger, 6 fr.

M. Félix JUVEN, Directeur. — Partie artistique : M. Arsène ALEXANDRE
La reproduction des dessins du RIRE est absolument interdite aux publications, françaises ou étrangères, sans autorisation

10, rue Saint-Joseph, 10
PARIS
Les manuscrits et dessins non
insérés ne sont pas rendus.

Guillaume II recevant, au Lustgarden, le serment des nouvelles recrues, leur a dit d'une voix retentissante : « Un homme n'a qu'une parole! » La parole de l'empereur d'Allemagne a été engagée en 1896. *(Les Journaux.)*

— Ne te tourmente donc pas, mon vieux Kruger. Si je suis venu en Angleterre, c'est seulement pour embrasser Grand-Mère.

Dessin de C. LÉANDRE.

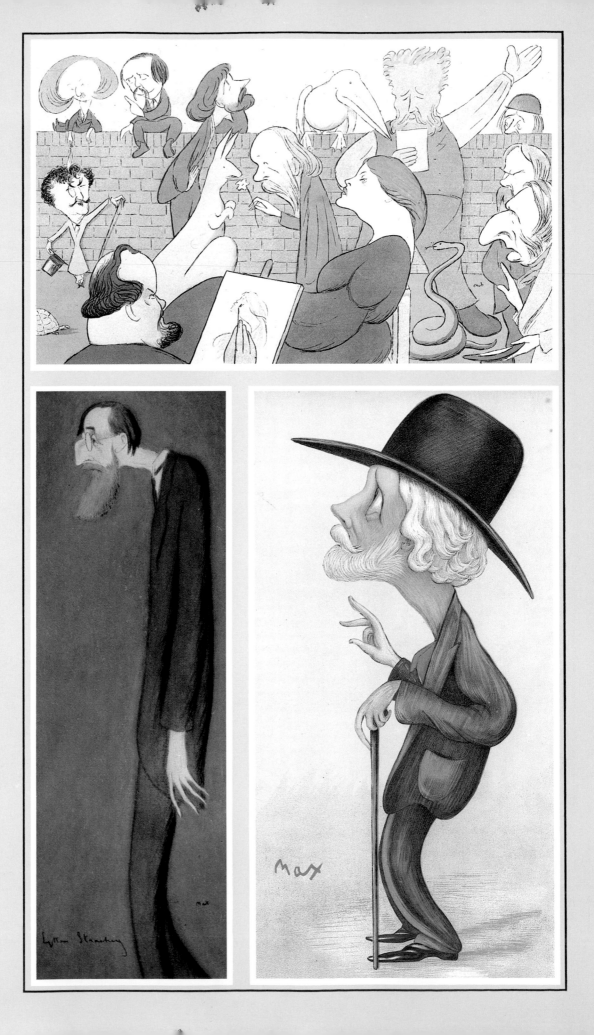

Max Beerbohm
1872–1956

Beerbohm's reputation as a wit, dandy and caricaturist was established while he was still an undergraduate at Oxford, where his Merton rooms were hung with drawings by Ape, whom he admired and originally imitated. He had started to draw at the age of six, though he never received any formal training. *The Strand* magazine first published his caricatures of clubmen in 1892 before he had left university, dealing, as he described it, 'an almost mortal blow to my modesty'. His striking impression of Oscar Wilde appeared two years later in *Pick-me-up* magazine, in the same year as he established himself as a writer in *The Yellow Book*.

Beerbohm's essential weapon as both a writer and a caricaturist was parody, though he discovered that 'to sit down to write is a business requiring thought and conscience. Caricaturing, on the other hand, is pure instinct without any trouble at all'. An inveterate diner-out, he did many of his drawings late at night. Unlike those of Ape and Spy, they were never taken from life; they were 'faces seen through the fog of memory'.

Caricatures of twenty-five Gentlemen (1896) was the first of ten collections published up to 1931, and it was soon obvious that Beerbohm had made a significant break from the then fashionable style of the *Vanity Fair* artists and the linear tightness of the political cartoonists. The exaggeration and distortions of scale were free essays in the delineation of character as well as parodies of attitudes and fashions in art and literary circles at the turn of the century. In particular, his use of colour, while harking back to the freedom of Rowlandson, echoed the 'greenery-yallery' tones of the aesthetic movement. He developed a particular ability to draw groups and struck a unique vein in caricaturing successfully figures from the past, *The Poets' Corner* (1904) being among his finest work.

Although Beerbohm drew spontaneously, he made careful notes on many of his subjects for later use either in his writing or drawings. His comments on Oscar Wilde included these pointers: 'Wax statue – huge rings – fat white hands – feather bed – pointed fingers – cat-like tread – heavy shoulders – enormous dowager.'

His drawings seldom caused offence, though his caricatures of the Royal Family, exhibited in 1923, caused such a storm that they were withdrawn. After his marriage – his American wife seldom understood his jokes – Beerbohm retired to Rapallo in Italy. From 1930 onwards his caricatures lost their sting ('I seem to have lost my gift for

dispraise'), though he still produced nostalgic echoes of his earlier drawings and also made 'additions' by re-touching and altering illustrations in various books in his library.

His many talents brought him a knighthood in 1939. During his last years the charm and informality of his talks on the BBC won him a new audience. Besides the legacy of his work, he left a fine definition of caricature: 'The most perfect caricature is that which, on a small surface, with the simplest means, most accurately exaggerates, to the highest point, the peculiaritics of a human being, at his most characteristic moment, in the most beautiful manner.'

W. G. Grace at his Benefit match – hence the cheque in one hand – complete with 'the funeral of one of his patients' (he was a doctor).

OPPOSITE *Beerbohm captured the personalities of his day with a new freedom of line and wash.*

TOP *'Dante Gabriel Rossetti in his back garden': the heads along the top are those of Algernon Swinburne, Theodore Watts, George Meredith, William Morris and Hall Caine, and those in the middle of James Whistler, Edward Burne-Jones, John Ruskin (with the nose) and William Holman Hunt. Rossetti kept his Chelsea garden stocked with exotic wild animals.*

BOTTOM, LEFT *Lytton Strachey.*

BOTTOM, RIGHT *'Our first novelist', George Meredith, from* Vanity Fair, *24 September 1896.*

Leonetto Cappiello
1875–1942

A born draughtsman, as a child Cappiello was already drawing portraits of his parents' friends in Livorno. At the age of nineteen he published a volume of assorted caricatures called *Lanterna Magica*. The success of the book led to his being introduced to Puccini, whom he also caricatured. In 1898, seeking to earn his living in Paris, he sold the drawing to *Le Rire*, and it brought him instant fame. Over the next five years, he caricatured 218 Paris celebrities and socialites. His drawings appeared in *Le Figaro*, *Le Gaulois*, *Le Cri de Paris* and *La Revue Blanche*. He published three albums which enhanced his reputation: *Nos Actrices*, which won him a name as *the* caricaturist of women; *Gens du Monde* and *Le Théâtre de Cappiello*. A swift worker, he drew from life without his subjects being aware of it.

In 1914, some years after he had ceased to draw caricatures, he wrote: 'The spirit interested me more than the body, the smile impressed me more than the shape of the mouth, the look more than the shape of the eye. . . . This is the aim to be reached: reveal the personality which is hidden behind every person.'

Although he continued to paint portraits throughout his life, he stopped the caricatures in 1905 and became one of the great poster artists. Today, his name is remembered above all in association with advertising, where his colour and bold designs were an innovation. The Chocolat Klaus poster of 1903 and the Thermogène Mephisto of 1909 are classics of outdoor publicity art, still familiar as trade images.

'Caran d'Ache, le seul peintre militaire de l'époque' – a reference to Caran d'Ache's early ambition.

Cliff Berryman
1869–1949

Kentucky-born and a self-taught artist, Berryman started as a draughtsman in the US Postal Service in 1886. Ten years later he joined the staff of the *Washington Evening Post*. His 1902 cartoon of President Theodore Roosevelt refusing to shoot a bear cub when out hunting was the origin of the term 'Teddy Bear', which became not only the artist's trademark but the name given to the best-loved children's toy across the world.

In 1907 he moved to the *Washington Evening Star*, and was still working there as chief editorial cartoonist when he was awarded the Pulitzer Prize in 1943, with the distinction of having provided long service as well as outstanding caricatures. In 1935 his son Jim joined him on the *Star*; father and son thereafter contributed alternate daily cartoons right up until his death in 1949. James T. Berryman then took over and was himself awarded the Pulitzer Prize in 1950.

Self-portrait, complete with the 'Teddy Bear' that had become his trademark, from Cartoon Magazine, *June 1912.*

Sydney Herbert Sime
1867–1941

From a poor family, when a boy Sime went down the mines before finding employment as a shop assistant. He learned sign-writing and studied at the Liverpool School of Art. In London his work appeared in many of the illustrated papers from the early 1890s onwards, including *Pick-me-up*, *The Tatler* and the *Windsor Magazine*. He was primarily an illustrator and his style was influenced by the Japanese print and Beardsley's work. After a decade of producing versatile drawings for magazines, he found a complementary spirit for his vein of macabre fantasy in the supernatural tales of Lord Dunsany on which he worked from 1908 to 1924, when he produced *The King of Elfland's Daughter*. Some of the original drawings are in the Victoria and Albert Museum collection. Like many of the illustrators of the day, he was an accomplished caricaturist.

An unpublished caricature of Aaron Penley, probably of one of Sime's friends.

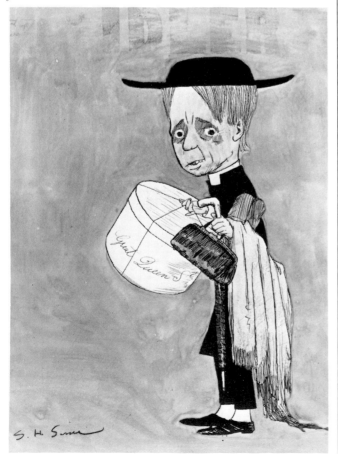

Eduard Thöny
1866–1950

A contributor to *Simplicissimus* during its entire run and one of its most popular artists, Thöny specialized in caricatures of military types, especially narrow-minded, uncultured officers, although he also turned his attention to the bourgeois *arrivistes* and, occasionally, to low-life subjects.

Like most *Simplicissimus* contributors, he saw himself chiefly as an illustrator and his work is more like painting than drawing in any conventional sense. Significantly, he neither wrote the texts for his cartoons, nor did he illustrate them; they were provided by others after he had done the art work. This practice was common at the time and it is surprising that it so often resulted in work that not only looked good but was also funny.

'In Caspar's Panopticon', 1898: the artist Heine, the playwright Wedekind and the publisher Langen on exhibition, probably a reference to their appearance in one of the law-suits brought against Simplicissimus.

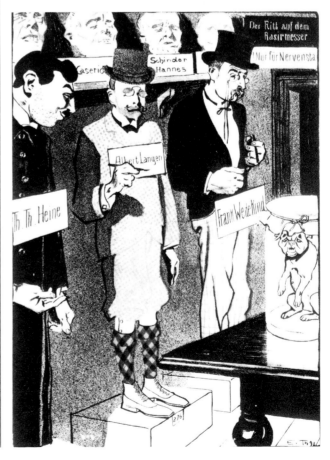

'SEM' Georges Goursat
1863–1934

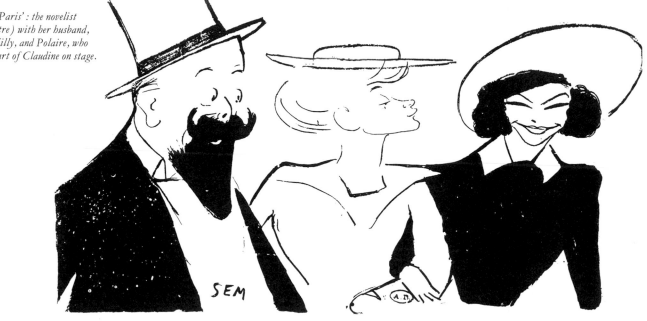

'Claudine à Paris': the novelist Colette (centre) with her husband, Monsieur Willy, and Polaire, who played the part of Claudine on stage.

Goursat chose his pseudonym in memory of Cham, whom he greatly admired. Born in Périgueux, he started his career with the publication of caricatures of local provincial types. After working in Bordeaux and Marseilles, in 1900 he moved to Paris. His album *Le Turf* caricatured the racing world: owners, jockeys, and all the fashionable set at Longchamp race-course. On the strength of the success of this book, he was taken on by *Le Journal*, and immediately entered the exclusive world of Paris society. His caricature of his close friend Forain remains the definitive image of that artist, whose distinctive profile appears in so many of Sem's group caricatures, including the book on the First World War which Sem wrote and illustrated, *Un Pékin Sur le Front* (*A Civilian at the Front*).

Sem's sketches epitomize the *belle époque* in the first decade of the twentieth century. Politicians, royalty, actors and writers were sketched in their familiar haunts. At the races, in the theatres, in restaurants and in the Bois de Boulogne, his sketches capture not only facial expressions but keenly observed characteristics of gait and gesture: in his portrait of Boni de Castellane, he focuses on the arched body, leaving the face relatively blank.

Though completely at home among the smart set, he retained an objective detachment, and caricatured himself without mercy. In the album *White Bottoms*, published in 1925, he pictures himself trying to dance the Charleston: the drawing conveys the pathetic quality of the artist's desperate attempts to keep pace with the music. His experiences during the war, when visiting soldiers at the front and in hospitals, affected him profoundly. He never regained the lust for life and verve of his pre-war work, and viewed post-war Parisian high society with disillusion. *White Bottoms* was his last publication; he stopped working nearly ten years before his death.

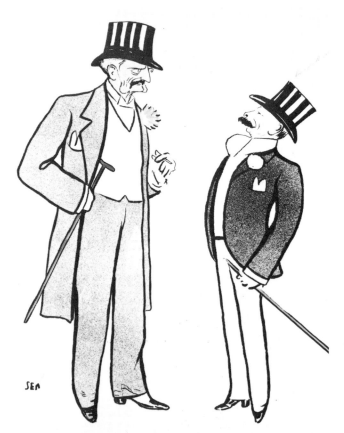

Grand Duke Vladimir of Russia and the Duc de Morny, Napoleon III's half-Russian step-brother, who had helped to make Deauville a fashionable resort.

OPPOSITE *Jean Lorrain (1855–1906), writer and reigning aesthete in Paris at the turn of the century, who introduced Sem to Parisian society.*

Lyonel Feininger
1871–1956

Born in America of German parents, Feininger studied art
in Germany and eventually made his name as an *avant-garde*
painter and member of the staff at the Bauhaus. Before
devoting himself entirely to painting, however, he earned
his living as a cartoonist for German, French and American
magazines. Many of these cartoons were political, the ideas
and captions being invariably provided by someone else,
and frequently included caricatures of politicians or
representative types. Feininger's style is linear and highly
mannered, emphasizing angularity, elongation and exag-
gerated proportions. This style, simplified and with the
addition of colour, reappeared in Feininger's comic strips
(*The Kin-der-Kids* and *Wee Willie Winkie's World* for the
Chicago Tribune from 1906) and, in a modified form, in his
paintings, which owe much to Cubism.

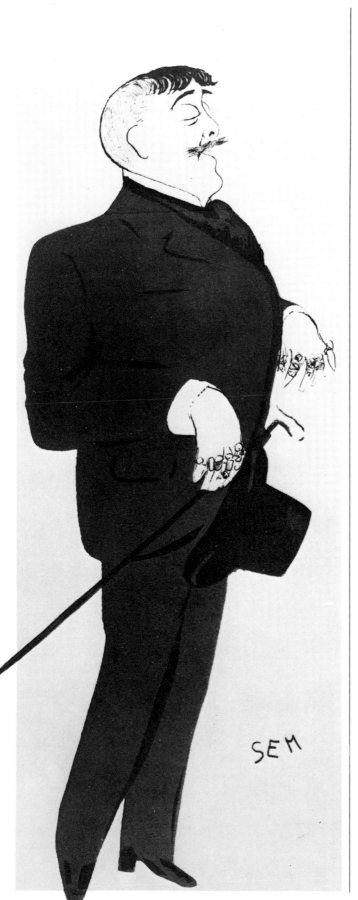

*Self-portrait of the artist as puppet-
master, with some of his comic
creations.*

Thomas Theodor Heine
1867–1948

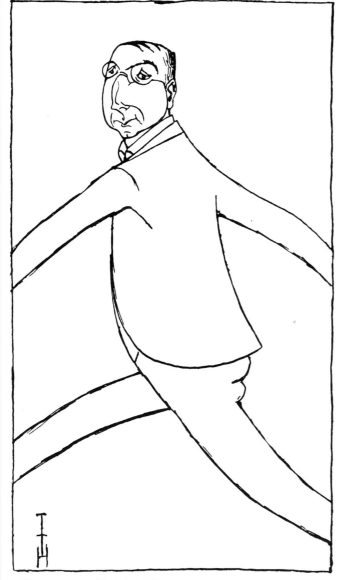

The German caricaturist Heine epitomized *Simplicissimus* for many of its readers. After training as a painter and working for the illustrated papers *Fliegende Blätter* and *Die Jugend*, he joined *Simplicissimus* as a staff artist from its foundation and contributed more to it than any other artist. He devised the magazine's symbol, a bulldog which has snapped its chain, and he specialized in producing the major cartoon for the front cover each week. His caricatures, generally works of political and social comment rather than single portraits, were in a clear linear style ahead of its time. An outspoken critic of the Nazi party from its earliest days, he produced drawings ridiculing Hitler and fascist philosophy that were often hilariously comic. Not surprisingly, he was forced to leave *Simplicissimus* and left Germany itself in 1933 when the Nazi regime gained power. He died in exile in Stockholm.

Albert Langen, wealthy industrialist and founder and publisher of Simplicissimus.

'An unproductive search of Hitler's house', 1930, finds no cause for concern: 'It's remarkable how little it takes to put things right.'

French and German Caricature Journals

FOLLOWING THE SUCCESS of *La Caricature* in 1830, many comic papers were launched. Most failed, but *Punch* (1841), *Fliegende Blätter* (1845), *Kladderadatsch* and *Fischietto* (1848), *Le Journal Amusant* (1856), *Le Chat Noir* (1882) and others thrived. They were an alternative to the sober pictorial weeklies (typified by the *Illustrated London News*), and divided into two main categories: the purely comic (for example *Fliegende Blätter*) and the politico-satirical. France, in particular, during the first decades of the Third Republic, had as many comic papers as minority causes. In the 1890s, for example, the Dreyfus affair led Forain to leave *Le Figaro* to start his own, violently anti-Semitic magazine, *Pssst...!*, in collaboration with Caran d'Ache. In *Le Chambard Socialiste*, Steinlen retaliated. Specific campaigns kept such papers going. But during the Nineties, a great variety of caricature papers also flourished because process engraving and simple forms of colour block printing made them viable. They included *Le Rire* (1895) and *Le Sourire* (1899). The most inventive and, in terms of portrait caricature, the most important, was undoubtedly *Simplicissimus*.

A Rhineland industrialist, Albert Langen, started the paper in 1896, in Munich, modelling it on *Gil Blas*, a literary and caricature journal. *Simplicissimus* had the distinction of being anti-Imperialist, not just as far as the British were concerned (though it made ample fun of Queen Victoria as a testy old frump and her son, the future Edward VII, as a fat and licentious big game hunter) but also in connection with Kaiser Wilhelm II, Victoria's grandson. The attitude was conveyed in a sparse, shadowless style influenced by Japanese woodcuts and, in German caricature, Toepffer and Busch.

The artist whose work dominated *Simplicissimus* from 1902 onwards was Olaf Gulbransson. Like Beerbohm, Gulbransson reduced those he caricatured to the bare essentials: the bulk of the body, the line of mouth and eyebrow, the blank pince-nez, the single hair trained across the bald patch. He brought to *Simplicissimus* a clarity, a lightness of touch that matched the paper's general philosophy.

Thomas Theodor Heine was *Simplicissimus*'s specialist in irate Junkers, the Prussian military in general, and God-fearing patriots in loud tweeds, both German and British. His characters could be the cast of John Buchan's *Greenmantle*, the tale of hot pursuits and repeated show-downs between rival national stereotypes during the First World War. Most of the caricature papers ceased publication during the War, partly because of newsprint shortages and staff difficulties, but also for more pressing reasons. Readers became conscripts; caricature, of a belligerent sort, became part of the war effort.

Olaf Gulbransson
1873–1958

The purity of Gulbransson's line, the richness and eloquence of his blacks and the daring of his early eccentric compositions may all be compared to Beardsley's work.

Having established himself as the leading humorous artist in his native Norway, Gulbransson moved to Munich in 1902 to work for *Simplicissimus* and, apart from the years 1922–27, which he spent back in Oslo, he remained faithful to the Munich magazine until it ceased publication in 1944. Gulbransson became one of Germany's best-loved cartoonists, admired especially for his caricatures, which were his forte. Whenever he drew other kinds of cartoon, the ideas and captions were invariably suggested by others.

His mature style was purely linear and related to *Jugendstil*, the German version of Art Nouveau. He had many imitators, the Gulbransson manner dominating German caricature for some time.

Georg Brandes, the Danish literary critic and historian, from Simplicissimus.

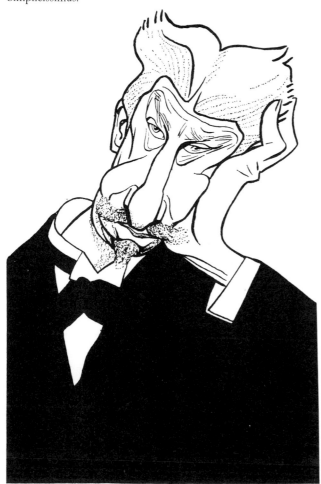

Henry Ospovat
1877–1909

The Ospovat family emigrated to England from Russia and settled in Manchester, where Ospovat went to art school. On leaving, he worked at printing and designing bookplates. In 1897 he gained a scholarship to study lithography at the National Art Training Schools, later known as the Royal College of Art. He was befriended by his teacher, Oliver Onions, and by the doyen of painting there, G. F. Watts. His decorative drawings for Shakespeare's Sonnets and Matthew Arnold's *Tristram* established his reputation for historical illustration, and his portrait paintings show great sensitivity and depth of character.

His mentor, Watts, encouraged another side of his art – the 'humoresque exercises'. Ospovat greatly admired Phil May and Steinlen. In his own work, he portrayed the human passion, action and emotion in the Jewish ghettos of London and Leeds, but it was above all in the theatres and music halls that he found his most inspired subjects – Little Tich, Harry Lauder, Marie Lloyd, Caruso and Squire Bancroft. Ephemeral movement and solidity of character are captured in the force of his line. He died tragically young, after suffering long illness.

Enrico Caruso, the Italian tenor.

The music-hall comedian Little Tich
(Harry Relph, 1867–1928).

Rudolf Wilke
1873–1908

A friend of Bruno Paul, with whom he shared a studio, Wilke saw himself primarily as an artist and illustrator and had studied Fine Art in Munich and Paris before becoming a regular contributor first to *Die Jugend* and then to *Simplicissimus*. His technically adventurous style, which makes use of expressive outlines and formal exaggerations, was unique at that time. Thomas Heine considered him the most gifted of all the artists working on his staff.

'The Prince's Tutor', from
Simplicissimus, *1906; Prince*
Willy, the Kaiser's son, asks:
'Why do you name Papa after
Demosthenes and Cicero?'
'Merely chronological order, Your
Royal Highness.'

Luther Daniels Bradley
1853–1917

An alumnus of Yale University, Bradley found his way into caricature through fortuitous circumstances. Having, as a young man, taken a period of recuperation from ill health in Australia, Bradley missed his steamship and was left stranded and penniless in Melbourne. A notice posted in a shop window attracted his attention, and led him to a small job as a cartoonist. Eleven years later, in 1892, after working for several Australian magazines, Bradley returned to the United States. From 1899 until his death he was political cartoonist for the *Chicago Daily News*, where he staunchly and unfashionably opposed America's imminent involvement in the First World War. During this time his caricatures parodied monarchs and anarchists alike. He died shortly before the United States entered the war.

Bradley's style is marked by a clarity and soundness of draughtsmanship reminiscent of *belle époque* illustrator Charles Dana Gibson. His caricatures have an inventiveness comparable to those of the British satirist John Tenniel.

'Design for a Union station', from
the Chicago Daily News, *1907:*
American railroad magnate Edward
H. Harriman.

Otho Cushing
c. 1871–1942

Otho Cushing's elegant style, reminiscent of the grand compositions of Frederick Leighton and of the linear classicism of John Flaxman, was quite an anomaly in the caricature of his time. Born in Fort McHenry, Maryland, he studied art in Boston and Paris. He became the European art editor of the *New York Herald*, and by 1903 was drawing for *Life* magazine, an association that lasted twenty-five years. His satirical drawings soon established him as an admired, if unique, illustrator in the midst of the new wave of Art Nouveau in American decorative and graphic art. In 1907 *Life* published Cushing's most popular work, 'The Teddyssey'; the caricatures therein of Roosevelt and industrial barons J. D. Rockefeller, J. P. Morgan and Andrew Carnegie reveal the artist's graphic brilliance and a keen sense of facial humour.

After the First World War (during which he served as supervisor of camouflage for US airfields in Europe), Cushing devoted his energies primarily to drawing and painting in watercolour in rural New Rochelle.

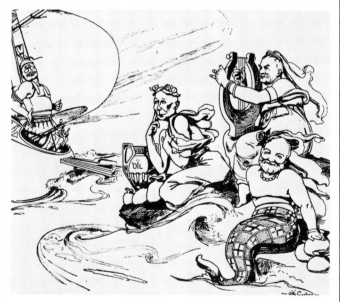

'The Teddyssey', from Life, *1907, shows Theodore Roosevelt resisting the blandishments of millionaires Rockefeller, Morgan and Carnegie as he pursues a policy of regulating trusts and monopolies.*

Golia
w. 1900–10

One of the leading political caricaturists of the Italian satirical revue, *Pasquino* of Turin, Golia had a linear style that was ideally suited to newspaper reproduction. His portrayals of Alphonso XIII of Spain, Edward VII and the King of the Belgians are keen delineations of character, in a line that echoes something of the power and influence of Caran d'Ache and Jossot, another striking satirical artist of the decade.

Alphonso XIII of Spain and his mother.

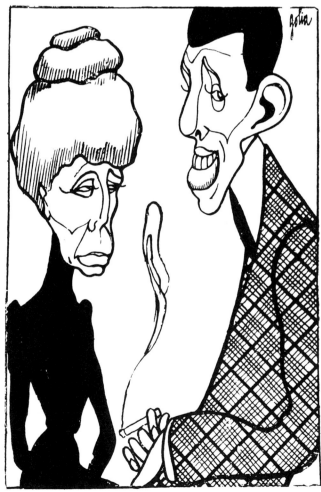

Enrico Caruso
1873–1921

The eighteenth child born to the wife of a Naples mechanic, Caruso was the first one to survive infancy, thanks to the help of a noblewoman who nursed him. His early talent was for drawing, and it was only later that the quality of his voice was recognized. After his appearance in *Rigoletto* at the Metropolitan Opera House, he was asked for a photograph for *La Follia*, the Italian newspaper in New York. Not having one, he sent a sketch, which greatly impressed the editor, Marziale Sisca. He persuaded Caruso to become permanent caricaturist for the paper, to the delight of the Italian community. He would send in drawings even when on tour. When Pulitzer offered him 50,000 dollars a year for a monthly cartoon, he turned it down; asked what *La Follia* was paying, he replied, 'Nothing.' His sketches were of fellow-artists, musicians and statesmen, observed on the spot and captured in a few deft lines – often striking likenesses drawn with remarkable verve.

Arturo Toscanini, the conductor, in Paris.

Edward Tennyson Reed
1860–1933

'I attribute my becoming a caricaturist, in preference to following other walks of life, to the fact that I fell over the bannisters at the age of five and landed on my head in a marble hall.' So said Reed when asked why he had not followed in his father's footsteps (Sir Edward J. Reed was MP for Cardiff and chief naval architect from 1863 to 1870).

Educated at Harrow, where he gained a football cap, after leaving school he sailed for Egypt and Japan. His first published sketch appeared in *Society*, and he started contributing to *Punch* in 1889. Elected to the Punch Table the following year, he succeeded Furniss as parliamentary caricaturist, and was noted for his Law Court sketches. But it was the series entitled *Prehistoric Peeps* that gained him his widest public; the stone-age antics, comparable to those of the more recent 'Flintstones' or 'Astérix' cartoons, proved so popular that they were issued in book form in 1896. His work was distinguished by a strong outline and compelling likenesses, despite the most ingenious transformations of his subjects. He continued to draw for *Punch* over the following decades, but the years 1890–1910 show the richest vein of fantasy.

Conservative minister Arthur J. Balfour, from Mr Punch's Animal Land, *1898.*

Gustav Brandt
1861–1919

Brandt worked for *Kladderadatsch* from 1884, becoming one of the main illustrators alongside Wilhelm Scholz. He was largely responsible for giving the Berlin weekly satirical magazine, founded in 1848, its new visual character. Dramatic, bold and impressive, the drawings produced by him after 1900 have been compared to those of Gulbransson in *Simplicissimus*.

Edward VII, 1901.

19

Eduard der Dicke

Bruno Paul
1874–1968

Having studied art in Dresden from 1886 to 1894, Paul moved to Munich, where he drew for *Die Jugend* and the newly-established *Simplicissimus*, the style of which he greatly influenced. His appointment in 1907 as Director of the Berlin Museum Art School cut short his career as a caricaturist, although he continued to contribute occasional drawings under a pseudonym. Most of his cartoons depict the Munich proletariat and the agricultural labourers of the Bavarian countryside. His caricature style exploited the strong curving line and careful juxtaposition of black-and-white areas that were derived from *Jugendstil*.

Self-portrait, in a delicate line which contrasts with the rugged and vigorous style of his other caricatures.

Daniël Cornelis Boonzaier
1865–1950

Born in South Africa, Boonzaier started work at the Magistrate's Office in Carnarvon, and at the age of sixteen transferred to the Colonial Office in Cape Town. He began to draw stage personalities and politicians from photographs, inspired by the *Punch* artists Du Maurier and Phil May and by Schroder of *The Knockberrie*. His cartoons appeared in the *Cape Punch*, *Telephone* and *The Owl*, and he became South Africa's first professional cartoonist. His drawings for the *South African News* from 1903 reflected his Afrikaner sympathies and seem to be greatly influenced by FCG's style. In 1907 he joined the newly founded *The Cape*, contributing the theatre columns and cartoons, and he worked in Johannesburg for two years on the *South African Post*, making contact with Transvaal artists and writers. He returned to Cape Town and worked as staff cartoonist of *De Burger* from 1915 to 1940. His first book, *Owlographs: A Collection of South African Celebrities*, was published in 1901; later works included *My Caricatures* in 1912 and *Rand Faces* in 1915.

William Henry Dyson
1880–1938

Between 1912 and 1919, Dyson's work was at its trenchant best: taking the entire front page of the Socialist *Daily Herald*, his cartoons scandalized a reactionary Establishment.

Dyson began his career drawing for the *Sydney Bulletin*, sailed for England in 1909 and three years later joined the *Daily Herald*. During the First World War he was appointed Official War Artist to the Australian Imperial Forces and was twice wounded. In 1925 he went back to Australia for five years, but returned to England via the United States where he exhibited, to much acclaim, a series of satirical etchings depicting literary, artistic and intellectual personalities of the day. Witty, occasionally daring, the prints are reminiscent of Beerbohm, in a more rugged, muscular guise. In spite of the financial independence which his new-found success had given him, Dyson rejoined the *Daily Herald* in 1930 where he remained until his death.

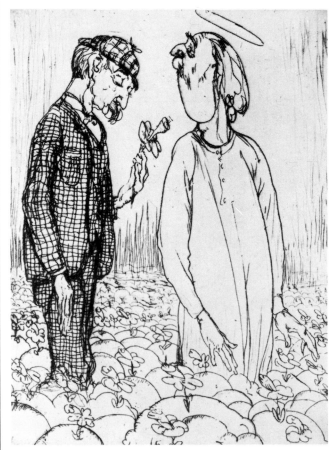

◀ LEFT *'Dr Muir gives practical encouragement to a famous movement', from* My Caricatures. *John Muir was a botanist with an interest in folklore who lived in the Western Cape.*

'Mr Thomas Hardy finds evidence of canker in the fields of Asphodel.'

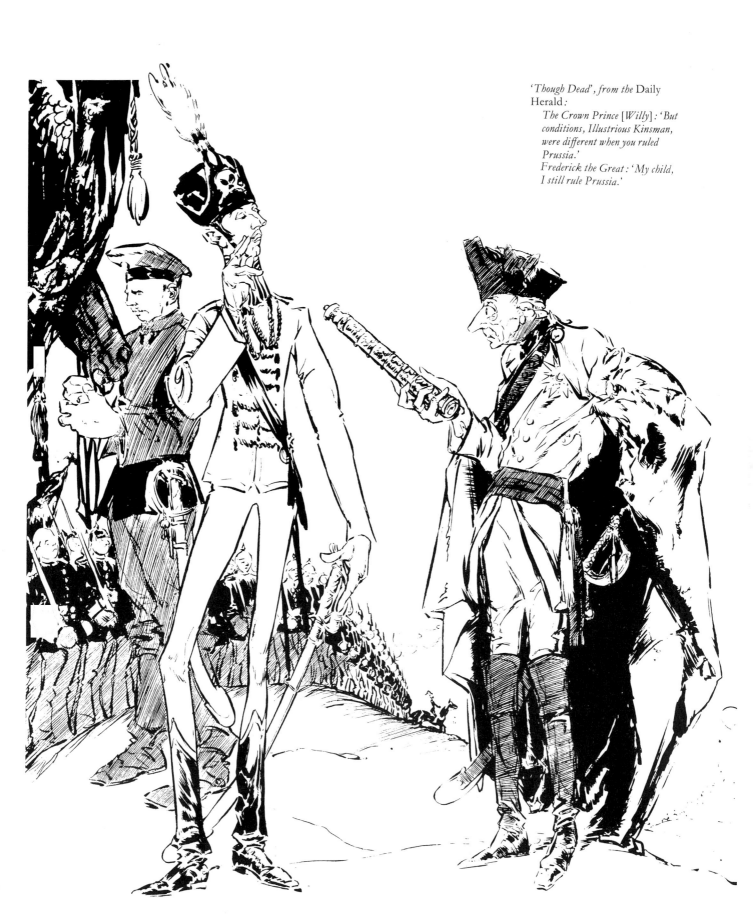

'Though Dead', *from the* Daily Herald:

The Crown Prince [Willy] : 'But conditions, Illustrious Kinsman, were different when you ruled Prussia.'

Frederick the Great : 'My child, I still rule Prussia.'

Louis Raemaekers
1869–1956

Raemaekers, a Dutchman of German extraction, was a great draughtsman and an outstanding First World War propagandist. He witnessed the flight of refugees as the Germans invaded Belgium, and his dramatic work roused public opinion by conveying the outrages of war. He depicted the Germans as godless and the Kaiser as an ally of the Devil. His art and allegories had an enormous emotive effect in England, where he lived for some years, and he also stirred American feeling over the issues of the Great War when he visited the United States in 1917 at the request of Lloyd George. His last great caricature was of Clemenceau, done on the statesman's death in 1929.

The Kaiser and his son, drawn in 1916 after the Battle of Verdun: 'It's not such a jolly war, then; I had thought it would be a lot more fun, my boy.'

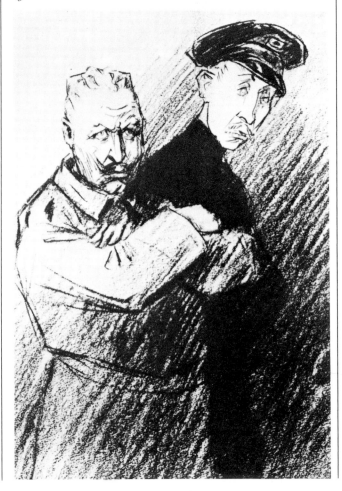

Leonard Raven-Hill
1867–1942

As second artist to Bernard Partridge on *Punch* from 1910 to 1935, following that magazine's tradition Raven-Hill drew the topical themes of the week. He was a great admirer of Charles Ricketts and Charles Keene, and his flair for capturing movement with bold pen-strokes won him the nickname 'Keene in action'. He looked on his work as pictorial reporting.

After attending Lambeth College of Art he studied in Paris, exhibiting at the Paris Salon in 1887 and at the Royal Academy in 1889. He worked with Phil May and in about 1890 he became art editor of the magazine *Pick-me-up*. In 1895 he founded the illustrated magazine *The Unicorn*, which failed after a short run. He joined *Punch* in the same year.

In his youth he had served as a volunteer with the 2nd Wiltshire Voluntary Battalion, and he frequently depicted military manœuvres. The cartoons he drew during the First World War depicted the situation of the 'Tommy' with humour and insight. Some of his finest portrait caricatures appeared at this time, showing, as many fellow-artists believed, that he was a greater draughtsman than Partridge, and an artist of wider talents and great versatility.

He produced many illustrations for *Black and White*, *The Butterfly*, the *Pall Mall Budget*, *Pearson's Magazine* and *The Graphic*, and his illustrations for Rudyard Kipling's *Stalky and Co.* won him enormous popularity and great acclaim. One of the friendliest and most cheerful members of the Punch Table, and a member of the Savage Club, he frequently caricatured his fellow-artists.

'The Old Man of the Sea', from Punch, 21 July 1915: Wilhelm II carries Admiral Tirpitz.
'Sinbad the Kaiser: "This submarine business is going to get me into trouble with America; but what can an all-powerful do with a thing like this on his back?"'
The Kaiser's fears proved justified two years later when a renewal of German U-boat attacks on American vessels brought the USA into the war.

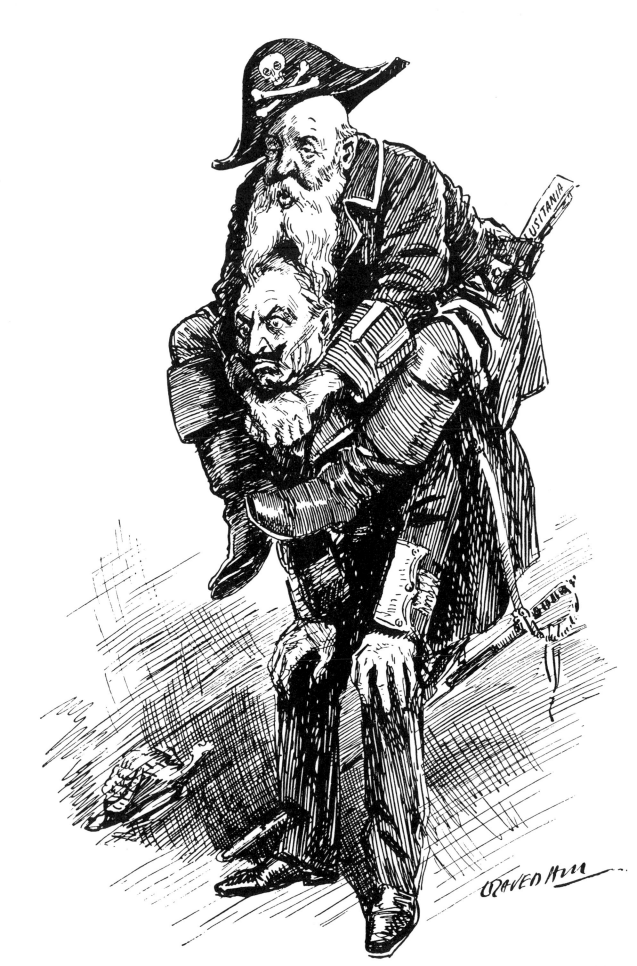

141

Edmund Joseph Sullivan
1869–1933

Among the foremost English black-and-white artists working early in the century, Sullivan was one of the first to draw for the *Daily Graphic*. He also contributed to the *Pall Mall Gazette*, the *Ludgate Monthly*, the *Windsor Magazine*, *Pearson's Magazine*, *Punch*, and many of the illustrated journals.

After studying with his father, he became a masterly draughtsman, admired for his fine pen-work and looser, decorative chalk-and-wash drawings. He was a highly influential teacher and lecturer in Book Illustration and Lithography at Goldsmith's College in South London. His work was considered to be on a par with that of Rackham, Dulac and Heath Robinson, though he never quite achieved their distinction. His book, *The Kaiser's Garland*, a collection of drawings in the Raemaekers genre, was inspired by the wave of hatred that swept over the Allies following the execution of Nurse Cavell and reports of atrocities in Belgium.

'The Hope of the Hohenzollern: The Good German Sword', a portrait of Crown Prince Willy from The Kaiser's Garland, *1915.*

William Orpen
1878–1931

The son of a Dublin solicitor, Orpen attended the Metropolitan School of Art there from the age of thirteen, and was later a brilliant student at the Slade School in London; William Rothenstein discerned in him 'a touch of Hogarth's frolic'. Newspaper proprietor Lord Riddell wrote: 'Orpen was most kindly and affectionate, but had a ruthless strain . . .; nothing could prevent him from giving play to the satire which was one of his chief qualities.' Intending to become a caricaturist, he tried for a position on *Punch*, but without success. He founded an art school with Augustus John and, when this failed, he took up portrait painting. His work was first hung at the Royal Academy in 1908; he was elected Associate in 1910 and Academician in 1919.

Orpen worked as an official war artist from 1917 to 1919; the caricatures he drew at the Paris Peace Conference were considered works of genius. He was knighted in 1918, became President of the Society of Sculptors, Painters and Gravers from 1921, but declined the Presidency of the Royal Academy, declaring that he hated formal speeches.

The Kaiser.

James Montgomery Flagg
1877–1960

An extremely versatile artist, the American caricaturist Flagg captured in his art the personality of the first half of the twentieth century. Probably his best-known work is the US Army recruiting poster, 'Uncle Sam Wants You . . .', produced during the First World War. His portraits, illustrations and caricatures record the New York café society and young Hollywood milieu with which the artist was, for decades, on intimate terms.

Flagg began his career at the age of twelve with the sale of a drawing for $10, and by 1915 was one of America's highest-paid illustrators. He was as much a celebrity as the film stars, authors and artists he drew. This was due in part to his public image as a bohemian and a prankster, a reputation he did much to nourish. His caricatures of luminaries of the American cultural community, a few of which were published in *The Well-Knowns* in 1914, bear the stamp of Charles Dana Gibson's influence and a strong sense of design inherited from Art Nouveau.

The original artwork for the cover of
Harper's Weekly, *25 April 1914,*
featuring Enrico Caruso.

'QUIZ' Powys Arthur Lenthall Evans
1899–

The son of a judge, Evans showed a gift for drawing early in life. Taught by the painters Spencer Gore and Robert Bevan, he then studied at the Slade School of Art under Professor Tonks. On finishing his studies, he joined Sickert in Dieppe. His portrait caricatures appeared in the *Saturday Review* under the pseudonym 'Quiz' and won him great acclaim. He drew the eminent figures of the day, and contributed to many magazines. Max Beerbohm wrote the preface to the catalogue of his one-man show at the Leicester Gallery in 1924. A restrospective show at the Langton Gallery in Chelsea, 1975, showed his extraordinary range of subjects, a notable portrait gallery of people in the public eye in the Twenties and Thirties portrayed with an incisive elegance.

The painter and critic, Roger Fry
(1866–1934).

Paul Deyvaux Gassier
1883–1951

A committed socialist, Gassier started his career in 1908 working on *L'Humanité*, the paper launched by Jean Jaurès. He also published caricatures in *Les Hommes du Jour*, the satirical magazine which bitterly attacked the French Third Republic régime and fell foul of censorship in 1908.

In 1915, Gassier, together with Maréchal, launched the satirical weekly *Le Canard Enchaîné*, to which he contributed regularly until his death. After the First World War he returned to *L'Humanité*, left it in 1926 when it became the Communist daily paper, but returned to it between 1945 and 1950. Between 1926 and 1939 he worked on *Le Journal*.

Gassier's distinctive and economical style concentrated on outlines and salient physical traits. He is generally considered to have been the pioneer of twentieth-century French political caricature.

Members of France's short-lived 1934 coalition government: (clockwise from top) President Gaston Doumergue, right-winger Pierre Laval, Radical leader Edouard Herriot, Socialist leader Léon Blum and Communist leader Marcel Cachin.

Erik Johan Smith
w. 1920s

Very little precise information has been recorded about Smith's life. Born in the USA around the turn of the century of Swedish forebears, he served in the US Navy during the First World War. He was a friend of the painter Raymond Jonson in Chicago in the Twenties and his theories of geometric composition were an influence on Jonson's work at one stage. He married the actress Miriam Kiper, and they went to live in Italy.

A pencil drawing of the oil millionaire John D. Rockefeller, 1923.

Jean Cocteau
1889–1963

The son of a Paris lawyer, during his childhood Cocteau met the leading artists, actors and writers of the day who were guests at his family's salon. He was regarded as a prodigy, publishing his first volume of poetry at the age of sixteen; and throughout his life he enjoyed a reputation as the *enfant terrible* of French intellectuals.

Before the First World War he was contributing satirical drawings to various Paris journals, using the pseudonyms 'Jim' and 'Candide'; and in 1914–15 he was associated with the journal *Le Mot*. His talents are evident in many fields, as poet, novelist, dramatist, critic, ballet designer for Diaghilev and film director. Caricature occupies only a minor phase of his creative work, but his drawings have a quite distinctive style. His interest in the graphic arts found lifelong expression in all his work; two of his major and permanent achievements are his decoration of the Chapel of Saint-Blaise-des-Simples at Milly-la-Forêt, and the triptych in the French Church in London, St Anne's, Soho.

Designer Léon Bakst with a dancer at a Ballets Russes rehearsal.

Bernard Partridge
1861–1945

The son of the Professor of Anatomy at the Royal Academy and nephew of the Portrait Painter Extraordinary to Queen Victoria, Partridge had early ambitions to become an actor. Adopting the name Bernard Gould, he played Laertes to Forbes-Robertson's Hamlet, and appeared in the first production of Shaw's *Arms and the Man*. On leaving university he worked in an architect's office, and studied stained glass. His drawings appeared in *Moonshine* and he drew a series with Jerome K. Jerome in *Playgoer*. In 1891 George Du Maurier persuaded him to join *Punch*. He was reluctant to draw the political 'cuts' until 1901, when he succeeded Linley Sambourne as chief cartoonist. His epic caricatures of people from the Kaiser to Hitler, and all the major figures of the inter-war years, were marked by his strong academic draughtsmanship and provided a weekly focus on national events. His death marked the end of an era, a century throughout which the *Punch* editorial cartoons followed a predictable format. He was knighted in 1925.

Sir Arthur Conan Doyle, chained to his most famous creation, Sherlock Holmes.

Bert Thomas
1883–1966

Thomas was a Welshman with a cockney sense of humour. His early work was influenced by Britain's Phil May and Germany's Eduard Thöny. He began his career around 1905, contributing to *Punch*, *London Opinion*, *The Humorist*, *The Sketch*, *The Bystander* and *The World*. ''Arf a mo', Kaiser!', his most famous cartoon, published in 1914, was drawn to promote a fund to provide the troops with tobacco and cigarettes and is credited with having raised £250,000. Bert Thomas's caricatures look effortless and, as he was capable of producing five or six finished drawings in one day, they probably were. Although he did not seek out the profound psychological depths of his subjects, he pinpointed their physical essence with verve, instinctive artistry and, when opportunity arose, a fine colour sense.

Hilaire Belloc and G.K. Chesterton.

Albéric Bourgeois
1876–1962

The eldest son of a typographer on the Montreal paper, *La Patrie*, Bourgeois studied at the École des Beaux-Arts and won the Conseil des Arts' first prize in painting. He continued his studies in the USA at Boston Art School, after which he joined the *Boston Post* as a caricaturist. In 1904 he was persuaded to return to work for *La Patrie* where, apart from political caricatures, he started the comic narrative strips *Les Aventures de Timothée* and *La Famille Citrouillard*. After his move to *La Presse*, the largest of the Quebec dailies, his draughtsmanship became more fluent and, as he tackled the current political scene, he developed a wider range of characterizations. His weekly chronicle, *Père Ladebauche and Baptiste*, entertained readers with a series of topical adventures for many years. In the Twenties and Thirties, his popularity established him as the major Quebecois caricaturist and a favourite throughout Canada. In his fifty years as a newspaper cartoonist before his retirement in 1956, he made over 20,000 drawings, many of them using themes from French folklore. He was also a chansonnier of satire and folk-songs, and during the 1920s composed songs and monologues for the cabaret 'Matou Botté', and for revues and musicals at the Théâtre Saint-Denis.

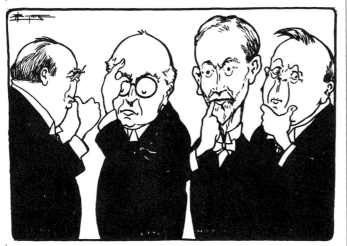

The four leading figures in Canadian politics during the Thirties: (left to right) Richard Bennett, Conservative Prime Minister 1930–35; Henry Stevens, founder in 1935 of the Reconstruction Party; James Woodsworth, leader of the socialist Co-operative Commonwealth Federation; and William Mackenzie King, Liberal Prime Minister 1935–48.

'DING' Jay Norwood Darling
1876–1962

The signature 'Ding' appeared during a fifty-year period on over 17,000 cartoons. It was the pen name of Jay Norwood Darling, a self-taught artist who spent most of his working career on the *Des Moines Register* as editorial cartoonist. Ding was originally a news reporter, and his first drawing for a commercial newspaper was a caricature of a trial lawyer, the subject of an assignment who had refused to be photographed. During the course of his long career Ding was twice awarded the Pulitzer Prize. He developed in his work a dynamism and clarity of composition that conveys his point quickly and successfully. By the time of his retirement in 1949 he was perhaps the country's best-known cartoonist, but he was equally renowned as a champion of wildlife conservation.

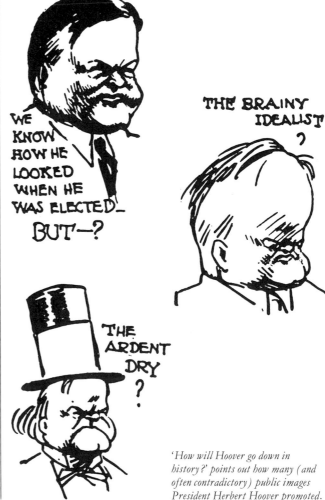

'How will Hoover go down in history?' points out how many (and often contradictory) public images President Herbert Hoover promoted.

George Gershwin, one of a number of portraits of jazz musicians and composers of the Twenties.

William Auerbach-Levy
1889–1964

In a style as original and forceful as that of the *Simplicissimus* artists, Auerbach-Levy sketched his subjects from life, and then worked from memory. The final minimal statements carry acute and sensitive likenesses, the line varying from broad brush-stroke to fine pen-line; their texture and skill derived from his origins as a painter-etcher. A reviewer of his book *Is That Me?*, published by Watson-Guptill in 1948, found he had 'the same indisputable authority [on caricature] as Freud on Sex, or Tilden on Tennis'.

Born in Brest-Litovsk, he came to the USA with his parents at the age of five and was sent from his Lower East Side school to the National Academy of Design when he was eleven. Graduating from City College, he went to Paris on an art scholarship, and returned to teach at the National Academy School of Fine Arts. His first caricatures of fellow-artists won a prize at Penn Academy and were noticed by an agent. From 1925 his striking portraits of theatre personalities headed Alexander Woolcott's column in the *New York World*. His portrait of Woolcott became the writer's trade-mark, the imprint of all his publications. Auerbach-Levy's drawing featured in *The New Yorker, Colliers*, the *New York Post* and the *Brooklyn Eagle* over three decades.

Margaret Rutherford and John Gielgud in Oscar Wilde's The Importance of Being Earnest.

Erich Schilling
1885–1945

A regular contributor to *Simplicissimus*, Schilling developed a style which imitates the bold, ragged lines and strong tonal contrasts of German medieval woodcuts. Always relatively conservative in his political views, he attacked the Nazis during their rise to power, but after 1934 became one of Hitler's most fervent supporters and Goebbels' favourite cartoonist. In the year of the collapse of the Third Reich, Schilling committed suicide.

'Kukolini and Mussirol – 'Dr Unbloody and Dr Bloody', a portrait of Mussolini in Kladderadatsch, *1925. Kukirol was the name of a brand of corn plaster.*

Alfred Frueh
1880–1968

The reputation of 'Alf Free' as a caricaturist of the American theatre world spans six decades. He went to school in Lima, Ohio, where his family were local farmers and brewers. While taking a course at Pitman's he found himself converting the shorthand signs to faces, and so in 1904 he left to join the *St Louis Post Dispatch*. Here his drawings progressed from court-room scenes to political cartoons. He was already an avid theatre-goer, and in 1907 it was a cartoon of a visiting music-hall star, Fritzi Scheff, that made him notorious: his drawing so enraged her that she cancelled her performance.

Frueh's sketches appeared daily in the *New York World* from 1910 to 1924, and it was during this period that he worked and studied in Paris, becoming friendly with Matisse and Braque. His first exhibition, in 1912, was arranged by Alfred Steiglitz. *Stage Folk*, a folio containing many of his portraits, was published ten years later. He designed the cover for the second issue of *The New Yorker* in 1925, and from then on covered their Broadway reviews with a succession of brilliant theatrical caricatures until his retirement forty years later.

'Sybil Thorndike as the gentle and sympathetic head of John van Druten's pleasant English family and Estelle Winwood as one of her problems', from The New Yorker, *12 January 1934.*

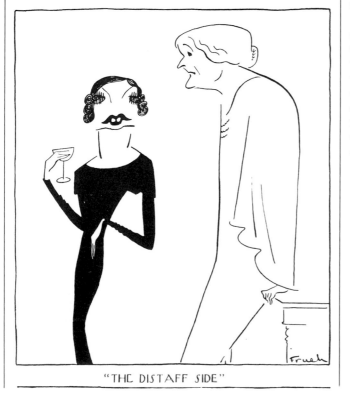

"THE DISTAFF SIDE"

George Grosz
1893–1959

Trained as an illustrator, self-taught as a painter and first celebrated as an original and highly controversial cartoonist, Grosz was not only one of this century's greatest draughtsmen but also one of its most gifted Realist painters.

Contributing cartoons to Berlin humorous journals such as *Ulk* and *Lustige Blätter* from 1910, he was converted to revolutionary politics during the First World War and began to produce bitter, obscene and even treasonable cartoons for Communist journals published by the Malik-Verlag. He worked exclusively for Malik until the 1920s, making drawings not only for magazines but also for books and portfolios of etchings and lithographs.

Although much of the work Grosz did for the Malik-Verlag journals like *Die Pleite* and *Der Knüppel* included impressively economical caricatures of leading politicians like Ebert, most of the people he drew were anonymous but representative types. The crippled veterans selling matches outside luxurious department stores and the bigoted *petit-bourgeois* families ignorant of the world beyond their lace-curtained windows appear as often in Grosz as do the fat, Satyric war profiteers gorging themselves in restaurants or cavorting with ugly tarts in brothels. Occasionally, such drawings offended so deeply that Grosz was taken to court where he and his publishers were always fined, lucky to escape imprisonment.

Grosz's sharp, spare line was partly the result of the artist's enthusiasm not only for Futurism but also for graffiti and children's art. He rarely employed large areas of black or tonal hatching, preferring to leave the subtly articulated contour to do all the work.

During the 1920s, by which time he was married and suspicious of the ambitions and tactics of the extreme Left, Grosz's drawings became more like humorous illustrations than cartoons, regaining their earlier, deadly edge only when directed against the Nazis. In fear of his life, Grosz emigrated to the USA where his work, although still brilliant, lost its savagery. Grosz always missed Berlin, whose inhabitants he had satirized so remorselessly, and he died there not long after deciding to return permanently to the city of his birth. He had many imitators but no equals.

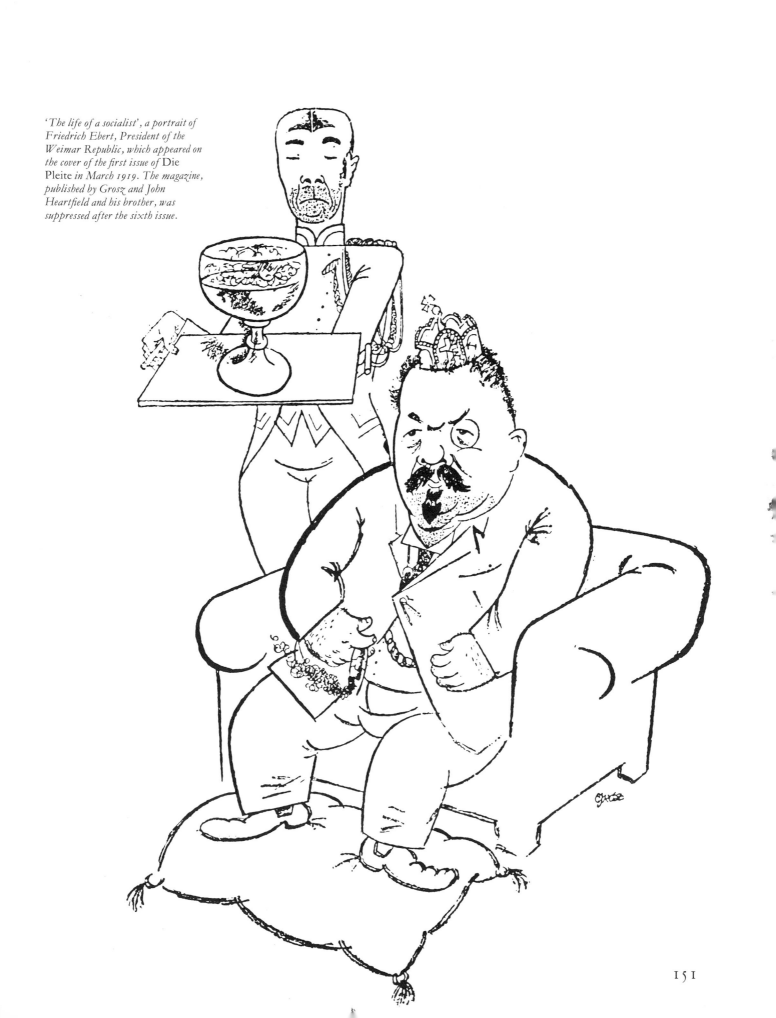

'The life of a socialist', a portrait of Friedrich Ebert, President of the Weimar Republic, which appeared on the cover of the first issue of Die Pleite in March 1919. The magazine, published by Grosz and John Heartfield and his brother, was suppressed after the sixth issue.

Alexander Calder
1898–1976

A unique international figure in the world of sculpture,
Calder came from a family of Philadelphia artists of Scottish
descent. His preference for mechanical rather than painterly
invention led him to study engineering at the Stevens
Institute of Technology in New Jersey. He travelled
extensively, working on freighters and in logging camps; it
was only after several years that he started drawing at New
York night school, and enrolled at the Art Students League,
where he was taught by Luks, Robinson and John Sloan.

Calder's first freelance illustrations were for the *National
Police Gazette*. They took the form of a series of circus
sketches, which sparked off his interest in making mobile
wire 'toys', and led to his famous improvizations and
performances with his circus figures. By 1930 he was well
known in the *avant-garde* art world, and held one-man
exhibitions in Paris, Berlin and New York. His wire figures
of Josephine Baker and Helen Wills, and his portraits of
friends, were innovations in the unmistakable spirit of
caricature which was evident throughout his work.

*Sheppard Vogelsgang, one of the wire
portraits exhibited by Calder in
April 1931 at the Gallerie Percier in
Paris.*

Paul Klee
1879–1940

The few caricatures which Klee produced convey a distil-
ation of his subjects' personalities with the sure linear touch
of his early graphic work and figurative drawings. Born in
Switzerland, Klee, one of the leading figures of modern art,
studied in Munich. In his intensely personal style he
developed abstract themes and fantasies, conveying a
mystical feeling of mood and colour. His theatrical writings
and practical teaching were among the main formative
influences of the Bauhaus, where he taught from 1921 to
1930.

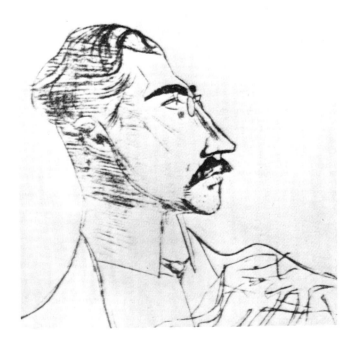

The composer Igor Stravinsky.

Henry Mayo Bateman
1887–1970

Determined since childhood to draw for publication, Bateman greatly admired Caran d'Ache and Ospovat. On Phil May's advice, on leaving school he went to Westminster School of Art; he later worked in van Havermaet's studio. His first humorous drawings were published in 1903. *The Sketch*, for which he drew a series of full-page theatre caricatures, dubbed him 'Our Untamed Artist', and Bernard Shaw asked him for posters for *Fanny's First Play* and *John Bull's Other Island*.

Bateman enlisted early in the First World War, but was invalided out after contracting fever. Rarely concerned with politics, he produced a series of cartoons of comic situations based on social gaffes such as 'The Boy who Breathed on the Glass in the British Museum' and 'The Man who Lit his Cigar before the Royal Toast'; his types epitomized the characters of clubland and suburbia. He toured America for *Life* magazine in 1923, and was in great demand from advertisers on both sides of the Atlantic; his advertising posters included classic ones for Guinness and Kensitas. Reputedly the highest-paid cartoonist of his day, he was certainly the most widely popular.

Bateman maintained an interest in painting throughout his life, and exhibited at the Royal Academy. During the Second World War publication of his work was curbed by wartime restrictions; he retired to Devon to pursue his favourite pastimes of painting and fishing.

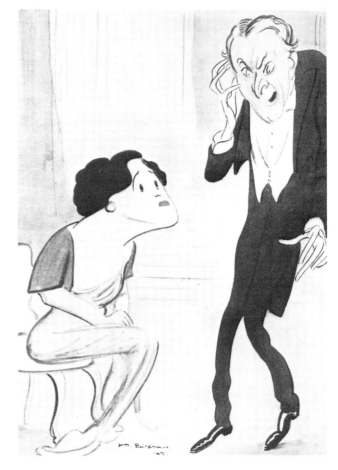

Mrs Patrick Campbell and Sir George Alexander in The Second Mrs Tanqueray, *from* The Sketch, *18 June 1913.*

Arthur Johnson
1878–1954

An American of German extraction, Johnson became known for his cartoons in *Kladderadatsch*, for which he began work in 1906. It took him some time to develop a characteristic style and when he did it was uncompromisingly modern, more like the drawings which appeared in *Simplicissimus* than the illustrations for which *Kladderadatsch* was known. His work was simple, dramatic and linear, and relied on strong tonal contrasts. His caricatures were frequently grotesque, never more so than in his depictions of John Bull during the First World War.

'Thomas Mann, the Poet Laureate of the German Republic', one of four drawings from Kladderadatsch, *1923, in which Mann, a recently converted supporter of the new Republic, labours to sing its praises.*

Jazz Age to Depression

THE GERMAN JOURNAL *Simplicissimus* survived the war unimpaired. Circulation rose once more to over 250,000 copies a week. Its leading artists, Olaf Gulbransson and Karl Arnold, were pre-eminent among caricaturists and were widely copied. Taken to one extreme, their trim outlinings broke down into the stuttery violence of George Grosz's unremitting attacks on the profit motive. On the other hand, Gulbransson–Arnold styling became basic to *The New Yorker* (founded in 1925), the epitome of Jazz-chic, the ideal means of portraying crooners, tycoons and men about town. Eventually the line turned to dough in the hands of Thurber.

There were new idols, new demands. Karl Arnold showed a group of characters, Frederick the Great and Charlie Chaplin among them, gazing with perplexity and a touch of chagrin at the latest figure to occupy the world stage: Mickey Mouse. From the Twenties onwards, the caricature hierarchy no longer held good. Monarchs were in abeyance, and politicians were no substitute as commanding figures on the world stage. The crises of ideology meant that from Left and Right caricature images now concentrated on Land and People. Hitler began to appear in *Simplicissimus*, ridiculed for a while, then, after 1933, treated as Führer. Caricaturists in exile could persist; John Heartfield gave the monsters of Fascism a new sort of *portrait-charge* reality by posing them in photo-collages: Hitler receiving backhanders from Big Business, Goering with the burning Reichstag, Goebbels as hyena.

Caricature was shaping up to figures created and boosted by the propaganda media. Newspaper photographs made leaders who had once, pre-war, been almost as remote as the gods on Mount Olympus, into everyday acquaintances. These men appeared in newsreels, haranguing the crowds, foregathering at conferences, shaping destinies. The caricaturist who came to terms with the new, specious intimacy of politics in the most adroit way was David Low. His employer on the *Evening Standard*, Lord Beaverbrook, recognized that Low's politics had to be tolerated, even though they differed from his, because his caricatures were the most important, most popular element of the newspaper. Low's immunity – 'complete freedom in the selection and treatment of subject-matter' (as his 1927 contract put it) – meant that he had licence to pursue his course of Dictator-baiting, Government-baiting and general side-swiping at matters of social concern. His great stand-bys – Colonel Blimp, the over-heated voice of Reaction, the dumb but loyal TUC Horse – sustained him through the day-to-day pressures of invention and composition. But it was his Hitler, yelping away in shiny jackboots, his Neville Chamberlain, like an ostrich endeavouring to please, his beaming Roosevelt, his complacent Baldwin, who dominated caricature.

Low drew for a vast public, for readers sufficiently versed in his subject-matter to be able to see each caricature as a fresh episode in Low's chronicle of his times. This continuity was sustained over an extraordinarily long period, from the Twenties to the Fifties. His brush, which gave his work its curiously glancing line, did not lend itself to the close-up; Low's figures disported themselves on a proscenium stage, boasting, strutting, constantly deceiving each other and fleecing the voters. The audience, looking on from somewhere in the dress circle, followed the almost daily unfolding of these Twentieth-Century Follies, applauded the witty characterization and no doubt shared the artist's derision and despair.

OPPOSITE *Cartoon by Ralph Barton from* The New Yorker, *19 February 1927. The accompanying notes on the production, at the Fulton Theatre, included the information that Miss Lillie was the wife of Sir Robert Peel.*

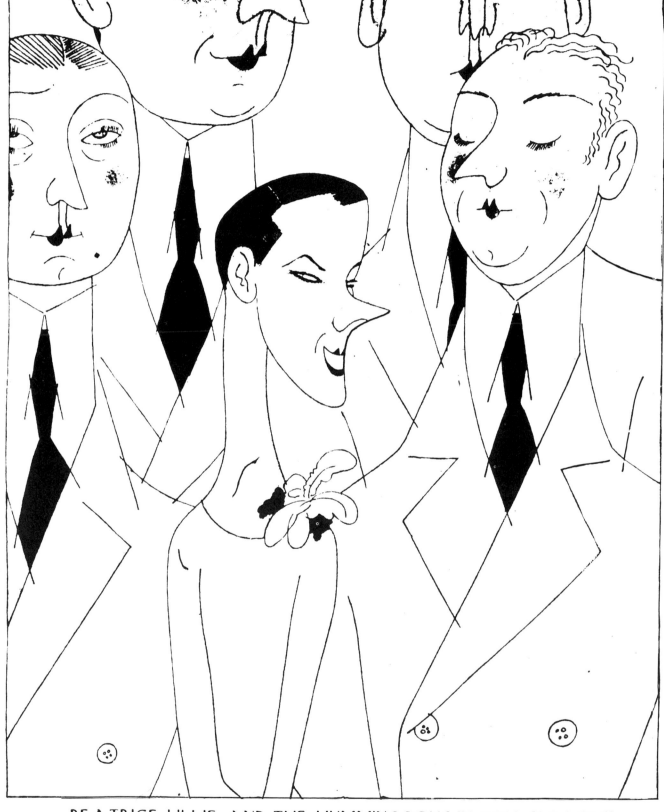

BEATRICE LILLIE AND THE HUMMING BOYS IN "OH, PLEASE!"

Ralph Barton
1891–1932

Barton's fortunes as an artist rose and fell with the 1920s. The son of a Kansas city preacher and an artist mother, Barton married young and moved east to New York city at the age of nineteen. He had spent only a brief time in art school, and somewhat longer in his mother's studio; but he was successful in getting a number of his drawings published in *Life*, *Puck*, *The Judge* and *Liberty*.

Barton soon attracted the attention of the editor of the more élite *Harper's Bazaar*, and graduated to drawing for the magazine and its cosmopolitan competitor, *Vanity Fair*. He was a founding contributor of *The New Yorker* in 1925, acting as both illustrator and theatre critic. His mature style was a distinctive mixture of Beerbohm and Oliver Herford. Like many of his contemporaries, Barton adopted some formal aspects of Cubism; unlike his fellow-artists on *The New Yorker*, he also had a penchant for the grotesque.

Barton took to the *bon vivant* life of New York and Paris in the Twenties, and moved easily among theatre people of the time. In 1932, however, after four marriages and persistent bouts of depression, Barton took his own life.

Edmund Dulac
1882–1953

Dulac's wide range of talents encompassed theatre décor, musical composition, richly exotic illustrations of fantasy and supremely elegant caricatures. After completing law studies, he attended the École des Beaux-Arts in his native town of Toulouse, where his flair for ornamental design soon brought him commissions. He arrived in London with his portfolio in 1906, and remained in England until his death. The blend of mystery and oriental detail in his illustrations for *The Arabian Nights*, *The Rubaiyat of Omar Khayyam* and various fairy tales led publishers to regard him as a successor to Arthur Rackham.

His caricatures, first exhibited in 1914, were remarkable stylized portraits of friends and celebrities. During the First World War Dulac designed charity stamps which clearly showed his mastery of typography and graphic design. He later designed the Jubilee and Coronation stamps, and was commissioned by de Gaulle to create posters, bank notes and stamps for the Free French. He made notable contributions to French and English journals, and designed covers for *American Weekly* from 1924 to 1951.

Throughout his career, his work in all spheres was distinguished by a miniaturist's attention to detail. On his death, his friend, the art historian Wilenski, paid tribute to him as 'a man in love with Craftsmanship'.

Self-portrait.

'*The Prime Minister*', *David Lloyd George, at the time of the 1919 Peace Conference, from* The Outlook. ▶

OPPOSITE *Two watercolours by Edmund Dulac:* TOP '*Grey Phantasms of Early Morn*': *Sir Thomas Beecham, Charles Shannon and Lady Emerald Cunard visit the painter and illustrator Charles Ricketts;* BOTTOM '*Ri-Ke-Tsan-Dcha-Nho-N', Charles Ricketts and Charles Shannon as Hindu gods, 1914.*

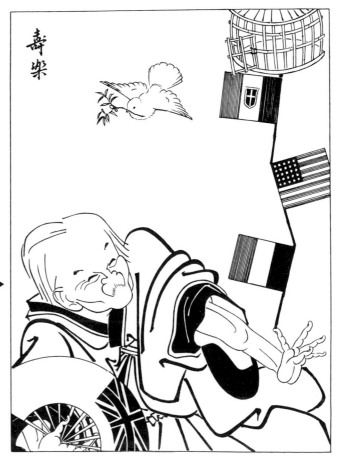

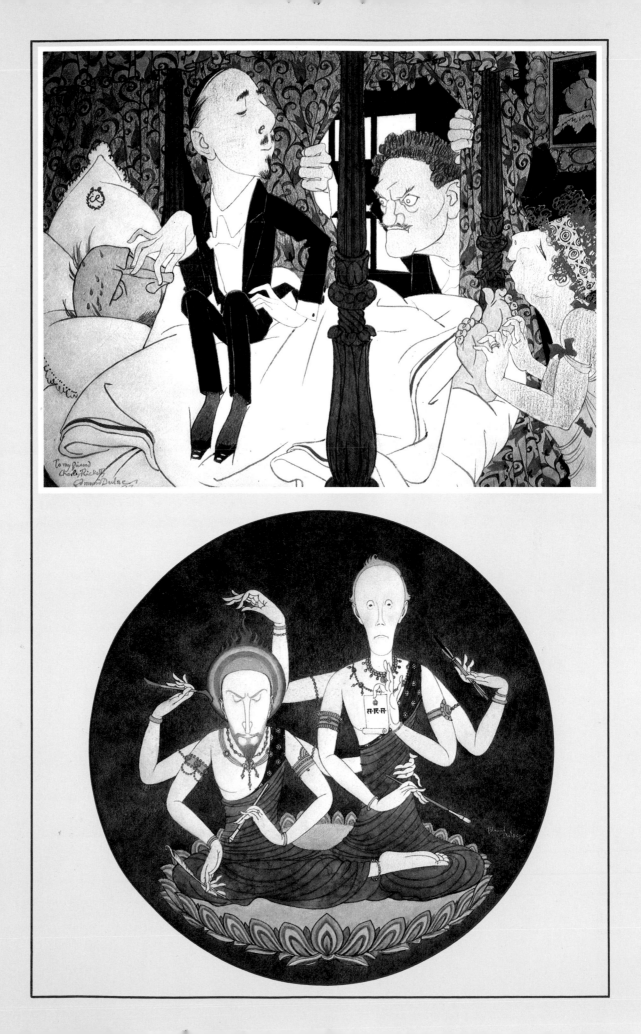

Miguel Covarrubias
1904–57

Miguel Covarrubias passed only briefly through the colourful world of American magazine and newspaper illustration. A scholarship brought him to New York in 1923 from Mexico, where he had taught drawing and crafts in outdoor schools set up by the Mexican government. His talents were quickly discovered by Frank Crowninshield, the editor of *Vanity Fair*, at that time the most elegant magazine of the Jazz age, rivalled only by the cosmopolitan *The New Yorker*. Covarrubias drew for both these and a number of other magazines, including *Life*, *Time* and *Fortune*. His caricatures of performers, artists and public figures made him the most sought-after illustrator of the time. His drawings are as graceful and stylized as the magazines in which they appeared; reflecting the artist's innate stylistic versatility, they incorporate the shifting, tinted planes of Cubism as often as the primitive forms and rigid system of hatching characteristic of Rockwell Kent.

In 1930, a fascination with the exotic Pacific Island cultures, which assumed the proportions of a cult among his society contemporaries, took him to the island of Bali; in 1937 he published a book based on his study of its native customs. Covarrubias's involvement with anthropology and archeology deepened as he immersed himself in the study of the Olmec culture of Mexico. He became an expert on the ancient peoples of that country, devoting the rest of his life to directing archeological explorations and teaching anthropology at the University of Mexico. He became such a major authority in these fields that a wing of the Archeological Museum in Mexico bears his name. His caricatures, on the other hand, have influenced the style of a number of American artists, the most prominent being Albert Hirschfeld.

OPPOSITE *Clark Gable and the Prince of Wales, later Edward VIII, 1924.*

TOP *Franklin Delano Roosevelt, elected Governor of New York in 1928, and US President 1933–45.*

RIGHT *Fellow-caricaturist Ralph Barton, who had a reputation as a wit and dandy. An acquaintance described him as 'a slight, dapper chap with patent-leather hair, blue eyes, boyish good looks and a zest for pleasure'.*

Rudolf Grossmann
1882–1941

An illustrator who spent five years of his youth in Paris amongst Matisse's circle, Grossmann became one of the most admired portraitists in the Berlin of the Weimar Republic, publishing drawings of his great contemporaries – industrialists, artists, intellectuals, politicians – in many of the city's newspapers and magazines. His work drew on the techniques of caricature, but he was never a cartoonist, always an illustrator and portraitist.

Dr Hjalmar Schacht, President of the Reichsbank, 1927.

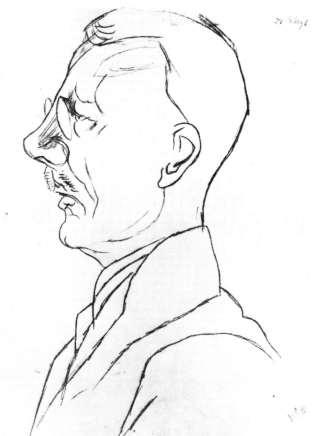

Otto Dix
1891–1969

The son of a railway worker, Dix trained as a decorative artist in Dresden. He taught in Düsseldorf from 1922 to 1925 and became a professor at the Academy in Dresden in 1927. One of the most obvious facets of the Realism then emerging in German painting was its reliance on caricature, often of an extreme and unsettling kind. Otto Dix became one of the best and most representative of these Realists. His drawings and paintings give a horrifying view of the types he saw as representative of society during the Weimar Republic; pimps and whores, cripples and beggars, lascivious businessmen and their lame-brained wives. Even the more restrained portraits of his friends have something desperate and demonic about them.

Elected to the Prussian Academy in 1931, he had all his professional appointments cancelled by the Nazis, and he was barred from exhibiting. He was jailed in 1939 for complicity in a plot to kill Hitler, then put in the Home Guard. After the war, his social realism had lost its appeal for West Germans, although his work was widely appreciated in East Germany and exhibitions were held in Dresden and elsewhere.

Art historian Paul Ferdinand Schmidt.

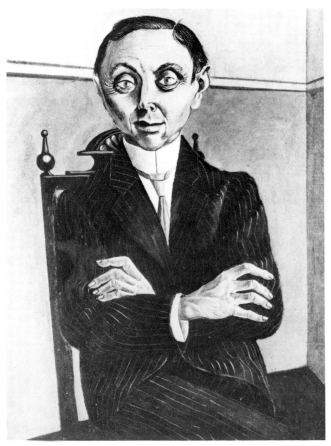

Boardman Robinson
1876–1952

At a time when caricature and newspaper cartoons were rendered mostly in line and their forms conventionalized (often to a fault), Boardman Robinson developed a distinctive tonal style. He drew for the *New York Tribune*, and later for *The Masses* and *The Liberator*, in black crayon with washes of India ink and white. After 1914, when he left the comfortable, conservative *Tribune* to accompany the American Marxist John Reid on a visit to Russia, he haunted the circle of New York socialist artists and writers focused for many years on *The Masses*, whose spirited staff he joined in 1916. Robinson's caricatures, which are strongly reminiscent of Daumier's work and reveal his awareness of the French school of *L'Assiette au Beurre* artists, are powerful indictments of the unsettlingly familiar relations between capitalism and the government of his day.

Sinclair Lewis, 1923, whose novels of American life made him the first American to win the Nobel Prize for Literature, in 1930.

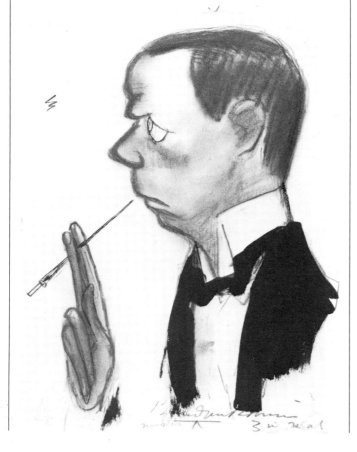

Edmond Xavier Kapp
1890–1978

Kapp's first exhibition of caricatures was mounted while he was still an undergraduate at Cambridge. After serving with the Royal Sussex Regiment throughout the First World War, he held a London show in 1919 at the Little Art Rooms, the Adelphi, which was introduced by Beerbohm. Praise from critics and fellow-artists brought success and commissions from *The Tatler* and other magazines, which he later abandoned to continue his studies in Vienna and at the British Academy in Rome. The publication of his *Personalities*, who included Shaw, Elgar, Einstein and Chesterton, was followed by a notable series of legal portraits. In the Thirties, Matisse and Picasso both sat for him. An official war artist in the Second World War, he drew *Life under London* and a series on the London Philharmonic Orchestra. A major retrospective exhibition was held at the Whitechapel Art Gallery in 1961. Despite his own reserve about caricature – he disliked the term, and maintained that he had drawn only three – he was undoubtedly a major figure in this field.

'The Preacher', Baptist minister John Clifford (1836–1923), one of the first Companions of Honour created by George V, from Reflections, *1922.*

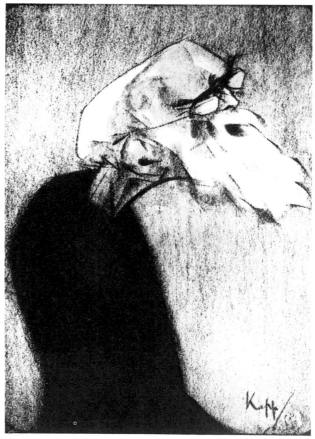

Albert Hirschfeld

1903–

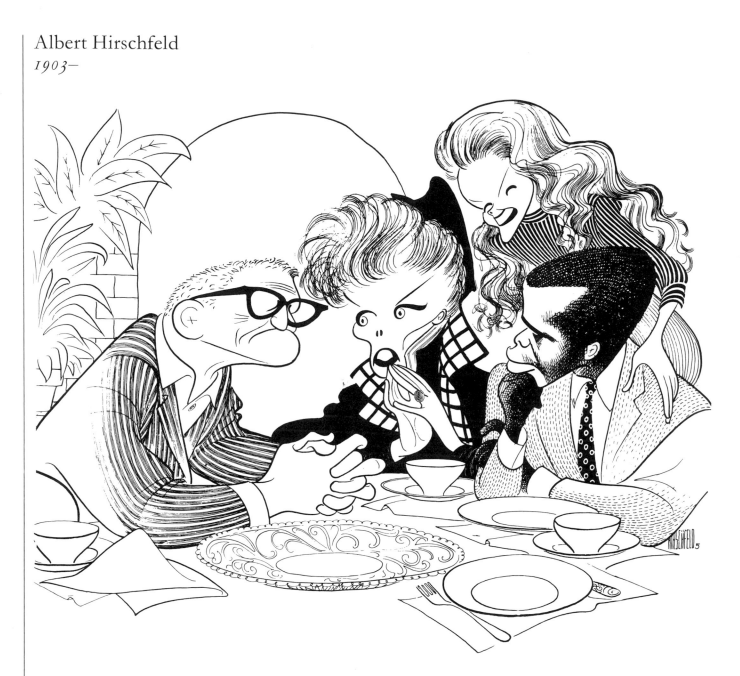

Hirschfeld's career as an artist spans almost six decades. He began it on the staff of *The New Masses*, a socialist magazine illustrated by several artists of the American social realist or 'ash can' school. Most of the 1920s he spent in Paris, however, painting, sculpting and print-making on the Left Bank. The early years were formative ones, providing him with a strong foundation in drawing and a deep understanding of French art of the early twentieth century.

According to Hirschfeld, a trip to the island of Bali in 1931 marked the beginning of his 'enduring love-affair with line', although he had been drawing for some New York newspapers since the mid-1920s. The drawings he did throughout the 1930s and 1940s for *The New York Times* established him as a fixture in American caricature. His portraits of performers, actors and playwrights, a regular feature in the newspaper's Sunday issue, provide an animated visual history of American theatre, especially Broadway, since the 1930s. His work displays an uncanny talent for capturing, in a few deft lines, the essential stage presence of his subject and the dramatic qualities of a production. His characterizations avoid satire in favour of humour and parody, isolating the typical mannerisms and expressions of the performer. Over the years Hirschfeld's technique has developed from the geometrical grace of his early drawings, reminiscent of Cubism and Aubrey Beardsley, to a graceful but comical array of sinuous lines, stars, checks, and spirals. Like Ralph Barton and Miguel Covarrubias, Hirschfeld has done a great deal through his drawings to reinstate caricature as an art form, as opposed to an aspect of political cartoons and satire.

'SAVA' Sava Botzaritch
1894–

OPPOSITE *Spencer Tracy, Katherine Hepburn, Katherine Houghton and Sidney Poitier in the film* Guess Who's Coming to Dinner?, *1968.*

RIGHT *Eamon De Valera, President of the Irish Republic, 1945.*

BELOW *The actor Basil Rathbone.*

Born in Belgrade, Sava received his early training from his father, who was a historical painter and professor at the National Serbian School of High Art, and with whom he travelled extensively. Intended for the diplomatic service, Sava took a post in the Serbian Embassy in Rome; but on moving to Athens he met the sculptor Ivan Meštrovič (1883–1962), under whose influence he abandoned diplomacy for art. He studied in Naples, under the sculptor Pellegrini, and in Paris, and won an Italian award for portraiture. After the First World War, in which he served as an interpreter for the Allies, he went to Belgrade to work with Meštrovič. In 1922, he settled in England, and achieved success with both his caricatures, notably of literary figures, and his portraits and busts.

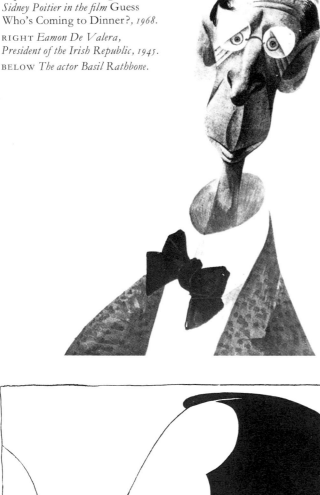

Novelist and playwright Sinclair Lewis.

George Finey
1895–

Born in Auckland, New Zealand, at the age of fourteen Finey was selling drawings to local newspapers. At the outbreak of the First World War he joined up as an under-age private with the New Zealand Expeditionary Force, and after three-and-a-half years' active service was appointed an official war artist. On demobilization he took a course at the Regent Street Polytechnic Art School, London, before settling in Sydney, Australia, where in 1921 he joined the staff of the recently established newspaper, *Smith's Weekly*.

Finey executed his large caricatures – many are nearly twice life-size – in several media, including pen and ink, oil paint and crayon; he also produced thoughtfully distorted portraits in collage. A collection of his work first published in 1931 is today a collector's item. A wartime editorial cartoonist with the *Sydney Daily Telegraph*, he spent his last years in journalism as a political cartoonist for the radical

press. Now in his eighties, and creating ceramics and paintings, Finey is still a genuine bohemian, with the same zestful eccentricity, tremendous generosity, perversity and anti-*status quo* attitudes that made him one of the most powerful and popular caricaturists of the inter-war years.

M. J. McMahon, a prominent Sydney magistrate, from Smith's Weekly, *c. 1930.*

William Gropper
1897–1977

A child of a poor New York city family, William Gropper served his apprenticeship as a cartoonist with various newspapers, most notably the *New York Tribune*. He was trained as an artist at the National Academy of Design and at the New York School of Fine and Applied Arts, where he studied with Robert Henri and George Bellows. Aside from his work in political satire in such widely diverse publications as the socialist *The New Masses* and the chic, cosmopolitan *Vanity Fair*, Gropper also established himself as an important American lithographer, painter and muralist. His caricatures and paintings show the influence of European expressionism, synthesized in the cartoons in a graphically concise and severe statement. Often employing broad colouristic effects and brushwork, his work is pervaded by a keen sense of social injustice – a biting comment usually underlies the surface humour. Gropper has been called the 'expressionistic Daumier'.

Lute Pease
1869–1963

One of his many caricatures of the American miners' leader, John L. Lewis, won Pease the annual national newspaper award, the Pulitzer Prize, in 1945. Then aged nearly eighty, he was still working regularly as the editorial cartoonist on the *Newark Evening News*, which he had joined in 1914. The strong and forceful flow of his line and the clear delineation of his portraits were an object lesson and an inspiration to cartoonists for over three decades, an example of the outstanding effects and basic strength of fine draughtsmanship and observation.

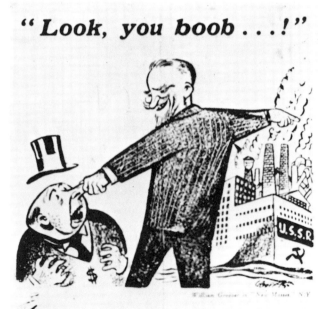

A leading member of the Fabian Society, Shaw, like many intellectuals in the Thirties, extolled the ideals of communism and took a great interest in Soviet Russia's achievements.

John L. Lewis, the miners' leader, facing up to a possible battle with Congress over the wartime no-strike pledge.

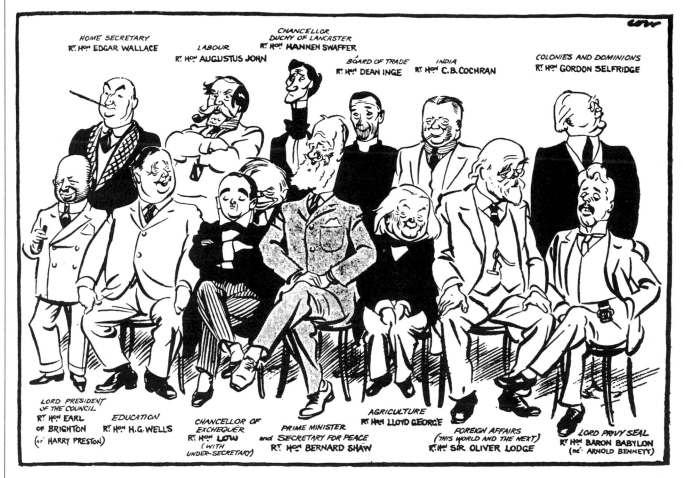

THE IDEAL CABINET (1928)

The most acclaimed political cartoonist of his generation, New Zealand-born Low made his début as a political commentator at the age of eleven in the *Christchurch Spectator*. Determined to succeed, in 1911 he travelled to Australia where he contributed to the influential *Sydney Bulletin*, and then, in 1919, was invited to England, to join the London *Star*. In 1927, he joined Lord Beaverbrook's Conservative *Evening Standard* where for twenty-three years Low, though a Socialist, was given full independence of thought and expression. During this period he produced his most impressive cartoons and created his famous character, Colonel Blimp, the epitome of British conservatism. Another controversial creation, the TUC cart-horse (the epitome of Socialist conservatism), appeared in the *Daily Herald*, which Low joined in 1950. Unhappy there, he moved to the *Guardian* in 1953 where he remained until his death. He was knighted in 1962.

Low's broad brush technique, painstakingly worked to survive and surmount the crudities of newspaper reproduction, spawned many imitators throughout the world, but his total command of the medium, both artistic and intellectual,

proved inimitable. In the Twenties he drew a series of full-page charcoal portrait caricatures of politicians and literary lions for the *New Statesman*. A rare labour of love, the series is a *tour de force* of the caricaturist's art.

OPPOSITE, TOP *Labour politician Aneurin Bevan, 1946.*

OPPOSITE, BOTTOM LEFT *Winston Churchill, 'in training for the budget', from the* Evening Standard, *1929 (detail).*

John Heartfield
1891–1968

Although Heartfield was not a caricaturist in any conventional sense, he belongs firmly within the tradition of caricature. He abandoned drawing during the First World War, depressed by the knowledge that he was so much less talented than his friend George Grosz. Instead, he developed the technique which he and Grosz had invented: photomontage, or the production of pictures by rearranging selected details of photographs to form a new and convincing unity.

Born Helmut Herzfeld, Heartfield anglicized his name during the war in protest at the Kaiser's prayer, 'May God punish England!'. A revolutionary, he worked for the Communist publishers Malik-Verlag, and later for the workers' illustrated magazine *A.I.Z.*. Forced into exile, first to Prague and then to London, he repeated some of his most effective photomontages for *Picture Post*. He returned to East Germany in 1955, but, condemned as a 'formalist', he was discouraged from further work in the medium he had once used so effectively.

Goebbels (with cloven hoof) leads the competing nations' athletes by the nose at the 1936 Berlin Olympics.

Antony Wysard
1907–

Born in Pangbourne-on-Thames, Wysard was educated at
Harrow, and from there was plunged into the City to learn
accounting. He soon realized that he would rather draw
figures than add them, and turned eye and pen towards
London's society scene of balls, picnics and parties. From
1928, his highly individual caricatures in line and wash
appeared in *The Sphere*, *The Tatler*, *The Bystander* and
Harper's Bazaar, and a series of line drawings were publish-
ed in the *Daily* and *Sunday Express* and various other
publications. His 1936 one-man show at Walker's Galleries,
Bond Street, had over a hundred exhibits, including group
studies of as many as ninety personalities.

While continuing to work in Fleet Street, he joined
Alexander Korda as Advertising Manager at the new film
studios at Denham. Commissioned in the Queen's
Westminsters, Territorial Army in 1938, he served with the
Greenjackets throughout the war, rejoining Korda after
demobilization. Three years later he joined *Harper's Bazaar*
as an associate editor before setting up his own advertising
consultancy, specializing in design and print production for
a diverse clientele; its most lasting concept, which Wysard
has edited and produced for over twenty-five years, is
Wheeler's Review, which has a readership of over 350,000 in
114 countries.

Robert Stewart Sherriffs
1908–61

Sherriffs' caricatures of stage and film subjects, stylish
brush-drawings of distinctive likeness using Chinese inks
for subtle colour work, carry traces of the linear quality of
Dulac and Beardsley.

Born in Edinburgh, he attended its College of Art where
he was attracted by heraldic design, which became a lifelong
hobby. Soon after his caricature of John Barrymore
appeared in *The Bystander*, a meeting with Beverley Nichols
led to a series of illustrations of celebrities for *The Sketch*.
His work for the magazine continued from 1934 to the out-
break of war with full-page drawings on theatre, and he also
drew weekly for the *Radio Times*. During the war, in which
he served with the Tank Regiment, he sent back work to
both magazines and produced illustrations for *The Rubaiyat
of Omar Khayyam* and his own book, *Salute If You Must*.

Though he had been considered the natural successor to
Dyson, the editorial cartoonist on the *Daily Herald*, the job
went to his friend George Whitelaw. Instead, in 1948 he
succeeded James Dowd on *Punch*, drawing the film carica-
tures until his death in 1961. Posthumous exhibitions were
held at the Times Bookshop in 1962 and at the National
Film Theatre in 1975.

'A Lido Reflection', from The
Tatler, *1 October 1930: (left to
right) ballet dancer Serge Lifar,
society columnist and party-organizer
Elsa Maxwell, famous beauty Lady
Abdy, banker's wife Baroness
d'Erlanger and her daughter, Princess
Jean ('Baba') de Faucigny Lucinge.*

Actor Ralph Lynn, 1938.

James H. Dowd
1884–1956

From 1906 to 1948 Dowd was a regular contributor to *Punch.* The liveliness and spontaneity of his theatre and film portraits were a constant delight for twenty years, his sensitive, free-flowing line expressing his keen observation and sympathy. He developed a special genre of drawings of children, catching in line and caption the pathos and humour of the situation.

Nigel Bruce and Basil Rathbone in The Adventures of Sherlock Holmes, *from* Punch, *1940.*

Tom Webster
1890–1962

Webster started work at fourteen as a booking clerk on the Great Western Railway. Between selling tickets, he studied the *Athletic News* and drew the sporting stars of his day. A prize drawing led to a job on the *Birmingham Sports Argus.* After four years, he became political cartoonist on the *Daily Citizen* in London. In 1919, after serving in the First World War with the Royal Fusiliers, he sold the *Evening News* a new style of sporting cartoon, with a witty running commentary; Lord Northcliffe saw it, gave him a job on the *Daily Mail,* and within the year he was the most popular sporting cartoonist in Britain.

Webster's favourite stock character was a racehorse called Tishy. His cartoons were projected on a vast screen in Trafalgar Square during the announcements of the General Election results in 1929; and in 1936 he designed murals for the liner *Queen Mary,* decorating the gymnasium with a panorama of leading sports personalities – his first venture in colour. He retired from the *Daily Mail* in 1940, later returning to Fleet Street with Kemsley Newspapers and the *News Chronicle* before his final retirement in 1956. Throughout his career, his *Tom Webster's Annual* had an enormous following.

Tom Inman and Melbourne Newman, 1936.

Raoul Cabrol
1895–1956

Though surprisingly little documentation of Cabrol's career exists, his name is prominent in the story of French twentieth-century caricature. His work appeared in a wide range of newspapers and magazines; first published in *Le Rire* in 1915, he contributed regularly to *L'Humanité*, also drawing for *Le Journal Amusant* and *Aux Écoutes* in the Twenties, and *D'Artagnan* in 1935. After the war he worked for *Le Canard Enchaîné* from 1945, and *La Vie Parisienne* from 1949 to 1951. A collection of later portraits, published as *En Quatrième*, covered leading politicians of the Fourth Republic Government. In the form of *portraits-charges*, the detailed penwork and tonal quality were in marked contrast to the sparse linear style of contemporaries like Gassier and Sennep. Leading cartoonist Tim expressed his admiration for Cabrol in an article for *L'Express*, when he quoted his name alongside those of Jerome Bosch, Daumier and Gill.

Parliamentarian Joseph Caillaux.

Ralph Sallon
1899–

Fleeing with his family from Poland in 1903 to settle in the East End of London, Sallon grew up amongst the poverty-stricken refugees of the pogroms. A scholarship to learn wallpaper design took him to Hornsey School of Art, but, disillusioned, he left after only a term and took a succession of clerical jobs. At eighteen he joined the Pioneer Corps; after the war, unable to find work in Britain, he spent two years in South Africa where he worked on the *Natal Mercury*. On his return, he attended St Martin's School of Art and had a series of caricature portraits published by *Everybody's*; another commission from newspaper magnate Guy Bartholomew led to regular work on the *Daily Mirror*. Never a political cartoonist – Sallon's interest lies in personalities, not policies – he is still to be found at gatherings and conferences, sketching away and as eager as ever to add new public faces to a repertoire that spans over sixty years.

Hugh Cecil Lowther, 5th Earl of Lonsdale (1857–1944), a keen sportsman whose interests included boxing and horse-racing.

Ben Shahn
1898–1969

Shahn's family emigrated to New York in 1906 from his birthplace in Kovno, Lithuania. At fifteen he was apprenticed to a lithographer, and continued studies at night school. He worked intermittently at commercial lithography until 1930, while attending City College and New York University and travelling to Europe. His famous Sacco and Vanzetti drawings of 1931 followed his first exhibition. Protest at social injustice, often inspired by news reports and press photographs, was a recurrent theme in his work; and text and lettering formed an integral part of his designs, executed with a controlled simplicity of line. During the Thirties he participated in many community projects for murals, collaborating with Diego Rivera on a fresco for the Rockefeller Center. Among many shows of his work over three decades, the major retrospective in 1960 at the Museum of Modern Art, New York, went on a world tour. In the post-war years, he taught and lectured, his work was featured in leading magazines and distinctive commercials, and he designed ballets for Jerome Robbins. With de Kooning, he represented the USA at the 1954 Venice Biennale. His 1956 lectures as Norton Professor at Harvard were published as *Shape and Content*, and he was elected Member of US Arts and Sciences in 1959.

A reproduction published in 1958 of Shahn's commemoration in 1931 of Sacco and Vanzetti, the Italian emigrant workers wrongly sentenced to death in 1929. In the McCarthy era of the 1950s, there was revived interest in historic cases of persecution and miscarriage of justice as a means of attacking the current witch-hunt.

IF IT HAD NOT BEEN FOR THESE THING, I MIGHT HAVE LIVE OUT MY LIFE TALKING AT STREET CORNERS TO SCORNING MEN. I MIGHT HAVE DIE, UNMARKED, UNKNOWN A FAILURE. NOW WE ARE NOT A FAILURE. THIS IS OUR CAREER AND OUR TRIUMPH. NEVER IN OUR FULL LIFE COULD WE HOPE TO DO SUCH WORK FOR TOLERANCE, FOR JOOSTICE, FOR MAN'S ONDERSTANDING OF MAN AS NOW WE DO BY ACCIDENT. OUR WORDS-OUR LIVES-OUR PAINS NOTHING! THE TAKING OF OUR LIVES-LIVES OF A GOOD SHOEMAKER AND A POOR FISH PEDDLER-ALL! THAT LAST MOMENT BELONGS TO US-THAT AGONY IS OUR TRIUMPH.

Einar Nerman
1888–1980

From his boyhood in Norrköping, Sweden, Nerman
sketched in the theatre and dreamed of acting. He studied
art in Stockholm, and in Paris with Matisse, but pays tribute
to Beardsley as the main inspiration of his fluent and
emphatic line.

When Ivor Novello saw Nerman's décor for a Stockholm
cabaret in 1918, he urged him to go to London to draw the
West End stars. Nerman followed this advice five years
later, and stayed in London for ten years, drawing the
weekly theatre cartoons for *The Tatler*, and contributing to
other magazines. He caricatured actors, comics and
musicians – Jessie Matthews, Clara Butt, Cicely Courtneidge,
George Robey, Sybil Thorndike – in a crisply witty style.
After some years back in Sweden in the 1930s, he moved to
America where he spend a decade on Broadway and in
Hollywood. His panorama of star-turns included fellow-
Swede Garbo and Mae West and he also drew visiting
celebrities such as the Windsors.

After returning to Sweden in 1950, Nerman settled to
portrait painting, illustration and theatre design. A retro-
spective exhibition of his caricatures was held at the Theatre
Museum of the Victoria and Albert Museum in 1976, to
coincide with the British publication of his book of draw-
ings, *Caught in the Act*.

The actor Cedric Hardwicke,
Hollywood, 1940.

Tryggvi Magnússon
1900–60

Tryggvi Magnússon may be said to have introduced
caricature to Iceland. His art studies took him to Denmark
and the United States and to Germany, where he was
exposed to satirical drawing at a time when German
caricature had international renown. Returning to Iceland,
he worked for various publications including the humorous
magazine *Spegillinn*. Taciturn and reserved, Magnússon had
an outsider's keen eye for the ridiculous. Most of his
drawings are sparse and catch likenesses in a few strokes. In
addition to drawing caricatures, he produced oil paintings
of nationalistic subjects and folklore; designed postage
stamps and playing cards; and redesigned the coat of arms
for the Icelandic republic.

Prime Minister of Iceland Jón
Thorláksson was rumoured to have
read a thriller during a parliamentary
session. From Spegillinn,
1 November 1930.

Karl Arnold
1883–1953

Trained in Fine Art, Arnold worked as both a painter and cartoonist, publishing his first humorous drawing in 1907 in *Simplicissimus*. He quickly became one of the journal's most popular contributors and although he occasionally appeared elsewhere (in *Die Jugend* and the *Münchener Illustrierte Presse*, for example) it was for *Simplicissimus* that he chiefly worked. He soon became a staff artist and shareholder of this most successful magazine.

Arnold was one of the wittiest commentators on German society during the Weimar Republic, satirizing its political absurdities, its sexual mores and its cultural pretensions. His style and outlook can be compared with those of George Grosz, although his line was never as hard and his attacks on the bourgeois philistines were never as bitter or angry. Like Grosz, he produced more caricatures of anonymous,

representative types than of specific people, although he occasionally drew famous literary figures as well as politicians. His caricatures of Hitler were famous, angering the Nazis because Arnold made him look silly rather than dangerous. Often asked, 'Do we really look the way you draw us?', Arnold would as often reply, 'Yes, and if some knew how they look, they wouldn't dare show themselves in the street.'

RIGHT *'Heil Prussia!', 1932. Hitler, unworthy successor to Frederick the Great, a champion of religious tolerance, distorts one of his predecessor's statements to fit his fascist philosophy: 'In my country everyone can get to heaven – in my way!'*

OPPOSITE *A 1924 cartoon by Karl Arnold, in which French President Raymond Poincaré is bullied by Uncle Sam, symbol of American power. France was under pressure from the USA to repay debts for American wartime supplies, and Poincaré's efforts to do so by increasing taxation led to his election defeat.*

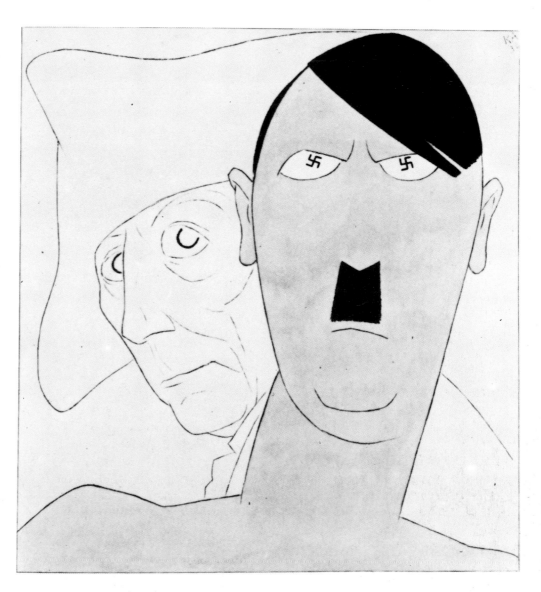

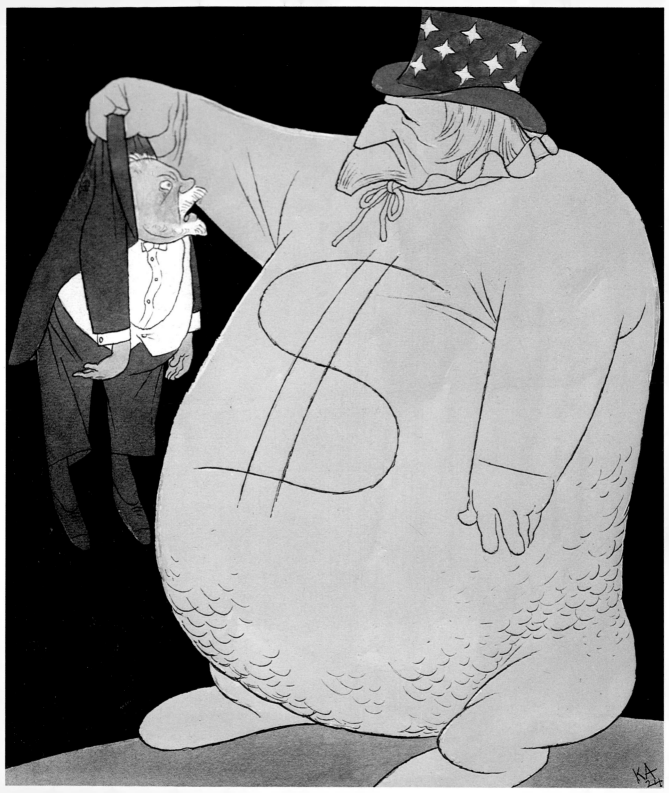

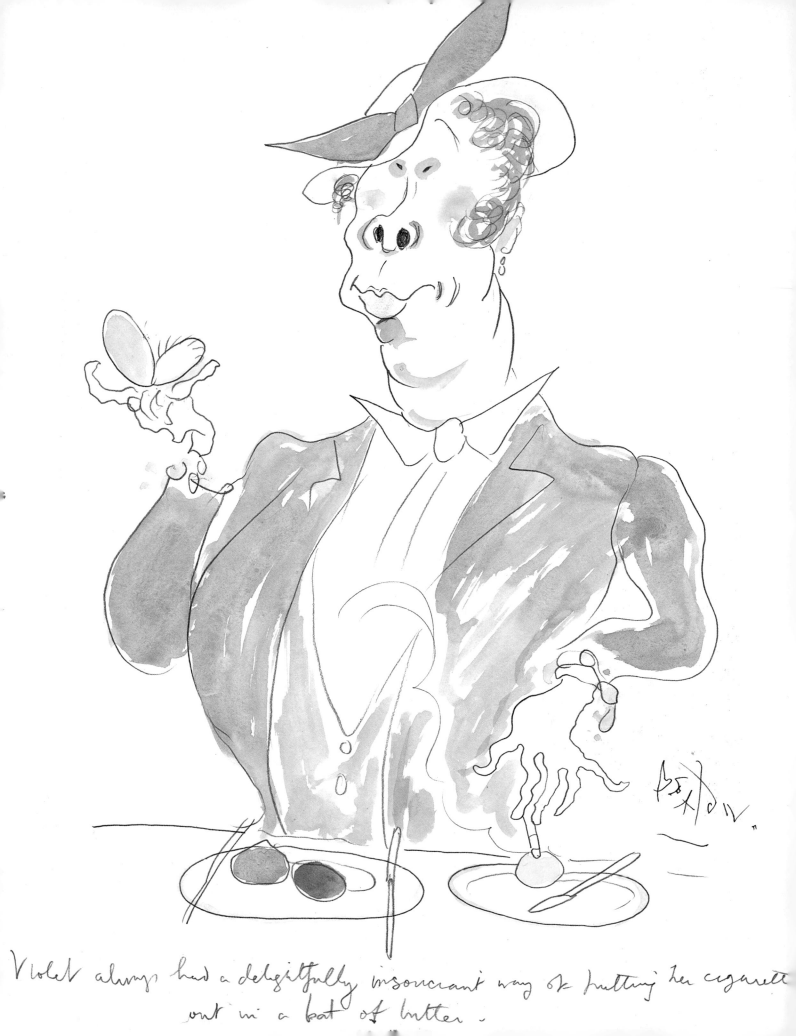

Violet always had a delightfully insouciant way of putting her cigarette out in a pat of butter.

Edward S. Hynes
w. 1930s–40s

The son of a surgeon from County Clare, Ireland, Hynes served as naval cadet and navigation officer for ten years before embarking on medical studies at Sheffield. He returned to sea, but later abandoned it once again to become cartoonist for the *Daily Sketch*, *Evening News*, *Sunday Express* and *The Bystander*. His black-and-white drawings in the Thirties were lively and inventive in style. His colour cartoons of celebrities of the day featured on the covers of *Men Only* in the early 1940s, in a series which included striking portraits of Noël Coward, Professor Joad and Bernard Shaw.

Oscar Berger
1901–

Born in Prešov, Czechoslovakia, Berger relates that he sketched throughout his childhood. He left home in 1919 for Prague, where his portraits of Masaryk and Karel Capek got him the post of staff artist on a Berlin newspaper. Expert in catching likenesses in a quick sketch, he covered international conferences, from the Munich trial of 1923, following Hitler's putsch, to business conventions in the USA, where he captured Henry Ford and a bevy of industrialists. The cartoons of Hitler he drew in Berlin in 1932 forced him to flee the country. He reached London in 1935, via Budapest, Vienna and Paris, in time for a Naval conference of the Big Five, and stayed in London throughout the war; his on-the-spot portraits in the House of Commons included Churchill. By V J day he was off again, to the USA this time for the United Nations conference, President Truman and the White House. His work has appeared in *Life*, *The New York Times*, *New York Herald Tribune*, *Look*, *Saturday Review of Literature*, *Daily Telegraph* and *Le Figaro*, and his book, *Famous Faces*, shows 250 faces from politics and show-business.

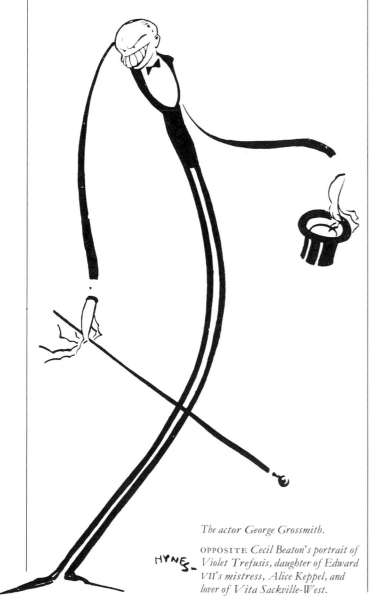

The actor George Grossmith.

OPPOSITE *Cecil Beaton's portrait of Violet Trefusis, daughter of Edward VII's mistress, Alice Keppel, and lover of Vita Sackville-West.*

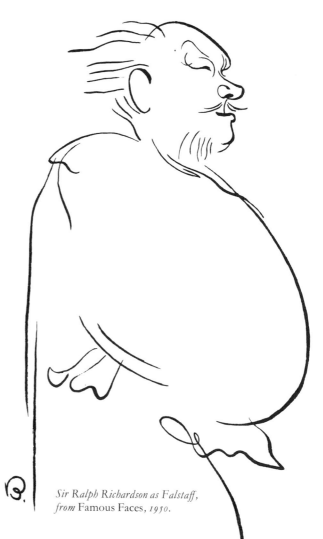

Sir Ralph Richardson as Falstaff, from Famous Faces, *1950.*

'RAKHA'
w. 1930s–40s

The dominant influence on Egyptian caricature in the 1930s–40s was Rakha, a prolific newspaper cartoonist on topical and international affairs.

Egyptian politician Ali Maher Pasha.

James Fitton
1899–

After an apprenticeship as a fabric designer, Fitton enrolled at Manchester School of Art, supporting himself by night-shift work in the docks. He moved to London in 1919, working as an illustrator and designer, and in 1933 became a founder member of the Artists' International Association. During the inter-war years, he worked closely with James Boswell, the New Zealand-born caricaturist and illustrator who later became art editor of *Lilliput* magazine, and James Holland. Known as the 'Three Jameses', a 'triple alliance against the absurdities and hypocrisies of the existing scheme of things', they were the leading left-wing carica-turists of the period. Fitton also contributed during the 1930s to *Lilliput* and *Time and Tide*, and was elected Royal Academician in 1954.

James Garvin, editor of the Observer for thirty-four years, and a supporter of Chamberlain's appeasement policy towards Hitler.

Henry Major
w. 1920s–40s

Brought up in a poor district of Budapest, Major studied art and moved to Paris at the age of nineteen. The caricatures he produced for *Paris-Match* won acclaim all over Europe. Drawing for *The Graphic* in the 1920s, he 'caught' all the Wimbledon tennis stars in swift pencil portraits. As he covered international conferences and trials, his work on the Democrats' 1932 convention appeared in the Hearst papers. Settling in New York, where his wife was a voice-coach to Hollywood and Broadway stars, he painted and caricatured the celebrities and worked on special assignments for King Features. During the Depression, he at one time drew portraits in nightclubs, and started a strip called 'The Genius'; but faces and heads were his only interest. He drew directly from his subjects, his eyes riveted on the face, scarcely looking at the drawing. He was commissioned to draw four celebrities a month for a new magazine, *Ken*, and his book of Hollywood caricatures, with captions by 'Bugs' Baer, was published in 1942. After his death, his paintings gained great popularity when published as prints.

'SENNEP' Jean Pennès
1894–

Though Sennep never had any formal art training, when he was sixteen his humorous sketches were already being published in *Le Sourire*. He freelanced for four years while continuing his education, but his studies were brought to a halt by the outbreak of the First World War. Called up in 1914, his brief service in the cavalry gave him a lifelong love of horses. After the war, married and with a family, he became a clerk in the Compagnie de Gaz de Paris, before moving to journalism and then back to caricature. In the Twenties he started drawing in the theatre. On the staff of *Candide* from 1932 to 1940, his cartoons also appeared in *L'Action Française* and *L'Echo de Paris*, and as cartoonist on *Le Figaro* for twenty-one years from 1946 he became a household name. Now retired from full-time work, he has continued to draw for *Point de Vue*, the weekly journal to which he has contributed since 1954.

Sennep's style owes much to that of Gassier, whom he admired. Despite their opposing political views, they were great friends and jointly illustrated a *History of France 1918–1938*. In time Sennep outgrew this early influence to develop his own distinctive line, particularly marked in his *Figaro* cartoons. His predilection for transforming people into inanimate objects and his ghoulish fascination with dismembered bodies evoke the magic powers of effigy and witchcraft. Concentrating on capturing the heads of his victims – bodies are usually reduced to outlines such as a child might draw – Sennep's caricatures of Hitler and the Vichy régime are as scathing and effective as the fuller portrayals by David Low.

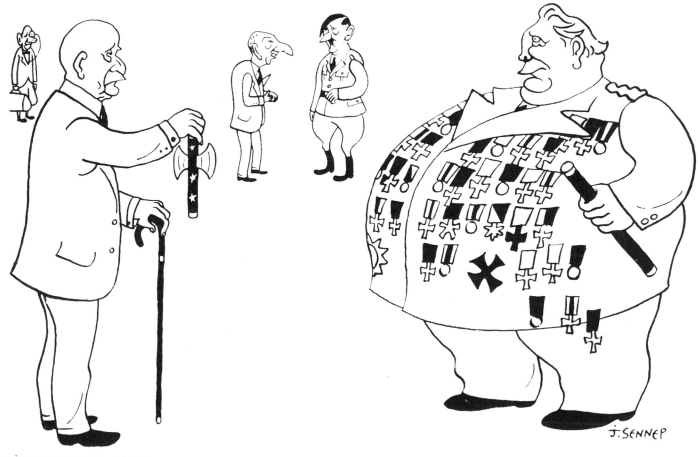

'*À Baden-Baden*': *Marshal Pétain, Chief of State of the Vichy régime, offers Field Marshal Goering yet another award (the double-headed axe was a fascist symbol):* '*What! You haven't got this one?*' *From* Souvenirs de Vichy, *1943.*

George Whitelaw
1887–1957

When Whitelaw succeeded Dyson as staff cartoonist on the
Daily Herald, he joined the Fleet Street band of artists –
Low, Strube, Illingworth and Vicky – whose art sustained
morale on the home front through the war years. His
reputation as caricaturist and illustrator had built up over
twenty years as a versatile and prolific black-and-white
artist. Since childhood in Dunbartonshire, Scotland, he had
been encouraged to draw. He studied at the Glasgow
School of Art under Grieffenhagen, and joined the Glasgow
Evening News at the age of seventeen. A first-class draughts-
man, he was a keen admirer of Phil May and Tom Browne.
After the First World War, in which he served in the Tank
Corps, he returned to London to work for *Passing Show* and
The Bystander, and drew theatre cartoons and jokes for
Punch; one brilliant colour series in *The Bystander* called
Who's Zoo compared celebrities with animals. The dramatic
brush style of his political cartoons showed the influence of
Low, but his portrayals were strongly individual. He
proved himself a major cartoonist, and won great national
popularity.

Harry Lauder, the music-hall star.

Cecil Beaton
1904–1980

Internationally famous as a photographer, theatre designer
and diarist, Cecil Beaton also possessed a considerable but
lesser known talent as a caricaturist. He published few
caricatures during his lifetime, partly because of their
waspishness, but mainly because of his great success in
other, more remunerative fields. His first published works,
however, were theatrical caricatures which he drew as an
undergraduate for the Cambridge University magazine,
Granta, in the Twenties.

His graphic work covered a wide field, ranging from
slight social sketches for *Vogue* to full portraits in oils.
Thought to be a dilettante, Beaton in fact worked hard at all
his talents, even enrolling at the Slade School of Art in later
life to improve his figure drawing. His ability as a photo-
grapher to make his sitters look 'interesting' if they failed to
be beautiful had a counterpoint in his observant skill with
pen, pencil and particularly brush. His most telling carica-
tures, many of them of women – in particular dragons of the
beau-monde – were done privately in later life. He was
knighted in 1972.

Actress Binnie Hale in Puppets *at
the Vaudeville Theatre, London.*

Sam Berman

1906–

One of the most prolific caricaturists of the picture maga-
zine era in the United States from the 1930s to the 1960s,
Berman developed a highly individual style in a variety of
media – pen and ink, airbrush, acrylic, watercolour and
sculpture.

His career started on his local paper, the *Hartford Courant*,
while he was still at high school. After studying at art school
and the Pratt Institute, New York, he found employment on
the *Newark Star Eagle* as the staff cartoonist at $10 a week. A
widely-reproduced airbrush portrait of Rudy Vallee led to
commissions for theatre magazines, Broadway reviews and
film posters. His work appeared in *Today* (later *Newsweek*),
Red Book, *Liberty* and *Fortune*, and *Life* magazine featured
photographs of his clay sculpture caricature heads. He also
devised the little moustachioed dandy, 'Esky', which
appeared as *Esquire*'s cover logo for many years, and for five
years produced weekly caricatures for the King Features
Syndicate. His political watercolour cartoons for *Colliers*
culminated in a fifty-six-issue series of caricatures of Nazi
leaders, *The Guilty*, which was continued by his friend
Covarrubias when Berman left for three years' army service
as a propaganda artist in India and Burma.

After the war, Berman began a new caricature series for
Colliers of radio stars such as Jack Benny and Bob Hope,
and his sculpture and ceramics were exhibited in New York.
Now retired and living in southern Spain, he has continued
to work, freed from the pressure of the deadline.

'*Henry Morgenthau's Diary*', a
portrait of the US statesman and
Secretary of the Treasury 1934–45.

Adolf Hoffmeister
1902–1973

While a law student in Prague, Hoffmeister exhibited with the *avant-garde* group of painters, 'Devetsil'. He travelled widely in Europe, visiting England and the USSR, meeting and drawing many fellow-artists – Grosz, Le Corbusier, Picasso, Cocteau, Mayakovsky – and published a folio of portrait caricatures in 1934. An exhibition of political cartoons in 1937 was closed when the anti-Nazi themes brought protests from German officials in Prague. He describes how he left Czechoslovakia and made his way to the USA in his illustrated book, *The Animals are in Cages*, published in Britain as *The Unwilling Tourist*. During his years in America he produced anti-Nazi posters and cartoons, and made radio broadcasts home. His exhibitions at the Museum of Modern Art, New York, later toured America. After the war, he was in charge of Foreign Affairs at the Ministry of Culture in Prague and, from 1948 to 1951, was Czech Ambassador in Paris; on his return he was made Professor of Film Cartoon and permanent delegate to UNESCO. Author and illustrator of over fifty books, his work incorporates typographic collage and experimental surrealist techniques.

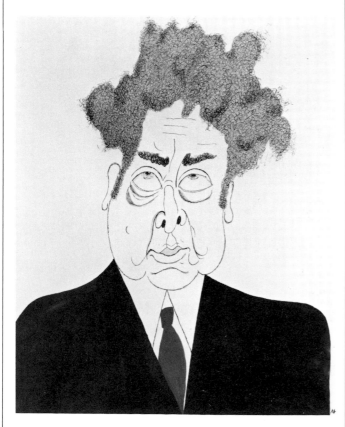

Self-portrait.

Nicolas Clerihew Bentley
1907–78

Bentley's father was E. C. Bentley, journalist, detective story writer (*Trent's Last Case*) and inventor of the four-line comic verse he named a 'clerihew', after their Scottish family name. As a child, Nicolas met such distinguished friends of his father as Beerbohm, Hilaire Belloc and G. K. Chesterton, who was his godfather. He studied art at Heatherley's, after showing his talent for writing and drawing at University College School. Having fulfilled his youthful ambition to be a clown by spending six weeks with a circus, he was employed in publicity work for Shell when Belloc asked him in 1931 to illustrate *New Cautionary Tales*. He later worked as a publisher, editor, author and thriller-writer, and illustrated books by Damon Runyon, T. S. Eliot, George Mikes and Kingsley Amis. His caricatures appeared in *Punch*, the *Daily Mail* and the *Sunday Telegraph* in the 1960s and in *Private Eye* through the 1970s. His autobiography, *A Version of the Truth*, was published in 1950.

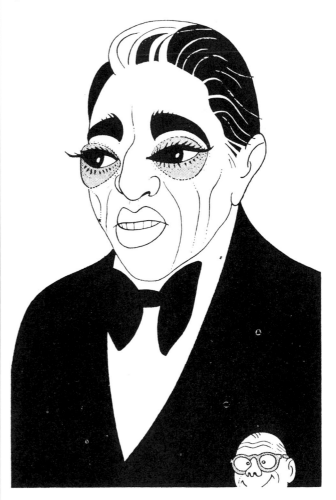

'You'd never think Onassis
Had such masses and masses.
If I had all that lolly,
I'd look ever so jolly!'

Boris Yefimov
1900—

Yefimov's first published caricature appeared in a Kiev newspaper in 1919, and in the four decades following 1922 he contributed regularly to *Pravda*, *Isvestia*, *Krokodil* and other leading Soviet publications. One of the USSR's most popular artists, he produced colourful posters and broadsheets, showing Hitler and Mussolini trapped in comic predicaments based on Russian folktales, which were forceful graphic propaganda during the Second World War. Post-war, his caricatures of Dulles and international politicians show that he was familiar with the trends among western political press cartoonists, and his work has often been reproduced outside Russia. Since 1966 he has been editor-in-chief of Agitplakat, an organization for creating propaganda posters, and he is a member of the USSR Academy of Arts. A book of his work, *Boris Yefimov in Isvestia*, was published in 1969.

Nazi leaders Hermann Goering (top) and Wilhelm Keitel, 1946.

Walter Trier
1890–1951

Trier studied art at the Academy in his native city of Prague, and left for Munich at the age of nineteen. His drawings appeared in *Simplicissimus* and *Kladderadatsch* and he also designed the décor for ballets and musicals and illustrated many children's stories, notably Erich Kaestner's *Emil and the Detectives*. Emigrating to Britain in 1936, he soon became popular as the cover-artist for *Lilliput*, with a series of over eighty covers that were as distinctive as those of *The New Yorker*. As well as his many contributions to British magazines, he was cartoonist for the London-based *Die Zeitung*, and during the war provided the Ministry of Information with anti-Nazi leaflets and political propaganda drawings. The deceptive naïvety of his line carried a barbed humour that delighted English readers. He died in Collingwood, Canada.

'Two weeds: the Creeping Quisling and the Common Heydrich.'

'KUKRYNIKSY'

Mikhail Vasilevich Kupriyanov
1903–

Porfiri Nikitich Krylov
1902–

Nikolai Aleksandrovich Sokolov
1903–

These three Soviet artists began working together in 1924, and work from their studio is signed with an anagram of parts of their names. Despite the collective approach, their political portraits have a rare sensitivity of line. During the Twenties, they concentrated on illustration and literary caricature, and attracted the interest of Maxim Gorki, who advised them to broaden their range and helped to organize an exhibition of their work in Moscow in 1932. In 1933 they began working for *Pravda*, contributing cartoons and caricatures relating to both Soviet life and international events, including the Spanish Civil War and the Nuremberg war trials; they have also contributed frequently to *Krokodil*. All three also work individually as landscape and portrait painters and are full members of the USSR Academy of Arts. Their work is on exhibition in the Tretyakov Gallery, Moscow, the Russian Museum, Leningrad, and other Soviet museums.

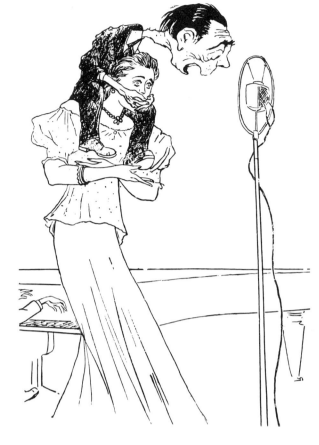

Dr Goebbels, Nazi chief of propaganda, 1942.

Leslie Gilbert Illingworth
1902–79

'Measles again', 30 December 1959, refers to an outbreak of anti-Semitism in Germany in which swastikas were daubed on synagogues. The leaders of state concerned for the health of the German nation are (left to right) Germany's Konrad Adenauer, France's de Gaulle, Israel's Ben-Gurion, Britain's Macmillan and America's Eisenhower.

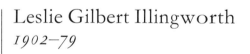

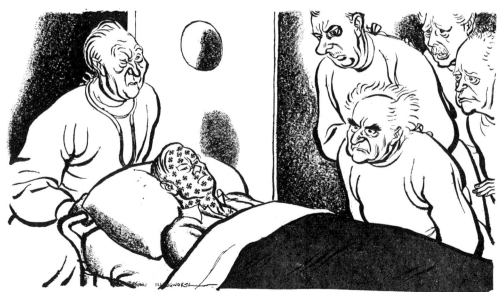

Journalist and broadcaster Malcolm Muggeridge and poet Sir John Betjeman, 1969.

Journalist and broadcaster Malcolm Muggeridge and poet Sir John Betjeman, 1969.

Inspired draughtsmanship and supreme mastery of his craft were the basis of Illingworth's work. Welsh-born of a Yorkshire father and Scots mother, he left the church school in Barry to go to Cardiff Art School, and while a student first drew for the *Western Mail*. He gained a scholarship to the Royal College of Art in London, where he was a contemporary of sculptors Barbara Hepworth and Henry Moore. At the age of twenty he returned to Cardiff and the *Mail* to become its cartoonist; but, spotted by an astute agent, he was soon back in London working for such leading magazines as *Nash's*, *The Strand*, *Passing Show* and *Good Housekeeping*.

His first contribution to *Punch* was a joke drawing in 1927; he graduated to sharing the 'big cuts', the leading political cartoons of the week, with Ernest Shepard, illustrator of *Winnie-the-Pooh*. During this time, he developed his distinctive style of scraperboard work, a commercial art process with the contrasts of wood-cut, obtained by scratching the surface of a black-coated board. On the outbreak of the Second World War he became chief political cartoonist on the *Daily Mail*, a position he held for three decades. His weekly drawings for *Punch* took on a new dimension of satire after 1953 when the magazine's editorship was taken over by the controversial journalist Malcolm Muggeridge; they included trenchant views of Suez, McCarthyism, nuclear power and Colonel Nasser. After retirement from *Punch* and the *Daily Mail*, he re-emerged as guest cartoonist on *The Sun*, and for three years drew for the *News of the World*.

When he was made Honorary Doctor of Letters at the University of Kent in 1975, he was described by the Public Orator, in the words of American cartoonist and historian Draper Hill, as 'simply the finest draughtsman of our times to have devoted his energies to editorial caricature'.

Richard Winnington
1905–53

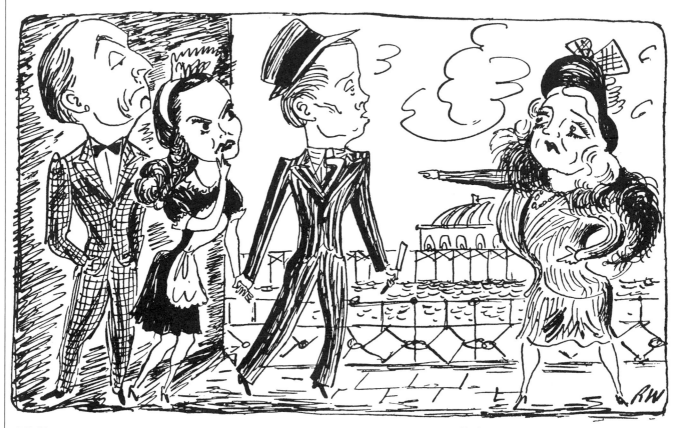

'Child's Guide to Graham Greene:
William Hartnell, Carol Marsh,
Richard Attenborough, Hermione
Baddeley in "Brighton Rock"', 1948.

From his early days Winnington, born in Edmonton, London, showed a flair for caricature and a passionate interest in films. As an unemployed youth during the years of the Depression he made lightning sketches in pubs for pocket money. After working as a salesman, his comic strip was taken by the *Daily Express* in 1936, and later that year he joined the *News Chronicle* as a draughtsman. When Vicky was 'taken on', he shared Winnington's room; the humour and line of the film critic's drawings proved a decisive influence on the development of Vicky's style.

Film critic of the *News Chronicle* from 1943 until his death, his brilliant spiky drawings delighted readers. As 'John Ross', he also contributed a cinema column to the *Daily Worker* between 1943 and 1948. On his death, the painter Augustus John lamented the loss of 'a brilliant draughtsman and true critic'.

American film star James Cagney.

Lionel Coventry
1906–

Born at Broken Hill, New South Wales, the son of a newspaper linotype operator, Coventry moved with his family to Adelaide at the age of two. On leaving high school in 1923 he became a cadet reporter on the *Adelaide News*; but he was more interested in caricature than reporting, and changed jobs to become the first black-and-white artist employed on the Adelaide morning newspaper, the *Register*.

When the *Register*, like many other papers, became a victim of the Great Depression, Coventry's portrait caricatures were accepted by the weekly paper, the *Bulletin*, where they appeared for many years. Meanwhile, he was published in several Adelaide newspapers, the most prominent of which were the *Advertiser*, the *News* and the *Mail*. During the Second World War, his comic strip *Alec the Airman* was featured in the *Mail*. In the forty-five years he has worked for the Australian Press, Lionel Coventry has had nearly 30,000 caricatures published.

Initially inspired by David Low's caricatures, which appeared in the *Bulletin*, Coventry rapidly developed a distinctive style of two-dimensional caricature, interpreting facial planes in a satisfying Art Deco manner, and integrating his ingeniously designed signature into the overall composition. Three collections of his caricatures have been published, and some of his original drawings have been purchased for the South Australian Art Gallery collection.

W.D. Edrich, English test cricketer in the team that toured Australia in 1946–7.

Robert LaPalme
1908–

Born in Montreal and brought up in Alberta, in 1972 LaPalme was decorated with the Order of Canada for his contribution to Canadian art. Yet at the age of seventeen he had been refused entrance to Montreal's Ecole des Beaux-Arts, and his first cartoons were drawn in his spare time as he worked in a series of menial jobs. His career as a caricaturist began on the intellectual daily, *L'Ordre*; over the next two decades he drew caricatures for almost every important French-language publication in Canada and his reputation as a cartoonist and painter spread to the USA and abroad. At the height of his career as a caricaturist in the late 1940s and early 1950s, he carried on a vitriolic campaign against Maurice Duplessis and his Union Nationale government, and in 1952 won the National Newspaper Award for his work in *Le Devoir*, which he described as 'Quebec's last fighting newspaper'.

In 1963 he organized an exhibition of caricatures which became established as an annual event, the International Salon of Cartoons. Now Director of its permanent collection, the International Pavilion of Humour, LaPalme has fostered contact between cartoonists the world over.

'The Pimp': former Quebec premier Maurice Duplessis sells out the province to the United States.

'VICKY' Victor Weisz
1913–66

Vicky's cartoons reached their zenith of political wit and popularity in the Fifties and Sixties. Born in Berlin of Hungarian – Jewish origins, the early death of his father left him supporting his family while still in his teens. He made a living drawing cartoons of theatre and sports personalities for the newspaper *12 Uhr Blatt*, until Nazi pressures became so overwhelming that he left for England.

When he presented himself as cartoonist to the *News Chronicle* in 1939, the editor Gerald Barry recognized his talent and set him on a course of acclimatization to English ways. For a year, he read avidly, from Chaucer to A. A. Milne, and visited institutions such as the Derby, Lord's Cricket Ground and Parliament itself, before joining the paper for fourteen years. In 1953 he moved to the *Daily Mirror*, also drawing regularly for the *New Statesman* and *Express*. His style evolved from the weighty brush-line of Low to a vibrant, brittle pen-line dating from days alongside Richard Winnington, film caricaturist and critic on the *News Chronicle*. Vicky succeeded Low on the London *Evening Standard* with the same concession of freedom to comment.

The genius of his caricature at times saddled politicians with a cliché of expression that dogged them thereafter: Douglas Home, Butler, Eisenhower, once drawn, were type-cast in their roles. However, the portrayal of Macmillan as Supermac proved more of an endearing image than a source of ridicule. Vicky confronted readers with hilarious political charades in deadly earnest, until his own underlying despair of the world's situation overcame him. His friend and fellow-journalist James Cameron recalls him as 'the most political human being I ever met in my life'.

Vicky's suggestions for a New Year Cabinet: (left to right) Lord Boyd-Orr (Minister of Agriculture), A.J.P. Taylor (Foreign Secretary), John Osborne (Minister of Education), T.S. Eliot (Minister of Labour), Dame Edith Sitwell (Minister of Health), Lord Hailsham (Prime Minister), Malcolm Muggeridge (Home Secretary), Bertrand Russell (Lord Chancellor), Victor Gollancz (Chancellor of the Exchequer), Capt. Liddell Hart (Minister of Defence), Kingsley Martin (Colonial Secretary) and Vicky (Duchy of Lancaster, Responsible for Information).

'TIM' Louis Mitelberg
1919–

A Polish Jew, Tim came to Paris in 1937 to study architecture at the École des Beaux-Arts. On the outbreak of war, he joined a Polish regiment of the French army. Taken prisoner, he managed to escape to Russia, and was transferred to England, where he joined the Free French. In London, some of his drawings were purchased by the War Artists Advisory Committee, and he discovered Hogarth; later, he came across Daumier, by far the greatest influence on his work. An observer of the individual rather than of types, he declared in his book, *L'Autocaricature*: 'The caricaturist does not distort faces . . . he differentiates. You are no longer just one face in the crowd. Suddenly you possess something the others do not have.'

He joined *Action* in 1945, and from 1952 worked on the Communist daily, *L'Humanité*; but he became disillusioned with the party line and left in 1958. On the liberal weekly *L'Express*, which was committed to the cause of Algerian independence, he assumed his pseudonym (the first three letters of his surname in reverse). He also changed both his style, which became lighter and less angular, and his method, drawing from memory or photographs rather than from life. He developed new techniques, a favourite device being the parody of art styles: the meeting between de Gaulle and Khruschev, for example, drawn after Cézanne's 'The Card Players'.

Tim now enjoys editorial status on *L'Express*, and his drawings are published in many foreign papers, including *The New Yorker* and *The New York Times*. He has illustrated Kafka, Zola, Gogol and Faulkner and designed many theatre posters.

OPPOSITE *Sir Winston Churchill supported Charles de Gaulle in his creation of the Free French Forces after the fall of France in 1940.*

ABOVE *Mao Tse-tung (and Richard Nixon), 1972.*

Osbert Lancaster
1908–

Doyen of Fleet Street cartoonists, Lancaster is also renowned as a writer, critic and designer for theatre and ballet. Educated at Charterhouse School, he abandoned his study of law at Oxford for life class at the Ruskin and Slade schools. After travels in Europe, he joined the Architectural Press. From 1938, his bestsellers *Pillar to Post – a Pocket Lamp of Architecture*, *Home Sweet Homes* and *Progress at Pelvis Bay* categorized and castigated pretensions of style in sweetly sardonic line and text. Some of his early published caricatures were signed 'Bunbury'. He has drawn 'pocket cartoons' for the *Daily Express* since 1939. During the war, while he was at the News Section of the Foreign Office, his fatuous types and sartorial farce on the Home Front and farther afield continued to delight the *Express*'s readers. *The Littlehampton Bequest* enjoyed the unique distinction of a dynastic exhibition at the National Portrait Gallery in 1973; Maudie, spokesperson and class cliché, proves as enduring as Blimp and Alf Garnett. A retrospective at the Redfern Gallery, London, in February 1980 displayed the artistic range of Lancaster's work.

Sir Max Beerbohm at Rapallo.

Roy Ullyett
1914–

While at his first job with a colour-printing firm in Essex, Ullyett started drawing cartoons for the *Southend Times*. At nineteen he moved to the London evening paper, *The Star*, as sports caricaturist. During the war he flew Mosquito bombers and, after demobilization, returned to the *Star*, also contributing to the *Sunday Pictorial* under the signature 'Berryman'. In 1953 he joined the *Daily Express*. He regards the sports cartoon as a sort of restorative for readers – 'Anyone who can read through to the back page of the newspaper deserves a laugh.' The lively line of his sports characters captures the action as well as lifting the spirit.

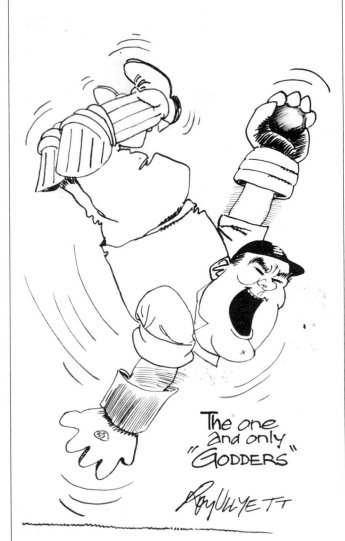

Godfrey Evans, wicket-keeper for many of England's test matches in the Fifties.

Noel Counihan
1913–

Born in South Melbourne, Counihan got his first newspaper job in 1935 when, as a result of an exhibition of his pencil portraits, he was invited by the editor of the *Melbourne Argus* to draw a weekly caricature. Throughout the Depression, his portraits of state personalities appeared in the *Bulletin*, the magazine *Table Talk* and the *Sun News-Pictorial*. His work has always been based on two uncompromising principles: socialism and the cause of the working man, and the discipline of sound draughtsmanship. In 1935 he also began to draw cartoons for the Communist Party newspapers, *Worker's Weekly* and the *Worker's Voice*, and for the trade union Press. By 1943 he was contributing a weekly cartoon to the Communist *Guardian*, and his powerful anti-fascist comment and attacks on political corruption and defeatism on the home front continued throughout the war until his departure for Europe in 1949. After travelling for two years, he returned to Melbourne and rejoined the *Guardian* until 1958, when he left again to travel and paint full time. In recent years, he has been commissioned to prepare portrait caricatures to illustrate two volumes of memoirs, and a selection of these have been acquired by the Ballarat Fine Art Gallery.

Inspired by George Finey's vigorous caricatures published in *Smith's Weekly*, the work of the *Simplicissimus* artists, and William Gropper's cartoons in *The New Masses*, Counihan's cartoons and caricatures are invariably drawn with a steel-nibbed pen, giving them an expressive variation of tone. Critics and fellow-artists alike agree that his comic portraiture puts him in the master class.

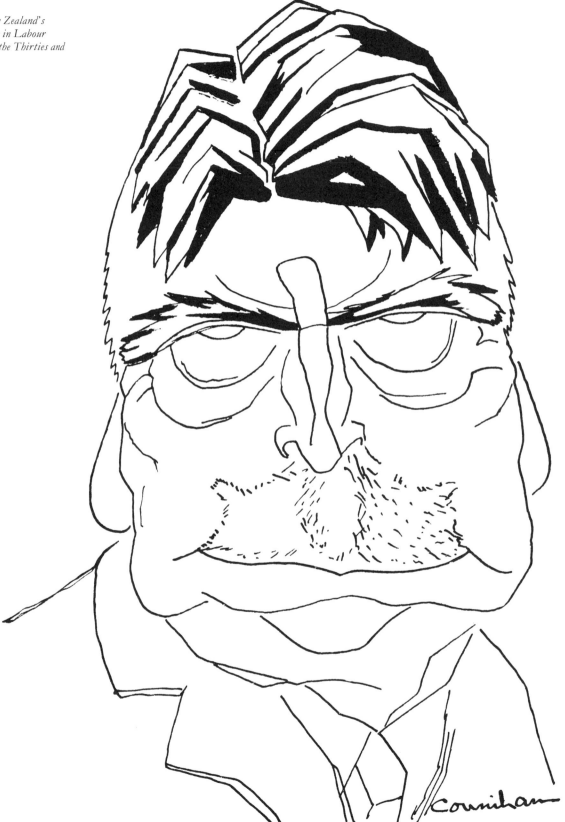

Walter Nash, New Zealand's Minister of Finance in Labour governments during the Thirties and Forties.

Post-War Caricature

EVER SINCE PHOTOGRAPHY began, caricaturists have had to face up to the invidious assumptions that the camera never lies and that caricature is therefore a distortion of the truth. Latterly, pressures have grown. Truth is now widely assumed to be enshrined in video-cassettes. It is said to be 'unvarnished', 'uncensored', 'unedited'. The caricature is thus a mockery of the truth, being an art of succinct statement and cunning definition.

Ersatz caricature has been developed. The television mimic shares air-time with the politician or pundit. The make-up department does wonders with hairpieces and padding in the cheeks and nostrils. The skilled impersonator captures mannerisms, turns of phrase and all the individual tics and quirks that once only a professional caricaturist would have been expected to notice.

There is also a confusion of function. Public figures are groomed to fit the roles society assigns them; that is, to suit the opinion polls. Presidential candidates can win on the strength of a convincing smile, fail because they have a shifty way of reading the auto-cue. Such physiognomic factors mean that those in a position where they are liable to be caricatured – those in the public eye for one reason or another – are pre-shaped into caricature beings: the People's President, the Man of Decision, the Contented Smoker, the Average Housewife.

Media consultants and psycho-analysts between them have made caricature an exceedingly self-conscious art. Motives are more questionable than ever. The familiarity of those most often caricatured – stars of screen, stage and despatch box – makes the temptation to be *outré* at all costs, to thwack each victim round the head, to exceed anything a clicking camera or a satirical mimic can do, almost irresistible. Thus week after week Gerald Scarfe turns quite ordinary, often quite inoffensive people into raging blowflies or overt genitalia. So when, once in a while, a genuine paroxysm of disgust seizes him, he has only his last resort to fall back on: the pen-and-ink death throe, a welter of blots and splatters. Free-for-all and overkill bring diminishing returns.

True caricature remains what it has always been: character-sketching; one person's more or less exaggerated reaction to another. It cannot be done prosaically, face to face, like portrait painting. It should not be done exclusively from the picture files: that only encourages systematic distortion. The true caricaturist works mainly from memory and so keeps his impressions intact. He makes sure that nothing comes between what twinkles in his mind's eye and the fixation on paper.

Gerard Hoffnung
1925–59

As a child in Berlin, Hoffnung went to the day school for non-Aryans next door to Himmler's residence. At ten, he was already disrupting classes with his caricature and mimicry. Brought to England by his mother, he attended Highgate School before enrolling as an art student at Hornsey. National Service took the form of bottle-washing and most probably chaos at the Express Dairy Farm on the outskirts of Golders Green. Once released, he became an art teacher at a boys' school, staff artist with the *Evening News*, and taught art at Harrow until 1950, when he went to New York to work for a year on *Cowles Magazine*.

From 1951 he contributed regularly to *Lilliput* and many international magazines, and illustrated several books. He held one-man exhibitions at the Little Gallery, Piccadilly, and his watercolours for Colette's *L'Enfant et les Sortilèges* were shown at the first of the Festival Hall Exhibitions. Full of Germanic humour and wistful delicacy, his drawings display his constant preoccupation with music. An incomparably witty and inventive broadcaster and public speaker, he was also a prison visitor at Pentonville for seven years. His sudden death was a great loss to his many friends and public; a memorial concert was held in 1960 in the Royal Festival Hall.

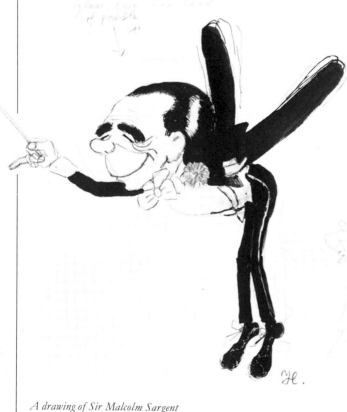

A drawing of Sir Malcolm Sargent for a model which dangled in the Albert Hall at the 1958 Chelsea Arts Ball.

Ronald Searle
1920–

Ronald Searle attended the School of Art at Cambridge, his birthplace, and contributed his first drawings to the *Cambridge Daily News* in 1935. Captured by the Japanese in Malaya in 1942, he spent more than three years as a prisoner of war. His record of this captivity, a selection published as *Forty Drawings* in 1946, established his reputation as a graphic artist. Popular success came with his drawings of the fiendish schoolgirls of 'St Trinian's' (1941–53), followed by the wider social satire of *The Rake's Progress*. Searle is a prolific illustrator and film designer. He was a leading draughtsman for *Punch* (whose staff he joined in 1951), *Life* and other internationally known magazines. Widely travelled, he works in Paris, London and the USA. Many albums of his work have appeared, and he has been a major influence on succeeding generations of cartoonists. In 1973 he was the first living foreign artist to be honoured by a major exhibition at the Bibliothèque Nationale, Paris.

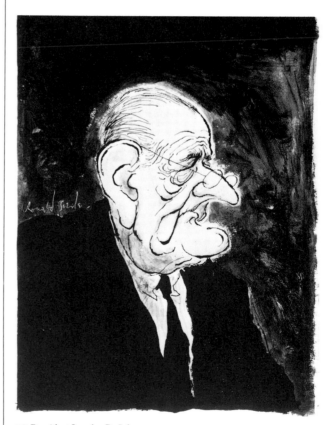

US President Lyndon B. Johnson, a colour cover-caricature for the Saturday Evening Post, *10 February 1968, which carried the article, 'How goes the campaign to dump LBJ?'.*

Arthur Wakefield Horner
1916–

Born in Melbourne, Horner spent his boyhood in Sydney where he trained at the National Art School. He became cartoonist for the the *Sydney Bulletin* and *Smith's Weekly*, and acted in radio drama. After five years' war service, he went to London to study painting under Meninsky and Ruskin Spear at the Central School of Arts and Crafts, and drew regularly for *Lilliput*, *Punch* and *Tribune*. In 1952 he created 'Colonel Pewter' for the *News Chronicle*, as a rival to 'Flook' on the *Mail*. Horner succeeded Vicky as political cartoonist on the *Chronicle* but it was when he joined the *New Statesman* that the strong line of his drawings had free rein, and he gathered his most dedicated following. After thirty years in England, he returned to Australia, where he now draws theatre and political caricature for *The Age*, illustrates and has made cartoon films for television.

Newspaper editor Cecil King (left),
from Punch.

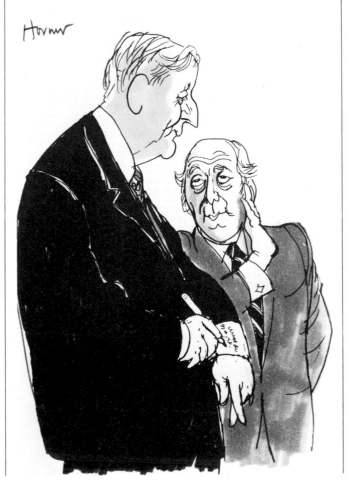

Halldór Pétursson
1916–77

In the small community of Iceland, Halldór Pétursson had to cover an extensive field. Apart from caricature, his prolific output ranged from drawing up monograms for pillowcases to painting altar-pieces.

He studied art in Denmark and the US. Returning home at the end of the Second World War, he set up a studio in Reykjavik. A versatile graphic designer with a large output of book illustration, he contributed to the humorous magazine *Spegillinn* for twenty-five years, for long periods supplying all of its artwork. He also co-published another magazine, *Skuggabaldur*, for three years. Of his additional work for newspapers and magazines, his theatre caricatures achieved distinction, and his drawings from the Fischer–Spassky World Chess Championship match had a wide circulation in the world Press.

German-Jewish physicist and
accomplished violinist Albert
Einstein weighs up the equation of
mass and energy.

Henry Meyer Brockmann
1912–68

A contributor to the revived *Simplicissimus* after 1953 and to the *Süddeutsche Zeitung* and the Munich *Abendzeitung*, Brockmann was one of the most gifted of the post-war German caricaturists. His style was based on the economic and disciplined use of a line of uniform thickness, rarely using areas of black or tone.

Rivals for the West German Chancellorship in 1964: Ludwig Erhard (who won) and Willy Brandt.

Tony Rafty
1915–

Born in Australia of a Greek father, from the age of eleven Rafty contributed to his family's income by working as a golf caddie. Although he became a skilful golfer himself, his interest in art was stronger, and in 1937 he began work as a freelance cartoonist, drawing for the *Bulletin*, *Labor Daily* and *Sun* newspapers. During the Second World War he was made a war artist and sent to New Guinea. On his return to Australia he joined the *Sydney Sun*, and for the next two decades produced caricatures in both black and-white and colour of distinguished Australian and world personalities. His caricatures are highly finished, and in nearly all cases contain suitable backgrounds – Sir Edmund Hillary, for example, is seen against the snowy peaks of Everest. Rafty left the world of journalism in 1969, but has continued to paint colour caricatures for gallery exhibition in Australia and the Pacific.

Graham Marsh, an ex-teacher who in 1973 became the first golfer to win over $100,000 outside the USA.

Timothy Birdsall
1936–63

Birdsall's artistic career started while he was still at
Cambridge University. He joined *The Sunday Times* to draw
the 'Little Cartoons' on the front page for two years, and
illustrated a book on London theatres by Mander and
Mitchenson, before turning to political caricature. His talent
for the comedy of political situations surfaced in cartoons
for the *Spectator* and *Private Eye*. But it was in the satirical
television show, 'That was the Week that Was', that he
reached his widest audience. Already gravely ill with
leukaemia, he produced drawings, done at home, that were
rich in invention and humour. His fine penwork ranged
from zany satires on advertising to astutely comic obser-
vations of people and politicians. He died in June 1963.

*'Eating people is wrong': newspaper
publisher Lord Beaverbrook.*

William Hewison
1925–

A contributor to *Punch* since 1949, Hewison frequently draws its theatre caricatures. His line has been described as having the power of a rhino whip and the spikiness of barbed wire. He draws from the stalls, catching the essence of the characters; having played with the London Actors' Theatre himself, he knows both sides of the footlights.

Following his interest in posters and lettering – his father was a professional sign-writer – he studied at Regent Street Polytechnic and the University of London. He then became Art Master at Latymer Upper School, Hammersmith, for six years, during which time he freelanced as a caricaturist. He joined the editorial staff of *Punch* in 1957, and in 1960 was appointed art editor.

Paul Scofield and Joan Plowright in
The Rules of the Game, *from*
Punch, *23 June 1971.*

'ZE'EV' Yaacov Farkas
1923–

Born in Hungary, Farkas emigrated to Israel in 1947, and his drawings have featured in the Israeli Press since 1952. Appointed art director of *Davar Hashavua* in 1955, in 1958 he became its political cartoonist. Since 1962 he has contributed the daily editorial cartoons to *Ha'aretz,* and the full-page cartoon for the weekly supplement. His caricatures are frequently reprinted in the world Press, appearing in *Time* magazine, *The New York Times*, *Le Monde*, *Weltwoche* and the *Jewish Times*. Exhibitions have included two one-man shows, at the Chamber Theatre in 1965 and the Tel Aviv Museum in 1969. A book of his cartoons, *Al Kol Panim*, was published in 1968. He has been awarded the Nordau Prize and the Schwimmer Prize for Journalism.

Leonid Brezhnev, President of the
USSR *and a major participant in*
East–West arms limitation talks.

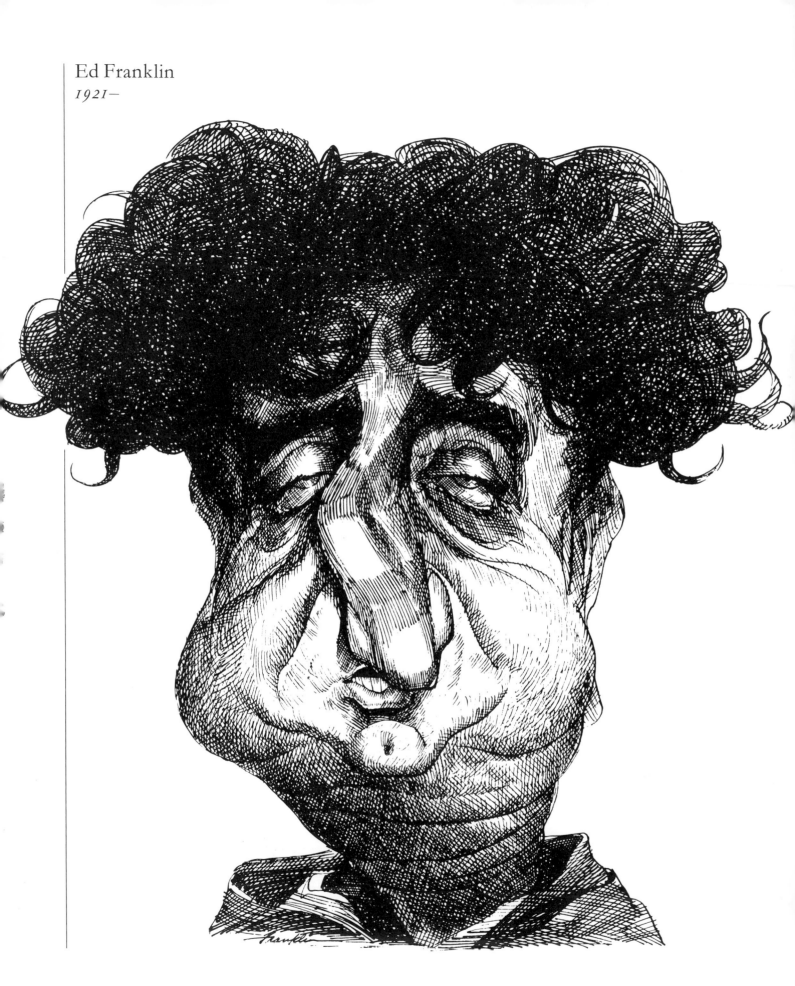

Paul Flora

1922–

Born in Texas, Ed Franklin started his career in the art department of the *Houston Press* in 1947, drawing occasional cartoons for the editorial page. Several years later he transferred to the *Houston Post*. By the mid-Fifties, he was in New York working as an illustrator for numerous magazines, including the *Saturday Evening Post*, *Argosy* and *True*. Family reasons prompted him to move to Toronto; and dissatisfaction with commercial and illustration work led to a return to cartooning, this time as a freelance for the Toronto paper, the *Globe and Mail*. He also contributed to the *Toronto Star*, sometimes filling in for its celebrated resident artist, Duncan Macpherson. In 1968, he joined the staff of the *Globe*, alternating on the editorial page with Jim Reidford, who had helped and encouraged Franklin for several years; and on Reidford's retirement in 1972, he became the paper's daily cartoonist.

Born in the South Tyrol, Flora is well known in all the German-speaking countries as an illustrator as well as cartoonist who has worked regularly for such newspapers as the *Süddeutsche Zeitung* and the *Neue Zürcher Zeitung*. His political cartoon was a regular feature of the weekly *Die Zeit* for many years. Flora's needle-sharp line and clever use of involved passages of cross-hatching are perfectly suited to his imagery, which ranges from the whimsical to the mysterious and threatening. He often includes caricatures, models of brevity, in his cartoons, but he cannot be regarded chiefly as a caricaturist or even as a cartoonist. He is rather a highly imaginative illustrator, firmly in the modern German tradition established by such artists as Alfred Kubin and Paul Klee. He now lives in Austria.

'A Monosyllabic General': Charles de Gaulle, September 1968. In the previous year he had vetoed the applications of four countries – Britain, Denmark, Norway and Eire – to join the EEC.

OPPOSITE *Brendan Behan (1923–64), the roaring boy of Irish writers.*

Fritz Behrendt
1925–

Born in the Weimar Republic and brought up in Berlin,
Behrendt left with his family in 1937 for political reasons
and settled in Holland. On leaving school, he became a
student at the Amsterdam School of Arts and Crafts.
During the last weeks of German occupation he was a
prisoner of the ss; after liberation he joined the Netherlands
Storm Troop, and in 1947 went to Yugoslavia as leader of a
youth reconstruction work team. He was awarded a
scholarship to the Zagreb Academy of Arts, where he
worked in the Graphics Department, but when he returned
to East Berlin he was arrested on charges of 'Titoism' and
held in solitary confinement for six months.

Following his release, Behrendt decided to take up
cartoon journalism; now, after his silver jubilee as a political
cartoonist and caricaturist, he has a daily feature in the
Dutch newspaper, *Het Parool*, and his work is seen inter-
nationally. Editorial cartoonist of the *New York Herald
Tribune* in the Sixties, his drawings have appeared in *Punch*,
Time and *Der Spiegel*, and he has also worked for Amnesty
International, the Red Cross and environmental action
groups. An exhibition, 'The Balancing Line', mounted by
the Netherlands Ministry of Culture to mark his jubilee,
toured Germany, Austria, Switzerland and England.
Several books of collected caricatures have been published,
including *Der Nachste Bitte* (1972), *Heroes and other people*
(1976) and *Haben Sie Marx gesehen?* (1978).

Hans Erich Köhler
1905–

Now best known for his cartoons in the *Frankfurter
Allgemeine*, for which he began work in 1958, Köhler has
also contributed to the *Nürnberger Nachrichten, Simplicissimus*
and *Die Zeit*. He is also active as a book illustrator. A book
of his work has been published, *Pardon wird nicht gegeben*, and
an exhibition was held at the Wilhelm Busch Museum in
Hanover in 1959.

*The conductor Herbert von Karajan,
1975.*

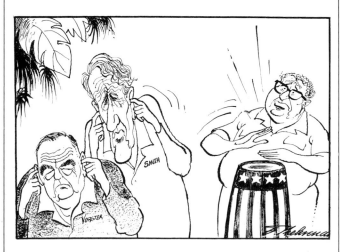

*'The Last Tam-Tam': South
African and Rhodesian Prime
Ministers Balthazar Johannes
Vorster and Ian Smith get a clear
and unwelcome message from
American foreign policy advisor
Henry Kissinger.*

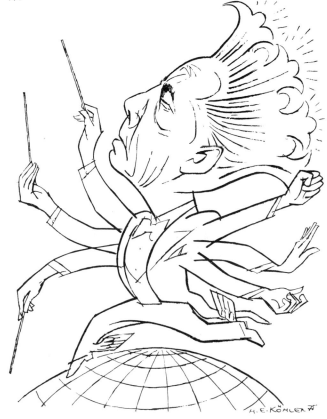

Robert Osborn
1904–

Educated in his home town of Oshkosh and at the Universities of Wisconsin and Yale, Osborn studied art in Rome and Paris before founding the art department at Hotchkiss School, Lakeville, where he was Head of Department from 1929 to 1935. At the end of the 1930s he left teaching to take up illustration and satire, and during the war he made information posters for the Navy. Head of the School of Art and Architecture at Yale University from 1960 to 1965, he has illustrated *Parkinson's Law* and written and illustrated a number of books, including *Osborn on Leisure* (1957). His work has been acquired by many museums, and some of his caricatures are in the Swann Collection.

'MOI SAN' Roland Moisan
1907–

Chief caricaturist on the French satirical weekly *Le Canard Enchaîné*, Moisan's strong line combines a directness of presentation with force of comment. Of Breton and German descent, Moisan studied at the École des Arts Décoratifs and the Collège Technique in Paris and concentrated on painting until, roused by the injustice of Parliament and Press in the Stavisky affair in 1934, he turned his pen to political satire. He drew first for *Le Merle Blanc*, and in 1956 joined the staff of *Le Canard Enchaîné*, succeeding Pol Ferjac as its leading artist. Independent of any political affiliations, he is free to comment on any issue. Collections of his work include *Dix ans d'histoire en cent dessins* (1968) and a series of de Gaulle cartoons entitled *Il y a été une fois*.

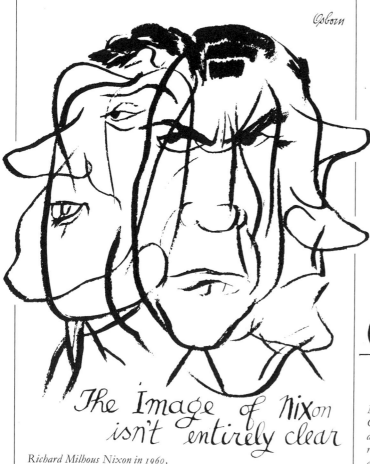

The image of Nixon isn't entirely clear

Richard Milhous Nixon in 1960, when he was US Vice-President.

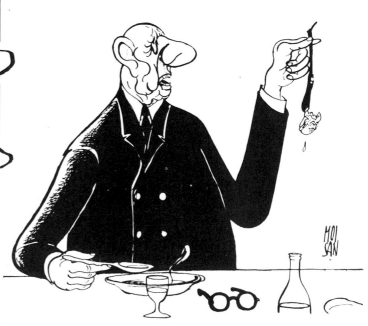

Moi San combines two of President de Gaulle's well-known traits, his dismissive attitude towards political rivals or other threats to his position, and his love of his wife's homely cooking.

'EWK' Gustave Adolphus Ewart Karlsson
1918–

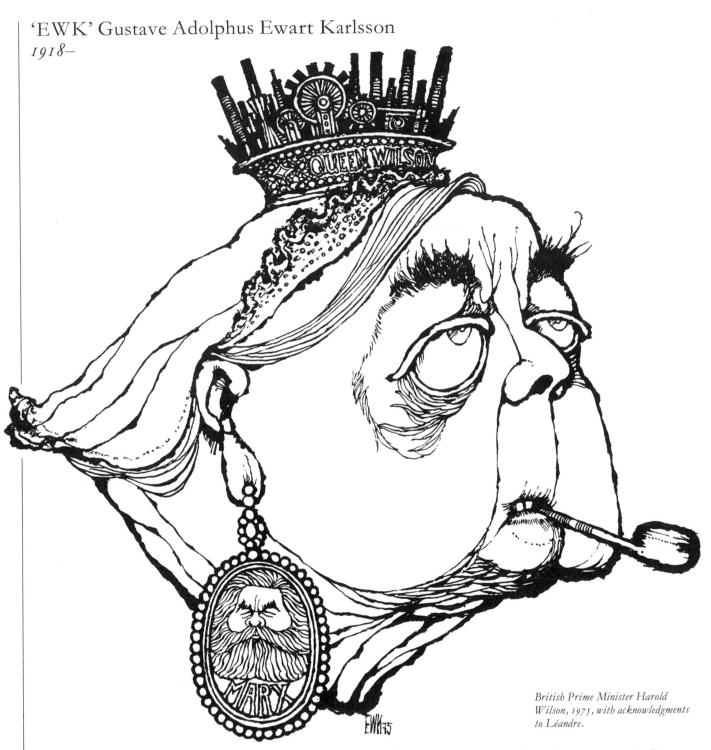

British Prime Minister Harold Wilson, 1975, with acknowledgments to Léandre.

Throughout childhood on his father's farm in Sweden and at school, Karlsson's time was divided between drawing and skiing. Giving up an attempt to ski his full name in the snow, he settled for 'EWK', his signature ever since. For some time, snow took precedence over paper as his favourite element. Cartooning, playing guitar and working on farms, he was sent to Stockholm in 1951, sponsored by the local newspaper and political group. Within two years, a collection of his portraits was published, and for over twenty-five years he has been contributing to newspapers and journals; he is now an editor on *Aftonbladet*, the socialist trade union paper. His caricatures appear in Europe and America; their individuality and powerful line have the quality of the great French *portraits-charges* of Léandre and Gill. Recent work has dealt with the themes of world poverty and environmental concern. He was elected Cartoonist of the Year in 1979 at the International Salon of Cartoons, Montreal, and a commemorative book on his work by Robert LaPalme was published for his exhibition there; other publications include *Världens store*, a book of sixty-three political portraits, and *Ettår med Nixon*, reports from the USA with Dieter Strand.

Duncan Macpherson
1924–

Macpherson's unique ability, confident style and relationship with his editors can be said to have revolutionized Canadian political cartooning.

 Having taken several art courses while serving in England during the Second World War in the Royal Canadian Air Force, he studied graphics at the Boston Museum of Fine Art and the Ontario College of Art. In 1948, while still a student, he was asked by the *Standard* to take over as the illustrator of their regular Greg Clark stories. Similar illustrative work on *Maclean's* during the Fifties gave way, in 1958, to political cartoons for the *Star*. Dealing with municipal, provincial, federal and international politics, his satires were an immediate success. Negotiating with the newspaper from a position of strength, Macpherson insisted on freedom to express his own – not necessarily the newspaper's – viewpoint, and to work at his own pace. This latter stipulation benefited other cartoonists who were asked to fill in on days when Macpherson was off, occasionally on sketching tours to other countries such as Cuba, Russia and, more recently, China.

 Macpherson's contribution to cartooning and caricature has been recognized by the Canada Council, from whom he received the Molson Prize for 'a man's total career rather than any single work', and he has won the National Newspaper Award an unprecedented six times since 1959.

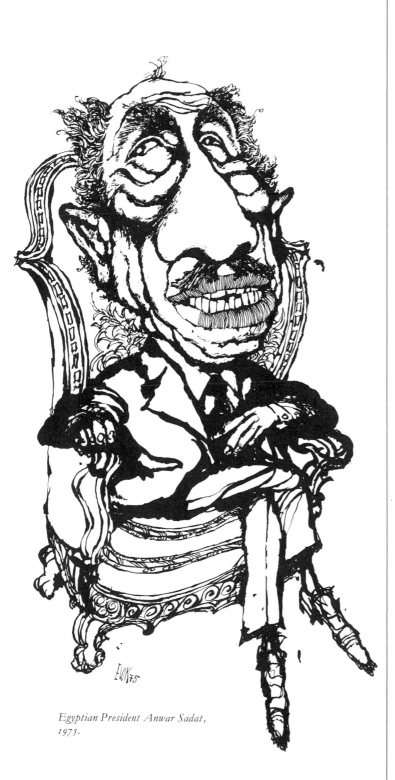

Egyptian President Anwar Sadat, 1975.

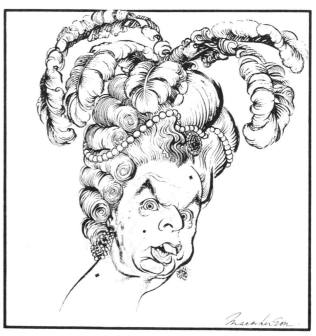

'Then let them eat cake!': John Diefenbaker, Canadian Prime Minister, from the Toronto Star, *1958.*

David Levine

1926–

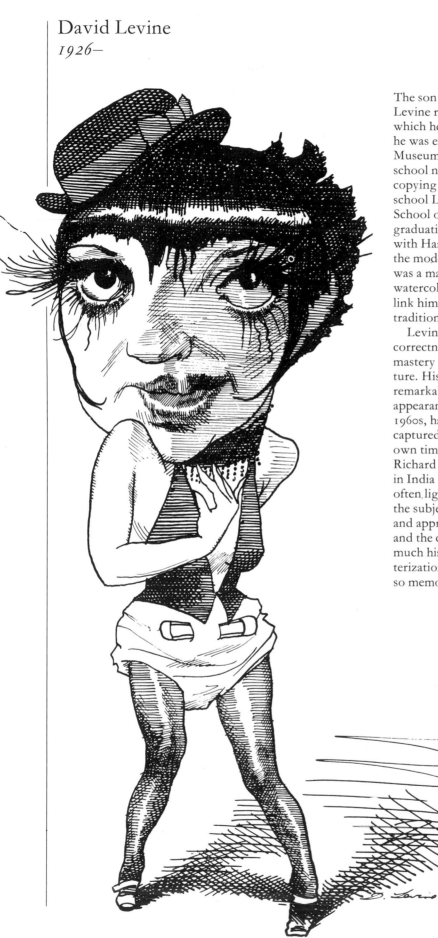

The son of a New York garment manufacturer, David Levine resolved early in life to be an artist, a pursuit for which he displayed marked talent as a boy. At the age of ten he was enrolled in the Pratt Institute and the Brooklyn Museum Art School, where he drew a comic strip for the school newspaper, and honed his drawing technique by copying the cartoon figures of Walt Disney. After high school Levine left New York to attend Philadelphia's Tyler School of Art where he studied painting. Following his graduation and return to New York, he studied for a year with Hans Hoffmann. He rejected the abstract tendencies of the modern American school of painting, in which Hoffman was a major figure, in favour of a realist bias. Levine's watercolours and oil paintings of figures and street scenes link him with 'The Eight', a group in the American realist tradition which included John Sloan and George Luks.

Levine has always been concerned about quality and correctness of draughtsmanship, and his emphasis on the mastery of drawing technique carries over into his caricature. His sure command of line is a key element in his remarkably incisive character studies which, since their first appearance in the *New York Review of Books* during the early 1960s, have brought him international fame. In these he has captured the luminaries of art, literature, and politics of our own time and previous ages. Voltaire, David Smith, Richard Nixon and Queen Victoria have all been set down in India ink, at least once, by Levine. The caricatures are often lightened with a sophisticated visual pun or jibe on the subject and his work. They have been compared in style and approach to the works of Thomas Nast, John Tenniel and the comic book artist Will Eisner. However, it is as much his uncanny knack for astute and humorous characterization as his style that makes David Levine's portrayals so memorable.

Film actress, singer and dancer Liza Minnelli, daughter of Judy Garland and Vincent Minnelli, and star of the film Cabaret, *1972.*

RIGHT *Novelist and poet John Updike.*

FAR RIGHT *US Secretary of State Henry Kissinger, 1977.*

BELOW *Subtle distinctions in posture and degree of perception define the development of the US presidency from Dwight D. Eisenhower through John F. Kennedy and Lyndon B. Johnson to Richard Nixon.*

"SO WHY ALL THE FUSS WHEN I SAY
THOU **NEEDN'T** LOVE THY NEIGHBOUR?"

'TROG' Wally Fawkes
1924–

Master of the clarinet and the caricature, Fawkes has signed his work 'Trog' since the war-time days when he played with a jazz band called the Troglodytes. His family moved to England from Canada when he was seven, and he later won a scholarship to Sidcup School of Art, Kent. Both he and trumpet-player Humphrey Lyttelton were founder-members of George Webb's Dixielanders Band, touring Britain and Europe at weekends. Working during the war at the Coal Board, he was spotted by the cartoonist Illingworth, and taken on by the *Daily Mail* to draw maps and illustrations. He cites the painter John Minton and his mentor and room-mate at the *Daily Mail*, Illingworth, as his chief influences.

Asked by Lord Rothermere in 1949 to draw a children's strip called 'Rufus & Flook', he worked with a succession of authors including Humphrey Lyttelton, Scottish author Sir Compton Mackenzie and jazz singer George Melly, developing it into a keenly-followed satire of current trends and personalities, parodying society figures and personal friends from the newspaper and jazz worlds. The wider field of politics was covered by the sharp-edged non-establishment humour of his work for *Private Eye*, the *New Statesman* and *The Spectator*, in collaboration with George Melly. His drawings have included several on the Royal Family, who are treated in the same irreverent way as Members of Parliament or show-business personalities. He has also contributed regular political cartoons to the *Daily Mail* and to the *Observer*, of which he is now the principal cartoonist, working from his own ideas, and has designed a number of full-colour covers for *Punch*.

Trog sees the cartoonist's role as that of a referee at a football match, 'running about in the thick of the action, and occasionally blowing the whistle on behalf of the reader and shouting "Foul"'. A slow and painstaking worker – he once described himself as a 'two-bottle-of-ink-a-day man' – he is sensitive to the subtle changes of appearance of his subjects, which he strives to bring to life when working from photographic references: 'When I can see the person looking back at me, I know I've got it.' He was voted International Political Cartoonist of the Year by the members of the International Salon of Cartoons in Montreal in 1976, and 1977 Cartoonist of the Year by Britain's Granada Television programme, 'What the Papers Say'.

Enoch Powell, maverick Conservative Member of Parliament whose statements about the race question in Britain have inflamed public opinion.

Andy Donato
1937–

Born in Toronto, after working for various commercial art studios Donato was hired by the *Toronto Telegram* in 1961 to work as a graphic artist; he later became the art director of one of the newspaper's magazine inserts. It was a busy time, during which he learnt to come to terms with pressing deadlines. He was encouraged to pursue cartooning by Al Beaton, the paper's staff cartoonist at the time, and as a result Donato began to fill in occasionally for Beaton on the editorial page. When the *Toronto Telegram* folded, Donato moved on with several other members of the staff to found the *Toronto Sun*. There he started drawing daily political cartoons which he has been doing ever since, and his work is widely syndicated throughout Canada. Recipient of the National Newspaper Award in 1976, he has published one collection of cartoons. He has also developed a reputation as a painter, having had several successful exhibitions in Toronto.

'Economic Recovery': Canadian Prime Minister Pierre Trudeau.

Michael Cummings

1919–

Keen likenesses and a comic view of political cross-currents, combined with a technique evolved from the line-and-wash fluency of earlier illustrations, make up the most assured cartoon style in Fleet Street.

Educated at Gresham's School, Holt, and the Chelsea School of Art, Cummings first illustrated for *Tribune*. The editor, Michael Foot, persuaded him to try political cartoons, whereupon in 1949 Lord Beaverbrook signed him up for the *Daily Express*. He joined the *Sunday Express* nine years later and has worked for them ever since. He was a contributor to *Punch* during Malcolm Muggeridge's editorship, and his drawings are frequently reproduced throughout the world. Churchill called him his favourite cartoonist, and tried to acquire the originals. Although he has been accused of being anti-socialist, anti-liberal, anti-Russian and various other things, many of his 'victims' have asked for their cartoons, from ministers to trade union leaders – though General de Gaulle's displeasure was once roused to the extent of producing a protest from the French Foreign Office to the British Government.

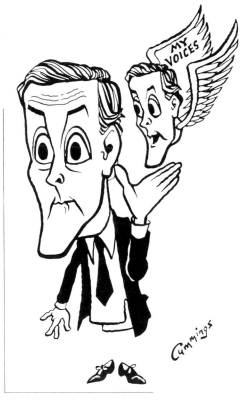

Labour politician Anthony Wedgwood Benn.

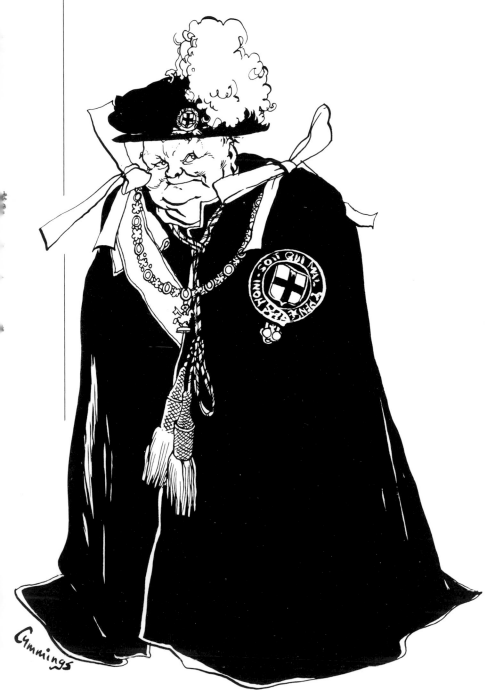

Sir Winston Churchill, awarded the Order of the Garter in 1953, in which year he also received the Nobel Prize for Literature.

Horst Haitzinger
1939–

Born in Austria, Haitzinger, a painter and illustrator as well as a cartoonist, spent four years at art school in Linz, from 1954 to 1958, before moving to Munich to study painting at the Academy until 1964. His first caricature for the revived *Simplicissimus* appeared in 1958, and he continued contributing to the magazine until 1967, but it was only in 1966 that he took up caricature as a career, freelancing for several magazines and newspapers, including the *Nürnberger Nachrichten* and the Swiss satirical magazine, *Nebelspalter*. His work is now published widely throughout German-speaking countries.

'IRONIMUS' Gustav Peichl
1928–

Born in Vienna, Peichl became a political cartoonist in 1955 after teaching and practising architecture. He works chiefly for the Viennese newspaper *Die Presse*, Munich's *Süddeutsche Zeitung* and Zurich's *Weltwoche*, and his witty caricatures and cartoons of international figures and events, drawn in fine pen-strokes, are widely reproduced in leading newspapers and magazines throughout the world. He has won several national and international awards, and his work is exhibited in the Museum of Modern Art, New York and the Albertina, Vienna. He has had several collections of drawings published, including a book on the Seventies.

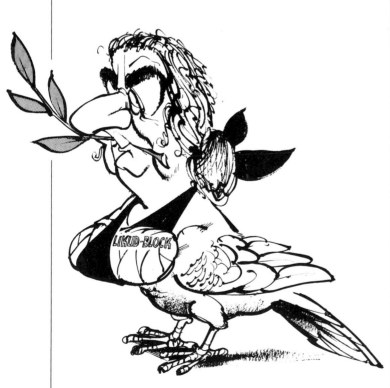

Israeli Premier Golda Meir, 1974, thwarted in her aim to bring about peace by a section of her own party.

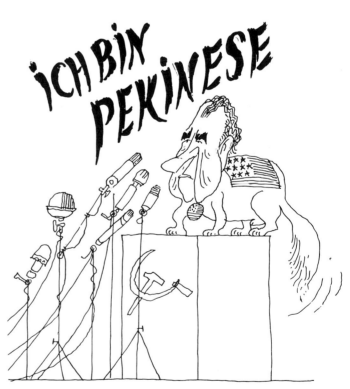

Richard Nixon's visit to China in 1972 is compared with John Kennedy's trip to Berlin in 1963, where he made a historic speech which included the popular declaration, 'Ich bin ein Berliner'.

Patrick Bruce Oliphant

1935–

Born and raised in Adelaide, Australia, Oliphant moved to the United States in 1964. Already an accomplished professional cartoonist, he set out quite methodically, in his drawings for the *Denver Post*, to concoct a Pulitzer Prize-winning cartoon. His attempt succeeded in 1967.

Oliphant's caricatures, which have more recently appeared in the *Washington Star*, are drawn with a brisk, energetic handling of line which, combined with his wry sense of humour, gives his works an air of absurd theatre reminiscent of Ronald Searle. A feature of many of Oliphant's drawings is 'Punk the Penguin', a tiny creature who delivers an ironic comment as a humorous postscript to each cartoon.

From the Denver Post, *1973.*

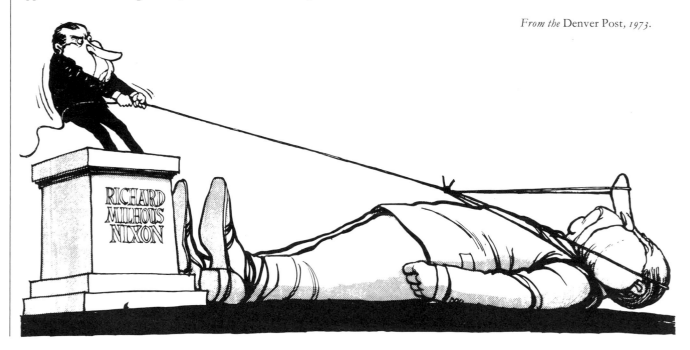

Nicholas Garland

1935 –

Political cartoonist for the *Daily Telegraph* since 1966, Garland produces cartoons rich with graphic metaphor and political wit and bite. Born in London, he spent part of his childhood in New Zealand, returning to England in 1954 to study Fine Art at the Slade. After working for some years in the theatre, he started to draw professionally in 1964. In *Private Eye* he and Barry Humphries created the comic strip 'Barrie McKenzie'. He has also worked for *The Spectator* and the *New Statesman*. He is a great admirer of Vicky, whom he acknowledges as a major influence; the fluency and freedom of his own line owes much to his other art etching.

*'"... Freezing fog predicted ..."
(long-range weather forecast)', from
the* Daily Telegraph, *17 November
1966: Labour politicians George
Brown, Harold Wilson and James
Callaghan.*

Jacky Redon
1946–

Born in Lyons, Redon started drawing when a schoolboy, and says that he never wanted to be anything other than a caricaturist. His style, completely self-taught, calls to mind that of David Levine, whom he admires greatly. Working quickly in pen and ink to catch a likeness which may then take an hour or more to finish off, Redon achieves his effects by an intricate criss-crossing of lines. He always works from photographs, never from life, distrusting a sitter's ability to influence the caricaturist.

He has contributed to *Paris-Match* and *Le Point*, and since 1970 has worked for *Le Figaro* and its Saturday magazine.

Alexander Solzhenitsyn, the Soviet dissident writer who left the USSR for exile in 1974.

'CHOÉ' Nguyen Hai Chi
1944–

Born in South Vietnam, Choé started drawing when a child and, without any formal art training or senior school education, began to contribute cartoons to Saigon's weekly paper in 1969. Portraying world figures with a grotesque savagery, his later work on the *Bao Den Daily* won him wide acclaim for his forthright political comment, but also a term of imprisonment.

US Secretary of State Henry Kissinger and North Vietnamese leader Le Duc Tho, joint winners of the 1973 Nobel Peace Prize despite the fact that hostilities continued in Vietnam throughout and after their negotiations, make a meal of the cooked dove of peace.

Robert Grossman
1940–

A Yale graduate, Grossman worked as a cartoon editor before starting to freelance as an illustrator and cartoonist in 1965. Contributing editor to *New York* magazine, he has also worked in advertising, gained a number of awards, and now teaches at Syracuse University, New York.

The effect of Grossman's bold, often brash design and colour lies closer to poster art than the traditions of newspaper cartoon. His surrealistic, large-scale airbrush caricatures are seen on the covers of *Time*, *Newsweek*, *Esquire* and other international magazines. His work for consumer features, ranging from petrol to lingerie, has a compelling force, and his caricatures of politicians, stylized into smooth areas and sharp facets, make them larger and deadlier than life. Despite the modernist techniques, his approach recalls that of great poster-artists such as Hassall and Paul Colin, who united simplified style with comic imagery.

Hugh Hefner, founder of the Playboy club.

Paul Szep
1941–

Born in Canada, Szep worked for four years in steel mills and played semi-professional hockey while studying at the Ontario College of Art. After working as cartoonist and illustrator with the *Financial Post* in Toronto, in 1967 he joined the *Boston Globe*. Winner of two Pulitzer Prizes for editorial cartoons in 1974 and 1977, he won the Rubin Award of the National Cartoonists' Society in 1979, and has received a number of national awards, including Honorary Doctorates from Framingham State College, the Ontario College of Art and Worcester State College. He lectures at various universities in Massachusetts, and has published seven books.

'Born-again' President Jimmy Carter.

Brad Holland
1943–

Beginning at the age of five by drawing his own comic strips, Brad Holland has travelled a somewhat irregular path to success as an illustrator and political satirist. His career has taken him from Arkansas to Chicago (and work as a tattoo artist) and Kansas City and, finally, to New York. Holland has contributed to *The New York Times* for years as well as to *Playboy*, *Time*, and *Newsweek* magazines, and has been the recipient of several professional awards and honours. His drawings, with areas of fine cross-hatching, show a great deal more care than is usual in works for the Press. The most distinctive feature of his work, however, is the sympathy, humanitarian concern and sincerity which penetrate to the heart of his chosen subject.

'The Comedian', Ugandan leader Idi Amin, 1977.

Gerald Scarfe

Gerald Scarfe
1936–

In a feature on Scarfe published in *Studio International*, John Berger has described him as 'a natural satirical draughtsman' in the line of Gillray and Grosz. Many of his caricatures are drawn with such savagery and distortion that he seems to do violence to his victims. He once said of his work, 'I can only express good by comparing evil with greater evil . . . when I am actually drawing people, then I hate them.' The only subject to escape the customary attack appears to be Malcolm Muggeridge, himself a past-master at contorting his own features during television discussions. In a superb coloured drawing, he emerges with the air of a benign leprechaun.

After a childhood isolated by recurrent illness, Scarfe started work in an art studio, turning freelance as his drawings appeared in *Punch* and *Private Eye*. He has been the leading cartoonist for *The Sunday Times* for over a decade.

Working in a wide range of media – colour prints, soft sculpture, papier-mâché, metals and, recently, animation, television and theatre posters – he has had a number of exhibitions in London and abroad. His work excites controversy: applauded by art pundits, it has profoundly shocked the more conventional, who prefer their cartoons mild and funny.

OPPOSITE *Unlikely friends, pop singer Mick Jagger and photographer and designer Sir Cecil Beaton.*

ABOVE US *Senator and presidential aspirant Edward Kennedy, whose behaviour following the death of his female passenger Mary Jo Kopechne, when their car plunged into the river at Chappaquidick on 18 July 1969, caused scandal and speculation.*

Archbishop Makarios, President of Cyprus, symbol and champion of Cypriot independence, 1974.

Roy Peterson
1936–

Born in Winnipeg, Peterson moved to Vancouver in 1948 and took some courses at the Vancouver Art School. One of his teachers there was the cartoonist Al Beaton, who was then drawing for the *Vancouver Province*; Beaton told his wife, 'There is this kid in my class who can draw circles around me and anyone I've ever seen. If he develops a political sense he's got it made!' Peterson began drawing for the *South Cariboo Advertiser* in 1956, freelanced for various publications and, after a brief flirtation with the *Vancouver Province*, began doing some work for the *Vancouver Sun* in 1962. His relationship with the paper flourished and he worked there in tandem with Len Norris. His work has appeared in most major Canadian publications as well as numerous international publications such as *Punch*, the *Spectator*, *Time*, *The New York Times*, the *Washington Post*, *TV Guide* and many others, and he has appeared in *Maclean's* on a regular basis for the last fifteen years.

Peterson has been the recipient of two National Newspaper Awards in 1968 and 1975. He also won first prize for Editorial Cartooning in Montreal's International Salon of Cartoons in 1973.

Joe Clark, then Canada's new Prime Minister, from the Vancouver Sun, *1976.*

Edward Sorel
1929–

Born in New York city, Sorel trained at the Cooper Union School of Art, and in 1953 joined two of his classmates, Milton Glaser and Seymour Chwast, in founding Push Pin Studios. They were extremely successful and exerted an enormous influence on graphic design throughout the world, originating what became known as 'the Push Pin style'. Glaser and Chwast went on to achieve extraordinary popularity as designers and illustrators in their own rights; Sorel pursued a different course, and in 1958 established his own studio as an illustrator. Since then he has become one of America's most prominent satirical artists. His drawings and cartoons have been published in virtually every major American magazine, including *Time*, *Esquire*, *Atlantic* and *Ramparts*. The *Village Voice* newspaper carried his adult comic strip for many years.

Although Sorel is professedly not a caricaturist, his portrayals of figures in American public life are drawn with an artful exaggeration and a flair for the absurd. His drawing style is unique, its seemingly undisciplined complexity of lines masking a real control and masterful draughtsmanship.

Richard Nixon, 1973: 'Milhous I, Lord of San Clemente, Duke of Key Biscayne, Captain of Watergate.'

OPPOSITE *'Cornelia's little boy', a portrait of George Wallace, Governor of Alabama, and his wife.*

John Jensen
1930—

Born in Australia, the cartoonist son of a cartoonist father, Jensen arrived in England in 1950. The work of H. M. Bateman and fellow-Australian George Finey were early influences. He spent six years in the provinces drawing for the *Birmingham Gazette* and *Glasgow Bulletin*, later contributing to *Lilliput*, the *Daily Express*, the *Evening News* and the *New Statesman*. Political cartoonist with the London *Sunday Telegraph* for nineteen years from its inception in 1961, he has also contributed theatre caricatures to *The Tatler*, social comment to *The Spectator* and has been regularly associated with *Punch*. He is currently drawing political and social cartoons for *Now!* magazine and television caricatures for *Punch*.

Comedian and impersonator Stanley Baxter, from Punch, *1979.*

Barry Fantoni
1940—

From a musical and artistic family of Italian – Jewish origins, Fantoni was a whiz kid of art and jazz at thirteen, and followed in the steps of Humphrey Lyttelton and Trog at the Camberwell School of Art. After a spell in Europe, he continued his studies while supporting himself by playing tenor sax. In 1963 he wrote for the satirical television revue, 'That Was The Week That Was', and in the same year his one-man show at the Woodstock Gallery was sold out to an American dealer. His picture of the Duke of Edinburgh in underpants led to a job on the editorial staff of *Private Eye*, where he remains as assistant editor. The *Observer* magazine featured a series of portraits, *Childhood Heroes*, in 1964. Since then, his activities have extended to film-making and acting, theatre design, thriller-writing – his detective story, *Mike Dime*, was published in 1980 – record production and musical composition. His illustrations, cartoons and caricatures have been published in *The Times* and *Sunday Times*, *The Listener*, *Cosmopolitan* and many other journals. A book of his cartoons was published by André Deutsch in 1977.

HRH the Prince of Wales, July 1977, one of a series of Prince Charles during his tour of Canada and the USA.

Pascual Locanto
1946–

Pascual Locanto was born in Montevideo, Uruguay, but has lived in Australia since 1973. His exciting caricatures are built up with skilful, multiple mapping-pen lines of great certainty and delicacy combined with a fine sense of intelligent distortion. Before he worked in Australia his drawings were published in various newspapers and magazines in Uruguay and Argentina. He has won three international awards for his portrait caricatures, in Montreal, Canada in 1966 and in 1968, and in 1971 at Le Salon de la Caricature, Paris, where his caricature of Georges Pompidou secured first prize.

Ernst Maria Lang
1916–

Born in Oberammergau, Lang began drawing caricatures while still at school. He studied architecture in Munich and in 1947, the same year as he gained his diploma, he had his first caricature published by the *Süddeutsche Zeitung*. He has become one of the best-known living German caricaturists, while continuing to work as an architect and educator. In 1977 he was made President of the Bavarian Chamber of Architects, and he has been awarded the Theodor Wolff Prize for caricature. His drawings, essentially spare and linear in style in keeping with the contemporary German idiom, are mainly political, although he occasionally produces straight caricatures.

Ludwig Erhard, economist, statesman and Chancellor of the German Federal Republic from 1963 to 1966.

Jim Killen, Australian Minister of Defence.

'MARC' Mark Boxer
1931–

In the amateur tradition, Marc first published caricatures as an undergraduate at Cambridge. In his last year he edited *Granta* and was sent down for blasphemy. Untrained in graphics, he went on to be art director of *Queen* magazine in the Fifties and the first editor of *The Sunday Times* magazine in the Sixties. He returned to drawing in the Seventies, introducing to *Times* readers his dreadful couple, the Stringalongs, in a regular pocket cartoon, while his caricatures appeared mainly in the *New Statesman* and occasionally in *The New Yorker*. His line is usually economical and feline, with occasional visual asides – for example Lord Longford's face becomes a phallus. Comparing his work to the serious political cartoonists who hack away at their victims, Noel Annan described Marc as employing 'the modern weapon of the hyperdermic in the umbrella. . . . His caricatures are incomparable because he picks on the one fatal defect in character, and depicts it so skilfully that the victim's jocular laughter dies on his lips.'

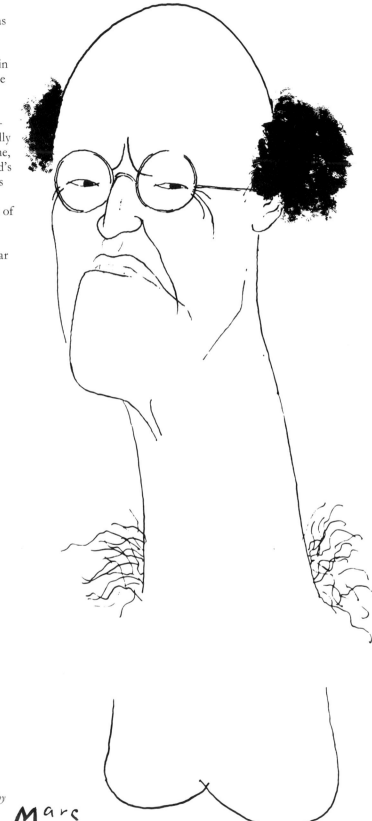

Lord Longford, anti-pornography campaigner, 1971.

'AISLIN' Christopher Terry Mosher
1942 –

Born in Ottawa, Mosher started drawing when a child.
Kicked out of high school for growing a beard, he
graduated from the École des Beaux-Arts, Quebec, in 1966.
He became a freelance cartoonist in 1968, and in the
following year joined the staff of the *Montreal Star* and was
made art director of *Take-One*. In 1970 he became a found-
ing and associate editor of *Last Post Magazine*. He then spent
some time in Europe, researching the history of caricature,
as a result of which he conceived and helped to produce a
National Film Board documentary on Canadian political
cartoons called *The Hecklers* which was finished in 1976. On
the *Montreal Gazette* since 1972, he has taught at the
Museum School of Fine Arts, and contributes to *Harper's*,
The New York Times, *National Lampoon*, *Quebec-Presse*, the
Washington Star and others. He was described in *Time*
magazine as the most astringent of Canadian cartoonists,
and the cover of his collected cartoons aptly displays heads
on a skewer. Awards include first prize at the 1970
International Salon of Cartoons, Montreal, and the
Canadian National Newspaper Award, 1977. Until recently,
he signed his work with the name of his daughter, Aislin,
but he has now reverted to the use of his surname.

Canadian John G. Diefenbaker,
leader of the Progressive Conservative
Party and Prime Minister from 1957
to 1963, prepares to write his
memoirs.

Jan Frits de Knoop
1940 –

De Knoop's caricatures, drawn in a brittle, free line which
captures likeness mercilessly and avoids cartooning clichés,
have the edge of fresh observation. He began as a carica-
turist in 1968, while working as a building surveyor for the
Dutch government, by contributing daily drawings for the
Haagsche Courant. In 1973, he was asked by Dutch television
to provide 'instant cartoons' for a series of political pro-
grammes for three seasons. For the last four years, he has
been contributing to the weekly magazine *De Tyd*.

Andreas van Agt, elected Dutch
Prime Minister in 1977, controls two
members of his government, Hans
Wiegel and Willem Aantjes.

Richard David Willson

1939–

Educated at Epsom College, Willson studied architecture at Kingston College of Art until, aghast at high-rise projects, he turned to the attack with cartoons in *The Ecologist*, took on book illustration and portrait sculpture, and caricatured for *Punch* and the *Observer*. As well as producing numerous portraits for literary magazines and newspapers, he is closely involved with the Third World Foundation; and since his 1972 cartoons for the Stockholm Environment Conference, he has travelled widely in Africa, Asia and America. Conferences covered have included ones on population, women's rights, arms control and science and technology. He is currently working on Oxfam and United Nations projects, while contributing to the *New Statesman*, *Encounter*, *The Times* and *Sunday Times*, *Washington Post* and other leading publications.

American actor, writer and director Woody Allen with one of his leading ladies, Diane Keaton, from The Sunday Times, *1980.*

Edd Uluschak

1943–

Edd Uluschak was born in Alberta, but his family moved to Edmonton when he was ten years old. With no formal art training, after high school he began freelancing in the Edmonton area, doing illustrations and working for a firm that published trade magazines. Some of his first cartoons appeared in *Roughneck*, an oil industry magazine. In 1968, he replaced Yardley-Jones as editorial cartoonist on the *Edmonton Journal*, and in the following year he won the National Newspaper Award. He has also won the Basil Dean Memorial Award for Outstanding Contributions to Journalism as well as numerous international awards from exhibitions in Greece, Bulgaria and Germany. Widely syndicated, his work has appeared in *Punch*, *Time*, *US News and World Report* and the *National Review*. The *Edmonton Journal* has produced an annual collection of his cartoons since 1973.

"Why doesn't the public learn to live with my faults? — I did."

Canadian Prime Minister Pierre Trudeau, from the Edmonton Journal.

Ranan Lurie

1932—

A sixth-generation Israeli, Lurie became a cartoonist on the leading newspaper *Ma'ariv* at the age of sixteen while still at college. After officers' training school, he was appointed major in the combat reserve, served as a paratrooper with the French Foreign Legion and was a unit commander in the Six Day War. In 1968 he moved to the United States to work exclusively for *Life* magazine; he later became contributing editor and chief political cartoonist on *Newsweek*. He is currently spending several years working in different countries: 1979 in Hawaii, where he also introduced a university course in communication through political cartooning; 1980 in Bonn, working for *Die Welt*.

Nominated for the highest Israeli award for journalism at twenty-two, he has been honoured in recent years by the Newspaper Guild of New York, the International Salon of Cartoons at Montreal, and over the past five years has repeatedly been voted among the top three editorial cartoonists in America by the National Cartoonists' Society. His dialogue with leading political figures and extraordinarily prolific output make him the most widely syndicated of political caricaturists today. The finely-hatched pen lines present portraits of the personalities in world affairs in shrewdly perceived contexts in the tradition of political satire. Apart from producing a prodigious amount of political work, Lurie lectures on art and the role of caricature and continues to experiment with new media and art forms.

Iranian religious and political leader, the Ayatollah Khomeini, 6 April 1979, soon after his arrival in Iran after the fall of the Shah.

'ZAC' Giuseppe Zaccaria
1930–

Probably the only caricaturist of any age to work simultaneously from three different countries, Zac commutes across the Continent weekly as he draws for *Pourquoi Pas?* in Brussels, *Le Canard Enchaîné* in Paris, and *Male, Paese Sera* and numerous left-wing newspapers in Italy. He first drew for the communist children's paper *Pioniere*, at the age of sixteen, and has been contributing regularly to *Paese Sera* and *Via Nuova* since 1951. Invited to Paris by *Le Canard Enchaîné* in 1958, he has stayed as unique guest artist. His drawings for them in Prague 1968 resulted in his expulsion. He declares himself a 'neo-feudal conservative libertarian anarchist of the extreme left'. Always in opposition, anti-clerical, anti-dogma of all kinds, his forceful, humorous drawings have an agitated, sketchy line. A naked Pope and Pompidou raised many establishment eyebrows: he intends to raise more when he founds a satirical journal in Italy in the spirit of *Le Canard* and *Private Eye*.

French President Giscard d'Estaing, whose family is rumoured to have received gifts of diamonds from Bokassa, ex-Emperor of the Central African Republic.

Yamafuji Shoji
1937–

While studying design at the Musashino Art College, Tokyo, Yamafuji won the international posters award at the Osaka International Festival. After graduation in 1960, he joined the staff of an advertising group, but turned freelance to work in graphics. With his nomination for the Bungei Shunju Cartoonists' Prize in 1971, his place as a major cartoonist was assured. One of Japan's leading illustrators, he has developed a highly individual style of caricature, an adaptation of traditional brush-line technique. Since 1971 resident caricaturist on *Asahi Shimbun*, the weekly illustrated Japanese magazine, he produces regular full-page colour caricatures of politicians for the cover.

Following disclosures of government corruption, two Japanese MPs, Kōno (left) and Nishioka, quit their party to form a new one, Shinjiyu. When, soon after, Nishioka left the alliance, Yamafuji likened it, in a pun on the new party's name, to the breaking of the suicide pact ('Shinju') of traditional Japanese drama – hence the costumes.

Ralph Steadman
1936 –

Born in Wallasey, Cheshire, Steadman wields the most anarchic pen in current caricature. He turned freelance after three years on Kemsley Newspapers, having previously taken a postal course in Press Art and studied part-time at technical college and the London School of Printing. His pen-and-ink drawings have appeared in a variety of publications, from *Black Dwarf, Rolling Stone* and *Private Eye* to the *New Statesman* and The *New York Times*. A prolific illustrator, he collaborated with Hunter S. Thompson on *Fear and Loathing in Las Vegas*; and his *Alice in Wonderland* won the Francis Williams Award. Recent etchings for the Royal Shakespeare Company of King Lear and Fool and his illustrated biography of Freud show the sustained power of his graphic invention. Early in 1980, he produced a beer mat for the Labour Party, showing the shaken image of Mrs Thatcher with the injunction, 'Upset Her, not your Beer'; then, evincing either true disinterest or, like Gillray, a preference for purse rather than party, he accepted a *Daily Mail* commission to design a further six beer-mats of Labour heads.

Conservative MP Enoch Powell, from Private Eye, *1968.*

'GAL' Gerard Alsteens

1940—

The Belgian artist Gal is one of the most forceful image-makers of caricature-reportage, achieving an intense visual impact with complex pictorial techniques. His allegories reflect his fundamental socialist and democratic viewpoint, and often evoke the human issues and graphic strengths of Goya and Daumier. At the Venice Biennale of 1980 his work appeared in the Belgian Pavilion in an exhibit representing the contemporary art scene in Belgium, the first time caricature has been featured at the Biennale.

Born in Oudergem, Gal studied graphics at the St Luke Institute in Brussels, where he taught from 1965 to 1975. He worked as layout artist on the Flemish weekly paper *De Linie*, and has designed many notable international posters. Since 1976 he has been tutor at the National School of Figurative Design. His political cartoons currently appear in Belgium's *Die Nieuwe*, *Knack* and *Tijdschrift voor Diplomatie*, in the Dutch journals *NRC-Handelsblad* and *Die Groene Amsterdammer*, and have been published in his books, *Galleria*, *Aaa . . . !* and *Kissinger, Carter, Cola and Co.*. Awards have included the special 'Gebrauchsgraphik' prize at the Knokke-Heist World Cartoon Festival.

President Jimmy Carter is seen as the puppet of various business interests, not all of them American.

Tullio Pericoli
1936–

Born at Colli del Tronto, Ascoli, Pericoli had no formal art training. He began work as a caricaturist in 1955 with Rome's daily paper, *Il Messagero*. In 1961 he moved to Milan to draw for the literary pages of *Il Giorno*, and illustrated a number of contemporary novels. Since 1970 he has been a contributor to *Linus*, *Corriere della Sera* and *L'Espresso*. His notable series of caricatures during 1977–78 was influential in the downfall of President Leone.

Pericoli is also an artist in watercolour, engraving and aquatint; his works are in collections at the Universities of Parma and Urbino. Publications include *Identikit di illustri conosciuti* (1974), *Fogli di via* (1976) and, in collaboration with Emanuele Pirella, *Il dottor Rigolo* (1976) and *Cronache dal Palazzo* (1979).

Eugenio Montale, winner of the 1975 Nobel Prize for literature, from La Republica.

Hermenegildo Sábat
1933–

Born in Montevideo, Sábat moved to Argentina in 1966 and has worked in a wide range of graphics – illustration, book jackets and record sleeves – as well as contributing to The *New York Times*, *Fortune* and the weekly *Primera Plana*. In 1974 his book *Scat* appeared, containing his interpretative portraits of the great jazz players, and he published separately a monograph on Bix Beiderbecke, *Yo Bix, tu Bix, el Bix*. Winner of the Grand Prix at the 1975 Punta del Este Biennale, his political caricatures have grown more surreal and macabre, and his graphics more brutally distorted. He is now a regular contributor to *La Opinion*, where he enjoys the rare privilege of freedom of comment.

Jazz cornet-player Bix Beiderbecke (1903–31).

'LUCK AND FLAW'
Peter Fluck
1941–
Roger Law
1941–

Maquettes, puppets, models: such words fail to convey the impact of the eerie tableaux of Luck and Flaw. The uncanny, fleshy quality of their three-dimensional caricatures seems to draw equally on the arts of sorcery and surgery. After studying together at Cambridge School of Art in the Fifties, where they were taught by Paul Hogarth and Ed Middleditch, they became freelance illustrators and part-time teachers. Both were making models early in the Seventies; their collaboration started in 1975 when Law, overwhelmed with work in New York, telephoned Fluck for help. Now working from Cambridge, they model the life-size heads with cadaver-coloured clay, fit glass eyes and dentures and heighten the surface with air-brush colour. Special effects include coiffures, taxidermy and costumes tailor-made to weird proportions; finally, on a stage set with props, they are photographed. Once on film, the models are dismembered.

Luck and Flaw's work has appeared in all of Britain's colour magazines and they provided a series for the cover of the *New York Times* Magazine during the 1976 elections. The Harvard *National Lampoon* commissioned a Common Market series and, politicians apart, they have created frogs for Smirnoff, Billy Connolly for Heineken and a whole range of celebrities from Royals to rogues.

Franz Josef Strauss, conservative West German politician defeated by Helmut Schmidt in 1980 in the Chancellorship election, and a supporter of tougher measures to combat terrorism.

Claude Morchoisne
1944–
Jean Mulatier
1947–
Patrice Ricord
1947–

Although each of these three French caricaturists works on his own and signs his portraits individually, their close professional association makes it necessary to introduce them together. It started in 1970 with the publication in the magazine *Pilote* of their *Grandes Gueules*, portrait caricatures of show-business and political celebrities. Mulatier and Ricord had known each other for ten years since attending the same *lycée*, where they caricatured their teachers, after which they studied at the Penninghen art school where Morchoisne had been a student. The three started work together as graphic artists and strip-cartoonists; they changed to caricature after Mulatier was commissioned by a French television magazine to produce weekly portraits of leading actors. Since then, they have become the leading exponents of colour caricatures for magazine covers throughout the world.

Their work relies on photographs, and each caricature

Chinese leader Mao Tse-tung by Patrice Ricord, July 1973.

ABOVE *Some of Jean Mulatier's sketches and the finished portrait of West German Chancellor Helmut Schmidt, May 1976.*

may take up to twelve successive sketches before the basis of the definitive face is chosen. Deadline allowing, Mulatier likes to spend a minimum of four weeks on any single caricature. Each of the three has a distinctive style – Ricord favours an angular, geometric approach whereas Mulatier seems to relate more to curves – and it is perhaps their exceptional colour technique, conveying in detail the texture of skin, hair and materials, that is the trademark of the work from their studio.

Their collaboration is one of mutual criticism, encouragement and appreciation, and the research and gathering of documents that precedes each caricature. They admit to no outside influence, although they admire the art of Jack Davis and Mort Drucker. In fighting what they see as the all-too-easy tendency to exaggerate and distort, they aim for close resemblance, with only a final emphasis on the face's distinctive features. The results of this approach have much of the dramatic power of a close-up, and it is to the cinema, rather than to the work of any other artist, that they attribute their fascination with portraits.

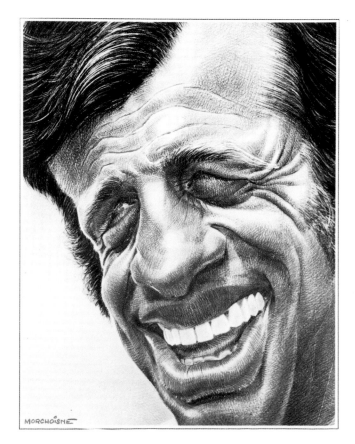

French film star Jean-Paul Belmondo by Claude Morchoisne, March 1971.

Bibliography

Books and journals

Adhémar, Jean: *Graphic art of the 18th century*, Thames & Hudson, London, 1964

Ashbee, C.R.: *Caricature*, Chapman & Hall, London, 1928

Bayard, Emile: *La Caricature et les caricaturistes*, Librairie Delagrave, Paris, 1900

Broadley, A.M.: *Napoleon in caricature*, 1795–1821, 2 vols, John Lane, London, 1911

Champfleury: *Histoire de la caricature moderne*, F. Dentu, Paris, 1865

Davies, Randall: *Caricature of today*, Studio, London, 1928

Delteil, L.: *Daumier*, Delteil, Paris, 1925–30

Dollinger, Hans: *Lachen streng Verboten! (die geschichte der Deutschen im Spiegel der Karikatur)*, Sudwest Verlag, Munich, 1972

Everitt, Graham: *English caricaturists from Cruikshank to Leech*, Swann Sonnenschein, London, 1886

Fuchs, Eduard: *Der Weltkrieg in der Karikatur*, Albert Langen, Munich, 1916

George, M. Dorothy: *English Political Caricature: a study of opinion and propaganda*, to 1832, Oxford University Press, 1959, 2 vols.
– *Social change and graphic satire, from Hogarth to Cruikshank*, Allen Lane, 1967

Gombrich, E.H. and Kris, E.: *Caricature*, King Penguin, 1940

Gombrich, W.H.: 'The experiment of caricature', in *Art and Illusion*, Phaidon, London, 1960
– 'The cartoonist's armory', in *Meditations on a Hobby Horse*, Phaidon, London, 1963

Gould, A., Jensen, J., and Whitford, F.: 'Politics in cartoon and caricature', in *20th-century studies* no. 13/14, University of Kent at Canterbury, Scottish Academic Press, 1975

Gould, Ann: 'La gravure politique de Hogarth à Cruikshank', in *Revue de l'art* no. 30, *Aspects de l'art anglais*, Editions C.N.R.S., Paris, 1975

Grand-Carteret, John: *Bismarck en caricatures*, Perrin et cie., Paris, 1890
– *Edouard, l'oncle de l'Europe*, Louis Michaud, Paris, 1906

Hess, Stephen and Kaplan, Milton: *The ungentlemanly art – a history of American cartoons*, Macmillan, New York, 1968

Hill, Draper: *Mr Gillray the caricaturist*, Phaidon, London, 1965
– *The satirical etchings of James Gillray*, Dover, New York, 1976

Hillier, Bevis: *Cartoons and caricatures*, Studio Vista, London, 1970

Hollweck, Ludwig: *Karikaturen von den Fliegenden Blätten bis zum Simplicissimus*, 1844–1914, Suddeutscher Verlag, Munich, 1973

Klingender, F.D.: *Hogarth and English caricature*, Transatlantic Arts, London, 1944

Kunzle, David: *The early comic strip*, University of California Press, Los Angeles, 1973

Lethève, Jacques: *La caricature et la presse sous la IIIème république*, Armand Colin, Paris, 1961

Lindesay, Vane: *The inked-in image*, William Heinemann, Melbourne, 1970

Low, David: *British caricaturists, cartoonists and comic artists*, Collins, 1942
– *Ye Madde Designer*, Studio, London, 1935

Lynch, Bohun: *A history of caricature*, Faber & Gwyer, London, 1926

Mellini, Peter and Matthews, Roy: *In Vanity Fair*, Scolar Press, London, 1981

Mosher, Terry and Desbarrats, Peter: *A history of Canadian caricature*, 1981

Paston, George: *Social caricature in the 18th century*, Methuen, London, 1905

Paulson, Ronald: *Hogarth's graphic works*, Yale University Press, New Haven, 1965

Searle, Ronald, Roy, Claude and Bornemann, Bernd: *La Caricature: art et manifeste*, Editions d'art Skira, Geneva, 1974

Siepmann, Eckhart: *Montage: John Heartfield*, Elefanten Press Galerie, Berlin, 1977

Spielmann, M.H.: *The history of 'Punch'*, Cassell, London, 1895

Stevens, F.G. and George, M. Dorothy: *British Museum catalogue of political and personal satires*, 12 vols, reprinted 1978

Wardroper, John: *The caricatures of George Cruikshank*, Gordon Fraser, London, 1977

Westwood, H.R.: *Modern caricaturists*, Lovat Dickson Ltd, London, 1932

Wright, Thomas: *A history of caricature and grotesque in literature and art*, Chatto & Windus, London, 1875

Catalogues

Cartoon and caricature from Hogarth to Hoffnung, Arts Council, 1962. Introduction by Draper Hill, foreword by Osbert Lancaster.

Wellington in caricature, Victoria and Albert Museum, 1965 (HMSO). Catalogue by John Physick.

The Franco-Prussian War and the Commune in caricature, Victoria and Albert Museum, 1971 (HMSO). Catalogue by Susan Lambert.

Hogarth, Tate Gallery, 1972. Notes and essays by Lawrence Gowing and Ronald Paulson.

George Cruikshank, Arts Council, 1974. Catalogue and notes by William Feaver.

The Townshend Album, National Portrait Gallery, 1974 (HMSO). Catalogue by Eileen Harris.

Daumier, eyewitness of an epoch, Victoria and Albert Museum, 1976. Introduction and notes by J.R. Kist.

The image of America in caricature and cartoon, Amon Carter Museum, Fort Worth, 1976. Introduction by Ron Tyler.

Vanity Fair, National Portrait Gallery, 1976. Catalogue by Richard Ormond, introduction by Eileen Harris.

Acknowledgments

The editor and publisher would like to thank the following museums, collections and private individuals by whose kind permission the illustrations are reproduced. Numbers are page numbers. Sources without parentheses indicate the owners of works of art; those within parentheses refer to illustration sources only.

Every effort has been made to trace the original sources of the illustrations; if any have been omitted the publishers will correct these acknowledgments in any further printing, if they are informed.

1: British Museum, London
Frontispiece: Keith Mackenzie Collection, London. © S.P.A.D.E.M, Paris, 1981
8: William Feaver Collection, London
9: Bibliothèque Nationale, Paris
10 top: Bibliothèque Nationale, Paris (Bulloz, Paris)
10 bottom: British Library, London
12: William Feaver Collection, London
13: British Museum, London
14: Ann Gould Collection, London
16 right: Keith Mackenzie Collection, London
17: British Museum, London
18 right: British Museum, London
19 (col) top and bottom: British Museum, London
20 (col): British Museum, London
22 top left: Gabinetto Nazionale delle Stampe, Rome
22 top right: Reproduced by gracious permission of Her Majesty the Queen. The Royal Library, Windsor Castle
22 bottom: Hessisches Landesmuseum, Darmstadt
23: Gallerie dell' Academia, Venice
24: British Library, London
27: National Portrait Gallery, London
28: British Library, London
29: Victoria and Albert Museum, London
30 top: Ann Gould Collection, London
32: © Gertrud Heartfield
33: Keith Mackenzie Collection, London
32: National Portrait Gallery, London
35: Fischer Fine Art, London. © S.P.A.D.E.M., Paris, 1981
36: © Express Newspapers Ltd.
37 (col): William Feaver Collection, London
38 (col) top left, top right, bottom

left: © Jean Mulatier
38 (col) bottom right: © Patrice Ricord
39: © David Levine
40 left: British Museum, London (Fotomas, London)
40 right: Reproduced by gracious permission of Her Majesty the Queen. The Royal Library, Windsor Castle
41 left: Ann Gould Collection, London
41 right: British Museum, London
42: (Courtauld Institute of Art, London)
43: British Museum, London
44: Ann Gould Collection, London
46: The Metropolitan Museum of Art, Elisha Whittelsey Collection, New York
47 bottom: Worcester Art Museum, Worcester, Mass.
48: British Museum, London (Fotomas, London)
49: British Museum, London
50 right: Keith Mackenzie Collection, London
51 left: The Langton Gallery, London
52 left: Victoria and Albert Museum, London
53: British Museum, London (Fotomas, London)
54 top: British Museum, London (Fotomas, London)
54 bottom: British Museum, London
55 (col) top and bottom: British Museum, London
56 (col) top and bottom: British Museum, London
58 left and right: British Museum, London
59 right: British Museum, London
60: Keith Mackenzie Collection, London
61 right: The Historical Society of Pennsylvania, Philadelphia
62 left: British Museum, London (Fotomas, London)
62 right: British Museum, London
63 top: British Museum, London (Fotomas, London)
63 bottom: British Museum, London
64 left: Musée de Versailles
64 right: (Arthur Brincombe, Exeter)
65 left: (Fotomas, London)
65 right: British Museum, London
66: British Museum, London
67 top and bottom, left and right: British Museum, London
68 left: National Portrait Gallery, London
68 right: British Museum, London
69: British Museum, London
70 left: Library of Congress,

Washington, D.C.
72 top: Musée Carnavalet, Paris (Bulloz, Paris)
73 top: Courtesy, American Antiquarian Society, Worcester, Mass.
74 left: British Library, London
75 bottom left: Hirshhorn Museum and Sculpture Garden, Smithsonian Institute, Washington DC
76: British Library, London
77 right: By permission of the Governors, Sutton's Hospital in Charterhouse, London
78 left: British Library, London
79 left: Library of Congress, Washington, D.C.
79 right: Musée Marmottan, Paris © S.P.A.D.E.M., Paris
80 left: Library of Congress, Washington, D.C.
83 right: Victoria and Albert Museum, London
84 right: Victoria and Albert Museum, London
87 left and right: Victoria and Albert Museum, London
89 left and right: Victoria and Albert Museum, London
90 right: Victoria and Albert Museum, London
93 top: Library of Congress, Washington, D.C.
93 bottom: Swann Collection of Caricature and Cartoon, Library of Congress, Washington, D.C.
96: Metropolitan Toronto Library Board
97: Library of Congress, Washington, D.C.
98 right: British Library, London
99 left: British Library, London
99 right: National Portrait Gallery, London
100: Keith Mackenzie Collection, London
101 left and right: Keith Mackenzie Collection, London
102: National Portrait Gallery, London
103 top, bottom left and right: National Portrait Gallery, London
105 (col): Ann Gould Collection, London
106 (col) top right: National Portrait Gallery, London
106 (col) bottom left: Scolar Press, London
106 (col) bottom right: Ann Gould Collection
107: Keith Mackenzie Collection, London
109 left and right: British Library, London
110 left: (Terry Mosher, Montreal)
110 right: Ann Gould Collection,

London
111 left: British Library, London
111 right: (Terry Mosher, Montreal)
112: Library of Congress, Washington, D.C.
113: (Roger-Viollet, Paris)
114 right: (Charles Press, Michigan)
115 left: Musée d'Albi
115 right: (Fotomas, London)
116 left: Keith Mackenzie Collection, London
116 right: Hunterian Art Gallery, Glasgow
117 bottom: Bymuseum, Oslo
118 left: (Ann Gould Collection, London)
118 right: © S.P.A.D.E.M., Paris, 1981
119: © S.P.A.D.E.M., Paris, 1981
120: Library of Congress, Washington, D.C.
121 left: British Library, London
121 right: The Mansell Collection, London
122: The Mansell Collection, London
123 (col): Rosette Glaser Collection, Mulhouse. © S.P.A.D.E.M., Paris, 1981
124 (col) bottom left: Ashmolean Museum, Oxford
124 (col) bottom right: Keith Mackenzie Collection, London
125: Lords Museum, Marylebone Cricket Club, London
126 left: © S.P.A.D.E.M. Paris, 1981
127 left: Keith Mackenzie Collection, London
128 top: © S.P.A.D.E.M. Paris, 1981
128 bottom: Ann Gould Collection, London. © S.P.A.D.E.M. Paris, 1981
129 left: (Roger Viollet, Paris). © S.P.A.D.E.M. Paris, 1981
129 right: The Museum of Modern Art, New York
130 left and right: © Ernest A. Seemann
132 left: © Mrs Olaf Gulbrannson
135 left: State Historical Society of Missouri
136 left: By permission of Dover Books, New York
137 left: (Fotomas, London)
142 right: Keith Mackenzie Collection, London
143 left: Draper Hill Collection, Detroit (Arts Council)
143 right: © Powis Evans
144 left: © S.P.A.D.E.M. Paris, 1981
144 right: Jonson Gallery, The University of New Mexico, Albuquerque
145: (Librairie Stock, Paris). © S.P.A.D.E.M. Paris, 1981
146 left: National Portrait Gallery,

London
146 right: © Mrs Bert Thomas
147 left: (Canada House Library, London)
147 right: Library of Congress, Washington, D.C.
149 left: Keith Mackenzie Collection, London
150: *The New Yorker*, New York
152 top: © A.D.A.G.P. Paris, 1981
152 bottom: © Cosmopress, Geneve and A.D.A.G.P. Paris, 1981
153 top: © Mrs Diana Willis
155: *The New Yorker*, New York
156 left: *The New Yorker*, New York
156 right: © Mrs Geraldine Anderson
157 (col) top and bottom: Fitzwilliam Museum, Cambridge. © Mrs Geraldine Anderson
158 (col): Iconography Collection, University of Texas, Austin
159 top: Iconography Collection, University of Texas, Austin
159 bottom: © 1925 by Alfred A. Knopf, Inc. and renewed 1953 by M. Covarrubias
160 left: Berlin Museum
160 right: (Frank Whitford, Cambridge). © Mrs Martha Dix
161 left: Minneapolis Institute of Arts, John de Laittre Fund
161 right: © Mrs P. Kapp
162: © Albert Hirschfeld
163 top and bottom left: © Albert Hirschfeld
164: (Vane Lindesay, Melbourne)
165 left: Ann Gould Collection, London
165 right: Special Collection, Rutgers University, New Jersey
166: © Express Newspapers Ltd.
167 top and bottom left: © Express Newspapers Ltd.
167 bottom right: (photo Dewag, Berlin). © Mrs Gertrud Heartfield
168: Antony Wysard Collection and copyright, Reading
169: (Keith Mackenzie Collection, London). © Mrs E. Sherriffs
170 left: Keith Mackenzie Collection, London

170 right: Keith Mackenzie Collection, London. © Associated Newspapers, London
171 left: © S.P.A.D.E.M. Paris, 1981
171 right: Keith Mackenzie Collection, London. © Ralph Zeilun
172: Collection Stedelijk Museum, Amsterdam
173 top: © Nerman: *Caught in the Act*, 1976, Harrap, London
173 bottom: © Jón Hjartarson, Reykjavik
174: Fischer Fine Art, London. © S.P.A.D.E.M. Paris, 1981
175 (col): Fischer Fine Art, London. © S.P.A.D.E.M. Paris, 1981
176 (col): Eileen Hose Collection and copyright, Salisbury
177 left: Keith Mackenzie Collection, London
177 right: © Oscar Berger
178 right: James Fitton Collection and copyright, London
180: © S.P.A.D.E.M. Paris, 1981
181 left: Keith Mackenzie Collection, London
181 right: Eileen Hose Collection and copyright, Salisbury
182: Sam Berman Collection and copyright, Malaga
183 left: © Adolf Hoffmeister
183 right: © Mrs Barbara Bentley
184 top: © Boris Yefimov
185 top: © 'Kukryniksy'
185 bottom: © Associated Newspapers, London
186: © *Punch*, London
187 top and bottom: © Associated Newspapers, London
188 left: (Vane Lindesay, Melbourne). © Lionel Coventry
188 right: © Robert LaPalme
189: © *New Statesman*, London
190: Louis Mitelberg Collection and copyright, Paris
191 top: Louis Mitelberg Collection and copyright, Paris
191 bottom: © Osbert Lancaster
192: © Roy Ullyett
193: (Vane Lindesay, Mellbourne). © Noel Counihan
194 left and right: Michael Cummings Collection and

copyright, London
195 left: Mrs Annetta Hoffnung Collection and copyright, London
195 right: Ronald Searle Collection and copyright, Paris
196 left: Arthur Horner Collection and copyright, Australia
196 right: © Fjóla Sigmundsdoftir
197 left: © Henry Brockman
197 right: (Vane Lindesay, Melbourne). © Tony Rafty
198: Mrs Jocelyn Birdsall Collection and copyright, London
199 left: (*Punch* Library, London), © William Hewison
199 right: Yaacov Farkas Collection and copyright, Tel Aviv
200: (Terry Mosher, Montreal). © Ed Franklin
201: © Paul Flora
202 left: © Fritz Behrendt
202 right: © H. E. Köhler
203 left: The Swann Collection of Caricature and Cartoon, Library of Congress, Washington, D.C.
203 right: © Roland Moisan
204: Gustave Karlsson Collection and copyright, Stockholm
205 left: Gustave Karlsson Collection and copyright, Stockholm
205 right: (Terry Mosher, Montreal) © Duncan Macpherson
206: © David Levine
207 top left and right, bottom: © David Levine
208: © Wally Fawkes
209: (Terry Mosher, Montreal). © Andy Donato
210 left: © Horst Haitzinger
210 right: © Verlag Fritz Molden, Munich
212 top: © Patrick Oliphant
212 bottom: Nicholas Garland Collection and copyright, London
213 top: Jacky Redon Collection and copyright, Paris
213 bottom: The Swann Collection of Caricature and Cartoon, Library of Congress, Washington, D.C. © 'Choé'
214 left: Robert Grossman Collection and copyright, New York

214 right: Paul Szep Collection and copyright, Boston
215: The Swann Collection of Caricature and Cartoon, Library of Congress, Washington, D.C. © Brad Holland
216: © Gerald Scarfe
217 left and right: © Gerald Scarfe
218 left: (Terry Mosher, Montreal). © Roy Peterson
218 right: Library of Congress, Washington, D.C. © Edward Sorel
219: Swann Collection of Caricature and Cartoon, Library of Congress, Washington, D.C. © Edward Sorel
220 left: John Jensen Collection and copyright, London
220 right: © Barry Fantoni
221 left: (Vane Lindesay, Melbourne) © Pascual Locanto
221 right: © Ernst Maria Lang
222: © 'Marc'
223 left: Terry Mosher Collection and copyright, Montreal
223 right: Jan Fritz de Knoop Collection and copyright, Amsterdam
224 left: © Richard Willson
224 right: (Terry Mosher, Montreal). © Edd Uluschak
225: Ranan Lurie Collection and copyright, U.S.A.
226 left: *Le Canard Enchâiné* Collection and copyright, Paris
226 right: (*Asahi Shimbun*, Tokyo). © Yamafuji Shoji
227: © Ralph Steadman
228: Gerard Alsteens Collection and copyright, Brussels
229 left: Tullio Pericoli Collection and copyright, Milan
229 right: © Hermenegildo Sabat
230: Peter Fluck and Roger Law Collection and copyright, Cambridge
231: Patrice Ricord Collection and copyright, Paris
232 top: Jean Mulatier Collection and copyright, Paris
232 bottom: Claude Morchoisne Collection and copyright, Paris
233: Jean Mulatier Collection and copyright, Paris

Index

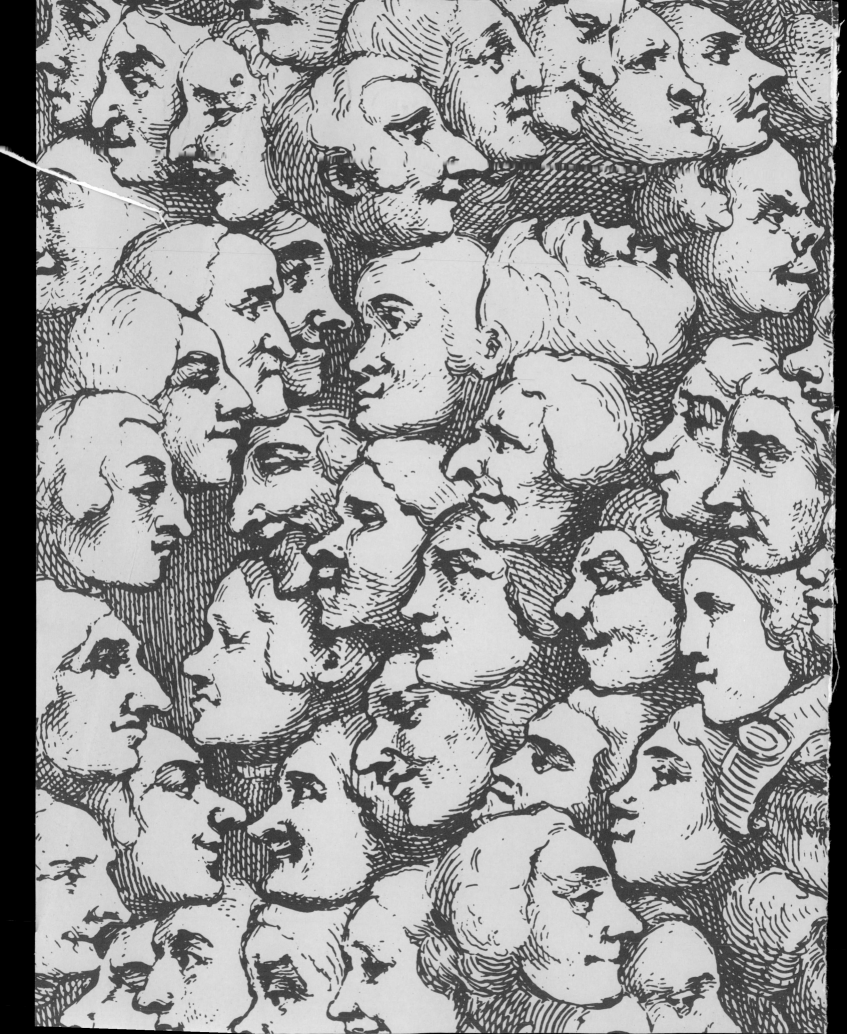